The Afro-American Artist

The Afro-American Artist

A Search for Identity

Elsa Honig Fine

Knoxville College, Tennessee

Holt, Rinehart and Winston, Inc.

New York Chicago San Francisco Atlanta
Dallas Montreal Toronto London Sydney

I dedicate The Afro-American Artist *to the professional inspiration provided by the late James A. Porter, art historian, whose pioneer research in Afro-American art made this current work possible. In addition, I wish to make a personal dedication in memory of my father, Samuel M. Honig, poet and attorney, and my husband, Harold J. Fine, and my two daughters, Erika and Amy.* E.H.F.

Editor Dan W. Wheeler
Production editors Rita Gilbert and Hermine Chivian
Picture editor Joan Curtis
Designer Marlene Rothkin Vine
Proofreader and indexer Patricia Kearney

Special acknowledgement is made to the following publishers
for permission to reprint copyrighted material:
Dodd, Mead & Company, Inc., for selections
from *17 Black Artists* by Elton Fax, copyright © 1971
by Elton C. Fax; The Viking Press, Inc.,
for an illustration from *God's Trombones*
by James Weldon Johnson, copyright 1927
by The Viking Press, Inc., 1955 by Grace Nail Johnson.

Preface

The story I have wanted to tell in brief is that of the evolution of American culture, insofar as this experience in civilization can be perceived from the point of view of the Black citizen whose expressive means have been those of the visual arts. From the time of the first arrivals of Black people in North America, forcibly transplanted there from African soil, Afro-Americans have been preoccupied with the creation of objects so carefully and finely formed as to possess aesthetic merit, however practical their purposes. Thus, there have always been Afro-American artists, even though other aspects of our culture failed so completely that now it is extremely difficult to retrace the steps by which workers in wood and iron and itinerant limners of the Colonial era became the population of Black painters and sculptors producing some of the strongest and most original art to be seen in contemporary America. The very success of the modern Black artists makes the story of a unique tradition—an experience simultaneously at one with yet independent of American civilization in general—so fascinating that such efforts as the present book seem called for, despite the inadequacies of current scholarship that inevitably prevent the narrative from being more than tentative and partial.

Throughout almost four hundred years of residence in what became the continental United States, the Black has fought for his citizenship, for all the rights, privileges, and responsibilities such status entails. Periodically, however, in response to frustration, anger, despair, and an inability to cope further with white hostility, the Black American has elected to withdraw from the dominant society, to establish his own economic enclaves within the ghetto, even to return to ancestral Africa. Withdrawal meant accommodation of those forces in white society—economic, political, or sexual—that felt themselves threatened by the Black presence. Identification with white society menaced the values of Blackness, its uniqueness, culture, racial pride, and the political and economic clout possible among people who share a common ideology by virtue of their living together as a densely concentrated population. A further irony is that the very leadership within the ghetto community—the businessmen, lawyers, and physicians who derive their livelihood from the segregated group—has been the main generative force in such integrationist organizations as the National Association for the Advancement of Colored People and the Urban League, the success of which must be, in most instances, a dissipation or relative loss of power for the Black establishment.

Formerly, resurgences of Afro-American creativity, as in the 1920s with the New Negro Movement, were affirmations of racial heritage and racial pride whose thrust and power remained dependent upon white financial support. Today, militant Black movements reject white leadership and participation and build from a foundation within the Black community itself. Here, the white liberal has become anathema, a symbol of paternalism and condescension, and an unwelcome reflection of past dependency.

Many Afro-American artists now feel compelled to direct their work toward the specific interests and sensibilities of Black people, toward an interpretation and an exposition of the struggle for equal rights, toward an enshrinement in paint, steel, or stone of the Black cultural heritage. Yet, many of these, trained in the American tradition, find their aesthetic language within the idiom of contemporary American art.

Schools are failing the American child, especially the Black child. The nature of education has changed, and the schools' traditional role of social equalizer is being challenged. All the while that recommendations based on research overwhelmingly favor education in racially integrated institutions, elements within the Black community feel compelled to accommodate white racism by demanding their own schools, where Black children can never be confronted with the world as it exists outside the classroom, and where white children cannot be confronted with their own racism.

Thus, the Black's dilemma: Who is he? Where does his identity lie? Are his needs to be met best by isolating himself within the Black community, or by struggling to gain full equality as an American citizen?

Factions in the Black community have formulated a multiplicity of answers to all these questions—questions asked again and again during the last four hundred years. In the late 18th century, a group of free Blacks, despairing of their treatment in slave-owning America, first advocated a return to Africa. "Buy

Black!" or "Black power!" is not a new cry; it is as old as the civil rights struggle. Some leaders, ardent protesters for integration in their early years, became separatists when they realized their life's work had achieved little change in the system that oppressed them by exclusion.

Periodically, in each century, the integrationists challenge the separatists. First, one movement seems sovereign, then fades, only to reappear under new leadership, with similar rhetoric. Although in no period did one attitude prevail exclusively among Afro-Americans, the dominant spirit of the age made itself felt in all aspects of Afro-American life. Just after Reconstruction, when the Black held little interest for the larger white society but by it was treated as a comic figure, few Afro-American visual artists sought to depict any aspect of Black life. It was a time when Afro-American writers composed novels and poetry to reveal to the white world the virtues of Black middle-class life. Today, however, in a renewed spirit of militancy and a desire to choose separatism, some Black leaders demand for the Black community separate schools controlled by Blacks, and, in addition, the Black artist is portraying the Black experience in both the United States and Africa and finding the means to monumentalize this representation with dignity.

Because of their ineffable power to express and communicate, the visual arts have invariably served Blacks, as they have provided a language for all humanity, in their search for selfhood and for an articulated image of that sense of self. Culture exists when a set of values comes to be acknowledged as sound and sacred by a group holding a common notion of the meaning of those values. Clear, cogent, successful expression of such a vision is the very foundation of a culture, and the visual arts are the vehicle for conveying the significance of what a civilization is about. Thus, we have Afro-American artists, and to better understand their work, I have attempted to recapitulate the search they have seemed to pursue through family, community, education, social status, economics, travel, politics, ideology, aesthetic formulation, and the sources of patronage. Although the text is a history of cultural experience, I have hoped to use it as a point of departure for savoring the greatness of the present while anticipating the promise of the future.

Where the opportunity presented itself, I have quoted in a selective way from commentaries made by historical and contemporary figures. These reflect the ideals and goals respected by the original authors and held at the moment when they worked, wrote, and spoke. In the contemporary section especially, I have excerpted liberally from remarks and statements made by artists themselves. In every instance, my objective was to reveal something of the sense the past had of itself and to capture the mood of the present in the life and work of Black artists.

First and last, there are the artists whose lives and achievements are the subject of this book, and without the interest and sympathetic support of the many Black masters to whom I appealed for illustrations, insight, and information, the book, whatever its qualities, could not have existed. Before all others, I want to acknowledge their generous contribution. In addition, I must thank the many libraries, museums, galleries, and private collectors that offered similar help—most especially Dr. Dorothy Porter of the Moorland-Spingarn Collection at Howard University; Ms. Rachel Puryear at the Museum for the National Center of Afro-American Artists in Boston; Ms. Ruth Ann Stewart of the Schomberg Collection in New York; and Ms. Shana Henze as well as Ms. Nancy Hallmark at the Museum of African Art, Frederick Douglass Institute, Washington D.C. To Mr. Clarence John Laughlin of New Orleans go my thanks for making available to us his photographs of and notations on Melrose Plantation. Kynaston McShine of the Museum of Modern Art in New York and Professors Marie E. Johnson of the University of California at San Jose, Lois Mailou Jones of Howard University, and James E. Lewis at Maryland's Morgan State College all looked at one or more versions of the manuscript as it developed, and to them I gratefully acknowledge the debt I owe for their encouragement and/or helpful criticism. I was also the beneficiary of a searching criticism offered by Romare Bearden on the passage that I prepared concerning his life and art. Joan Curtis at Holt, Rinehart and Winston performed heroics in the difficult enterprise of finding and obtaining appropriate illustrations. To all the publisher's staff responsible for the art books—Dan Wheeler, Rita Gilbert, Marlene Vine, and Patricia Kearney—I give my sincere thanks for the expertise and enthusiasm with which they guided my book through the editorial narrows leading to publication. Significant because ultimate, my last acknowledgment is to my family for their steadfastness and forebearance throughout the years that *The Afro-American Artist* functioned as a transcendent cause in my life.

E. H. F.

Knoxville, Tenn.
March 1973

Contents

The Search for Identity

The Black is today engaged in forging his image on the American cultural scene. Unlike his brethren in the earlier decades of this century, the Black is no longer content with a second-rate imitation of white middle-class society, but seeks to be judged on his own terms, by his own values and standards. He takes new pride in his distinctive speech patterns, hair texture, and body structure. He is forcing changes in the curricula of schools and universities. Refusing to remain the "invisible American," the Black demands not only recognition but compensation for centuries of subjugation and prejudice. The Black musician has already left his imprint on American culture, and the Black artist intends to do the same.

The position of Black artists in the United States today poses several questions: Why is there not a Black visual art tradition comparable to that in music? What is the role of the Black visual artist? Where do his traditions lie—with the American culture or with his African heritage? What should be the unique contribution of the Black artist? Should he express his personal emotions in his art, or does his responsibility rest with his people? These are not new concerns. Indeed, they have troubled Black artists and writers for nearly a century, reaching their climax during the Harlem Renaissance of the 1920s and reemerging with the militancy of the sixties and seventies.

In the early years of the Republic, the system of slavery, especially the domestic and rural form, forced rapid assimilation on the newly arrived Afro-American.[1] The plantation (Fig. 1) created a social system all its own. Both isolation and intimate contact with the master's family compelled American Blacks to adopt the

[1] All notes to the text will be found in a special section beginning on page 288.

1

white man's language, religion, and values. Furthermore, the white man's blood was often forcibly mingled with that of the Blacks, producing children of mixed origin. These offspring, who frequently served as "house niggers," became the elite of Black plantation society and scorned the boisterous common field hands. Mimicking their masters' conservative standards and restrained manners, the domestic servants "wanted to *be* the quality people with whom they identified."[2] The middle rank of slaves included the artisans, the cook, and the gardener, who "knew their place" and enjoyed special privileges. It was not from these groups but from the field hands—with their bent and tortured bodies, their cramped intimacy in the slave quarters, their burden of overwork—that the Black folk arts emerged. This Black folk culture eventually crystallized into an American peasant culture. With its rejection of the poor whites and its paternalistic acceptance of the Black, the southern plantation system became the "closest approximation in American social history to the conditions and social climate of peasantry." Because it was never assimilated into the great American "melting pot," the Black folk culture did not dissipate. Rather, enforced segregation helped to strengthen and

enrich the Black's expressive style. Today, the Black folk culture, as communicated through the blues, the spiritual, jazz, soul music, and rhythmic dances, has finally become an integral part of the American cultural experience.[3]

When Afro-American artists began to receive national attention in the late 19th century, they were considered pretentious by Blacks, as well as by whites, since painting was thought to be the "ultimate expression of a civilized people." Although Black Africa boasted a long tradition in the arts, most Afro-Americans, cut so abruptly from their cultural roots, were unaware of it. Stripped of all expressive materials, the captive Blacks fulfilled their creative urges through their bodies—in song, speech, dance, and pantomime. In Africa, weaving, metalwork, and sculpture were the principal arts, and African artistic skills were "technical, rigid, controlled and disciplined; characteristic African art expression is, therefore, sober, heavily conventionalized, and restrained." However, in isolated areas with heavy slave concentrations, elements of the folk art traditions of basketry, woodcarving, and ceramics survived.[4] Symbols and motifs were reworked to serve new functions, and substitutes were found in

1. THOMAS CORAM. *The Street and Great House at Mulberry.* Late 18th century. Oil on wood, miniature. Carolina Art Association, Charleston, S.C.

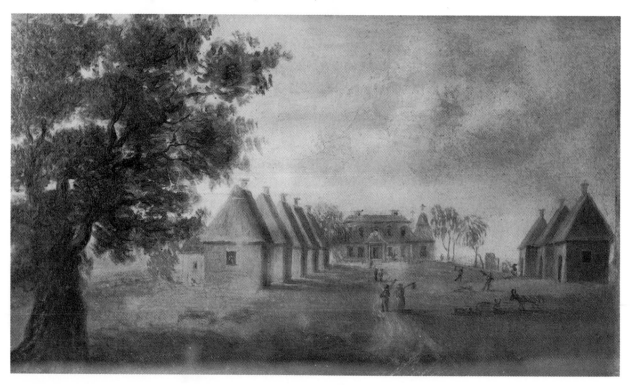

the North American soil to replace the materials of the African continent.

Visual expression in Western culture is an essentially middle-class endeavor. Painting as a fine art grew out of the artisan class, which eventually became the middle class. The aristocrat could be a connoisseur and a patron of the arts; his background prohibited actually working with his hands. The peasants developed a folk art, but the fine arts are a product of leisure, security, and education.[5] Ever since Edmonia Lewis, a Black sculptor (Figs. 92–97), matriculated at Oberlin College in 1859, the serious Black artist has followed the white man's course in seeking to develop his art. In fact, most of the artists reviewed in this book—despite the indignities they have suffered from being Black in a white society—have had training and experience similar to those of white artists. Educated in the predominantly white art schools at home, polished by travel and study abroad, most Black artists responded to the rapidly changing 19th- and 20th-century art movements as artists, not specifically as Black artists.

Margaret Just Butcher has written:

> We must not expect the work of the Negro artist to be different from that of his fellow artists. Product of the same social and cultural soil, the Negro's art has an equal right and obligation to be typically American at the same time that it strives to be typical and representative of the Negro. Ultimately the American Negro must make as distinct a contribution to the visual arts as he has made to music.[6]

There is a problem in the last sentence of this statement. Afro-American music developed as the folk expression of an oppressed people who were denied most other means of creative experience. Music and dance of this nature spring from the grass roots, while art is a function of middle-class life. Although Black painters have participated in the American visual art scene for more than a hundred years, their contribution has been minimal compared to the Black musician's role in American music.

This inadequate representation of Blacks may be the result of an inferior education, from their obsolete elementary schools to their poorly financed Black colleges. John T. Scott, instructor in art at Xavier University, states that "because of no education in art (or a very poor education that functions negatively), the lower-income bracket Negro is visually illiterate."[7] About 60 percent of Black Americans who attend college are enrolled at predominantly Black colleges. The art instructors at such institutions are lower paid and lower ranked than their colleagues at predominantly white colleges; their work is exhibited less frequently. Moreover, their own training may have suffered from the same deficiencies as that of their students, so the cycle is self-perpetuating. Slide collections and library resources at the Black colleges are limited, as are print collections and exhibition space. In other words, students arriving at these institutions begin with an inadequate background and continue with limited facilities and poorly prepared teachers, so their chance for professional competence is remote.[8]

In the early part of the 20th century a number of artists working in Paris—including Pablo Picasso, André Derain, Maurice de Vlaminck, and Henri Matisse—"discovered" African art and began to incorporate elements of it in their own painting and sculpture. The Fang mask reproduced in Figure 2 is still

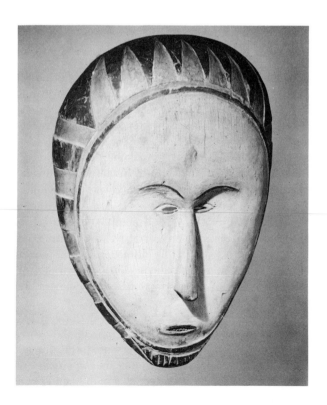

right: 2. Fang mask from Gabon, given in 1905 to MAURICE DE VLAMINCK who subsequently sold it to ANDRÉ DERAIN; also seen by MATISSE and PICASSO. Wood whitened with kaolin, height 18⅞″. Collection Alice Derain, Chambourcy, France.

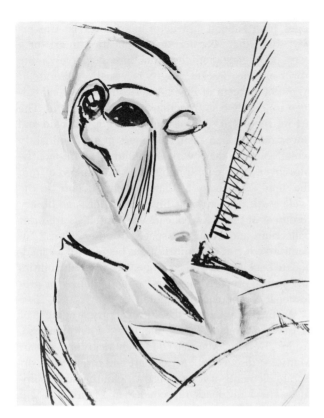

3. Pablo Picasso. *Head of a Man*
(study for *Les Demoiselles d'Avignon*). Early 1907.
Watercolor, $23\frac{3}{4} \times 18\frac{1}{2}''$.
Museum of Modern Art, New York.

owned by Derain's widow and is the only piece of African sculpture now verified as having been in the possession of this group. This mask or a similar one may have inspired Picasso when he executed the drawing reproduced in Figure 3, a study for *Les Demoiselles d'Avignon* (1907). In any event, the "neoprimitive" work by these artists helped to stimulate the growing popularity of Black African art, a vogue that eventually reached the United States. At first the artifacts were regarded as awkward attempts at realism, but with increased observation and study, the sophisticated Europeans realized that the distortions were "not a crude attempt at realism but a skillful reworking of forms in simplified abstractions and deliberately emphasized symbolisms."[9]

A question was raised about the relationship between African art and the production of the Afro-American. Many Black artists resented this forced identification with Africa, claiming the American experience was stronger than the racial one. Alain Locke

(Fig. 4), an early advocate of Black consciousness and a leader in the historic Harlem Renaissance of the 1920s, hoped for the development of an Afro-American art idiom based on the discovery of African forms. The European artists had, in a sense, been liberated by their awareness of an aesthetic and a form totally alien to their own traditions. But to the Europeans, claimed Locke, it was just an "exotic fad." For the Black American artists, since there existed a "historical and racial bond between themselves and African art . . . [it] should act with all the force of a rediscovered folk-art, and give clues for the repression of a half-submerged race-soul."[10]

The search for identity by the Black artist in America has been a continuous process. The 19th-century artist often sought solace in Europe, and many 20th-century artists have done the same.[11] But the essential question remains unanswered: Who is the Black artist, and whom does he represent? The Black poet Paul Laurence Dunbar (Fig. 72) responded in the following manner to a query about the difference between white and Black poetry: ". . . [Black] poetry will not be exotic or differ much from the white's. For two hundred and fifty years the environment of the Negro has been American, in every respect the same as that of all Americans."[12]

Poet Langston Hughes (Fig. 5) has urged his brethren to portray their blackness in their art. Expressing contemporary slogans such as "Black is Beautiful" and "Black pride," Hughes was documenting the separateness and uniqueness of the Black experience as long ago as 1926. He also urged the Black artist to be honest in his interpretation of Black life. He wrote:

> We younger artists who create now intend to express our individual dark skinned selves without fear or shame. If the white people are pleased, we are glad. If they are not, it doesn't matter. We know we are beautiful. And ugly too. . . . If colored people are pleased we are glad. If they are not, their displeasure doesn't matter either. We build our temples for tomorrow, strong as we know how, and we stand top of the mountain, free within ourselves.[13]

Afraid of being identified with the caricatures created by white artists, the Black artist usually shunned Black subject matter. If a Black was portrayed in a less-than-appealing manner—whether the depiction was honest or not—the Black middle class protested. When the playwright Eugene O'Neill caught what W. E. B. DuBois called the "Negro temper" in

The Emperor Jones (Fig. 6), educated Blacks rebuked him, and they in turn were chastised by DuBois, who wrote that the Black should feel secure enough to "lend the whole stern human truth to the transforming hand of the artist." At this time DuBois developed his "Truth in Art" theory, which appealed for honest expression, rather than mere propaganda. As early as 1913 he viewed the Black as "primarily an artist," and later wrote: "We are the only American artists."[14]

A Black cultural regeneration labeled the "Harlem Renaissance" or the "New Negro Movement" was in evidence in large northern urban centers by the middle of the 1920s. The shape and direction of the movement was a subject of active debate among the leading Black intellectuals of the day. Alain Locke continued to urge that Black artists, lacking a tradition of their own, adapt their ancestral forms. Locke affirmed, "We ought and must have a school of Negro art,

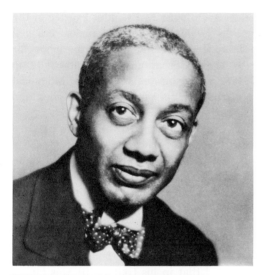

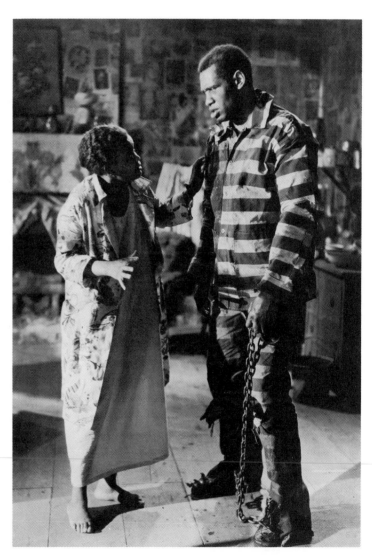

above left: 4. ALAIN LOCKE (1886–1954).

left: 5. LANGSTON HUGHES. May 5, 1967.

above: 6. PAUL ROBESON in a scene from EUGENE O'NEILL'S *Emperor Jones.* c. 1924.

a local and racially representative tradition."[15] By this time, discouraged by constant rebuffs from white society, DuBois had changed his attitude. Writing in *Crisis*, the official publication of the National Association for the Advancement of Colored People, he expressed his anger at literature such as Carl Van Vechten's *Nigger Heaven*, which he felt treated the Black as a buffoon. "'Truth in Art' be damned," he wrote. "I do not care a damn for any art that is not used for propaganda."[16] In 1926, at an NAACP convention, DuBois argued that: ". . . the Negro artist . . . must turn his art into conscious propaganda, because for the Negro, though not for white America, art and propaganda were unified by their common devotion to truth, beauty and right."[17] By 1931, when he was advocating a separate Black society and attracted by Communist ideals, DuBois declared that the role of art was to lead society in fulfilling its highest principles. Art was to serve the people, and the Black artist would be judged according to racial, not artistic standards.[18] DuBois' thought was much influenced by the Communist aesthetic, which has produced a school of "social realism" in art, thereby negating the great achievements in Russian art that were manifested in the first decade of this century.

7. James A. Porter (1905–1970).

Other writers disagreed with Locke and DuBois, arguing that the latter's philosophy would only further segregate the Blacks. A split developed that threatened to enfeeble the new movement. According to Black art historian James Porter (Fig. 7), one group contended "that to avoid imitation of white tradition the Negro must deny everything that might be construed as derivative from white experience"; the other insisted "that the Negro should encompass all experience, not attempting to suppress non-Negro influence, for such suppression meant intellectual and aesthetic negativism."[19] A more rational guide for the Black apologist was elicited by sociologist E. Franklin Frazier in the Black anthology *Ebony and Topaz*. Frazier reasoned that ". . . to turn within the group experience for materials for artistic creation and group tradition is entirely different from seeking in the biological inheritance of the race for new values, attitudes, and a different order of mentality."[20]

All the propaganda of the 1920s failed to produce a Black aesthetic. Those who attempted to identify with their African heritage were reduced to academicism or superficial renditions of stereotyped images,[21] and still the search for an identity continued. When the Afro-American was content with his personal role in American art, he was challenged by his colleagues. Accused by a white artist of painting like a white man, Malvin Gray Johnson (Fig. 8), a promising painter of the 1930s, replied that in his training he was taught the principles of art, the use of lines, forms, and colors, the same as the white student. "We Americans of both races know and live the same life, except the Negro encounters racial restrictions."[22] In 1968 Hale Woodruff (Pl. 9, p. 109; Figs. 165–171), a prominent Black artist and former Professor of Art Education at New York University, was asked during a symposium if he thought the Afro-American had a special relationship to American society. His response revealed longings similar to those that Johnson had expressed more than three and a half decades earlier:

> Everything the Negro artist does has to do with his image of himself and his aspirations. It involves human as well as racial fulfillment. The Negro artist faces all the "artistic," hence, economic and cultural problems all artists face. But for the Negro artist these problems are aggravated by the fact that the "power structure" of the art world is not altogether prepared to accept him as "just another artist," particularly in the visual arts. They still desire, seemingly, a non-white quality which presents the Negro artist as being unique and therefore different from other artists.[23]

8. MALVIN GRAY JOHNSON.
Meditation. c. 1932.
Oil on canvas.
Courtesy National Archives,
Washington, D.C.
(Harmon Foundation).

Charles Alston (Pl. 13, p. 127; Figs. 184–189), a contemporary of Woodruff's, agrees that there is no such thing as "Black art," but, rather, a "Black experience." "I've lived it," commented Alston. "But it's also an American experience. I think Black artists want to be in the mainstream of American life, and I believe in their insistence on it."[24] Most of the participating members of the symposium expressed similar sentiments. However, Julius Lester, the militant Black writer, urged Blacks to repudiate all white institutions.[25]

A visitor from another country sees the Afro-American as an American. His attitudes and values, his goals and ideals are all shaped by the American environment. His dream has been the American dream. Yet his experience in the United States has proved unique. Snatched from his ancestral home, denied any cultural continuity, the Black was forced to absorb the life he saw but was never allowed to become an integral part of it. He has been an alien in his own land. However, one might argue that this situation can be used to advantage. In order to explore new worlds, the creative artist must remain separate from the larger culture, for outside the culture he is free to mold it, shape it, and lead it to higher ideals, without fearing the judgment of society as a whole. This is both the tragedy and the opportunity of the Black artist. Shaped by his environment, trained by its institutions, he has a deeper and richer—though often tragic—experience from which to

draw his inspiration. As Robert Bone said of the Black novelist, "If his art cuts deep enough, he will find the Negro world liberating rather than confining."[26]

Returning to Africa for roots and tradition is not always the answer, for the Afro-American seeking solace in Black Africa may find he is a stranger in a distant land. By taking advantage of the opportunities offered by both American societies, Black and white, separate yet similar, the Afro-American artist will be free to create. On the other hand, the bloodshed and hostility engendered by the battle with white America may have just the opposite effect from the one intended, leading to creative and intellectual impotence, a diversion of energies from the artist's unique contribution to the Black experience.[27]

Perhaps Edward Wilson, a sculptor and Professor of Art at the State University of New York in Binghamton, has the answer. Rather than dedicating himself exclusively to the fight for equality, the Black artist should "commit himself to seeking humanistic values." To discover the universal in the specific, to transform the Black experience into "universally understood terms"—this is the role of the Afro-American artist. The Black jazz musician has done this, and, claims Wilson, the painter Jacob Lawrence, whose *Praying Ministers* is reproduced as Figure 9, comes closest to realizing this goal within the visual arts.[28]

Robert Bone seems to agree with Wilson's directives for the Black creative artist. In his introduction to *The Negro Novel in America*, Bone wrote that the Black novelist, like any artist, should strive for a universality "through a sensitive treatment of his own culture." A double burden confronts him, however. Because he belongs to two cultures, "... he must be conversant with Western culture as a whole ... and at the same time be prepared to affirm a Negro quality in his experience, explaining his Negro heritage as a legitimate contribution to the larger culture."[29]

9. Jacob Lawrence. *The Praying Ministers.* 1962. Tempera on masonite, 24 × 36".
Formerly collection Spelman College, Atlanta, Ga. (destroyed by fire, 1972).

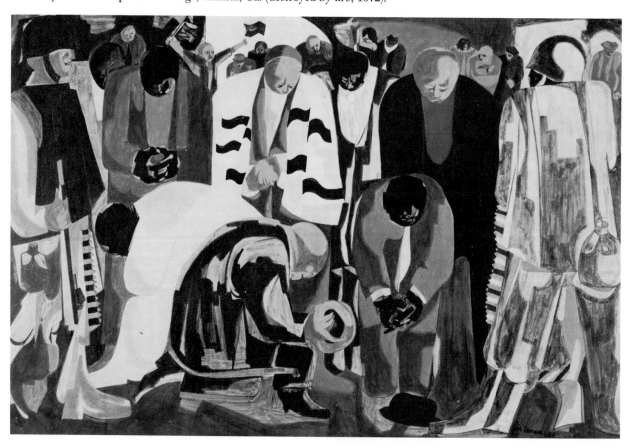

The Journeymen Artists: From the Colonial Period to the Mid-19th Century

With little education and a great lack of leisure time, slaves had limited opportunity to develop their creative capacities, and those encouraged in that direction by economic necessity were rarely rewarded with recognition. Therefore, scant documentary evidence recording slave art has been uncovered. Most ironwork and other craft items were made for the white man's use and patterned after examples in English copybooks; few art objects were ever found in the slave quarters. In all probability, the baskets, vessels, and woodcarvings created in the islands off South Carolina and Georgia, the tools or utensils necessary for survival, and the iron ritual figures found in Virginia were the only genuine folk art—art made by the people of the community for community use—produced by the slaves of North America.

The degree to which the African slaves—uprooted from their native lands and set down in a radically different environment—were able to maintain a measure of cultural continuity depended largely upon where and under what circumstances they were sold. In the Latin American countries, where slaves were employed on sugar plantations in work forces averaging two hundred or more fellow tribesmen, there was ample chance for sustaining cultural patterns. However, in North America, particularly in urban areas, the slave typically was sold as part of a small group or as an individual (Fig. 10), so that cultural ties with Africa were broken quickly. Consequently, the slaves easily fell victim to the colonists' desire to suppress all customs that did not conform to the familiar patterns of Western tradition.[1]

Unfamiliar Western mores were not the only source of culture shock for newly imported slaves. They often had to adjust to the cultures of other tribes as well. The tribes from Upper Guinea—Yoruba, Fon, Fanti, Ashanti, and Ibo—provided most of the slave population in the 18th century, and their cultural beliefs were gradually imposed upon the new arrivals. In Africa, the kinship of the tribe had been of prime importance; the extended family, ancestor worship, and the mystical divinity of the king helped to maintain cohesive tribal units. When this system broke down, the need for religious ritual—and therefore for art objects—was soon obliterated.

It is possible that the southern plantation slave, in general, fared somewhat better (Fig. 11), and that his less drastic adjustment to a new way of life permitted some cultural continuity. Upon his arrival, the slave often found members of his tribe already in residence on the plantation. Moreover, certain parallels existed between the plantation community and that of tribal Africa. Each was a self-contained unit with a rigid hierarchy of work and behavior. Land was owned by the family, and each member was required to work for the benefit of the group. Punishment for misdeeds was immediate and severe. The community as a whole prospered when the crops were abundant and suffered together during lean years. In both systems jobs were assigned according to age and social stratum, and parents jealously guarded the right of their children to inherit their social and economic positions.[2]

10. Notice posted for a sale of slaves to be held aboard ship off Charleston, S.C. Library of Congress, Washington, D.C.

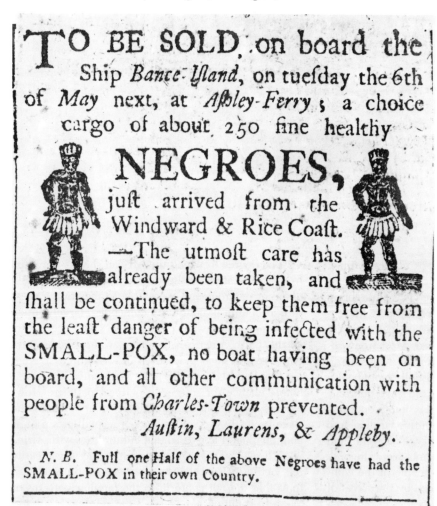

TO BE SOLD on board the Ship *Bance-Island*, on tuesday the 6th of *May* next, at *Ashley-Ferry*; a choice cargo of about 250 fine healthy

NEGROES, just arrived from the Windward & Rice Coast. —The utmost care has already been taken, and shall be continued, to keep them free from the least danger of being infected with the SMALL-POX, no boat having been on board, and all other communication with people from *Charles-Town* prevented. *Austin, Laurens, & Appleby.*

N. B. Full one Half of the above Negroes have had the SMALL-POX in their own Country.

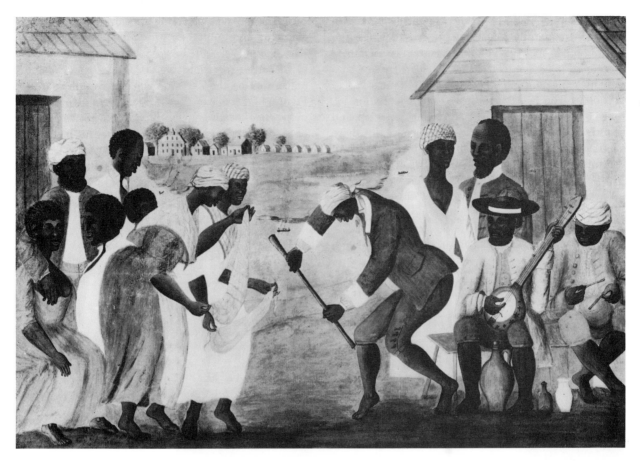

11. *The Old Plantation*. Late 18th century. Watercolor on paper, 11¾ × 17⅞″.
Abby Aldrich Rockefeller Folk Art Collection, Williamsburg, Va.

Anonymous Artisans

Many scholars agree that African influences in narrative, healing, music, dance, and the "rites of passage" marking birth, puberty, marriage, and death did survive.[3] Robert F. Thompson, a Yale art historian, claims that there is evidence of such continuity in the visual arts as well, but that few experts have bothered to search for it. Thompson finds traces of a visual art tradition in the "stoneware vessels shaped in the form of anguished human faces" by 19th-century Black South Carolinians; in the "basketry modes of astonishing purity" found near Charleston; in "the deliberate decoration of graves in the African manner with surface deposits of broken earthenware"; and in the wood carvings unearthed in Livingston County, Missouri, and Onondaga County, New York. All of these artifacts, he maintains, point to a continued visual tradition by Afro-Americans, who adapted remembered ancestral arts to new materials.[4] Also, the circular house with a central fireplace built by Afro-Americans for their own use in Midlothian, Virginia, is African in derivation, and its style is in marked contrast to the English architecture of the period.[5] Other scholars of Afro-American art claim that the wrought-iron balconies, grilles, and doorways attributed to slave labor that have been found in New Orleans, sections of South Carolina, and other South Atlantic states show African influence.[6] James Porter believed that the Janson House, built on the Hudson River for a Dutch patroon in 1712, displays certain features of construction and ornamentation—such as the hand-forged hinges on the Dutch hall-door and the delicately detailed fireplace—that are clearly African in origin.[7]

There exists in what is now Aiken County, South Carolina, an Afro-American ceramic tradition. The

water jugs found in the area (Fig. 12), which Thompson labels "Afro-Carolinian face vessels" and which the slaves called "monkey pots," are composed of mixed sand and pine ash glazed in subdued greens and browns, with removable eyes of kaolin (a pure porcelain clay). The faces have "bared teeth in Kaolin . . . long noses with flaring nostrils, drooping at the tip, and slightly hooked in profile." Thompson maintains there is no precedent for these jugs in the history of Western ceramics, and he suggests a West African geneology. The Afro-Carolinians used the regional white kaolin for texture and contrast in much the same way their ancestors had incorporated white cowerie shells, pieces of mirror, and tin in their mixed-media sculpture (Fig. 13).[8] The pots are often called "grotesque jugs," owing to the odd expressions on the faces—expressions not unlike that on the Bapende wooden cup illustrated in Figure 14. Men were the woodcarvers in Africa, but in America they took over the traditionally female task of pottery making. It was not unusual for patterns to be transcribed from one material to another.[9]

Gullah, a word derived from the name of the African nation of Angola, has been used to identify both the crafts and the dialect of the Sea Islands and coastal

12. South Carolina "face vessel" with porcelain (kaolin) clay-inset eyes. 19th century.

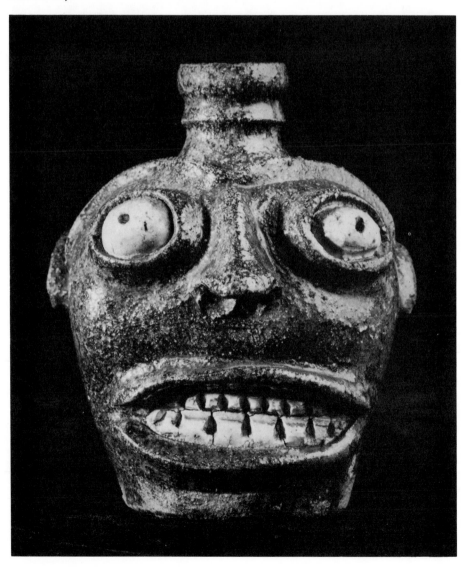

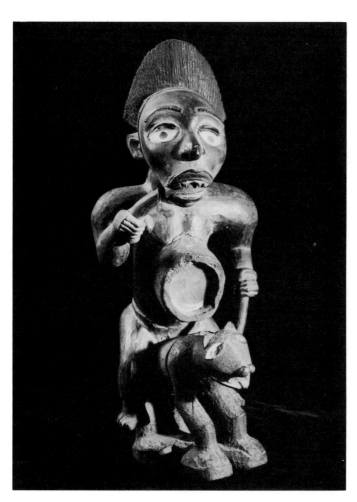

13. Figural sculpture with glass-inset eyes, from Bakongo, Zaïre, Republic of the Congo. 19th century. Wood, glass, and paint; height 13″. Museum of Primitive Art, New York.

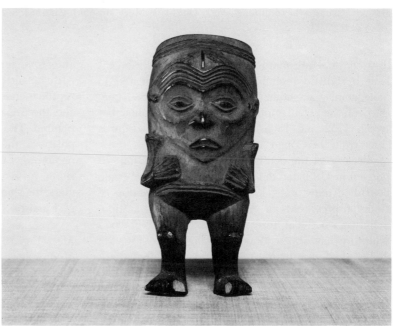

14. Cup, from the Bapende tribe, Zaïre, Republic of the Congo. Late 19th–early 20th century. Wood, height 5⅝″. University Museum, Philadelphia.

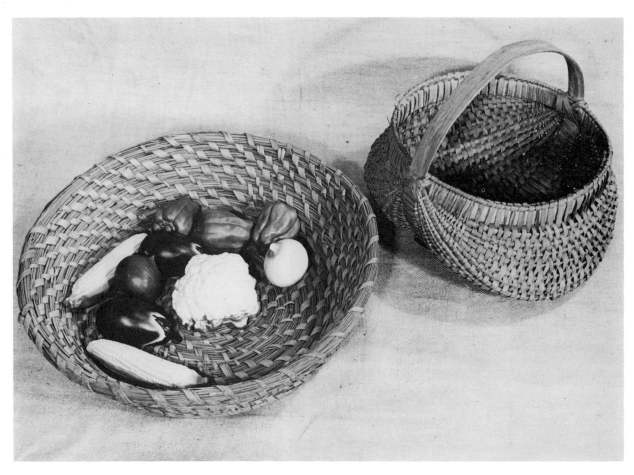

15. Basketry made by the Gullah people of South Carolina.
Coiled vegetable basket (*left*) and egg basket (*right*).
Modern examples of traditional work. Old Slave Mart Museum, Charleston, S.C.

districts of South Carolina. Gullah baskets (Fig. 15) bear a stylistic resemblance to those fabricated in Senegambia, a section of Africa that provided one-third of the slave population in South Carolina between 1752 and 1808.[10] (The remaining two-thirds came from the Congo-Angola area.)

Because of the density of its Black population (70 percent in 1790) and the fact that an illegal slave trade flourished there until 1854, the tidewater section of Georgia preserved an African visual art tradition, mainly in wood sculpture. Three classifications of wood sculpture have been found: walking sticks (Fig. 86) embellished with figural relief carving, small statuary in the round (Fig. 18), and virtuoso openwork abstractions each carved from a single piece of wood. The symbolism in these carvings is reminiscent of African woodwork (Figs. 87, 88). Reptiles—lizards, tortoises,

alligators, serpents—are depicted frequently in both African and Afro-American carvings. In Africa, the reptile is endowed with magical and mythical qualities, and there is evidence that the magic has been transplanted. The portrayal of the human figure in frontal positions, the monochromatic coloring, the "simultaneous use of two or more vantage points with the same frame or visual reference," the ubiquitous beads and glass, the smooth surfaces, and the frozen faces all suggest artistic continuity.[11]

Another example of transplanted style is the *Iron Man* (Fig. 16), a figure 14 inches high that was discovered under a blacksmith's shack on a Virginia plantation. Probably wrought by a slave, the statue is rigidly posed in a manner that recalls African ritual figures (Fig. 17); the "crude portrait head of a southern colonel suggests that . . . [it] figured in a quasi-voodoo ritual."[12]

below: 16. *Iron Man,* discovered under a blacksmith's shack on a Virginia plantation. c. 1800. Height 14″. Collection Mrs. Adele Earnest, Stony Point, N.Y.

right: 17. Figure representing a member of the Lilwa Society, from the Mbole tribe, Zaïre, Republic of the Congo. Wood, height 36¼″. Musée Royal de l'Afrique Centrale, Tervuren, Belgium.

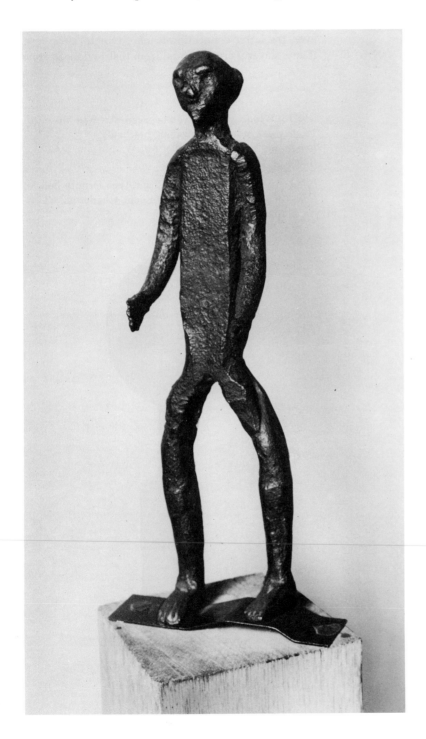

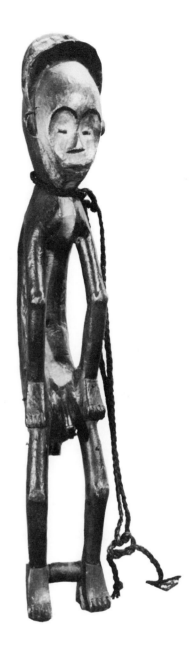

According to Judith Wragge Chase, the slave carving from Missouri reproduced in Figure 18 is a likeness of George Washington. The figure was carved from a single piece of wood, and, like much African sculpture (Fig. 19), it is armless.[13] Another characteristically African feature is the rigid, frontal pose. There is an unusual resemblance between the carved figure and an armless stone image from South Africa (Fig. 20). However, the latter connection is more remote, since few, if any, slaves were imported from that region. In spite

left: 18. *Wooden Doll,* carved by Negro slaves in Missouri. Single piece of hollowed walnut, height 29″. Rendering. National Gallery of Art, Washington, D.C. (Index of American Design).

below: 19. *Armless Akua'ba,* Ashanti-type fertility doll, from Ghana. Old Slave Mart Museum, Charleston, S.C.

of all these stylistic parallels, Thompson concluded that, because of the traumatic ocean crossings and the exigencies of bondage, the surviving visual art tradition was "generic, simple, and (almost completely) restricted to areas of dense and recent contact with tropical Africa."[14]

In all likelihood, the Colonial slave traders were unaware of African craftsmanship, nor were they aware of the role played by the artist in West African tribal societies. The African craftsman functioned (and still functions) as an integral part of the community. Since he depended primarily on the patronage of the king, many of the objects he created were intended to glorify the monarch's semidivinity. Although he was allowed some latitude, his work had to meet rigid standards, which, in many cases, are still maintained. Certain crafts were the province of particular families or guilds, and the kind of work assigned to a given family affected the social status of its members. The highest

ranked artisans were the ironworkers, who were viewed with "respect, a mixture of fear and honor."[15] Much ritual and many taboos were associated with the worker and his craft.

> Because his skills were needed to fashion various cult objects, he was necessarily a member of the secret societies and was privy to all important decisions made by the cult in controlling the tribal community. In addition, because of his contact with fire, magic powers were often ascribed to him. Thus, through these twin elements of the sacred and the secular, he often combined the functions of medicine man, chief, and maker of magic figures. A religious aura surrounded his work and a certain mythology, born of awe of the fire and the molten metal, enveloped the process of ironmaking.[16]

Not even the ironmonger's wife was allowed to share his secrets, and, in fact, all women were banned from the smithy. Sexual relations were prohibited before work, for fear they would divert energy from the artist's creativity.

Next in importance to the ironworker was the woodcarver, a thoroughly trained craftsman who was intimately familiar with the nature of the wood he used. Wood was employed primarily for masks, fetishes, and ancestor figures. The African believed that the wood was alive throughout the carving process and that cutting produced pain, so he always asked the spirit of the tree for forgiveness. Since a variety of sacred objects were made from wood, the craftsman's life was circumscribed by many of the same rituals, taboos, and prohibitions that were typically applied to the ironworker.[17]

Basketry and weaving were considered to be women's work, and girls learned these skills when they were very young. Pottery making was also reserved to the women; the wife of the local smith was often the potter of the community.[18]

Art played a crucial role in African tribal life. All the arts—music, dance, sculpture in the form of carved figures—were interrelated on ceremonial occasions. Even in fashioning the humblest tool for his daily needs, the African brought to bear all his creative energies. "Artistic expression was a vital part of the lives of everyone."[19]

When the African tribesman became an American slave, all his skill and experience as a craftsman were

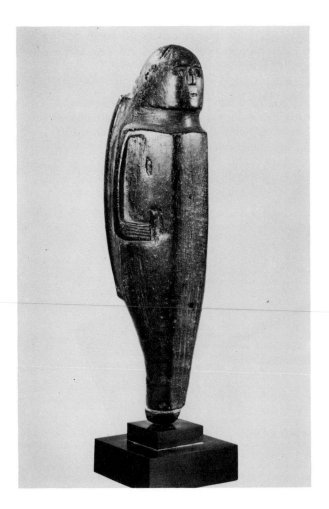

left: 20. *Zimbabwe Figure,* from South Africa.
Stone, height 13⅛″. Collection Paul Tishman, New York.

wasted. Not until the mid-18th century, when there developed in the Colonies a severe shortage of artisans, were the talents of the slaves used to any extent. In 1731 South Carolina had only one potter. Benjamin Franklin called attention to the need for trained workers to supply houses, furniture, and utensils—items that could not be imported easily. Many of the crafts-

men who arrived from Europe quickly left their trades to cultivate new lands, while those who remained in business demanded high prices for their skills and wares. Because of sheer economic necessity, the slave was trained as an artisan.[20]

The earliest recorded slave craftsmen were in Virginia, in 1649, where one planter had "forty colored helpers whom he instructed in spinning, weaving and shoemaking." By the 18th century, the Black artisan figured in the economy of every province in Colonial America, with the largest concentration in the Middle Atlantic cities.[21] Slaves were trained as potters, blacksmiths, weavers, carpenters, and seamstresses (Figs. 21–26); they were instructed in the building crafts; the children were taught to sew and embroider. Planters built looms, and the slaves provided all the fabric needs of the plantation. As Booker T. Washington later pointed out, the plantation was the first industrial training school.[22]

Most slaves, by virtue of their servitude, were rendered faceless and anonymous and seldom were credited with their achievements. However, a few gained recognition for their creativity. In Andover, New Jersey, slave craftsmen produced ironware of such high quality that items bearing their brand names enjoyed

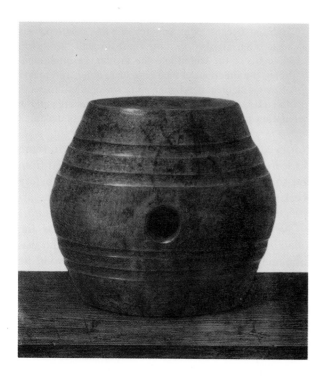

left: 21. Spirit flask, probably from Connecticut. Early 19th century. Ceramic with brownish-orange glaze. Rendering. National Gallery of Art, Washington, D.C. (Index of American Design).

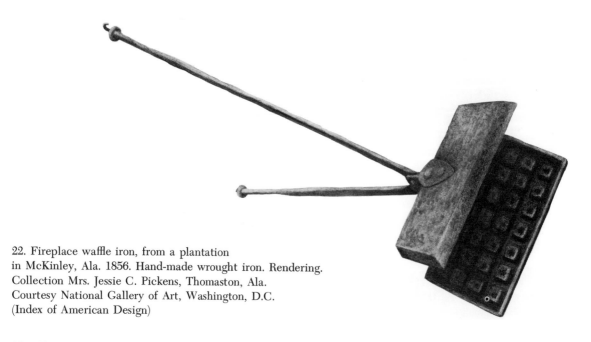

22. Fireplace waffle iron, from a plantation in McKinley, Ala. 1856. Hand-made wrought iron. Rendering. Collection Mrs. Jessie C. Pickens, Thomaston, Ala. Courtesy National Gallery of Art, Washington, D.C. (Index of American Design)

below: 25. Waxed mahogany bureau, made by Negro slaves at Randall Plantation, near Huntsville, Tex. Early 19th century. Rendering. National Gallery of Art, Washington, D.C. (Index of American Design).

bottom: 26. Shoulder cape, made by Negro slaves at Elm Hall Plantation, Raceland, La. 1835–60. Rendering. National Gallery of Art, Washington, D.C. (Index of American Design).

top: 23. Wrought-iron latches, made by Negro slaves in New Orleans. Rendering. National Gallery of Art, Washington, D.C. (Index of American Design).

above: 24. Fragment of woven comforter, made of domestic wool by Negro slaves in Bowling Green, Ky. 1835. Rendering. National Gallery of Art, Washington, D.C. (Index of American Design).

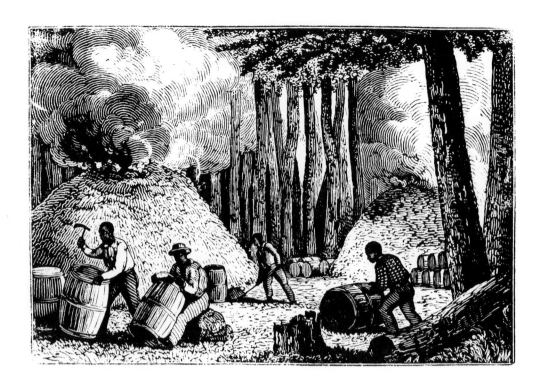

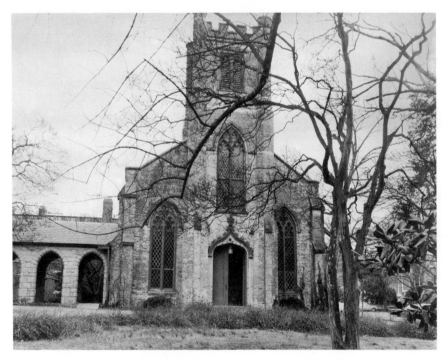

top: 27. *Slaves Making Barrells.* 19th century.
Wood engraving. Prints Division, New York Public Library
(Astor, Lenox, and Tilden Foundations).

above: 28. THOMAS U. WALTER. Chapel of the Cross,
Chapel Hill, N.C. 1843–48.

brisk sales.[23] Furthermore, those with outstanding skills were extremely valuable and were hired out for twenty to forty dollars more than the average slave (Fig. 27).[24]

In time, an economic relationship developed between the southern white man and the Black. Recognizing the skills of the slaves he had trained, and of the trained Blacks who were clever enough to have saved the five hundred dollars needed to purchase their liberty, the "Southern white man did business with the Negro in a way that no one else has done business with him." According to Booker T. Washington:

> In most cases, if a Southern white man wanted a house built he consulted a Negro mechanic about the plan and about the actual building of the structure. If he wanted a suit of clothes made he went to a Negro tailor, and for shoes to a shoemaker of the same race.[25]

Slaves helped construct many southern churches and mansions, among them Cross Chapel in North Carolina (Fig. 28) and Thomas Jefferson's Monticello. The elegant ironwork of the Vieux Carré in New Or-leans, which includes the splendid convent first occupied by the Ursuline nuns in 1734 (Fig. 29), is also attributed to slave craftsmen.[26] When New Orleans was leveled by fire in 1788, the Black ironworker had an unusual opportunity to leave his mark on the city. In an attempt to preserve their architectural heritage, the descendants of the predominantly French and Spanish settlers hired Black men to construct balconies, gateways, and courtyards according to sketches the local gentlemen-architects had made during their travels abroad. The Afro-American artisans interpreted European designs of Gothic, Rococo, and Neoclassic origin in "terms of pure smithing," and the results continue to lend grace and charm to the buildings of the Vieux Carré (Fig. 30).[27]

A guide to Alabama prepared by the Works Progress Administration during the 1930s claimed that:

> While the affluent toyed with painting and filled the role of patrons of art, Negro slaves and members of small farmer families developed rare skill with miterbox, hand-saw, hammer, and needle. Many of the finely

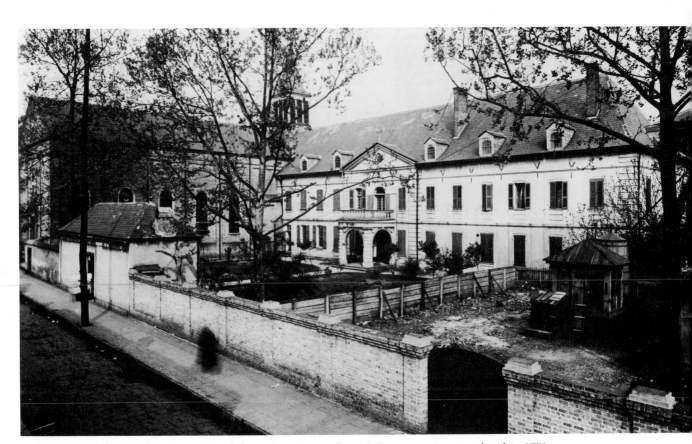

29. Convent of the Ursuline Nuns, New Orleans, La. Designed in 1745, construction completed in 1750.

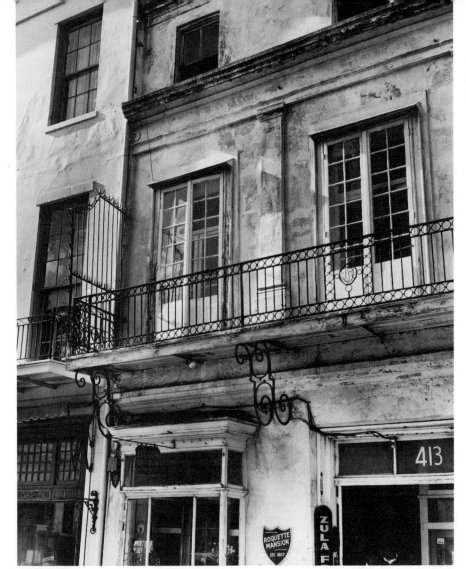

30. Roquette Mansion,
413 Royal Street, New Orleans,
La. 1807.

carved cabinets and mantels that grace plantation homes were made by skilled Negroes who were also adept in ornamental iron work, tinsmithing, and shaping utensils of various design from pewter.[28]

There is ample documentation from newspapers of the late 18th century that slaves also were employed as sign painters, cabinetmakers, and printers. The *Maryland Gazette* of November 2, 1774, announced the sale of a "person . . . who understands engravings in all different branches . . . , and likewise making small cuts of all kinds, woodcuts, arms, and figures on plate in the neatest manner," and on May 1, 1784, a reward was offered in the *Pennsylvania Packet* for information regarding the whereabouts of "a negro named John Frances, by trade a goldsmith."[29]

After the Revolutionary War, the slaves were encouraged to pursue their art, for trade with England had become tenuous, and the masters needed the luxuries formerly imported from abroad. With the economy expanding, the larger plantations established their own workshops, while the smaller ones employed traveling artisans, who were often accompanied by their own slaves. An advertisement placed in a New Orleans paper by a Mr. Bonamy on October 6, 1809, described the relationship: "To Planters. A white workman, blacksmith by trade, who owns a negro slave also a blacksmith . . . wants employment upon a plantation where a smithy is already established or whose owner wishes to establish one."[30] In this way, many slaves earned enough money to buy their freedom. Others were apprenticed, and became free after a prescribed

period of servitude. Although the slave artisan was treated liberally on the plantation, the free Black artisan was never allowed full integration into late 18th-century society.[31]

The Black's hegemony over the skilled crafts and trades began to wane after the War of 1812 restored an open sea, for increasing numbers of German craftsmen began to immigrate. These enterprising workers resented the Blacks, who still dominated the trades, and ultimately they rioted. In the end, however, the Germans' victory over the Blacks was a technological one, for the former had the advantage of mechanical labor-saving devices and were able to set up large foundries that eventually put the smaller, less efficient smithies out of business. Foundry-produced cast-iron decorative items flooded the plantations and the cities. The more creative wrought iron, the product of slave ingenuity and European design, began to disappear in the 1830s.[32] Slave labor, however, did not, and slaves were found working in most of the foundries.[33]

In the spring of 1852 an exhibition of work by Black artisans was presented in Philadelphia. A reviewer for the *New York Herald* wrote the following account for the April 16 issue:

> There is now in Philadelphia an exhibition of colored mechanics on the plan of the Franklin Institute, and for the first effort it exceeds the most sanguine expectations of all. On visiting the place I was surprised to see the beautiful specimens of work exhibited there, which would be of credit to any mechanic. The portrait painting of Vidal of your city, and Wilson of this, are very creditable. The marine paintings of Bowser are excellent. Dutere, an undertaker, has some fine work in his line. Dr. Rock has some of the most splendid specimens of artificial teeth that we have ever beheld, and his recommendation as to character and science we have never seen equalled. There is an invention by Roberts for replacing cars on the track when thrown off which is quite ingenious. There are many creditable things such as sofas, spring bedsteads, fancy tables, bonnets, embroidery, stoves, stereotyped plates, stone-walls, saddles, etc. For the whole, we think the exhibition reflects credit on the colored people.[34]

In the 19th century the artisan-painter was considered a manual worker, because he worked with his hands. This explains the grouping of portrait and marine painters with "mechanics." Evidence suggests that many Black artisans, slave as well as free, became portrait painters, since this was the path followed by most Early American limners (self-taught portraitists).

An advertisement in the *Boston News-Letter* of January 7, 1775, sought clientele for a "Negro man whose extraordinary genius has been assisted by the best masters in London; he takes faces at the lowest rates."[35] Most of the slave artisan-painters remained anonymous, but one exception was Neptune Thurston of Rhode Island. Peterson's *History of Rhode Island* suggested that Gilbert Stuart, the great American portraitist who spent his formative years in the colony of Rhode Island, "derived his first impression of drawing from witnessing Neptune Thurston, a slave who was employed in his master's cooper-shop, sketch likenesses on the heads of casks."[36]

The work of many artisan-painters in this period—and in later centuries as well—can be described as *primitive*, a term that is much abused and contradictorily defined in art history texts. For purposes of this survey, the term *primitive* is used more or less interchangeably with *naïve* to describe artists whose work remains outside the mainstream of Western art. The primitive painter rarely has had formal training, and whatever his interest in the art of others (which could be great), he typically holds fast to a strong personal style based upon technical limitations and an ingenuousness of vision. Certain aspects of primitive painting—from medieval times until the present—have been fairly consistent and universal. The great Russian modernist painter Wassily Kandinsky has said that in the equal weight they give to imagination and reality, primitive painters, like children, operate on a level of "grand reality," a kind of magic realism. Thinking themselves completely objective, these artists produce work that appears totally subjective. Unconscious of formal stylistics, they set out to paint a tree by giving a literal representation of each strip of bark, and the result of this obsessive concern for one aspect of natural phenomena, and one that has nothing to do with optical reality, is the antithesis of visual objectivity. Painting what he knows or dreams to be present, the primitive artist produces a fantastic treatment of what is optically perceptible in nature and a literal treatment of fantasy (Figs. 152, 160). Such art has a truth and a sophistication of its own, and it pleases not only for the freshness of the conception the artist has brought to his work but also for the emphatic way he has composed designs and patterns in strong, pure colors. Among the artists discussed in this text whose work (or some of it) can be called "primitive" are G. W. Hobbs, Joshua Johnston, A. B. Wilson, and Horace Pippin. The best-known modern primitives are the Frenchman Henri Rousseau and the American "Grandma" Moses.

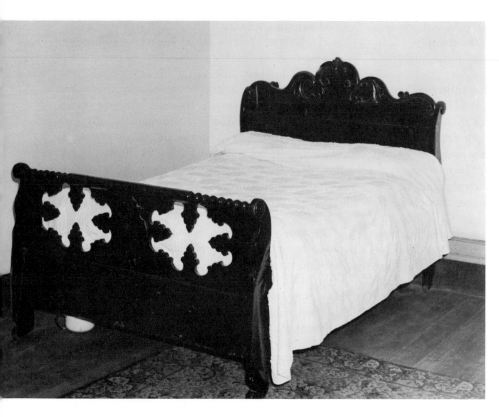

Thomas Day (?–1861)

Family traditions have in some cases preserved the names of artisans who furnished their ancestral homes. One was Thomas Day, a free Black born in the West Indies during the late 18th century and educated in Washington and Boston. His name has been associated with much of the fine cabinetwork found in the stately homes of Virginia, the Carolinas, and Georgia, which is identifiable by its massive form and curvilinear style (Fig. 31). The carved newell post reproduced in Figure 32 intrigues us because of the apparently African-inspired stylization.

Records show that Day's workshop was operating as early as 1818, and that in 1823 he moved to Milton, North Carolina, where he converted an old tavern into a studio. At first he trained the slaves of wealthy white men and employed a few white apprentices to assist him in his expanding business. However, as soon as the slaves became proficient, their owners called them home; thus, to maintain a permanent staff, Day became a slaveholder.

Day found many wealthy customers, including the governor of North Carolina and a judge whose descendants still own a mahogany dining table signed by

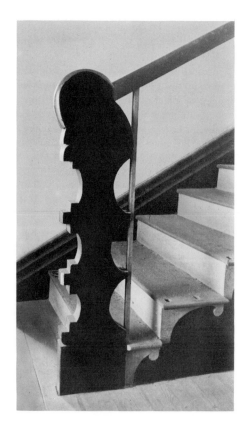

the craftsman. Dated 1820, it is Day's earliest known piece. He would visit a home, often stay for a week, and design and plan the scale for the furnishings of each room. Most of his work was in mahogany.

Describing the craftsman in the *Antiquarian* of September 1928, Caroline Pell Gunter wrote "that Tom Day, an issue free Negro and owner of Negro slaves lived at a time and in a country where Anglo-Saxon supremacy precluded recognition of the Negro race save as laborers—yet he mastered the difficulties of life and used the wonderful talent that was given him to design and build."

With the price of mahogany rising in the pre-Civil War economy, Thomas Day's business failed in 1858. He died soon after.[37]

Scipio Moorhead

A poem dedicated to Scipio Moorhead—"To S. M., a Young African Painter, on Seeing his Works"—by Phyllis Wheatley, identifies Moorhead as one of the earliest slave artists. Although no signed work of his has been found, it is possible that the engraved portrait of Miss Wheatley (Fig. 33) that adorns much of her published poetry is from his hand. Moorhead, the servant of the Reverend John Moorhead of Boston, was instructed in the arts by Mrs. Sarah Moorhead, an artist and art teacher. The primitive drawing, showing a pensive Miss Wheatley sitting at her writing desk with quill pen in hand, is enclosed by a border that identifies the subject as "Phyllis Wheatley, Negro servant

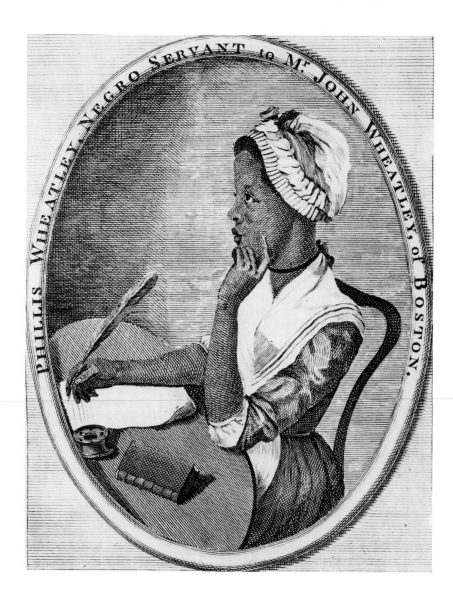

33. SCIPIO MOORHEAD (?). *Phyllis Wheatley,* engraving from *Poems on Various Subjects, Religious and Moral.* 1773.

to Mr. John Wheatley, of Boston." Miss Wheatley was a Black poet whose work is now included in most anthologies of Afro-American poetry.[38] The poem she wrote for Scipio Moorhead displays the elegant literary style of the period:

To S. M., a Young African Painter on Seeing His Works

To show the lab'ring bosom's deep intent,
And thought in living characters to paint,
When first thy pencil did those beauties give,
And breathing figures learnt from thee to live,
How did those prospects give my soul delight,
A new creation rushing on my sight!
Still, wondrous youth! each noble path pursue;
On deathless glories fix thine ardent view:
Still may the painter's and the poet's fire,
To aid thy pencil and thy verse conspire!
And may the charms of each seraphic theme
Conduct thy footsteps to immortal fame!
High to the blissful wonders of the skies
Elate thy soul, and raise thy wishful eyes.
Thrice happy, when exalted to survey
That splendid city, crowned with endless day,
Whose twice six gates on radiant hinges ring:
Celestial Salem blooms in endless spring.
Calm and serene thy moments glide along,
And may the muse inspire each future song!
Still, with the sweets of contemplation blessed,
May peace with balmy wings your soul invest!
But when these shades of time are chased away,
And darkness ends in everlasting day,
On what seraphic pinions shall we move,
And view the landscapes in the realms above!
There shall thy tongue in heavenly murmurs flow,
And there my muse with heavenly transport glow;
No more to tell of Damon's tender sighs,
Or rising radiance of Aurora's eyes;
For nobler themes demand a nobler strain,
And purer language on the ethereal plain.
Cease, gentle Muse! the solemn gloom of night
Now seals the fair creation from my sight.

G. W. Hobbs

A pastel of Richard Allen at age 25, drawn in 1785 by G. W. Hobbs, is the first positively identified portrait of a Black by a Black (Fig. 34). Allen was a precocious youth who had bought himself out of slavery when he was seventeen. In his autobiography he wrote that he spent time in the Philadelphia-Baltimore area in 1784 and 1785. It was during this period that he probably had his portrait painted by Hobbs, a minister who had established himself as the official artist of the Methodist Episcopal Church. Allen was the founder and first bishop of the African Methodist Episcopal Church, a

34. G. W. Hobbs. *Richard Allen.* 1785. Pastel. Reproduced from James A. Porter, *Modern Negro Art.* New York: The Dryden Press, 1943.

group he established in 1787 with Absolam Jones, when the two men realized that Blacks would never be allowed to assume leadership in the predominantly white Methodist Church. Allen was also a founder of the Free African Society and, in 1830, a sponsor of the first national Negro convention. The portrait must be considered the competent work of a primitive painter. It is of historical importance for two reasons: It preserves the image of one of the earliest Black leaders, and it demonstrates that Black artists were at work in the 18th century.[39]

Joshua Johnston (1765–1830)

Current information about Joshua Johnston, the most celebrated of the Afro-American artisan-painters, indicates that he was active in the Baltimore area for more

than 35 years, from 1789 to 1825. The descendants of his subjects, who were members of the wealthy and aristocratic slaveholding families of the area, provide conflicting evidence concerning the identity of the artist who painted their ancestors. Some claim he was a slave in the subject's household; other family traditions hold that the artist was a West Indian immigrant. Either version (or both) is possible, but neither can be verified. Johnston was listed in the *Baltimore Directory*, however, as a "free Negro Householder" for some thirty years. In the 1817 segregated edition, he appeared with the "Free Householders of Color"; in the others, Blacks were designated as "black man" or were identified with the symbol +. It is almost certain that no slaves were listed in the city directory.[40]

Since many talented Blacks were able to purchase their freedom, Johnston may have started life as a slave. The possibility that his master was a limner has been proposed. Specifically, observers have remarked upon the stylistic resemblance of his work to that of the Peale family of Maryland—a noted artistic dynasty founded by Charles Willson Peale. Perhaps the closest parallels exist between Johnston and Charles Peale Polk (Fig. 35), a nephew of the renowned Charles Willson. None of the thirty paintings now attributed to Johnston are signed or dated. However, similarities of style and background effects—such as the frequent appearance of Sheraton chairs and settees, the ubiquitous brass tacks, the cords and tassels, the preference for white dresses, and the unusual attention paid to details of lace

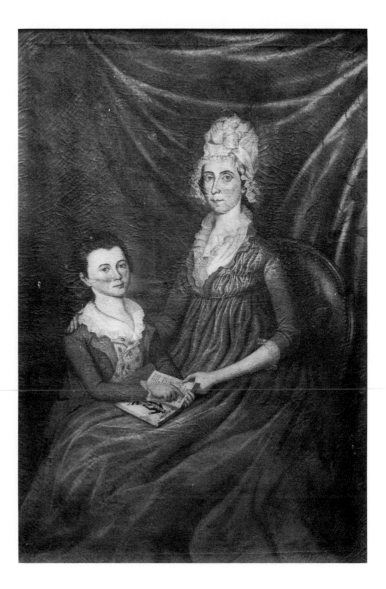

35. CHARLES PEALE POLK.
Mrs. Isaac Hite and James Madison Hite. c. 1798.
Oil on canvas, 4′ 11⅝″ × 3′ 4⅝″.
Maryland Historical Society, Baltimore.

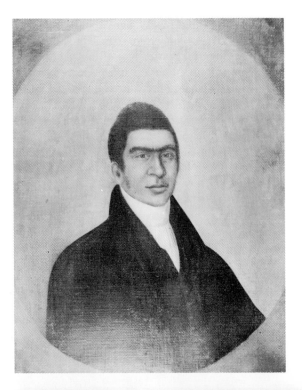

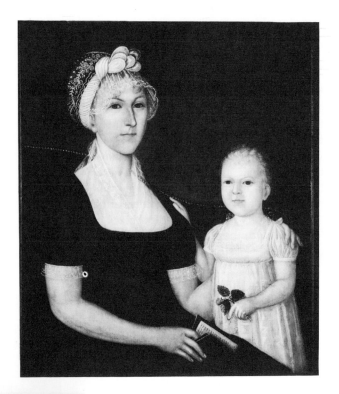

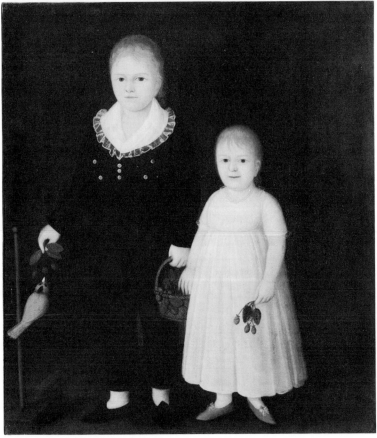

above left: 36. JOSHUA JOHNSTON.
Portrait of a Cleric. 1805–10.
Oil on canvas, 28 × 22″.
Bowdoin College Museum of Art,
Brunswick, Me. (Hamlin Fund).

above right: 37. JOSHUA JOHNSTON.
Mrs. Abraham White and Daughter Rose.
c. 1810. Oil on canvas, 30 × 25½″.
Collection Edgar William
and Bernice Chrysler Garbisch, New York.

left: 38. JOSHUA JOHNSTON.
Edward and Sarah Rutter. c. 1805.
Oil on canvas, 36 × 32″.
Metropolitan Museum of Art, New York
(gift of Edgar William
and Bernice Chrysler Garbisch, 1965).

and hair—have convinced scholars that the portraits are all from the same hand. The subject stares directly at the viewer, the children are always somber, and the conception is two-dimensional and linear—all characteristics Johnston shared with his contemporary artisan-painters. Johnston, however, displayed a warmth and sympathy toward his subject, as revealed by the *Portrait of a Cleric* (Fig. 36), his only known Black subject. Like all American artists in the post-Revolutionary period, Joshua Johnston turned to portraying white people. Only biographical investigation revealed his race.

The scholarly efforts of J. Hall Pleasants have brought Joshua Johnston to our attention. In 1948, the Peale Museum in Baltimore gathered together 23 of his paintings for an exhibition that captured the attention of scholars and collectors interested in early American portraiture and in the art of the Black American. Three of his paintings, *Mrs. Abraham White and Daughter Rose* (Fig. 37), *Edward and Sarah Rutter* (Fig. 38), and *The Westwood Children* (Fig. 39) are in the Edgar and Bernice Garbisch collection of American naïve painting.[41] The double portrait *Benjamin Franklin Yoe and Son* (Pl. 1, p. 55) reveals characteristics typical of the primitive limner, as well as those peculiar to Johnston. The eyes are elipses, the eyebrows are heavily drawn, the nose is clearly outlined, and the hands lack bone structure. Johnston's exquisite treatment of fabric is displayed in the little boys' collars, and the hairline of each subject is delicately detailed.

39. Joshua Johnston. *The Westwood Children.* 1807. Oil on canvas, 41⅛ × 46″.
National Gallery of Art, Washington, D.C. (gift of Edgar William and Bernice Chrysler Garbisch).

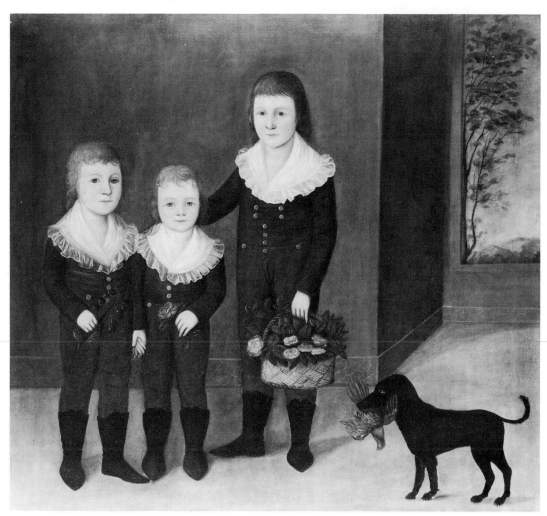

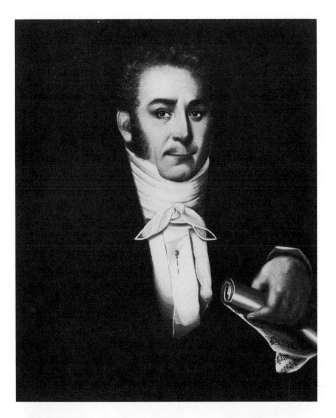

Julien Hudson (active c. 1830–40)

The free Blacks in New Orleans enjoyed an unusual status. Many of them married French citizens, educated their children abroad, and lived a life style as lavish as their white contemporaries—a style which, among other things, meant having one's visage preserved for posterity. There were probably many Black artists in the area, but only the name and work of Julien Hudson have been positively identified. His skillful portrait of Jean Michel Fortier, Jr. (Fig. 40), commander of the battalion of free Blacks during the 1815 Battle of New Orleans, hangs in the Louisiana State Museum. Although the hand is awkwardly drawn, the face depicts a man of warmth and sensitivity. Hudson's self-portrait (Fig. 41), despite its "rigid conventionality," is historically important because it identifies the race of the artist.[42]

Metoyer Family Portraits

One of the more interesting families in the New Orleans area was descended from Marie Thérèse, a slave freed in the first years of the 18th century. Her home was Melrose Mansion, begun about 1750. Today the original portion is the oldest extant dwelling built for a Black by Blacks and one of the oldest structures in Louisiana. Near the mansion is an "African house" (Fig. 42), built of brick and cypress, designed as a temporary prison for rebellious individuals among the 58 slaves owned by Marie Thérèse and her French spouse, Thomas Metoyer. As the family prospered, the plantation expanded into a showplace that reflected the best taste of the period (Fig. 43). A full-length portrait of Madame Metoyer's oldest son Augustine hangs in the living room of the mansion (Fig. 44). The painting, signed "Feuville, 1829," shows the subject pointing to St. Augustine's church, which he built for the Blacks of the community.

Nothing is known of the artist. Two unsigned and undated portraits also hang in Melrose Mansion, one

above left: 40. JULIEN HUDSON.
Colonel Jean Michel Fortier, Jr. 1838.
Oil on canvas, 30 × 25".
Louisiana State Museum, New Orleans.

left: 41. JULIEN HUDSON. *Self-portrait.* 1839.
Oil on canvas, 8¾ × 7".
Louisiana State Museum, New Orleans.

left: 42. "African House," a construction
of brick and cypress
at Melrose Plantation (originally Yucca),
Natchitoches, La., built by slaves
for Marie Thérèse, a freed slave
who married Thomas Metoyer of Paris.
c. 1750. See also Figs. 43, 44.

below: 43. Mansion at Melrose Plantation,
Natchitoches, La. View of
the central part, built for
Louis Metoyer, the grandson
of Marie Thérèse Metoyer, a freed slave.
c. 1833. See also Figs. 42, 44.

44. Interior of the original house
that Marie Thérèse Metoyer
had built at Melrose Plantation,
Natchitoches, La. (Figs. 42, 43).
right wall: Portrait, signed "Feuville, 1829,"
of Augustine Metoyer, the son
of Madame Metoyer.

The Journeymen Artists 31

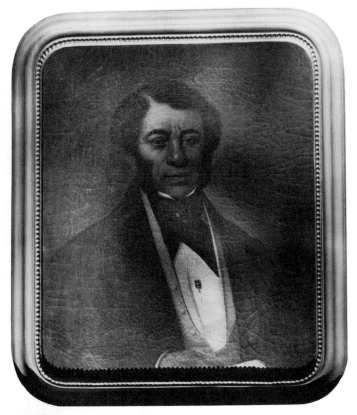

right: 45. *Louis Metoyer* (?), portrait
of Madame Marie Thérèse Metoyer's grandson.
Before 1830. Oil on canvas.
Melrose Plantation, Natchitoches, La.

below: 46. *Granddaughter of
Madame Marie-Thérèse Metoyer.*
Before 1830. Oil on canvas.
Melrose Plantation, Natchitoches, La.

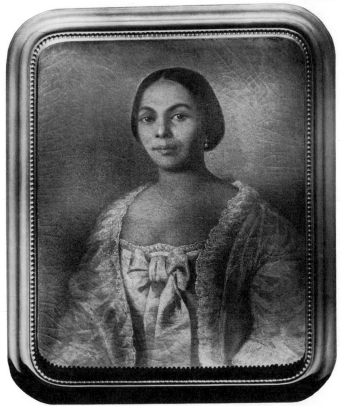

of Marie Metoyer's grandson, Louis (Fig. 45), the other of her granddaughter (Fig. 46). Probably the work of a Black artist before 1830, they are skillfully executed and portray a handsome pair in fashionable attire.

The center portion of Melrose Mansion was built by Louis Metoyer in 1833. By 1847, with slave insurrections threatening the white southern population, New Orleans' Blacks were subjected to repressive measures, and the house passed to white owners.[43]

Patrick Reason (1817–?)

In the early decades of the 19th century the free Black artist often enjoyed the patronage of antislavery organizations. Promising young artists were sent abroad to study or were apprenticed to lithographers and engravers at home. The antislavery groups commissioned lithographic portraits of leading reformers; one firm advertised them as suitable for hanging in the parlor.[44]

Patrick Reason, the son of a Haitian couple who immigrated to New York in the early 19th century, was a graduate of the New York African Free School. Through the efforts of the abolitionists, he was apprenticed to a white engraver and at thirteen was commissioned to illustrate the frontispiece of Charles C. Andrews' *History of the African Free Schools* (Fig. 47). Later commissions included an engraved portrait of the pioneer English abolitionist Granville Sharp (Fig. 48), and a pencil drawing of DeWitt Clinton (Fig. 49), the

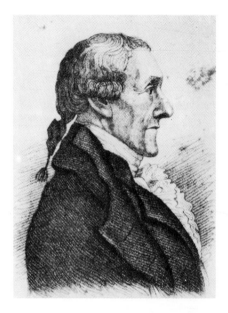

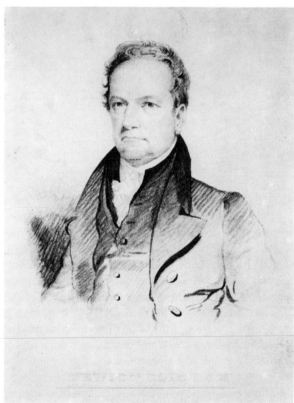

47. PATRICK REASON. *New-York African Free-School, No. 2.* Frontispiece engraving for Charles C. Andrews' *History of the African Free Schools.* 1830.

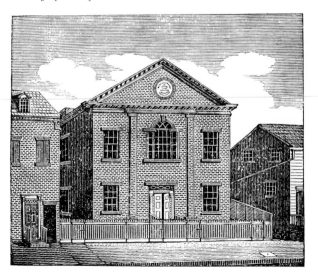

top: 48. PATRICK REASON. *Granville Sharp.* 1835. Engraving. Reproduced from James A. Porter, *Modern Negro Art.* New York: The Dryden Press, 1943.

above: 49. PATRICK REASON. *DeWitt Clinton.* 1835. Pencil and wash. Reproduced from Cedric Dover, *American Negro Art.* Greenwich, Conn.: N.Y. Graphic Society, 1960.

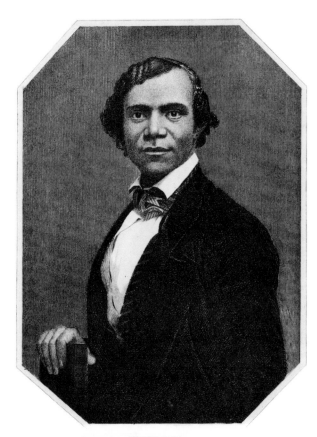

50. PATRICK REASON. *Henry Bibb.*
Copperplate engraving for *Narrative of the Life and Adventures of Henry Bibb.* 1848.

"Philosophy of the Fine Arts," delivered before the Phoenixonian Literary Society of New York on July 4, 1847, was reported to be "ably written, well delivered and indicative of talent and research."[45] The possibility exists that Reason taught drawing and painting in the New York Schools after 1850, because these subjects were included in the curriculum of Public School Number One, an institution connected with the American and Foreign Anti-Slavery Society. Reason had close ties with this organization.

Patrick Reason's art is stylistically and technically primitive in the manner of many 19th-century artisan-painters. However, the honesty of his portraits, "his passionate feelings about the injustices of the day," and his association with and portrayal of the leaders of the abolitionist movement endow his work with historical importance.[46]

In 1852 a contemporary of Reason's, Martin R. Delaney,[47] wrote the following about him in *The Condition, Elevation, Emigration, and Destiny of the Colored People in the United States:*

> Patrick Henry Reason, a gentleman of ability and a fine artist, stands high as an engraver in the city of New York. Mr. Reason has been in business for years, in that city, and has sent out to the world, many beautiful specimens of his skillful hand. . . .[48]

William Simpson (1818–72)

William Simpson's talents as a portrait painter were first noticed by William Wells Brown,[49] whose writings provide information about the artist. Simpson spent most of his life in Buffalo, New York. Brown wrote of his problems in elementary school, where he was chastised for drawing instead of pursuing his assignments; of his subsequent apprenticeship with "Matthew Wilson, Esq., the distinguished artist" in 1854; and of his stay in Boston between 1860 and 1866. Brown attested to Simpson's skill and acceptance when he indicated that the artist's "patrons came from several of the Northern states and Canada," and that he often painted whole families on a single canvas. Although Brown claimed that Simpson was a prolific artist, the only paintings now extant are the Loguen portraits (Figs. 51, 52), which reveal highly competent draftsmanship, a fine sense of color, and an unusual artistic sensibility. Jermain Wesley Loguen of Syracuse, New York, was a bishop of the African Methodist Episcopal church, a fugitive slave and strenuous opponent of the Fugitive Slave Act of 1850, a leader in the Underground

great reformer and erstwhile Governor of New York. In 1830 Reason executed a full-length lithographic portrait of Henry Bibb, an escaped slave who became a leading abolitionist lecturer. The head, although overlarge for the body, displays the expressive intensity characteristic of a Reason portrait. A later copperplate engraving for the frontispiece of *The Narrative of the Life and Adventure of Henry Bibb* (Fig. 50) reveals a more mature version of the same subject. An engraving of a chained slave pleading "Am I not a man and a brother?" became the emblem of the British antislavery movement and enjoyed worldwide circulation on abolitionist plaques, publications, and medals. Reason is also credited with having engraved the copper nameplate for Daniel Webster's coffin and the Certificate of Membership of the Masonic Fraternity.

As an active member in the abolitionist movement, Reason was called upon to illustrate the frontispieces of slave narratives and to lecture before Black literary and abolitionist societies. A speech dealing with the

Railroad, and an antislavery orator. The elegant portraits of Loguen and his wife Caroline "reflect the dignity and the well-attested culture of their subjects."[50]

Robert Douglass (1809–87)

Although no Robert Douglass paintings or prints exist, many private and public documents record the artist's long, versatile career. Born in Philadelphia, the son of a West Indian father and a freeborn mother, Douglass was educated by the Quakers.[51] The abolitionists sponsored his art studies. An early reference appeared in *The Emancipator* of July 20, 1833:

> This gentleman is a very respectable colored gentleman, in Philadelphia, and has for several years carried on the business of sign and ornamental painting.... He has lately turned his attention to portrait painting in addition to his other employment. In this too he has been eminently successful. We have seen several of his paintings that would scarcely suffer in comparison with those of many who are considered among the finest artists of our country....[52]

In September of 1833 Douglass utilized the columns of *The Emancipator* to inform the public of his latest accomplishment. He announced that:

> ... he has completed a lithographic portrait of Mr. Lloyd Garrison from a painting by himself. R. D. flatters himself that, from the admiration and esteem entertained for this great philanthropist, and the novelty of his first effort, a portrait from the life of so distinguished a gentleman, by a man of color will insure for him a portion of public patronage....[53]

Following a contemporary tradition, Douglass placed the prints on sale in New York and Philadelphia, charging fifty cents each. In this way he hoped to raise funds for the abolitionist cause.[54] At the time it was a common practice for an artist to paint a local or national hero, engrave the likeness or have it engraved by a craftsman, and then offer the print for sale to an

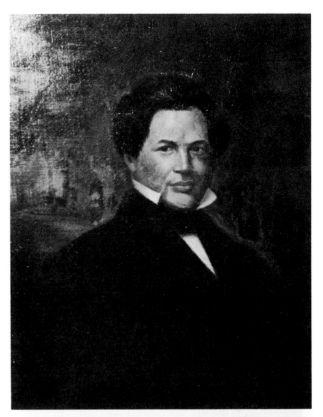

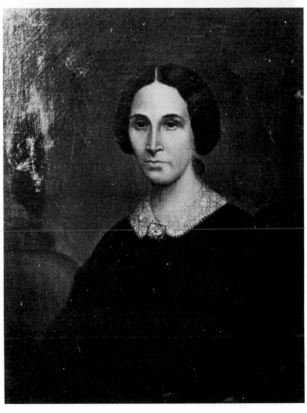

above right: 51. WILLIAM SIMPSON. *Jermain Loguen.* 1835. Oil on canvas.
Howard University Art Gallery, Washington, D.C.

right: 52. WILLIAM SIMPSON. *Caroline Loguen.* c. 1845. Oil on canvas.
Howard University Art Gallery, Washington, D.C.

eager and patriotic public. None of the much-publicized prints have survived.

Thomas Sully was Douglass' mentor, and when the young man sought to study abroad in 1839, he was supplied with letters of the "highest commendations" from the famous portraitist. His passport application was denied, however, for "people of color were not citizens and therefore had no right to passports to foreign countries."[55] Eventually, Douglass did visit England, where he studied at the British Museum and the National Gallery. Announcement of his return home and of his readiness to resume his career appeared in *The Pennsylvania Freeman* of August 1844.[56]

Douglass continued to be identified with abolitionist causes. He kept a gallery of paintings and daguerreotypes in his Philadelphia studio and was also active in the literary societies, one of which he helped organize. However, much of his time during the late 1830s and again in the late 1840s was spent in the West Indies. Douglass was silent about his extended visits, although it is known that he received many commissions from the West Indian government. Frederick Douglass, as editor and publisher of *The North Star* (an abolitionist publication), suggested the reasons for the artist's long absences from his homeland:

> . . . Robert Douglass is an artist of skill and promise, who in this country, was unable to gain a livelihood by his profession . . . , and has therefore emigrated to a country where he hopes the colors he uses, and the way he uses them, will be the test of his merit, rather than that upon his own body, which he neither put on nor can rub off.[57]

53. A. B. WILSON. *Bishop Daniel Payne and Family.* 1848. Oil on canvas. Formerly Wilberforce University, Ohio. Present whereabouts unknown.

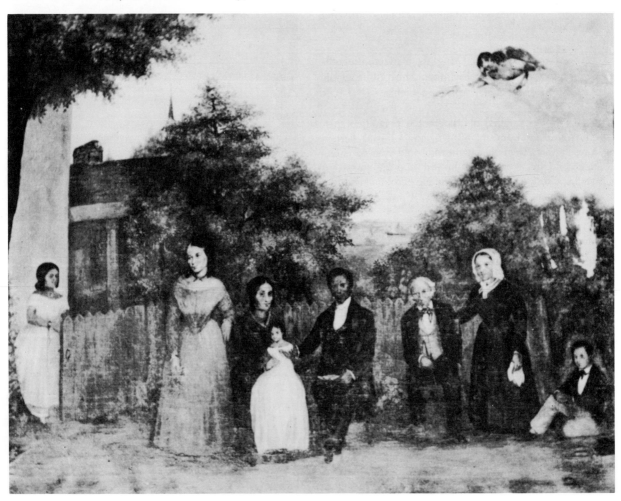

left: 54. A. B. WILSON. *John Cornish.* 1840.
Lithographic copy by M. A. TRAUBEL.
Reproduced from James A. Porter, *Modern Negro Art.*
New York: The Dryden Press, 1943.

A. B. Wilson

Toward the middle of the 19th century, as the literary and self-help societies began to flourish, a concomitant interest in art developed. Daniel Payne, later Bishop Payne of the African Methodist Episcopal Church, recounted in his history of that institution his efforts to initiate a literacy program for the clergy and to encourage the aesthetic tendencies of church members. He began in Baltimore about 1849, with a "literary and artistic demonstration for the encouragement of literature and the fine arts among the colored population." Competitions were held and prizes awarded. Payne, who later became president of Wilberforce University in Ohio, served as patron to many young Black artists.[58]

A portrait of Bishop Payne and his family (Fig. 53), which hangs at Wilberforce University, has been attributed by Alain Locke[59] to Robert Duncanson, but according to Payne's history, the commission for the group portrait was given to A. B. Wilson, the son of a member of the Bethel A. M. E. Church in Philadelphia, "who had a gift in this direction, but it was un-

cultivated." The stilted poses, the proportions, and the spacial relationships all reveal the hand of a self-taught craftsman and are at variance with Duncanson's figure treatment or the sense of space and handling of the foliage in *Blue Hole, Flood Waters, Little Miami River* (Pl. 2, p. 56). Therefore, it is highly probable that the group portrait, an ambitious undertaking for an amateur, was the work of Wilson.

Another Wilson portrait, depicting the Reverend John Cornish, minister of the Bethel A. M. E. Church, is known to us through a lithographic copy by M. A. Traubel (Fig. 54), although the original painting has yet to be found. Cornish is posed at the pulpit, his hand pointing to a line in an oversize Bible. The head is too large, the attempt at foreshortening seems awkward, and the left arm appears wooden; yet a sense of the pastor's concern and warmth for his congregation is communicated to the viewer.

Evidently, the artist died early, for Payne commented about his family portrait:

> . . . [the painting] is certainly the work of a genius. No one can tell to what eminence he might have attained had he been trained in some school of design and lived long enough to have had his talents fully developed.[60]

By the mid-19th century, the Afro-American with a serious commitment to art, following the pattern set by his white counterpart, traveled to Europe to find peace, freedom, and acceptance—the ambience needed to create. Just as the white artist sought to escape the cultural provincialism of his homeland, the Black artist hoped to escape the restrictions that circumscribed his life. He was accepted by the French and English academies and could thereby receive the kind of training seldom forthcoming at home. Although schooling was increasingly available to the free young northern Black—the group from which the artists emerged—his education remained inferior to that provided for white youth. Many of the Black artists abroad were recognized and rewarded for their talents; others were applauded for their charm and uniqueness. Some found the peace they were seeking in Europe and never returned home.

The Flight to Europe: From the Mid-19th Century to World War I

The political and social climate of the pre-Civil War, Civil War, Reconstruction, and post-Reconstruction periods showed little interest in the Black's creative development. The politics of war and the subsequent need to educate and find employment for the freedmen occupied the minds of Black leaders and of those whites concerned with the progress of the newly liberated Blacks. Only a few Blacks pursued art careers, and those who did tended to follow the course of their white counterparts. They were educated in the predominantly white art schools, made their pilgrimages to Europe, and, once established in their careers, worked in styles that dominated the contemporary art world on both sides of the Atlantic. During the postwar period in the United States, the prevalent art trends were, by and large, European imports, for it was not until well into the 20th century that New York assumed the position of leadership long held by Paris and Rome.

In the mid-18th century the fashion for Neoclassical art—painting, sculpture, and architecture—had swept Europe and was eagerly adopted by the American colonies after the Revolution. Neoclassicism means just that—a new classicism based on the ideals and forms of antiquity, especially of Greece and Rome. It was a formal art that took for its principles rationalism, heroism, and purity of design and motive. The Neoclassical style is perhaps easiest to see in architecture, for the newly established United States, no doubt hoping to solidify its legitimacy as a nation in the concrete symbols of the past, constructed a rash of Roman government buildings, Greek banks, and—somewhat later—Romanesque and Gothic churches. In American painting the Neoclassical style was best exemplified by the work of Benjamin West (1783–1820), a native of Pennsylvania who spent most of his life in Europe. West's canvases dealt with American and academic

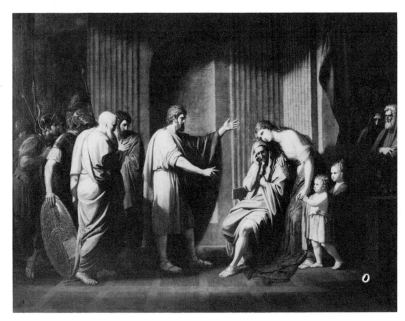

themes, but he endowed both with historical monumentality by the strict formalism of their compositions (Fig. 55). Neoclassical sculpture is epitomized by the cool, idealized marbles of Antonio Canova (1757–1822), an Italian sculptor whose fame was enhanced by service to the Emperor Napoleon. Canova's work had an enormous influence on many American sculptors, particularly Horatio Greenough (1805–53), Hiram Powers (1807–73), and Thomas Crawford (1813–57). Early in his career Powers (Fig. 56) took up residence in Florence, from whence he never returned, and it was to him that many young American sculptors turned

when they journeyed to Europe for their apprenticeship. The influence of Crawford's sculpture (Fig. 57) can be seen in certain works by Edmonia Lewis (Figs. 96, 97), among others.

Another European "school" that had an impact on American art was the Barbizon, so called for the village on the edge of the Forest of Fontainebleau in which these artists painted directly from nature. The Barbizon school constituted one aspect of the Romantic "back-to-nature" mood and the abiding preoccupation with the nature of reality that gripped European society throughout most of the 19th century. Lush, rea-

58. JEAN-FRANÇOIS MILLET.
The Gleaners. 1857.
Oil on canvas, 33 × 44″.
Louvre, Paris.

listically observed landscapes, sometimes containing idealized representations of peasants at work and prayer, predominated in the painting of this group (Fig. 58). Camille Corot (1796–1875) and Jean-François Millet (1814–75) worked in the style and had a profound effect upon younger artists whose development, based on mid-century Realism, anticipated the whole movement of modern art in France. Among the Afro-American artists influenced by French Realism as practiced among the Barbizon painters were Edward M. Bannister (Pl. 3, p. 56; Figs. 80–83), William A. Harper (Fig. 112), and, years later, Richard Mayhew (Pl. 23, p. 217; Figs. 267, 268).

A related but quite different phenomenon was the Hudson River School of painting, which flourished in the United States during the mid-19th century. The Hudson River tradition was based ultimately on the lyrical landscapes of the 17th-century Frenchman Claude Lorrain (Fig. 59), yet despite this root it was uniquely American. In a nation without a past and with a constantly changing present, the great mountain ranges became a form of antiquity, while the expanses of countryside served to symbolize a land of limitless opportunity. Religious, romantic, and patriotic values were all implied in the opulent, glowing, panoramic views of mountains and valleys, rivers and streams (Fig. 60). Sharing this outlook were a group of painters working in New England, western Pennsylvania, and the Hudson River Valley of New York, of whom the leader was Thomas Cole (1801–48). It was this group

who influenced Robert Duncanson (Pl. 2, p. 56; Figs. 73–79) and a score of other mid-century painters.

Inspired by the kind of forthright naturalism present in the work of the Barbizon painters, a band of closely associated young French artists, led by Camille Pissarro (1831–1903), Claude Monet (1840–1926), and Pierre-Auguste Renoir (1841–1919), experimented with nature and their optical sensation of it until they perfected a style that became the foundation for most of the formal innovations subsequently made in Western art. To achieve their style the Impressionists conceived of form as modeled in light and color, rather than in the light and dark of traditional painting. Their procedure was to analyze the local color of objects for its spectral components as light would reveal these to the eye and to apply them with short, choppy strokes so that colors, in a comparatively pure state and laid on one next to another, could fuse in visual perception and give the effect of scenes and objects vibrating within a light-filled atmosphere (Fig. 61). In their focus upon empirical phenomena, the Impressionists did not compose the elements of their pictures in the pyramidal fashion traditional to high art in the West but looked for compositions already present in the general environment—landscape, still life, urban scenes, and the images of friends and family. Thus, the impressions of Impressionist painting often resemble slices of life as a camera might record these in a snapshot taken from close up. The allover shimmering surface created by the color patches, the objec-

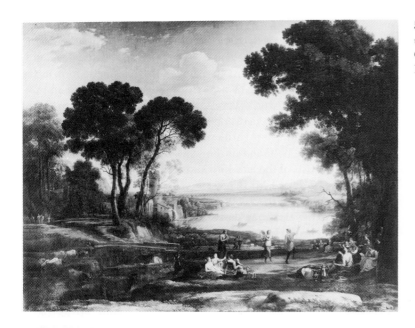

59. CLAUDE LORRAIN. *Landscape with Dancing Figures.* c. 1648. Oil on canvas, 4′ 10½″ × 6′ 6″. Palazzo Doria, Rome.

left: 60. THOMAS COLE. *The Oxbow.* 1836. Oil on canvas, 4′ 3½″ × 6′ 4″. Metropolitan Museum of Art, New York (gift of Mrs. Russell Sage, 1908).

below: 61. CLAUDE MONET. *Water Lilies.* c. 1925. Oil on canvas, 6′ 7¾″ × 18′ 5½″. Formerly Museum of Modern Art, New York (Mrs. Simon Guggenheim Fund).

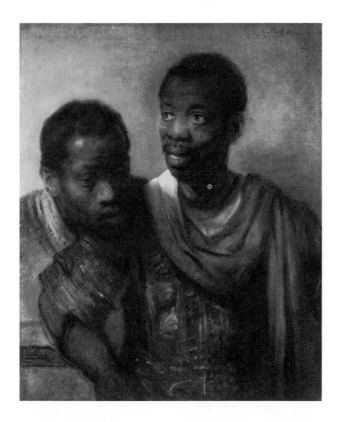

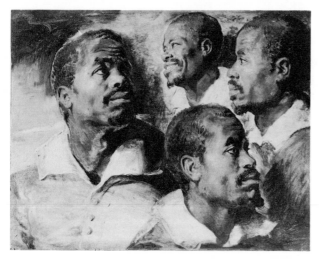

top: 62. REMBRANDT. *Two Negroes.* 1661.
Oil on canvas, $30\frac{3}{8} \times 25\frac{1}{8}''$.
Mauritshuis, The Hague.

above: 63. PETER PAUL RUBENS. *Studies of a Negro.*
1615–20. Oil, transposed from wood to canvas;
$19\frac{7}{8} \times 25\frac{1}{4}''$.
Musées Royaux des Beaux-Arts, Brussels.

tive, almost scientifically cool preoccupation with the reality of how we see, and the relative indifference to what is looked at (subject matter) would lead ultimately to the modern concern for aesthetic form as the true subject of art. The most representative Impressionist works were accomplished during the 1870s, but the style had an immediate and powerful influence upon avant-garde painting for the next forty years. It can be found in the work of many Afro-American artists of the late 19th and early 20th centuries, including Edward M. Bannister.

By the 1880s a new way of seeing in art began to develop, one derived from the light and color aesthetics of Impressionism but less concerned with optical reality than with the reality of the imagination and the expressive potential of form and subject for giving symbolic significance to the imagination and its myth-making capability. The new innovators were Paul Cézanne (1839–1906), Paul Gauguin (1848–1903), Vincent van Gogh (1853–90), and Georges Seurat (1859–91), a group much more complicated in personality and life experience than the sunny-spirited, earth-loving Impressionists. Called Post-Impressionism, their work had its principal effect upon American art after it appeared in the great Armory show held in New York in 1913. This one, massive exhibition of the most experimental and advanced art produced in Europe catapulted the American consciousness into the visual experience of the 20th century.

Attitudes Toward Art

Just as the history of man is reflected in much of the art he produces, so the changing role of the Black in America has been revealed in the attitudes of the artists who painted him. During periods when the white artist portrayed the Black in a condescending or derogatory manner, the Black artist tended to shy away from themes that would identify him with second-class citizenship. The plantation tradition, with its glorification of the contented slave, enjoyed a vogue during the Reconstruction era, and the stereotype of the Black as clown, minstrel, pickaninny, and Uncle Tom—a form of low genre—became entrenched in the subject matter of American painting.[1] The Black artist was apparently unaware of an earlier tradition. Acknowledged masters such as Rembrandt, Peter Paul Rubens, Hieronymus Bosch, Diego Velázquez, and the American artist John Singleton Copley, among others, had produced portraits that captured the dignity and grace of the Black man (Figs. 62–66).[2]

64. Hieronymus Bosch. *Black King,*
detail from *The Adoration of the Magi.*
c.1495. Oil on panel, 4′ 5⅞″ × 28″
(entire central panel of a triptych).
Prado, Madrid.

65. Diego Velázquez. *Juan de Pareja.* 1650.
Oil on canvas, 32 × 27½″.
Metropolitan Museum of Art, New York
(acquired with purchase fund and special contributions
bequeathed or given by friends of the museum).

66. John Singleton Copley.
Watson and the Shark. 1778.
Oil on canvas, 6′ × 7′ 6¼″.
Museum of Fine Arts, Boston
(gift of Mrs. George von Lengerke Meyer).

The Flight to Europe 43

This movement away from identification with his people and the concomitant search for white middle-class values produced conflict in the Black artist. He lived in an ambiguous world, "without cultural roots in either the Negro world with which [he] refuse[d] to identify, or with the white world which refuse[d] to permit the black bourgeoisie to share its life. . . . [And] when Negroes attain middle-class status, their lives generally lose both content and significance."[3] Since artists usually emerge from the middle classes, and since Blacks who have pursued the fine arts have traveled a path similar to that of their white counterparts, the above quotation is, to say the least, a dis-

quieting comment on the potential of the Black artist.[4] Langston Hughes has referred to the barrier between the Black artist and an authentic Black experience as a "racial mountain"—"this urge within the race toward whiteness, the desire to pour racial individuality into the mold of American standardization, and to be as little Negro and as much American as possible."[5]

One of the first departures from the stereotype occurred in 1899 with a painting by Winslow Homer entitled *Gulf Stream* (Fig. 67). Here, a Black sailor in a rough sea, surrounded by sharks, faces danger with strength and dignity. His chances of survival are minimal; yet he has not panicked. A decade later, public

69. Booker T. Washington (1856–1915).

interest in artistic realism was awakened by the notoriety of The Eight, a group of painters led by Robert Henri. The Eight sought their subject matter in "real life"—often in the more vigorous, even "seedy" aspects of human experience—and cultivated the loose, expressive, virtuoso technique already seen in the painting of Homer. Their earthy realism aroused both the general public and the art critics, who labeled the group the "Ash Can School," a name by which they are still more commonly known. Despite condemnation by the academic establishment, the group did gain the respect of progressive elements within the art community, and Robert Henri became one of the most effective teachers of painting ever to have worked in the United States. Aesthetically, however, their influence terminated once the Armory Show revealed to the American audience the true potential of modern art. This is evident in the work of George Bellows, who, though not one of the original Eight, had studied with Henri. *Both Members of This Club* (Fig. 68) depicts two fighters, a Black man and a white, "trying to beat each other's brains out for money."[6]

As the Black became an acceptable subject for serious interpretation by the larger community of artists, the Black artist gradually started to paint his brethren. However, not until the 1920s did the Negro as caricature really begin to disappear from the subject matter of American painting.[7]

A continuous effort was made to increase the cultural opportunities for the free Black in the mid-19th century. Abolitionists sponsored promising artists, and there was a movement to include art in the curricula of the all-Black schools. However, after the Civil War, when the Black was fighting for citizenship and civil rights, interest in his cultural life was negligible, both among Black leaders and among members of the press who would have reported his achievements. The philosophy of Booker T. Washington (Fig. 69), which stressed the virtues of industry and thrift and the acquisition of property, placed little emphasis on the Black's creative development, and the more aggressive Niagara Movement was little better in that regard. A protest organization led by W. E. B. DuBois, the Niagara Movement was founded in 1905 to agitate for the full realization of the Black's constitutional rights. This, of course, was in direct contrast to Washington's claim that the former slave was content with his "natural and gradual" progress. Although they recognized

the need for well-equipped schools to train Black artisans, the professionals in the Niagara Movement showed little interest in the art, music, or literature of the Afro-American. Consequently, there was a reduction in the general public's commitment to the cultural advancement of the Black. This attitude of indifference or even hostility toward Black betterment was perpetuated by the literature of Reconstruction and lasted well through the first decade of the 20th century. No organizations or institutions existed to counter the myths of the post-Civil War period, nor was there a Black intellectual elite sufficiently powerful or concerned to champion the cause of the people. There was

not even a middle class of sufficient size for the artist to represent culturally, and he did not want to identify with the cultural trends of the poor Black.[8]

The progeny of the white masters—those who had worked in the manor houses or managed the plantations—together with the free urban Blacks, formed the post-Civil War middle class. Mostly literate, they flocked to the colleges newly opened by northern churches, missionary societies, and the Freedmen's Bureau. The writers and artists who evolved from this group reflected the genteel traditions of the Guilded Age. Proper dress, proper deportment, the right schools, and the correct churches and clubs were important, and for the educated Black they were a means to escape his origins. The success drive was very strong, and the Protestant work ethic received support in Black periodicals and fiction. The Afro-American novelist of this period had the "soul of a shopkeeper." However, he was also an advocate of racial improvement, for he believed that through hard work, thrift, and wealth the racial barriers would desist.[9] He found his leadership and ideology in the philosophy of Booker T. Washington. Besides stressing thrift and industry, Washington was a proponent of Social Darwinism, the theory of the "survival of the fittest" so appropriate to the freewheeling economy in the latter years of the 19th century.

The protest activity of the middle-class Black was mainly lodged against the "Jim Crow" legislation, the enforced segregation and disfranchisement of the post-Reconstruction period, and the caste system that increasingly circumscribed his life. During this period the novel became an instrument of propaganda in the fight against oppression. In trying to depict the purity of Black interests, the Afro-American artist often identified with the oppressor. He adopted the prevailing white prejudices—not only against the lower-class Blacks, but against Jews, Asians, Indians, anarchists, and European immigrants.

The post-Reconstruction middle-class Black objected to being pigeonholed with the common Black. He advocated a system of segregation along class rather than color lines, and to this end he appealed to his "white family."[10] However, cultural and social segregation was the rule. White patronage for the Afro-American artist was minimal, and those Blacks affluent enough to purchase art joined the hordes of nouveau riche Americans who were scouring Europe for the work of old masters. Without patronage, the aspiring young Black artist had limited opportunities for study. The Black teacher-training institutions, such as Ohio's Wilberforce University and Hampton Institute in Virginia, offered only sporadic instruction in representational drawing and industrial design (Fig.

70. Francis B. Johnston. *Field Work in Sketching,* from *The Hampton Album.* 1899–1900. Platinum photographic print, 7½ × 9½″. Museum of Modern Art, New York (gift of Lincoln Kirstein).

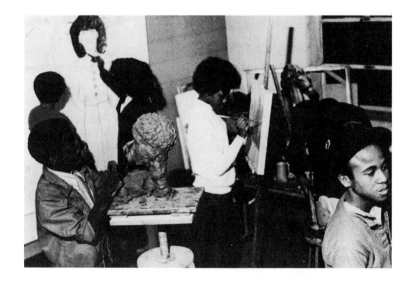

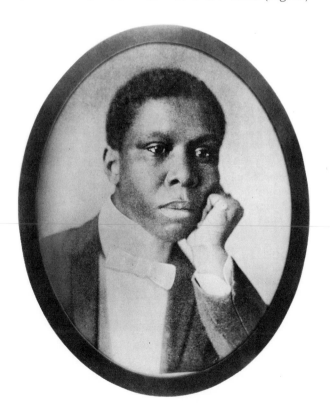

left: 71. Art class at Karamu House. 1972.

below: 72. PAUL LAURENCE DUNBAR (1872–1906).

70). A few white academies, notably Pratt Institute in New York, the Philadelphia Museum school, and the Art Institute of Chicago, enrolled exceptional students. Most Afro-American artists joined their white counterparts for study abroad, not only to avoid discrimination and rejection, but to escape the provincial attitudes of the American public toward art in general.[11]

A few isolated attempts were made in the period under consideration to encourage the artistic development of the Afro-American. Through the efforts of Edward M. Thomas of Washington, D.C.—a Black contributor to Black and white periodicals who displayed a remarkable knowledge of Western art traditions—the first comprehensive American showing of Afro-American fine and industrial arts was presented in New York City. James Porter considered the date, October 1862, "a pioneer date in the cultural history of the American Negro."[12] In 1912, a group of New York teachers, desiring to open communications between the Afro-American artist and the public at large, helped sponsor an exhibition called "Colored Students of Greater New York"; and in 1915, the Washington *Evening Star* made note of an art exhibit of "colored folk," which featured, among others, the sculptor May Howard Jackson, who subsequently enjoyed wider recognition.[13]

An experiment in the cultural education of the Afro-American was begun in Cleveland in 1915. Founded by Russell and Rowena Jelliffe and staffed by Black and white instructors, the program of Karamu House (Fig. 71) sought to: 1) direct the Black's talents into the mainstream of American life, thereby removing him from the isolation that had been detrimental to his creative development; and 2) enable the Black artist to communicate his unique experience as Black man and artist to the nation. Among the graduates of Karamu House, which is still in operation, were Hughie Lee-Smith (Pl. 14, p. 128; Figs. 190–193) and Charles Sallee.[14]

An Afro-American literary tradition began to emerge in the late 1890s,[15] when writers such as Charles Chestnutt and Paul Laurence Dunbar (Fig. 72)

began to publish their work, followed soon after by James Weldon Johnson. The poetry was either in dialect, with a limited range of expression, or else it followed the genteel, Victorian style. None was of exceptional quality, nor did it often reflect the "soul" of the Black man.[16] The artist's dilemma remained his ethnic dualism. He was attempting to write of the Black experience in the contemporary idiom, but the elevated style of the white writer was not designed to grasp the depth of the Black soul. Similarly, most of the painters discussed in this chapter made no attempt to interpret the Black mood and worked exclusively within the Victorian tradition.

Paul Laurence Dunbar became the "first American Negro to give lyric expression to a truly esthetic feeling for Negro life." The reputation he gained throughout England and the United States for his warm and sympathetic interpretations of the Black did not please him, for he wanted to win his acclaim as a writer of classic English verse. Unfortunately, the poems he composed in this vein were rather sentimental and conventional. His attitude concerning folk or dialect poetry reflected the ambivalence of the Afro-American artist and writer toward the folk Negro.[17]

An article written by William Dean Howells in a 1900 issue of *Atlantic Monthly* praising the merits of Dunbar, Booker T. Washington, and the painter Henry O. Tanner (Figs. 98–107) was influential in reversing the public's condescending attitude toward Black art and artists. Citing the many achievements of the Black throughout history, Howells wrote that:

> . . . In many of the arts [the Negro race] has already shown, during a single generation of freedom, gifts which slavery apparently only obscured. With Mr. Booker T. Washington the first American orator of our time . . . , with Mr. [Paul Laurence] Dunbar among the truest of our poets, with Mr. Tanner, a black American, among the only three Americans from whom the French government ever bought a picture.[18]

Robert S. Duncanson (1817–72)

One of the last artists to benefit from the benevolence of the antislavery groups was Robert Duncanson, the son of a Scottish-Canadian father and a free Black mother. Duncanson was born in upstate New York, where his father had sought temporary employment, but the family returned to Canada when Robert was a boy. As a result of the Underground Railroad, there was a growing colony of Blacks in Canada, and the Duncansons enjoyed greater freedom and mobility than they could have anywhere in the United States.

Duncanson was educated in Canada, and there is evidence that he attended school in Edinburgh, Scotland, under the sponsorship of the Anti-Slavery League. By the early forties he was back in the United States, and in 1841 or 1842 he took up residence in Cincinnati, at the time a thriving cultural and commercial center. Educational opportunities for the Afro-American were abundant, art patronage was readily available, and civic leaders encouraged the general public to pursue the fine arts. The freedom of a frontier city, with its open society, enabled Duncanson to establish friendly relations with white artists, and some of his colleagues may have been T. Worthington Whittredge (1820–1910), Eastman Johnson (1824–1906), or Frank Duveneck (1848–1919), all of whom worked in the Ohio city at some period during Duncanson's lifetime.

In 1847 the Western Art Union—a group devoted to the propagation of fine art through the distribution of original works and reproductions—was established in Cincinnati. The contributors included George Caleb Bingham and Thomas Cole (Fig. 60), who were active in the Cincinnati area during the 1840s. Engravings after the work of Bingham, also Cole and other members of the Hudson River School, were widely circulated. Therefore, although Duncanson was largely self-taught, he had ready access to all the latest developments in American art.[19]

Almost as soon as he arrived in Cincinnati, Duncanson began to exhibit his paintings. Three works— *Fancy Portrait*, *Infant Savior*, and *The Miser* (a copy)— were listed in the June 9, 1842, catalogue of an exhibit sponsored by the Society for the Promotion of Useful Knowledge. Like many young artists of the period, Duncanson studied engravings of famous paintings, for this was often the only way an American could familiarize himself with the European masterpieces. Sometimes he would merely copy the master's work, but at other times he adapted compositional devices for his own use. *The Trial of Shakespeare*, a painting after an 1837 engraving showing Shakespeare on trial for poaching, was greeted enthusiastically in 1843. It is now at the Frederick Douglass Community Association in Toledo. Duncanson exhibited at the Fireman's Fair in 1845.

By the mid-forties the artist was spending much of his time in Detroit, where he later acquired property. The Detroit *Daily Advertiser* commented favorably on two paintings completed in that city—a bridal portrait

described as "one of the most striking likenesses and tasteful pictures . . . ever seen from the pencil of so young an artist," and "several historical and fancy pieces of great merit." Detroit society was evidently pleased with Duncanson's portraits, for he was never at a loss for sitters. Among the most charming of the portraits from this period is that in Figure 73.[20]

In Cincinnati Duncanson enjoyed the patronage of Nicholas Longworth, a philanthropist and friend of young artists, whose home, now the Taft Museum, was the center of the city's cultural life. As a gesture of respect for the artist, Longworth commissioned Duncanson to decorate the walls in the main entrance of the mansion. The result was a series of eight murals and several overdoor pieces completed between 1848 and 1850 (Fig. 74). Painted with *trompe l'oeil* ("fool-the-eye") frames, the murals were said to "reflect their Hudson River background in their grandness and transposition of the experience of nature into a spiritual reverie. They also reveal [the artist's] European influences, his study of paintings by Nicolas Poussin or even more likely Claude Lorrain [Fig. 59]. The soft-

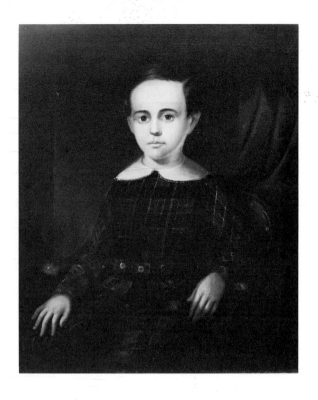

above: 73. ROBERT S. DUNCANSON. *William Berthelet.* 1846. Oil on canvas, 30 × 25″. Detroit Institute of Arts (gift of W. T. Berthelet).

left: 74. ROBERT S. DUNCANSON. *Mural.* c. 1848. Oil on plaster, 6′ 10″ × 7′ 2¾″. Taft Museum, Cincinnati.

ened atmosphere of these paintings relates more to European conceptions than to the sharper, more detailed works by contemporary Americans."[21] Porter described the murals as the "veritable capstone of the classic-romantic landscape as conjured up by Americans ... [completing] the landscape tradition which descended from Poussin and Claude Lorrain and which was first introduced in America by Thomas Cole."[22] Subsequent owners of the mansion covered the murals with wallpaper, but they were rediscovered and restored in the 1930s.

Duncanson was listed as an exhibitor with the Western Art Union in 1849 and 1850. Several of his paintings were sold, including a series representing the four seasons. The paintings were engraved and distributed by the Art Union. Probably to earn additional funds—as well as to explore a new medium—the artist formed an association with J. P. Ball, a successful Black daguerreian. The 1851 and 1852 city directories list Duncanson as a "daguerreotype artist." *View of Cin-*

cinnati, Ohio, from Covington, Kentucky (Fig. 75), a work dating from about 1851, was painted from a daguerreotype.

Blue Hole, Flood Waters, Little Miami River (Pl. 2, p. 56), a beautiful landscape within the Hudson River tradition, was executed during the early 1850s. It is considered to be one of Duncanson's finest works; the artist combined attention to detail with his personal lyricism to achieve a "unifying overall glow, realising all the romantic possibilities of the spot."[23]

In 1853 Duncanson was commissioned by James Francis Conover, editor of the Detroit *Tribune*, to illustrate a scene from Harriet Beecher Stowe's *Uncle Tom's Cabin* (1850). A rare foray into Black subject matter, *Uncle Tom and Little Eva* (Fig. 76) displays

below: 75. ROBERT S. DUNCANSON.
View of Cincinnati, Ohio, from Covington, Kentucky. c. 1851. Oil on canvas, 25 × 36″. Cincinnati Historical Society.

the artist's awkwardness with figures. A reviewer for
the Detroit *Free Press* of April 21, 1853, commented:
"Uncle Tom according to the artist is a very stupid
looking creature and Eva instead of being a fragile
child is a rosy complexioned healthy seeming child, not
a bit ethereal."[24] An 1858 commission for a portrait
of Nicholas Longworth (Fig. 77) again revealed Dun-
canson's difficulty with the human figure. The imposing
full-length study is awkwardly posed, illuminated by
an unexplained light, and surrounded by incongruous
details. Porter, however, has high praise for the por-
trait, maintaining that "the artist here draws upon re-
alism, luministic romanticism and academic neo-classi-
cism all at once to achieve a work of sincerity and
fitness."[25]

Duncanson always identified more with his father's
people, the Scottish, than with the African-American,
and during each of his trips abroad he spent time in
Scotland. His second trip to Europe in 1853 was spon-
sored by the Anti-Slavery League. Duncanson ar-
ranged to tour the art centers of France and Italy, as
well as of England (where he was particularly im-
pressed with the landscapes of J. M. W. Turner). The
artist was accompanied by John Robinson Tait and
William Sonntag, the latter an American painter of the
Hudson River School whose work often resembled
Duncanson's own. He also carried a letter of introduc-
tion from Nicholas Longworth to the American Neo-

classical sculptor Hiram Powers (Fig. 56), who had settled in Florence. Longworth described Duncanson as "a self-taught artist. . . . He is a man of integrity and gentlemanly deportment, and when you shall see the first landscape he shall paint in Italy, advise me the name of the artist in Italy, that with the same experience can paint so fine a picture."[26]

In 1861 Duncanson began what many critics believe to be his most ambitious work—*Land of the Lotos Eaters* (Fig. 78), an illustration for the poem by Alfred, Lord Tennyson. The painting, which is now in the collection of the King of Sweden, was widely admired, first in Cincinnati, then in Canada, Scotland, and England. The Reverend Moncure D. Conway, an abolitionist, saw *Lotos Eaters* in Europe and later wrote to the Cincinnati *Gazette:*

> In walking through the gallery of miniatures at the South Kensington Museum the other day, I met Mr. Duncanson, whom some of your readers will remember as one who, a few years ago, was trying to make himself an artist in Cincinnati, and who had already produced a worthy piece of imaginative art in a picture of Tenny-

son's "Lotos Eaters." Duncanson subsequently left Ohio and repaired to Canada, where his color did not prevent his association with other artists and his entrance into good society. He gained much of culture and encouragement in Canada, retouched his "Lotos Eaters," produced one or two still better paintings, and set out for England. In Glasgow and other Scotch cities he exhibited these paintings with success. He has also received a letter from the poet laureate, Tennyson, inviting him to visit at his home in the Isle of Wight, where he will go and take with him the "Lotos Eaters."[27]

Eventually, Duncanson became one of the most popular personalities in the London art world, enjoying the patronage of, among others, the Duchess of Sutherland. A painting was purchased by Queen Victoria and now hangs in Windsor Castle. The London *Art Journal* in 1866 referred to Duncanson as "one of the outstanding landscapists of his day."[28]

Many of the artist's later works maintained the cool objectivity of the Hudson River School, while others created a romantic, rather mournful ambience. *Ellen's Isle, Loch Katrine* (Fig. 79), first owned by the abol-

78. ROBERT S. DUNCANSON. *Land of the Lotos Eaters.* 1861. Oil on canvas. Collection His Royal Majesty, the King of Sweden.

79. ROBERT S. DUNCANSON. *Ellen's Isle, Loch Katrine.* 1870. Oil on canvas, 2' 5½" × 4' 2". Private collection.

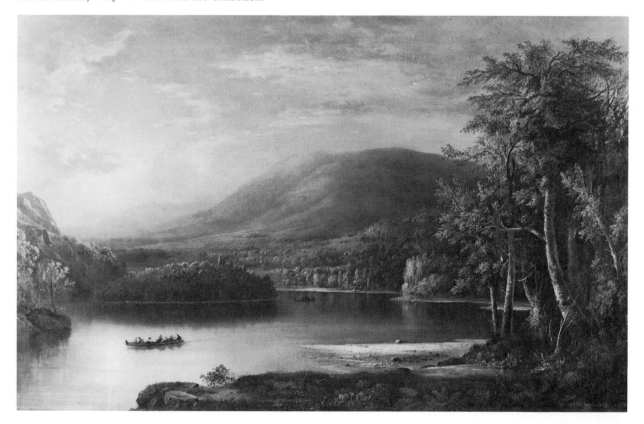

itionist Charles Sumner, appears "nostalgic, reminiscent of some passing glowing moment, so sensitively painted and deeply felt that [its] message of serenity and solitude is unmistakably transmitted."[29]

During the last year of his life Duncanson was plagued by mental illness; in 1872, while arranging for the Detroit exhibition of his latest European works, he died. A centennial exhibition at the Cincinnati Art Museum (March 16–April 30, 1972) has contributed to the growing reputation of this long-neglected artist.

Edward M. Bannister (1828–1901)

Although his father was from the West Indies, Edward Bannister's mother was a native of St. Andrews, New Brunswick, Canada, the town where he was born. The young Bannister served as cook on a vessel involved in the coastal trade. Many of his paintings reflect his love for the sea, and much of his time in later years was spent sailing in Narragansett Bay and Newport Harbor. He settled in Boston about 1850, probably

choosing the city because it was a center of American intellectual life and because it provided a liberal atmosphere for the free Black. There he enrolled in art classes at the Lowell Institute and studied under the sculptor William Rimmer. He also established a successful business making solar plates.[30] A friend, William Alden Brown, revealed in a biographical essay on Bannister that the artist pursued his career with utmost determination after reading in an 1867 issue of the New York *Herald* that, "while the Negro may harbor an appreciation of art, he is unable to produce it." Bannister accepted the challenge but refused to accept patronage—he never studied in Europe—or to gain his reputation from "racial themes."[31]

In about 1855 or 1856 Bannister married a Rhode Island-born Narragansett Indian, Christiana Cartreaux.[32] The couple settled in Providence in 1871, at a time when that city was seeking to establish itself as an art center. Apparently, Bannister was well received in his adopted home, for he became a founder, with several white artists, of the Providence Art Club,

above: 80. EDWARD BANNISTER. *Swale Land.* 1898.
Oil on canvas, 2′ 8″ × 3′ 10″. Frederick Douglass Institute,
Museum of African Art, Washington, D.C.
(collection G. William Miller).

left: 81. EDWARD BANNISTER. *Sad Memories.* 1882. Pencil,
8½ × 6″. Frederick Douglass Institute,
Museum of African Art, Washington, D.C.
(collection G. William Miller).

which formed the nucleus of what would emerge as
the Rhode Island School of Design. National recogni-
tion came in 1876, when he won an award for *Under
the Oaks,* exhibited at the Philadelphia Centennial Ex-
position. Bannister had proved to the world that a
Black could be accepted as a serious artist. However,
when he arrived to receive his gold medal, the guards,
who were unaware of the prize-winner's race, refused
to admit him to the galleries. The painting was pur-
chased by James Duffe of New York for fifteen hundred
dollars, but it has since disappeared.

A keen observer of nature, Bannister loved the
woods and water of the American landscape (Fig. 80).
He recorded the area in which he lived and was the
first Afro-American to earn a reputation as a regional
painter. As far as is known, he painted no Blacks, nor
was he ever identified with racial causes. However,
there does exist a small sketch, *Sad Memories* (Fig. 81),

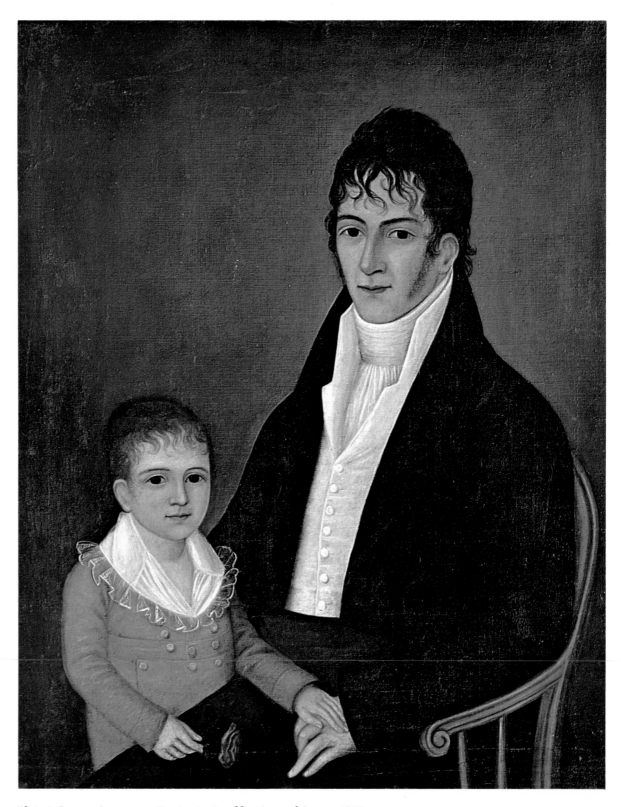

Plate 1. JOSHUA JOHNSTON. *Benjamin Franklin Yoe and Son.* c. 1810.
Oil on canvas, 36 x 29⅜″. Museum of Early Southern Decorative Arts, Winston-Salem, N.C.

Plate 2. ROBERT S. DUNCANSON. *Blue Hole, Flood Waters, Little Miami River.* 1851.
Oil on canvas, 29¼ x 42¼″. Cincinnati Art Museum (gift of Nobert Heerman).

Plate 3. EDWARD BANNISTER. *Approaching Storm.* c. 1890(?).
Oil on canvas, 3′4″ x 5′. Frederick Douglass Institute, Museum of African Art, Washington, D.C.

of an Afro-American woman seated near a fireplace, with a small child playing at her feet, possibly a recollection of his early family life. Though Bannister is considered primarily a landscape painter influenced by the Hudson River School, there is in his canvases a suggestion of the "low-keyed but charmingly lyrical paintings of more than one master of the Barbizon school." *Approaching Storm* (Pl. 3, p. 56) is a well-structured painting that has caught the mood of nature with sympathy and honesty, as well as eloquence. Two small oil sketches depart radically from the Hudson River–Barbizon tradition. *Street Scene* (Fig. 82) displays a lighter palette and looser technique than most of Bannister's paintings and suggests that the artist was aware of the Impressionist movement in European art; *After the Shower* (Fig. 83) reveals a freedom and excitement in texture and movement surprising in a painter known for his tranquil scenes.[33]

A competent but rather conventional talent characterizes the bulk of Bannister's work. He had reached the climax of his creative energies by the time of the Centennial award and repeated himself endlessly, with few exceptions, in his later works. However, his naturalistic landscapes projected more originality than many of the outmoded Neoclassical studies executed by his fellow artists.[34]

Contemporary critics, and the general public as well, reacted favorably to Bannister. Of the 101 paintings displayed in a memorial exhibit at the Providence

above: 82. EDWARD BANNISTER. *Street Scene.* c. 1895. Oil on panel, $8\frac{1}{2} \times 5\frac{3}{4}''$. Museum of Art, Rhode Island School of Design, Providence.

left: 83. EDWARD BANNISTER. *After the Shower.* c. 1895. Oil on board, $9 \times 10''$. Frederick Douglass Institute, Museum of African Art, Washington, D.C. (collection G. William Miller).

Art Club held five months after his death, all but two, which belonged to Mrs. Bannister, were borrowed from the private collections of leading Providence citizens.[35] An affectionate portrait highlighted the essay accompanying the exhibition catalogue:

He early came to this city, and for thirty years was prominent in the Providence group of artists. His gentle disposition, his urbanity of manner, and his generous appreciation of the work of others, made him a welcome guest in all artistic circles. While he painted cattle, sheep and figures with life and force, yet he introduced them only as incident to the effective portrayal of his scene. He was par excellence a landscape painter, the best our State has yet produced. He painted with profound feeling, not for pecuniary results, but to leave upon the canvas his impressions of natural scenery, and to express his delight in the wondrous beauty of the land and sea and sky. Had his nature been more self-reliant and adventurous, and had early opportunity been more varied, he might easily have been one of America's greatest landscape painters; it was his lot, however, to pursue his humble path among us, and to gently lead us into the greater life of art which only a fine man and the fine artist can inspire.[36]

George Whittaker, a critic for the *Providence Magazine* in 1914, claimed that "his paintings were poems of elevating tendency."[37] An artist friend described Bannister's feeling for landscape: "He looked at nature with a poet's feeling. Skies, rocks, field were all absorbed and distilled through his soul and projected

84. EUGENE WARBURG.
John Young Mason. c. 1860(?).
Marble, height 23″.
Virginia Historical Society, Richmond
(gift of Miss Fanny Mason Cooke).

upon the canvas with a virile force and a poetic beauty...."[38] According to Daniel Robbins, author of an essay in the catalogue for a recent exhibition of Bannister's work, the artist is important for two reasons:

1. He represents the level of Providence painting at the moment when the community determined actively to engage itself in the promotion of art.
2. As an American Negro, he represents one of the earliest artists to achieve recognition in a field where none had practiced before.[39]

Eugene Warburg (c. 1825–67)

A portrait bust of John Young Mason (Fig. 84), the Virginia statesman who became United States Minister to France, is the only known work of Eugene Warburg, a freeborn Black from New Orleans. A chronicle of Negro life in New Orleans, *Nos Hommes et Notre Histoire*, written by an obscure Creole teacher, Rodolph Desdunes, provides the sole source of information concerning the lives of Eugene Warburg and his brother Daniel (Fig. 85), a stonemason and engraver who shared a studio on St. Pierre Street in New Orleans. According to Desdunes, Eugene, who displayed a "natural penchant" for sculpture, received formal training from a French artist called Gabriel and was soon flooded with commissions for cemetery tombs, religious statuary, and portrait busts. His success aroused the jealousy of local artists, who drove him from his studio. Warburg fled to Europe in 1852, where he remained until his death, gaining a moderate reputation for the sculpture he did in the Neoclassical style. He visited France, Belgium, and Italy, and in England was commissioned by the Duchess of Sutherland to illustrate episodes from *Uncle Tom's Cabin* in a series of bas-reliefs.[40] Warburg represented the state of Louisiana at the 1867 Paris Exposition.

Henry Gudgell (1826–95)

Some continuity of an African visual tradition—a blend of "remembered ancestral" arts with new "alien modes"—survived well into the 19th century, especially in areas where the slave trade persisted or where the Black population remained dense. One example is a hardwood walking stick carved by Henry Gudgell

right: 85. DANIEL WARBURG. *Holcombe Memorial,* Metairie Cemetery, New Orleans. c. 1860(?).

(Fig. 86), with the "tense vigor one finds in the past of this people."[41] A blacksmith from Livingston County, Missouri, Gudgell carved the stick for John Bryan, who sustained a leg wound in the Civil War. When compared with a chief's staff from the Bakongo cluster of people in the Weyo territory of western

left: 86. HENRY GUDGELL. Walking stick. 1863. Rendering. National Gallery of Art, Washington, D.C. (Index of American Design).

below left: 87. Chief's staff (detail), from the Bakongo people of the Weyo tribe, Zaïre, Republic of the Congo. Wood, entire height $32\frac{7}{8}''$. Musée Royal de l'Afrique Centrale, Tervuren, Belgium.

below right: 88. Staff, from Nzadi tribe, Mbaka, Zaïre, Republic of the Congo. Collected 1953. Carved wood, height 3' 4''. Musée Royal de l'Afrique Centrale, Tervuren, Belgium.

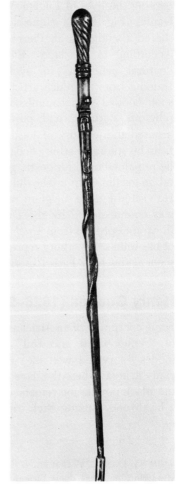

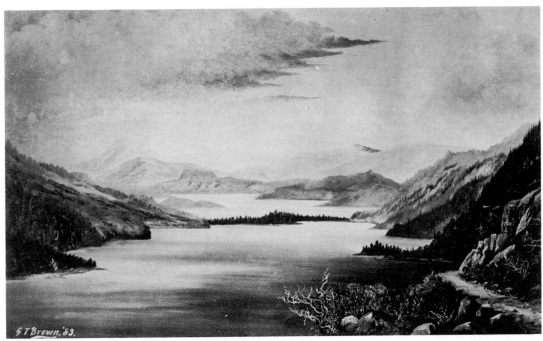

89. GRAFTON TYLER BROWN. *Long Lake.* 1883. Oil on canvas, 16 × 24″. Provincial Archives, Victoria, B.C.

Africa (Fig. 87), amazing similarities of motif were found, including a "human figure with bent legs, reptiles carved as if seen from above, [an] entwined serpent motif" (Fig. 88). The placement of figures is different, but this may be attributable to function.[42]

Henry Gudgell, the son of a white man, was born into slavery in Kentucky, a state that had absorbed many of the coastal slaves in 1793. With his mother, who was a slave, he traveled to Missouri on foot and became part of the property of the Spence Gudgell farm in Livingston County. Little is known about Gudgell's childhood or the teacher from whom he acquired his remarkable skills. He was a master at coppersmithing and silversmithing, a fine blacksmith and wheelwright. Unfortunately, his craft seems to have died with him. Although other examples of carving vaguely reminiscent of African styles have been found in Missouri, none exhibit Gudgell's skill. There is a similarity between his symbolism and that found in Afro-Georgian sculpture, but more research must be done before any direct relationship can be verified.[43]

Grafton Tyler Brown (1841–1918)

Grafton Tyler Brown was born in Harrisburg, Pennsylvania, the first son and second child of Thomas and Wilhelmina Brown. By 1861 he had moved to San Francisco, where he was employed as a draftsman and lithographer for Charles Kuchel, a German-born lithographer. Kuchel had set up a shop in Philadelphia before migrating to San Francisco, and Brown may have followed him to California. An inveterate traveler, Brown recorded the magnificent landscapes of California, Washington, Oregon, and British Columbia —first in prints and then in oils.

The Kuchel firm was noted for its views of western mining towns and California cities. However, the company also printed stock certificates, street maps, letterheads, sheet music, and diplomas—the stock-in-trade of the lithography business. Brown stayed with Kuchel for several years, then continued to manage the firm for Kuchel's widow. He opened his own establishment, G. T. Brown & Co., in 1867. Two years later he sold the business and moved to Victoria, British Columbia, from which base he took part in a Canadian Government geological survey in 1882. In 1883 an advertisement appeared in the *Williams British Columbia Directory* for "G. T. Brown, artist," giving his address as the Occidental Hotel in Victoria.

The early eighties must have been productive years for Brown. In June of 1883 the *Victoria Colonist* allowed him office space and covered his first Canadian exhibition. He showed 22 paintings, including *Long Lake* and *The Gorge* (Figs. 89, 90). An anonymous pho-

tographer documented the exhibit (Fig. 91), which was described in the *Victoria Colonist* under the headline "Exhibition of Oils of British Columbia Scenery":

Yesterday was the opening day of the exhibition at *The Colonist*'s new building of oil paintings from the brush of our local artist, Mr. G. T. Brown. Viewed in the light of artistic productions they were excellent, but when inspected by those with whom the scenes represented were familiar, their fidelity elicited an extra meed of praise, proving that the artist has taken great pains to make them correct portraits as well as good paintings. They are executed from sketches made on the spot by Mr. Brown, and have, therefore, the full benefit of little details that would not be produced by one who had never viewed the various localities. The scenes portrayed are 22 in number, comprising views of Victoria and surroundings, in addition to scenes on the mainland. . . . Several of the paintings have been already sold, and considering the general excellence of the display, the fact is not surprising. All who can spare the time should pay a visit of inspection which is free to all. The paintings will be on view every day this week from 1 to 5 p.m.[44]

The artist continued to travel. In 1884 and 1885 he painted mountain landscapes in the state of Wash-ington. The Portland, Oregon, directory listed Brown as an artist, and he was a member of the Portland Art Club in the late 1880s. Brown's last 25 years were spent in St. Paul, Minnesota, where he worked with the United States Engineers and the St. Paul Civil Engineering Department. No paintings or lithographs from this period are known to exist.

Brown's death was reported in the *St. Paul Pioneer Press* of March 3, 1918: "G. T. Brown, 77 years old, 646 Hague Avenue, for years a draftsman in the City Civil Engineering department, died late yesterday. He had been ill for five years. Born in Harrisburg, Pennsylvania, Feb. 22, 1841, Mr. Brown came to St. Paul 25 years ago. He is survived by his widow."[45]

In the spring of 1972 the Oakland Museum in California presented an exhibit of Brown's work, featuring all his known lithographs and paintings, as well as examples of the type of lithographic equipment that would have been available to Brown in the late 19th century.

below: 90. GRAFTON TYLER BROWN. *The Gorge.*
1883. Oil on canvas, 16 × 25″.
Provincial Archives, Victoria, B.C.

Edmonia Lewis (1843–c.1900)

Edmonia Lewis was an unusual woman, whose manner and rather masculine attire "departed radically from the conventional." She was born near Albany, New York, of a Chippewa Indian mother and a free Black father. Orphaned early, the youngster was reared in the tribal tradition of her mother. Later, she was adopted by abolitionists and sent to Oberlin College in 1859.[46] Her education there was short-lived, however, for she was dismissed from the college in 1862 after having been accused of poisoning two of her white roommates with drugged wine. The case created a national sensation, and the town of Oberlin, always hostile to the Black collegians, reacted wildly. Edmonia was attacked and beaten by vigilantes, then arrested by the local authorities. Her trial, which was characterized by "heated forensics," ended in her release. The defense

attorney, John Mercer Langston, was a Black abolitionist leader and graduate of Oberlin, as well as a resident of the college town. At the trial Langston claimed the girls were victims of a prank. Edmonia and her roommates had planned a sleigh ride with several male friends, and Edmonia had adulterated her friends' wine with "Spanish fly," the celebrated aphrodisiac.[47]

Lewis left for Boston, where she studied briefly with Edmund Brackett, a sculptor of local renown, and then opened her own studio. The proceeds from the sale of a medallion portraying Colonel Robert Gould Shaw, the leader of one of the earliest Black combat units of the Civil War, combined with the assistance of her patrons, the Story family of Boston, enabled the artist to travel to Rome in 1865. Although her earlier works were marked by a "crude realism," in Rome she adopted the Neoclassical style, partly through the influence of Harriet Hosmer and Hiram Powers (Fig. 56)

of Biblical symbolism. Many of the artist's later works were Neoclassical in theme as well as in style.[49]

When Lewis returned to the United States in 1873, she traveled to San Francisco with five of her sculptures: *Hiawatha's Marriage, Asleep, Love in a Trap, Awake,* and a bust of Abraham Lincoln. All five were exhibited at the Pine Street Exhibition Hall of the San Francisco Art Association. While the critic for the San Francisco *Bulletin* thought the works were "really beautiful," the *Chronicle* reviewer had mixed feelings:

> All the pieces give evidence of considerable artistic taste ... still there is so much labored finish to them that very little expression is left. The chisel has been used with too much mechanical nicety, and even if the

left: 92. EDMONIA LEWIS. *Forever Free.* 1867. Marble. Howard University Art Gallery, Washington, D.C.

below: 93. EDMONIA LEWIS. *Old Indian Arrow Maker and His Daughter.* 1872. Marble, height 27″. Carver Museum, Tuskegee Institute, Ala.

—both of whom were "under the spell of Graeco-Roman art and the reputation of Canova."[48] Lewis' subject matter continued to reflect her dual heritage. *Forever Free* (Fig. 92), completed in Rome in 1867, celebrated the passage of the Thirteenth Amendment, which forbade slavery; *Old Indian Arrow Maker and His Daughter* (Fig. 93) is an anecdotal piece with ethnologically detailed accuracy. *Hagar in the Wilderness* (Fig. 94), a work that has just recently reappeared, deals with the struggle of the Afro-American in terms

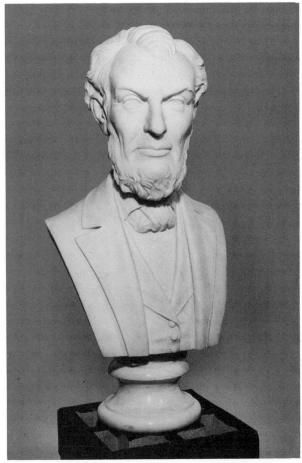

left: 94. Edmonia Lewis. *Hagar in the Wilderness.* 1896. Marble, height 4′ 4″. Frederick Douglass Institute, Museum of African Art, Washington, D.C.

above: 95. Edmonia Lewis. *Abraham Lincoln.* 1867. Marble, height 26½″. San Jose Public Library, Calif.

conceptions were originally beautiful, the over careful manner in which they have been carved out would prevent them from ever taking a high rank in art. Miss Lewis is a skillful manipulator of marble and the polish she gives it is very fine, but compared with the works of Powers and other eminent sculptors her efforts make a poor show. It cannot be denied, however, that she has acquired a certain excellence in art.[50]

In an interview with a *Chronicle* reporter, Lewis explained the reason for her California trip: "Here they are more liberal, and as I want to dispose of some of my works, I thought it best to come West."[51] Two of the pieces were sold in San Francisco. With the remaining three, the artist traveled to San Jose, where they were displayed at the City Market Hall. The San Jose Library Association raised funds to acquire the bust of Lincoln (Fig. 95), and Mrs. Sarah L. Knox, a wealthy patron of the arts, purchased *Asleep* and *Awake* (Figs. 96, 97), both of which eventually found their way into the library collection as well. Lewis'

below: 96. EDMONIA LEWIS. *Asleep.* 1871.
Marble, height 26½″. San Jose Public Library, Calif.
(collection Mrs. Sarah L. Knox; gift to San Jose Library).

right: 97. EDMONIA LEWIS. *Awake.* 1872.
Marble, height 23″. San Jose Public Library, Calif.
(collection Mrs. Sarah L. Knox; gift to San Jose Library).

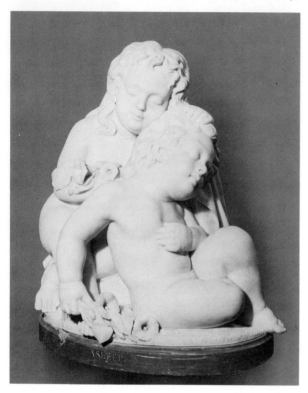

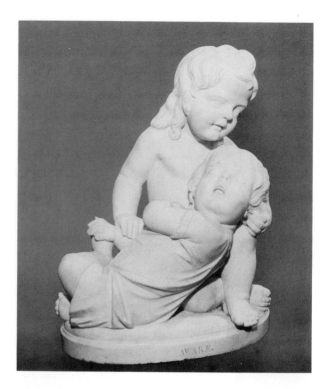

work was well received in San Jose. More than sixteen hundred visitors attended the week-long exhibition. A reviewer for the San Jose *Patriot* wrote:

> The two pieces, "Asleep" and "Awake" are very beautiful, perfect creations, and establish Miss Lewis' claim to high rank as an artist. The little children seem to have fallen asleep while sitting up, the little girl having her arm around her brother. The features are beautiful and extremely natural ... and we were struck with the wonderfully expressive features of the little girl in "Awake" on half opening her eyes and beholding her dear little brother still asleep, resting on her arm.[52]

Lewis again visited home in 1875. Receptions were held in her honor in Boston and Philadelphia, and she appeared at a concert in St. Paul, Minnesota. The artist had attracted patrons among the aristocracy of En-gland and Italy as well as support from leading art authorities.[53] A sculpture now lost, *The Death of Cleopatra,* won an award in the Philadelphia Centennial Exposition of 1876. Of this work, Lorado Taft wrote in *Artists of the Nineteenth Century:*

> This was not a beautiful work, but it was a very original and striking one, and it deserved particular comment, as its ideals were so radically different. . . . The effects of death are represented with such skills as to be absolutely repellent. Apart from matters of taste ... it could only have been reproduced by a sculptor of very genuine endowments.[54]

Henry Tuckerman, the chronicler of 19th-century artists, visited her studio in Rome and later wrote enthusiastically of her talents:

> . . . Miss Lewis is unquestionably the most interesting representative of our country in Europe. Interesting not alone because she belongs to a condemned and hitherto oppressed race, which labors under the imputation of artistic capacity, but because she already distinguished herself in sculpture, not perhaps in its highest grade, but in its naturalistic, not to say the most pleasing form . . .[55]

Tuckerman urged Americans to abandon their Neoclassical pretentions and work in the more natural style of Edmonia Lewis. However, by this time Lewis herself was engulfed in the sentimental Neoclassicism sanctioned by the academicians. After a brief period of popularity in her native country, she sank into obscurity. The date of her death has never been verified, and much of her work is only now being identified. In 1943 James Porter wrote that three of Lewis' works were at the Municipal Library in San Jose. However, the library was unaware of its treasures until 1968, when Philip M. Montesano, a frequent library visitor who had perused Porter's book in a "dingy" San Francisco bookstore, rescued *Awake, Asleep,* and the Lincoln bust from dust-covered oblivion in the library basement.

Henry O. Tanner (1859–1937)

When Henry Ossawa Tanner, the son of a Bishop of the African Methodist Episcopal Church, was elected to the French National Academy, he proved to the world that a Black could achieve international acceptance as a serious artist. A third-generation Pittsburgher, Tanner was more fortunate than most Blacks of his time, for his family belonged to the small group of middle-class Blacks that had existed prior to the Civil War. His parents (Figs. 98, 99) were educated, and he was free to cultivate his love for beauty. Tanner decided at age thirteen to study art, after viewing a landscape artist at work in Fairmont Park in Philadelphia (where his family had moved), and he was enrolled in the Pennsylvania Academy of Fine Arts. There, he

98. HENRY O. TANNER. *The Artist's Mother.* 1897. Oil on canvas, $29\frac{1}{4} \times 39\frac{1}{2}''$. Collection Sadie T. M. Alexander, Philadelphia.

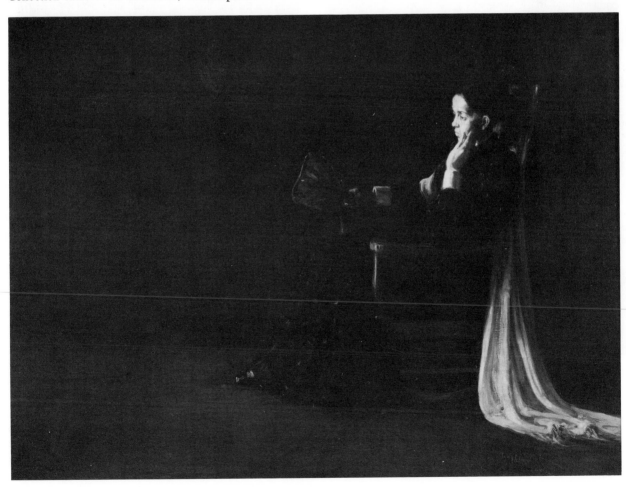

below: 99. HENRY O. TANNER.
Bishop Benjamin Tucker Tanner. 1897.
Oil on canvas, 15 × 14″.
Collection Sadie T. M. Alexander,
Philadelphia.

right: 100. THOMAS EAKINS.
Henry O. Tanner. 1900.
Oil on canvas, 24 × 24¼″.
Hyde Collection, Glens Falls, N.Y.

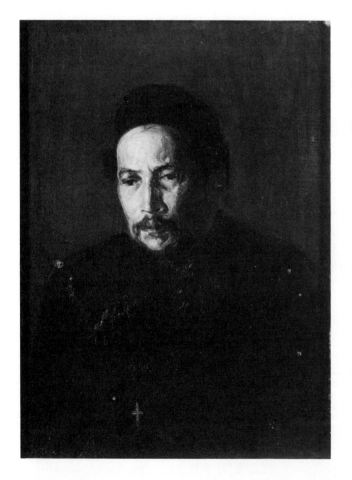

had the good fortune to study with Thomas Eakins
(1844–1916), who became his friend and mentor. In a
period when sentimentality and gentility dominated
the art world, Eakins portrayed his environment and
the people who inhabited it with an objectivity and
honesty of characterization that often raised the wrath
of his sitters. As a teacher he insisted that his students
work from life and not copy the Greco-Roman casts
so popular in contemporary art schools. In 1900 Eakins
painted Tanner's portrait (Fig. 100).

Eakins turned his young student from landscape to
genre painting. His early efforts, such as *The Banjo
Lesson* (Pl. 4, p. 89), display an "unsentimental, ro-
bust honesty," and bear a strong resemblance to Eakins'
work. For a brief period there was hope that Tanner
would become an interpreter of everyday life in the
manner of his teacher, that he would be the path-
breaker, developing the Black as subject matter for
Black artists. However, post-Reconstruction America
was supportive of neither Black artists nor "Negro
genre." After a brief teaching career at Clark College
in Atlanta, and an unsuccessful exhibit of his paintings
in Cincinnati, Tanner fled to France in 1891 to absorb,

according to Alain Locke, "brilliantly but futilely, a lapsing French style." Nevertheless, he was not completely without patrons in the United States. Bishop Payne offered his support, and three of Tanner's paintings now hang at Wilberforce College. Bishop Joseph C. Hartzell and his wife not only arranged the Cincinnati exhibition, but actually bought all the paintings, thus providing the funds that enabled Tanner to study abroad.

The Bohemian world of Paris accepted Tanner, and he made the French capital his home. He later married Jessie M. Olssen, a white American singer sixteen years his junior. Tanner studied for five years at the Julian Academy—an institution that, famed for such illustrious graduates as Henri Matisse, would later attract many Afro-American artists—where he enjoyed the friendship and advice of the French academician Benjamin Constant. Summers were spent in Brittany, recording on canvas the leisure activities of the peasants.[56] *The Young Sabot Maker* (Fig. 101), a genre painting of this period, won favorable mention at the Paris salon. Like *The Banjo Lesson*, it portrays an unsentimental affection and tenderness—this time between an older Breton man and his young apprentice.

Tanner gradually acquired an international reputation; he was an award-winner on both sides of the At-

101. HENRY O. TANNER. *The Young Sabot Maker*. 1895.
Oil on canvas, 41 × 35".
Collection Sadie T. M. Alexander, Philadelphia.

left: 102. HENRY O. TANNER.
Daniel in the Lions' Den. 1895–1921.
Oil on paper on canvas, 3′ 5″ × 4′ 2″.
Los Angeles County Museum of Art, Calif.
(Mr. and Mrs. William Preston Harrison
Collection).

below: 103. HENRY O. TANNER.
Study for Raising of Lazarus. 1896.
Oil on plywood, 6 × $7\frac{7}{8}$″.
Frederick Douglass Institute,
Museum of African Art, Washington, D.C.

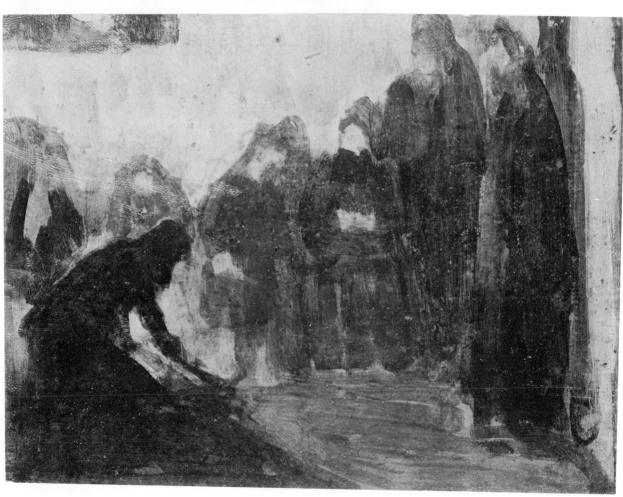

104. HENRY O. TANNER. *Christ and Nicodemus.* 1899. Oil on canvas, 34 × 40″.
Pennsylvania Academy of the Fine Arts, Philadelphia (Temple Fund purchase).

lantic. In 1896 *Daniel in the Lions' Den* (Fig. 102) received an honorable mention in the Paris Salon and praise from the academician Jean-Léon Gérôme; *The Raising of Lazarus* (Fig. 103), which was purchased by the French Government and hung in the Luxembourg Palace, won the salon's Gold Medal the following year. After viewing the painting in the Ministry of Arts, the American art critic W. R. Lester described it in *Figaro*:

Mr. Tanner's work illustrates very interestingly a sympathetic alliance of art traditions with the glowing modern temperament of the young American race.

Those who pass by quickly and gaze superficially would be likely to say of this dramatic and tonally sustained

"Resurrection of Lazarus": "a fine old picture, quite in the Rembrandt manner." But such a careless and summary judgment would work injustice to Mr. Tanner's powerful and well-poised painting.

His figures are strongly grouped, energetically designed, tense in expression without gesticulation. The color scheme, with its tonality derived from the tone of oil paintings, is rich and forceful throughout.[57]

In 1900 Tanner received a Lippincott prize; and *Christ and Nicodemus* (Fig. 104) was awarded a purchase-prize by the Pennsylvania Academy of Fine Arts. In 1905 one of Tanner's "characteristic biblical subjects" was singled out in the Carnegie competition. The

following year *Two Disciples at the Tomb* (Fig. 105), described as "strictly an exhibition picture, boldly painted," won the N. W. Harris five-hundred-dollar prize at the Chicago Art Institute's nineteenth annual exhibit, which attracted more than 350 artists, including such well-known figures as William M. Chase, Childe Hassam, and Daniel Chester French.

The recognition he received for *Daniel in the Lions' Den* had encouraged Tanner to change his style, and from that point he began to specialize in religious subjects. His religious upbringing afforded him a personal knowledge of the characters and events in the Bible, and subsequent trips to the Holy Land provided further inspiration. He was forever absorbed by the mysteries of man's existence, and a sense of mysticism pervades all his paintings, secular as well as sacred.[58]

Tanner never meant to proselytize in his religious paintings; he was concerned primarily with the formal problems of the artist. A recent critic claimed that the subject matter was relatively unimportant in Tanner's work—a theme around which to paint.[59] Tanner explained his aesthetic creed in the following statement:

It has very often seemed to me that many painters of religious subjects forget that their pictures should be as much works of art as are other paintings with less holy subjects. Whenever such painters assume that because they are treating a more elevated subject than their brother artists they may be excused from giving artistic values or from being careful about the color harmony— they simply prove that they are less sincere then he who gives his subject his best attention.[60]

A contemporary of Tanner's wrote that the artist was:

. . . a practical believer in the fact of spirit. His somber, dramatic portrayals of moving scriptural scenes unite modern art with religion, as in those earlier days when immortal masters pictured on walls of canvas the earnest faith and profound soul-experience of humanity.[61]

After his early attempts at Negro genre, Tanner abandoned the Black as a subject for his paintings, Biblical or otherwise. To Henry Tanner race was a "ghetto of isolation and neglect from which [Black artists] must escape if they were to gain artistic freedom

105. HENRY O. TANNER.
Two Disciples at the Tomb. 1906.
Oil on canvas, 4' 2½'' × 3' 4½''.
Art Institute of Chicago
(Robert Alexander Waller Fund).

and recognition."[62] When young Black artists sought his advice in Paris, he was quick to tell them he was interested in them not as Blacks, but as artists. He saw himself as an expatriate in search of aesthetic truth, "rather than a Black artist committed to his people's heritage."[63] Except for a rare family or business trip to the United States and an occasional sojourn to the Far East, northern Africa, or Palestine, Tanner spent his remaining years in France, where, as time passed, he became increasingly withdrawn, spending days isolated in his studio.[64]

Success lasted through World War I, after which his academic, romantically religious paintings were overshadowed by modernism. Tanner's palette lightened under the influence of French Impressionism, but his paintings were stylistically related to the Art Nouveau movement (Fig. 138)—a decorative mode that derived its forms from the flowing silhouettes of plant life. Tanner was an independent man, who ignored most of the controversies that disrupted the European art world in the early 20th century.[65] At a time when the French were experimenting with "loss of faith"

paintings, when Paul Gauguin engaged in objectifying religious symbolism (Fig. 136), when Georges Rouault was interpreting the religious experience in a personal, yet contemporary manner—Henry Tanner continued to produce his sensitive, sentimental, and idealized Biblical scenes.

James Porter considered Tanner a genius. He was particularly inspired by the work of Tanner's middle period, such as *Disciples at the Tomb*, in which the artist "[came] as close to the real essentials of painting as he ever came."[66] His blues and blue-greens effect a surface of iridescent enamel; they are subtle, yet luminous and gently drawn. His figures are represented as mere brush strokes. In fact, the artist often posed his models at great distances so he would not be tempted by detail. *Moses in the Bullrushes* (Fig. 106), with its luminous blue-green palette and sketchy human forms placed in a nocturnal light, hints at the artist's deeply felt religious beliefs. Even Tanner's nonreligious paintings, such as *Gate of Tangier* (Pl. 5, p. 89), manage to create an ambience of mystery and mysticism.[67]

106. Henry O. Tanner. *Moses in the Bullrushes.* 1921. Oil on panel, $22\frac{1}{2} \times 15\frac{1}{4}''$.
Frederick Douglass Institute,
Museum of African Art, Washington, D.C.

above: 107. Henry O. Tanner.
Abraham's Oak. c. 1897.
Oil on canvas, $21\frac{1}{2} \times 28\frac{3}{8}''$.
Frederick Douglass Institute,
Museum of African Art,
Washington, D.C. (collection
Mr. and Mrs. Norman Robbins).

right: 108. Albert P. Ryder.
Spring. c. 1880.
Oil on canvas, $14\frac{1}{4} \times 18\frac{1}{4}''$.
Toledo Museum of Art, Ohio
(gift of Florence Scott Libbey, 1923).

The rediscovery of seventy missing Tanner paintings that had been stored away in a Paris attic for forty years prompted an exhibition at the Grand Central Galleries in New York during the winter of 1967. Of this show, Lawrence Campbell wrote:

His work is dated, but there is something about his system of multiple glazes which adds a mystical feeling [Fig. 107] akin to [Albert Pinkham] Ryder [Fig. 108] . . . [the paintings do] little to further or hinder a reputation which has been on the rise during the last few years. The drawings show that he was a competent, academic draftsman.[68]

Another major exhibition, organized by the Frederick Douglass Institute in collaboration with the National Collection of Fine Arts of the Smithsonian Institution, was seen in Washington, D.C., Cleveland, San Antonio, New Orleans, Pittsburgh, and Waltham, Massachusetts. At a time when the Black is seeking authentic cultural heroes, the exhibitions have once again focused on a "highly accomplished" and "sensitive" painter, almost forgotten in American art.[69]

Meta Vaux Warrick Fuller (1877–?)

When Meta Vaux Warrick displayed precocious talent as a sculptor, her parents, who were members of Philadelphia's Black middle-class community (her father a barber, her mother a beautician), were able to provide her with adequate training. She began her studies at the Pennsylvania School of Industrial Arts in 1894. At her graduation five years later, she was awarded a first prize, for a metal crucifix showing Christ in anguish, and an honorable mention in clay modeling. Journeying to Paris in 1899 for further study, Warrick enrolled at Colarossi's Academy, where she remained for three years and met Auguste Rodin, the artist who elevated sculpture to a new eminence in the late 19th century with his dramatic, highly textured, romantic-realist figures. Upon viewing *Secret Sorrow*, Rodin purportedly said, "Mademoiselle, you are a sculptor; you have a sense of form." According to a contemporary critic, *The Wretched*, exhibited at the Paris Salon of 1903, revealed an artist of "power and originality."[70]

When Warrick returned to America in 1905, the Philadelphia School of Industrial Arts honored "a young colored woman with a strain of white blood," with what was described as an "interesting" exhibition. Her sculpture—portrait busts and figurines—"is extremely individual, showing a morbid, strong imagination and the influence of Rodin, who has great interest

109. META VAUX WARRICK FULLER. *Water Boy.* 1914. Bronze. National Archives, Washington, D.C. (Harmon Foundation).

in her progress."[71] During this period many state fairs and expositions awarded commissions to Black artists and began to exhibit their work. In 1907 Warrick was commissioned by the Jamestown Tercentennial Exposition to execute a tableau representing the advance of the Black, and in 1913 a group was completed for the New York State Emancipation Proclamation Commission. After her marriage in 1909 to Dr. Soloman Fuller of Framingham, Massachusetts, her activities centered around the Boston area. Apparently accepted by the local citizens, the artist gained entrance into the Boston Art Club, the Wellesley Society of Artists, the Women's Club, and the Civil League.[72]

A 1917 work entitled *Peace Halting the Ruthlessness of War* won second prize in a competition sponsored by the Women's Peace Party. Warrick's early efforts were termed "gruesome and macabre," for they dealt with powerful subject matter—themes of death, war, despair, and human anguish. Her later sculpture demonstrated a social interest and included sentimental ethnic pieces such as *Water Boy* (Fig. 109).

Meta Warrick Fuller is of historical importance because of her earlier productions, which we now know primarily through the writings of her contemporaries. Her studio caught fire in 1910, and most of her work was destroyed. A survivor was *John* (Fig. 110), a plaster head that shows a strength and vitality lacking in the later works (Fig. 111). Although "grim and terrible," wrote Benjamin Brawley in *The Negro Genius*, "they are also vital and from them speaks the very tragedy of the Negro race in the New World."[73]

William A. Harper (1873–1910)

William A. Harper's untimely death on a sketching trip in Mexico during his thirty-seventh year quite probably denied American and Afro-American art the visions of a creative giant. According to Cedric Dover, "Harper had a technical command and poetic vision, alert to new trends, which should have brought a lively mind and master's palette into the resurgence of American

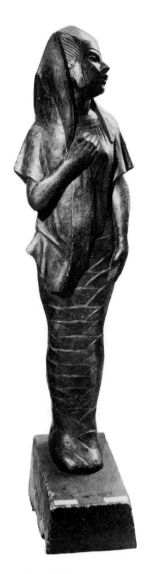

art after the First World War."[74] Harper was born in Canada. He studied at the Art Institute of Chicago and briefly in Paris with Tanner. Alain Locke considered him to be one of the genuine talents of his generation, and many thought him more original than Tanner—an elegant landscape artist in the tradition of Claude Lorrain (Fig. 59) and the Barbizon school (Fig. 58). Harper's paintings, although well received during his

left: 110. META VAUX WARRICK FULLER. *John*. 1899. Plaster. Reproduced from Alain Locke, *The Negro in Art*. New York: Hacker Art Books, 1968.

above: 111. META VAUX WARRICK FULLER. *The Awakening of Ethiopia*. 1914. Plaster, height 5′ 6″. Schomburg Collection, New York Public Library (Astor, Lenox, and Tilden Foundations).

lifetime, have not been seen collectively since his memorial exhibition in 1910.

Early Afternoon at Montigny was awarded a thirty-dollar prize for being the "most worthy landscape shown" in the annual exhibit of Chicago artists at the Art Institute in February of 1905, and in March of the same year Harper showed "two excellent landscapes" at the O'Brien Galleries in Chicago.[75] He also collected favorable reviews for each of his one-man exhibitions in the United States. Writing in the Chicago *Record-Herald,* art critic Florence Bently claimed that Harper had "in no way fallen from the standard of excellence" set by his previous show. Miss Bently described his European-based landscapes—scenes of Brittany, Provence, and England, such as *Autumn Landscape* (Fig. 112)—as filled with charm and beauty. She concluded that "when it is considered that this devoted worker is a Negro, one of that class of Americans of whom American prejudice takes nothing good for granted, the situation is not without peculiar interest."[76]

112. WILLIAM A. HARPER. *Autumn Landscape.* c. 1900–10.
Oil on canvas, 47″ square. Carver Museum, Tuskegee Institute, Ala.

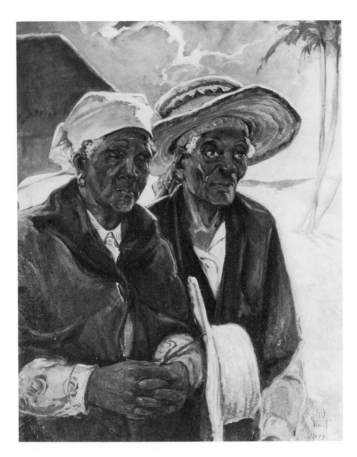

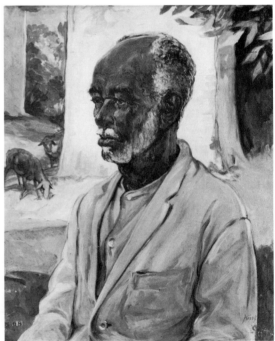

William Edouard Scott (b.1884)

Another Black American who gained entrée into the
Paris Salons was William Edouard Scott, best known
as a portrait painter and muralist. Born in Indianapolis,
Scott studied at the Art Institute of Chicago. As a
young and brilliant student, he was one of the prize-
winners in a poster competition heralding the arrival
of a Shakespeare festival in Chicago. In 1907 he was
among a group of advanced students selected to exhibit
panels illustrating the conditions of labor in the Chi-
cago area—"the factory, the sweat shop, the stock
yards, Ghetto street scenes. . . ."[77]

Following a well-worn path, he left Chicago to
study abroad, at the Julian and Colarossi academies in
Paris and in the atelier of Henry Tanner, which he
entered in 1912. Tanner's influence as a teacher is dis-
cernible in certain of Scott's earlier works. Specifically,
La Pauvre Voisine, which is now owned by the Argen-
tine government, reveals the artist's debt to Tanner in
both subject and technique. The painting was accepted
in the Paris Salon in 1912, and in 1913 *La Connoisseure*
was exhibited at London's Royal Academy.

In 1931 Scott traveled to Haiti on a grant from the
Rosenwald Foundation. Through studies of the Haitian
people, including *Blind Sister Mary* and *Kenskoh Haiti*
(Figs. 113, 114), his brushwork became freer and his

color richer. After his one-man show at Port-au-Prince, twelve of his Haitian paintings were purchased by the Haitian Government. Scott was also capable of rendering sensitive and compassionate portraits of his people. His study of Booker T. Washington (Fig. 115) captures the warmth, as well as the dignity, of that much-maligned Black leader. *Old Age* (Fig. 116) features an old Black woman sitting beside her window and staring into space—a moving essay on the loneliness of the elderly. It is a well-constructed, finely painted portrait.

Scott's career as a muralist began when he returned home. Hospitals and public buildings in Indiana, Illinois, West Virginia, and New York are decorated with

115. WILLIAM E. SCOTT. *Booker T. Washington.* 1916.
Oil on canvas, $44\frac{1}{2} \times 36''$. Carver Museum, Tuskegee Institute, Ala.

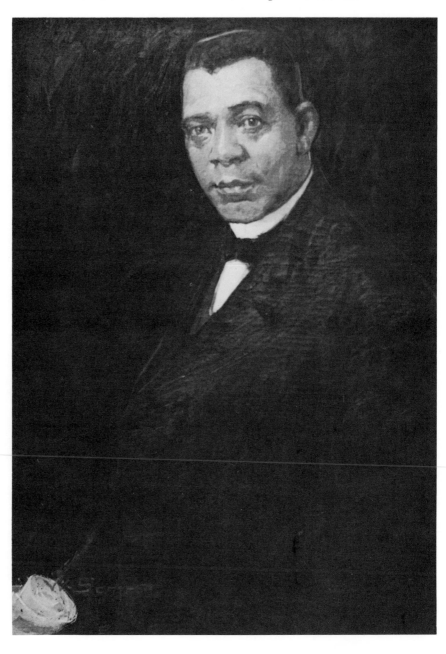

his compositions. Although he is an able draftsman, the artist is most admired for the richness of his palette.[78]

Most of the artists reviewed in this chapter were products of the Black middle class that emerged in the northern states before and after the Civil War. They attended local public schools, and most received training in American art schools or the European academies. Whatever success they achieved rested on their adherence to prevailing academic standards, for none were innovators. Their social and cultural isolation at home, plus their desire to please in Europe, divorced them from the controversies raging in the art world. So removed from the mainstream of art was the Black artist before World War I that the impact of the Armory Show of 1913 did not reach him until the late 1920s. He remained an academic realist or a decorative Impressionist, gaining favorable reviews from those critics who sought to preserve the status quo, while the mainstream of American art was in ferment.[79]

116. WILLIAM E. SCOTT. *Old Age.* 1933. Oil on canvas, 25 × 21½″. Carver Museum, Tuskegee Institute, Ala.

The New Negro:
From World War I
to 1960

The migration of hundreds of thousands of Blacks from the rural South to the urban North gave rise to a new spirit in the Afro-American. Stimulated by newspapers such as the Chicago *Defender* (founded in 1905), which extolled the virtues of living in a northern urban community, the rural Black traveled North during and after World War I to take advantage of the burgeoning job opportunities created by war needs and to give his children access to a better education. In the South the Black had lived among the whites, a holdover from the days of slavery, when the belief had been that a scattered population would be easier to control. However, upon his arrival in the northern cities, he was channeled into densely populated ghettoes, usually in decaying areas. The Black migrant thus was confronted with an alien life style, and the subculture he created for himself "took on new adaptations to new types of traumatic individual and social experiences. The subculture became one increasingly difficult to permeate with the ordinary intentions and devices of formal education"[1] Educating the newcomers seemed a formidable task, and latent hostilities were aroused. Consequently, educational journals began to publish articles supporting the need for segregated schools.

There were, however, some positive aspects to this cultural isolation. A new sense of community paved the way for racial self-reliance, as well as the potential for political and economic power. Growing community needs fostered the development of a business and professional class. Finally, a sense of race pride and an interest in the African heritage began to emerge. All these factors joined to create an atmosphere for the Garvey movement and the cultural regeneration known as the Harlem Renaissance. And, it was from

this urban base that the protest movement of the 1950s and 1960s evolved.

Marcus Garvey's Universal Negro Improvement Association attracted millions of Blacks. Preaching racial dignity and pride—the beauty of Blackness—Garvey planned to develop an independent state in Africa and to establish economic and political unity among Blacks all over the world. The colonization plans never materialized, but Garvey's efforts evoked a sense of hope and solidarity among the masses of Black people. By contrast, the Harlem Renaissance or New Negro Movement appealed to a different stratum of society, for it reflected what was rich and beautiful in the Black ghetto. Black poets, painters, musicians, and writers were creating at an unprecedented rate, and moreover they were being featured in the white urban press. Drawn by the exoticism of the Black and the spirit of the "roaring twenties," whites flocked to Harlem to share in the excitement. For the Black artist and intellectual, the Renaissance was an affirmation of racial pride and a call to portray the Black with dignity. It also marked the end of an era of accommodation that had prevailed for more than a generation.

The twenties and thirties saw a growth in the Black's desire to discover his past. Slave narratives had served this purpose in the 19th century, but the 20th century required a more formalized approach, as Afro-American historians sought to destroy the myths created and perpetuated by white historians. The Association for the Study of Negro Life and History was founded in 1915; its publication, *The Journal of Negro History*, originally edited by Dr. Carter G. Woodson, continues to meet the standards of historical research and scholarship. In 1926 a group of historians organized "Negro History Week"—a period centered around President Lincoln's birthday—in which an attempt was made to communicate the role of the Black in American history to Black children. The *Journal of Negro Education*, designed to analyze all aspects of the Black's educational life, was founded in 1932 and still provides a forum for debate on educational controversies, reflecting the changing attitudes and goals of Black educators.

The Harlem Renaissance

The Harlem Renaissance or New Negro Movement of the 1920s was a culmination of the optimistic spirit among northern Blacks after the turn of the century. The Renaissance took root in the social and intellectual movements of the Booker T. Washington era and was nourished by the quest for education and wealth, the literary strivings, and the philosophies of racial pride, self-help, and solidarity that began about 1900.[2] The movement was ushered in by the "near-Broadway" production in the early twenties of *Shuffle Along* (Fig. 117), a musical created by Black authors and performed by Blacks; it ceased with the onset of the Depression. Harlem was its capital: Black artists and intellectuals from all over the world were attracted to the free and spirited "city within a city." *The New Negro*, a special issue of *Survey Graphic* edited in 1925 by Alain Locke, became its manifesto.[3]

A change was beginning to take place in the Afro-American and in society's attitude toward him. He was being studied, not merely discussed, by social scientists; he was portrayed seriously by painters and writers. At last the old stereotype was disappearing. The new Black rejected paternalism, social dependence, and a double standard of judgment; he placed far greater emphasis on self-respect, self-reliance, and race pride. The Black no longer wanted to be part of the social debt, for he was ready to make his *own* contribution to the social development of his country. Writing in *The New Negro* reflected this change in attitude: Countee Cullen's poems offer no apology for the "brown girl's swagger"; Rudolph Fisher's short stories treat the impact of urban life on the southern Black without sentimentality; Alain Locke speaks with pride of the legacy of ancestral arts and urges the Black artist to return to Africa for inspiration.[4]

By the 1920s the Black middle class was large enough to have produced an intellectual elite. The artists and writers of this group rejected the rigid middle-class standards. After World War I they began migrating to Harlem, where they formed a "community of intellectuals" who differed from their counterparts of the post-Reconstruction period in one essential way: Whereas the earlier group had desired equal treatment within the white middle-class society, the second-generation Blacks rebelled against their parents' staid values. Instead, they sought alternate life styles and inspiration for their art in the folk culture their elders had rejected. Unfortunately, the very people who were now celebrated by the Harlem Renaissance intellectuals—the great majority of mostly unemployed and illiterate poor Blacks—were unaware of the existence of a "New Negro."

White writers such as Gertrude Stein and Waldo Frank looked to the Black for a "creative expressiveness" not corrupted by modern civilization. During the Harlem Renaissance, African art enjoyed a vogue

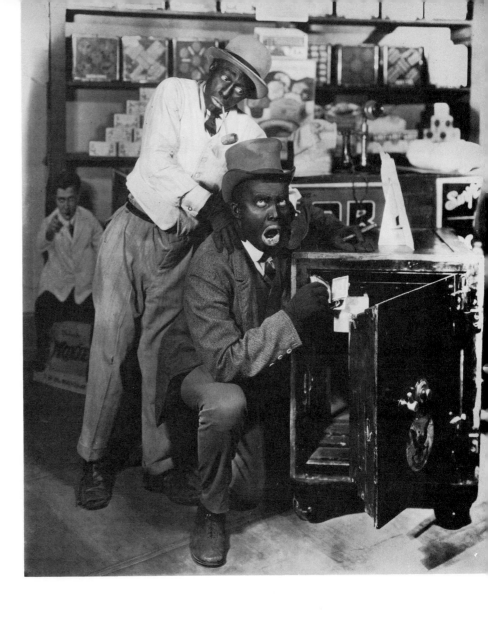

117. Scene from the 1921–22 production of *Shuffle Along*, an all-Black musical that originated in Harlem and played successfully on Broadway.
Book by FLOURNOY MILLER and PAUL GERARD; music by EUBI BLAKE; lyrics by NOBLE SISSLE.

among white collectors, and new emphasis was placed on the folk and "primitive" aspects of the Black. In other words, the whites created new myths, new stereotypes for the Afro-American. He was a child of nature, sexually uninhibited, and replete with unspoiled creativity. When a Black writer or artist proved a bit too sophisticated, he was dropped by his white patron.[5] The Black middle class failed to support the New Negro in his honest reporting of the "Negro scene." Claude McKay and Langston Hughes were both rebuked for portraying an earthy Black model for the white world to criticize. However, it was the common people that Hughes admired most. Their music, their dancing, their dialects, and their life style stimulated much of his poetry, while the pretentiousness of the Negro middle class simply bored him.

The role of the Black artist—propagandist or free interpreter of life—was a subject of heated debate during the Renaissance. DuBois criticized the filth of the novelist; Benjamin Brawley, an early writer on "Negro culture," attacked the perverted music—jazz—that was emanating from the slums. The middle class insisted that the artist should use his talent to enhance society's image of the Black, in order that cultural barriers might disappear. However, the "new Negro" propagated a cultural dualism. He rejected purely protest literature, choosing instead to present a forthright picture of "Negro life." Racial injustice and group acceptance were but secondary themes in his work.[6]

The Harlem Renaissance was an essential part of the *zeitgeist* of the twenties—a period of revolt, of experimentation, of seeking new freedoms and new life styles.

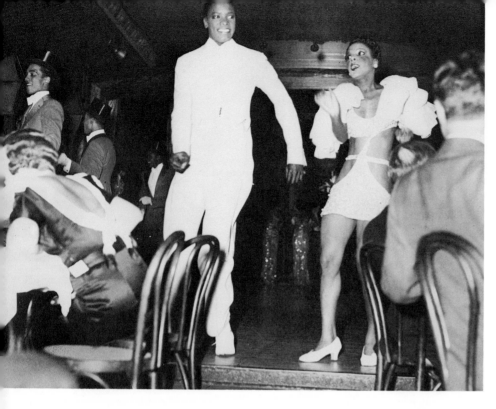

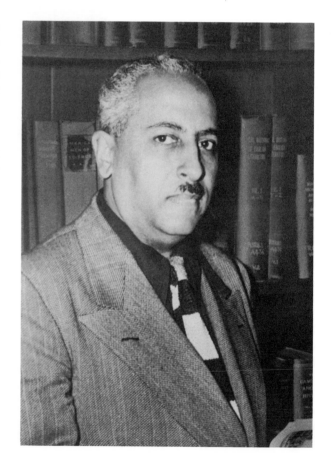

left: 118. Dance revue at Harlem's Cotton Club. c. 1934.

below: 119. ARNA BONTEMPS. 1971.

Forever in pursuit of the exotic, the Bohemian, white café society flocked to hear jazz at night spots like the Cotton Club (Fig. 118), where Blacks could perform but could not sit in the audience.[7] The music of the Black eventually came to represent a whole complex era—"the Jazz Age."

The literary contributions of the Renaissance reflected the dominant ideologies of the twenties, but, more important, they also focused on specifically Black themes. Writers such as Langston Hughes, Countee Cullen, and Arna Bontemps (Fig. 119) explored the Afro-American past; the traditions of the Black subculture appeared in the poems and short stories of Jean Toomer and the novels of Claude McKay; the problems of middle-class respectability and "passing" were delineated in novels by Walter White and Jessie Fauset; the theme of protest permeated much of Countee Cullen's poetry. Publishers found it profitable to distribute the work of Black writers to segments of the white reading public who now wanted to share the Black experience. The Harlem Renaissance was not a withdrawal from the prevailing culture, but rather a reaffirmation of cultural pluralism, whereby the Black man, proud of his racial heritage and his American citizenship, could maintain his integrity and at the same time enrich the American culture through his music, art, and literature. As Alain Locke wrote, the

120. Aaron Douglas. Illustration for *The New Negro*,
edited by Alain Locke. New York: Boni, 1925.

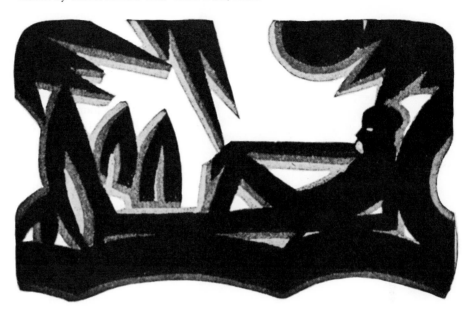

Black must be "a collaborator and participator" in American society while simultaneously preserving and enhancing his racial heritage.[8]

Arna Bontemps, in the foreword to a book of his poems, described what it was like to be a young Black writer in Harlem during the height of the Renaissance:

> It did not take long to discover that I was just one of many young Negroes arriving in Harlem for the first time and with many of the same thoughts and intentions. Within a year or two we began to recognize ourselves as a "group" and to become a little self-conscious about our "significance." When we were not too busy having fun, we were shown off and exhibited and presented in scores of places to all kinds of people. And we heard the sighs of wonder, amazement and sometimes admiration when it was whispered or announced that here was one of the "New Negroes."[9]

Although the Harlem Renaissance was primarily a literary movement, every attempt was made to discover and promote the visual arts. Winold Reiss, an Austrian artist, was selected to illustrate *The New Negro*. For an assistant he chose his student, Aaron Douglas, a young Black artist from Topeka, Kansas, with a Bachelor of Fine Arts degree from the University of Nebraska and a Master of Arts degree from Columbia University. The two men included Black

portraits, photographs of African sculpture, and African-inspired decorative motifs (Fig. 120)—all of which not only inspired young Black artists to explore Afro-American themes in their art, but added "considerably to the total effect of the volume as a testimonial to Negro beauty, dignity, and creativity."[10] Douglas, former chairman of the Department of Art Education at Fisk University, described how desperate the search was for new Black talent:

> Harlem was sifted. Neither streets, homes nor public institutions escaped. When unsuspecting Negroes were found with a brush in their hands they were immediately hauled away and held for interpretation. They were given places of honour and bowed to with much ceremony. Every effort to protest their innocence was drowned out with big-mouthed praise. A number escaped and returned to a more reasonable existence. Many fell in with the game and went along making hollow and meaningless gestures with brush and palette.[11]

Douglas was the only Black artist of significance to emerge from the Harlem Renaissance. In 1927 he prepared the illustrations for James Weldon Johnson's *God's Trombones: Seven Negro Sermons in Verse*, a book that captured the image of the fundamentalist Negro preacher. The illustrations were unique in that

they utilized geometric symbolism instead of concrete realism (Fig. 121).

Douglas' large-scale murals, with stylized figures in geometric settings, displayed a subtlety and sophistication unparalleled by the other Works Progress Administration muralists working in the thirties. His murals are concerned with the broad themes of Afro-American history, but they are never cast in traditional settings. In the four murals on display at the Countee Cullen Branch of the New York Public Library (Figs. 122–125) Douglas created a mystical atmosphere through which his ethereal figures move as though in a tableau.[12] For the artist, they encapsulate the history and experience of the American Black:

The first of the four murals . . . indicates the African cultural background of American Negroes. Dominant in it are the strongly rhythmic arts of music, the dance and sculpture—and so the drummers, the dancers, and the carved fetish represent the exhilaration and rhythmic pulsation of life in Africa.

Panel Two. Exultation followed the abolition of slavery in America. . . . Many Negro leaders emerged who are

above: 121. Aaron Douglas. Illustration of "The Prodigal Son" for James Weldon Johnson's *God's Trombones.* New York: Viking Press, 1927.

right: 122. Aaron Douglas. *Aspects of Negro Life* (panel 1, on African backgrounds). 1934. Oil on canvas, 6' 1" × 6' 8". Countee Cullen/ Schomberg Collections (sponsored by the W.P.A.), New York Public Library (Astor, Lenox, and Tilden Foundations).

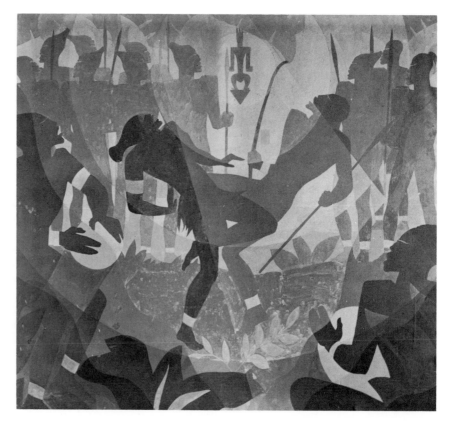

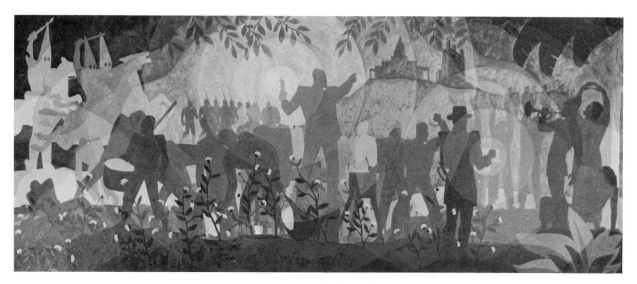

123. AARON DOUGLAS. *Aspects of Negro Life* (panel 2, on slavery through Reconstruction). 1934.
Oil on canvas, 4′ 11″ × 11′ 8″. Countee Cullen/Schomberg Collections
(sponsored by the W.P.A.), New York Public Library (Astor, Lenox, and Tilden Foundations).

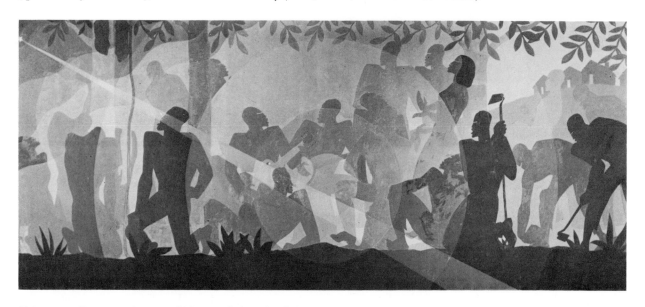

124. AARON DOUGLAS. *Aspects of Negro Life* (panel 3, "The Idyll of the Deep South"). 1934.
Oil on canvas, 4′ 11″ × 12′. Countee Cullen/Schomberg Collections
(sponsored by the W.P.A.), New York Public Library (Astor, Lenox, and Tilden Foundations).

symbolized by the orator standing on a box. But soon a new oppression began in the South . . . the Ku Klux Klan. . . .

Panel Three. Lynching was an ever-present horror, ceaseless toil in the fields was the daily lot of the majority, but still the Negro sang and danced.

Panel Four. A great migration, away from the clutching hand of serfdom in the South to the urban industralized life of America, began during the first World War. And with it there was born the creative self-expression which quickly grew into the New Negro Movement of the 'twenties. At its peak, the Depression brought confusion, dejection and frustration.[13]

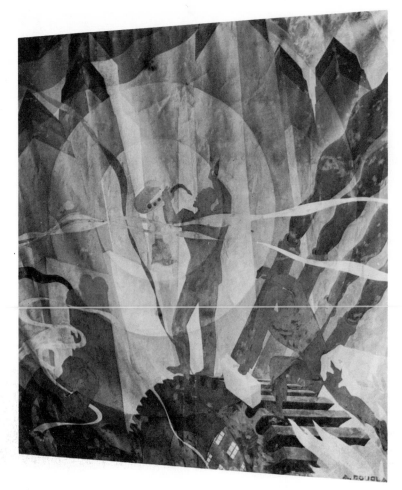

125. Aaron Douglas. *Aspects of Negro Life* (panel 4, "Song of the Towers"). 1934. Countee Cullen/Schomberg Collections (sponsored by the W.P.A.), New York Public Library (Astor, Lenox, and Tilden Foundations).

Although Harlem was the capital of the New Negro Movement, there was similar activity in other urban centers where Blacks had settled in large numbers during the great migration. In 1922, the Tanner Art League of Washington, D.C., selected and displayed 112 paintings and 9 sculptures by Black artists; in Chicago, in 1927, a week-long festival called "The Negro in Art" was presented by the Chicago Women's Club. The latter program—which included literature, drama, and the visual arts—had a lasting effect in the Chicago community, for it marked the collective strength of the Black creative artist and demonstrated that there was now a large Black middle class responsive to Black art and artists.[14]

The Harmon Foundation

The Harmon Foundation was created by William E. Harmon in the early 1920s as an "experimental service for human welfare." A man with a "deeply rooted sense of justice," Harmon became vitally concerned with the plight of the Afro-American and his role in the economic structure of the United States. To encourage the Black's creative development, Harmon established the William E. Harmon Awards for Outstanding Achievement Among Negroes. In 1926 he added awards for artistic achievement, and in 1928 the first Harmon Foundation art exhibition was held at International House in New York. Although most of the 87 paintings exhibited were of amateur quality, many competent artists were discovered. The Gold Award winner was Archibald Motley (Pl. 7, p. 107; Figs. 148–151).[15]

By assembling the work of Black artists from all regions of the country, the Harmon Foundation hoped to encourage the Black to develop an art devoid of academic or Caucasian influences and to promote the Afro-American theme as a vital phase in the artistic expression of American life. Alon Belmont, the director

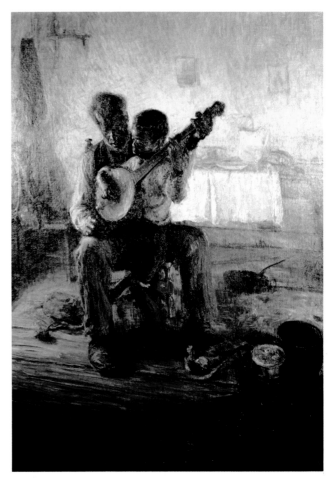

above: Plate 4. Henry O. Tanner. *The Banjo Lesson.* 1893. Oil on canvas, 4'½" x 3'11". Hampton Institute, Va.

left: Plate 5. Henry O. Tanner. *Gate of Tangier.* c. 1910. Oil on plywood, 22¾ x 19½". Frederick Douglass Institute, Museum of African Art, Washington, D.C.

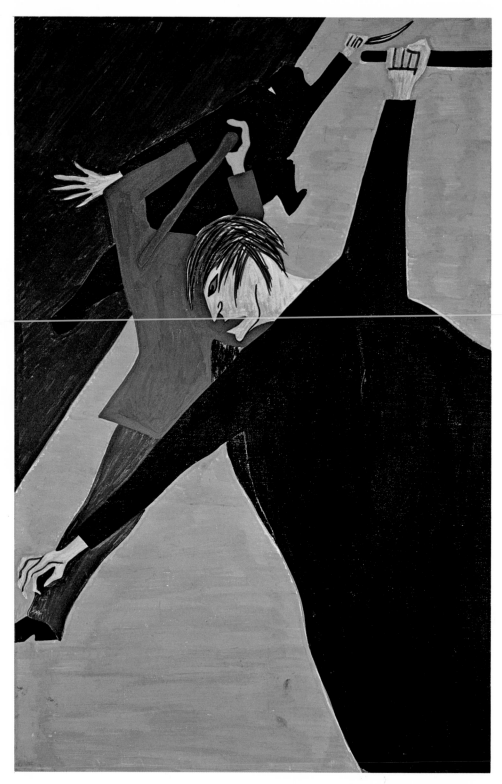

Plate 6. JACOB LAWRENCE. *Race Riots Were Very Numerous All Over the North*, panel 50 from *The Migration of the Negro* series. 1940–41. Tempera on composition board, 18 x 12″. Museum of Modern Art, New York (gift of Mrs. David M. Levy).

126. Exhibition sponsored by the Harmon Foundation at Dillard University, New Orleans.

of the National Alliance of Art and Industry, was a cosponsor of the 1931 and 1933 exhibitions.[16] Belmont wrote in the 1931 catalogue that "the first exhibition in 1928 . . . was so disappointing in this respect[17] that many critics decided that the Negro had no original and vital contribution to make in the visual arts." Supporters of the foundation's goals continued to believe "that a race which can express itself through its music so characteristically in rhythm, color and strength, must eventually have something equally important to express in the visual arts." Belmont claimed that the 1931 exhibit justified this belief. Since many more artists were inspired by the African and Afro-American experience, he wrote, there was a "beginning of race consciousness" in the Black man's art.[18]

The foundation also sponsored traveling art exhibitions (Fig. 126). By 1933 the shows had been seen in 50 cities and 27 states; attendance had exceeded 350,000, of which at least 30 percent were Blacks. In addition, the foundation helped to develop art-education programs in the Black schools and colleges and, through the competition for cash awards, encouraged the artists who had matured during the New Negro Movement. Among the exhibitors were James Porter, Malvin Gray Johnson, William Edouard Scott, Hale Woodruff, Lois Mailou Jones, Beauford Delaney,

Richmond Barthé, and Meta Warrick Fuller. By 1935 the Harmon Foundation was communicating with approximately four hundred Afro-American painters, both full-time and amateur.[19] When its activities ceased in 1967, some of its records were turned over to the National Archives and Record Service in Washington.

A traveling Harmon Foundation exhibit was reviewed in the March 1939 issue of *Survey Graphic:*

> In accordance with its policy of having the museum serve the people of the whole community, the Baltimore Museum of Art has held the first exhibition of work by Negro artists to be shown in that city, whose population is more than one-fifth colored. Paintings, prints, drawings and sculpture by some thirty Negro artists were assembled from all over the United States with the aid of the Harmon Foundation, New York. They represent, the art critic of the Baltimore *Sun* points out, a so-to-speak first generation of Negro artists. Yet they work in varied styles, and without self-conscious, strained efforts to produce racial art.[20]

Some critics took severe attitudes toward the exhibitions. Malcolm Vaughan of the *New York American* wrote: "But in the field of painting and sculpture, [Negro artists] appear peculiarly backward, indeed so inept as to suggest that painting and sculpture are to

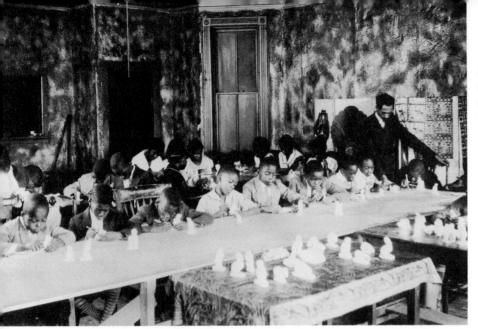

127. Harlem Art Workshop, one of the many art workshops established for children during the Great Depression.

them alien channels of expression."[21] A *New York Times* reviewer was equally harsh:

> Such racial aspects as may have once figured have virtually disappeared, so far as some of the work is concerned. Some of the artists, accomplished technicians, are seen to have slipped into grooves of one sort or another. There is the painter of the Cezannesque still life, there is the painter of the Gauginesque nudes, and there are those who have learned various "dated" modernist tricks.[22]

Romare Bearden, who became a leading figure in the Black art revolution of the 1960s (Pl. 18, p. 164; Figs. 206–208, 240), was sharply critical of all organizations and foundations that coddled and patronized Black artists. According to Bearden, the Black artist lacked a social philosophy and a definite ideology. Instead of trying to interpret the life he knew, the Black artist proudly exhibited European landscapes that were not only alien to him but bloodless imitations of an outmoded European tradition. Bearden continued:

> At present it seems that by a slow study of rules and formulas the Negro artist is attempting to do something with his intellect, which he has not felt emotionally. In consequence he has given us poor echoes of the work of white artists—and nothing of himself . . . the Harmon Foundation . . . has encouraged the artist to exhibit long before he has mastered the technical equipment of his medium. By its choice of the type of work it favors, it has allowed the Negro artist to accept standards that are both artificial and corrupt.[23]

However valid Bearden's criticisms were, at least the artists had an opportunity to see their work evaluated by professional standards. Galleries and museums took note, and as a result of his exposure in the Harmon Foundation exhibits, Richmond Barthé sold to the Whitney Museum of American Art the plaster *African Dancer* that is reproduced here as Figure 174.[24]

Black Artists and the Depression Years

For many Black artists and intellectuals, the struggle during the Depression was seen in terms of class rather than race. The economic catastrophe was so devastating that it temporarily eclipsed the concern about individual oppression. Artists, who seem always to be at the fringes of the economy, were especially hard-hit, and various New Deal programs were implemented to find work for the unemployed. In 1933 the Public Works of Art Project was established within the Treasury Department, only to be superseded a year later by the Federal Art Project, a division of the Works Progress Administration. The latter included the Index of American Design, which attempted to catalogue the American decorative arts. W.P.A. art programs were very successful, and the project was not disbanded until 1943, during World War II.

Fortunately, the Black artist was considered worthy of public support, for his very existence was at this time extremely precarious. Now considered part of the mainstream of American art, the Black was liberally awarded mural commissions—some in Black institutions and others in post offices, banks, and hospitals

used by the community as a whole. Many of the white artists who survived this period of work and growth emerged as leaders of the art world during the post-World War II period, when the center of art activity shifted from Paris to New York. The Black artists who endured—such as Hale Woodruff (Pl. 9, p. 109; Figs. 165–171), Charles Alston (Pl. 13, p. 127; Figs. 184–189), and Romare Bearden—are now considered among the "grand old men" in Afro-American art.

The Depression caused artists, Black and white alike, to diversify. Some became muralists, others were supported as easel painters, still others catalogued silver and furniture for the Library of Congress. Blacks were trained in the community art centers and workshops (Fig. 127) that began to sprout all over the country; they learned silk-screen printing, show card work, weaving, architecture, and photography. Many entered the various crafts and became part of the creative life of American industry, a role the Black had not played since plantation days.[25] Among the muralists were Aaron Douglas, Charles White, Charles Alston, Hale Woodruff, and Archibald Motley. Their subject matter usually included scenes from Afro-American life and history. It has been said that, collectively, the historical murals of the aforementioned artists would "relate the complete history of the Negro people in the United States."[26] Richmond Barthé produced two marble reliefs, *Exodus* and *Dance* (Figs. 128, 129) that now adorn the Harlem River House in New York.

above: 128. RICHMOND BARTHÉ.
Moses, Aaron, and Hezekiah,
detail from *Exodus: The Green Pastures.*
1938. Marble relief.
Harlem River House, New York
(U.S. Treasury Art Project).

left: 129. RICHMOND BARTHÉ.
Negro Dancer, detail from *Dance.*
1938. Marble relief.
Harlem River House, New York
(U.S. Treasury Art Project).

Joseph Delaney (Fig. 130; Pl. 11, p. 110; Figs. 179, 180) catalogued Paul Revere silver for the Library of Congress; Norman Lewis (Pl. 17, p. 163; Figs. 203–205) and Eldzier Cortor (Pl. 20, p. 166; Figs. 211–214) were subsidized as easel painters; Jacob Lawrence (Pl. 15, p. 161; Figs. 9, 132, 194–201, 239, 241) studied under Charles Alston at the Harlem Workshop.

The Black artist was accepted, but not completely; there was moral concern for his right to exist, but only through the white man's largesse. Although he was granted mural commissions, he rarely, if ever, was included in the art exhibitions sponsored by the W.P.A.

130. JOSEPH DELANEY. *Crows Nest.* 1942.
Oil on masonite, 4′2″ × 2′4″. Courtesy the artist.

during the 1930s. At a politically inspired exhibit—"Art Commentary on Lynching"—held at the Arthur V. Newton Galleries in 1935, John Stuart Curry, Isamu Noguchi, Thomas Hart Benton, and Paul Cadmus, all celebrated artists of the thirties, were sufficiently moved by the inhumane treatment of the southern Black to contribute paintings. However, no Black artists were included.[27]

In conjunction with the opening of Black composer Hall Johnson's *Run, Little Chillun*, an informal art showing was held at the Lyric Theatre in New York. Most of the paintings were *of* Blacks but *by* whites; Martha Simpson's *Harlem May Queen* was cited as best in the show. Hale Woodruff was the only Black artist mentioned, and his work was not described.[28] White artists continued to scour the streets and cabarets of Harlem and the cotton fields of the South to find subject matter for their paintings and sculpture, and this served only to perpetuate the stereotype. Rarely was a Black man treated as a complex human being or as an individual member of his race. The attitude of the Establishment artist and art critic of the period is revealed in a review of Elizabeth Paxton Oliver's twenty canvases of American "negroes" at the Ehrich-Newhouse Gallery in 1936:

> What is lacking in artistic grounding is compensated by human appreciation: the work should be judged by other standards than aesthetic. . . . Although the painting is uniformly of average quality, she is to be commended for taking the time and energy to think about the negroes in a kindly way.[29]

Black Art Exhibitions of the 1940s

During the forties, when an exhibit was labeled "Negro art," the artists, not just the subjects, were Black. In 1941 Alain Locke organized "Afro-American Art on Both Continents," sponsored by McMillen, Incorporated, a decorating firm. In his review, James W. Lane wrote: "the farther removed the Negro artist is from copying a white man's style or subject matter, the better he is." He found in Romare Bearden's *Pickin' Cotton* the "deep, reverencing rhythm of the colored people. No white man . . . could have painted a picture like this." Also shown were the two Delaney brothers— Beauford with Central Park, considered to be "like Van Gogh [Fig. 137] in brushing, but like Cézanne [Fig. 135] in 'fête-champêtre' spirit"; and Joseph, whose *Movie Theatre* is "brown and dark inside, but dramatic." Accompanying the exhibition were African

131. "American Negro Art: 19th and 20th Centuries" exhibition at the Downtown Gallery in New York (installation shot). December 9, 1941–January 3, 1942. *left:* JOHN H. SMITH. *Tough Boy.* 1938. Wood. *center:* ROBERT DUNCANSON. *The Blue Hole, Flood Waters, Little Miami River* (Pl. 2, p. 56). 1851. Oil on canvas. *right:* JOHN H. SMITH. *Family.* 1940. Wood.

sculptures which, according to Lane, complemented "in an appropriate manner the art of the Negro from our own hemisphere and show[ed] how he has always had his own highly original artistic sense which he keeps uncontaminated."[30] Two days after the bombing of Pearl Harbor, an event of "major importance"—an exhibition called "American Negro Art: 19th and 20th Centuries"—opened at Edith Halpert's Downtown Gallery in New York (Fig. 131). James Lane reported discernible "Negro characteristics" in the work included in the exhibition:

A Negro uses color with more resonance than the white man. It is apt to be wilder, more exotic color, but it is also purer, deeper, more unconventional. The Negro, Horace Pippin for example, will do things with color juxtaposition that we never would. He will portray a colored type, as in Eldzier Cortor's "Southern Landscape," much more recognizable than does the white man. In sculpture the nervous energy of the Negro, his sensitiveness sharpened by long years of persecution or injustice, makes his work less static, as we see in the case of Barthé.[31]

Still a stereotype, still a collective soul, the Black artist was admired only when he demonstrated obvious "Negro characteristics." However, a star emerged from the exhibit. Jacob Lawrence's series *The Migration of the Negro* (Pl. 6, p. 90; Figs. 196–198) was purchased immediately, and to this day Lawrence remains the most widely celebrated Afro-American artist.

In 1943 a show in Grand Rapids, Michigan, included one hundred "Afro-American professionals," along with the art of Africa and of Afro-American children. According to an *Art News* review: "The modern adult paintings are forthright, dramatic, and colorful, while the children's pictures testify to the same sort of warmth and emotional intensity."[32] That same year the Museum of Modern Art in New York exhibited a group of paintings by students from the Hampton Institute. The works embodied "a form of race and social consciousness utterly incompatible with sincere artistic expression." The students were judged blameless, but their "heavy-handed" teachers were faulted for encouraging protest art in their charges.[33] At an exhibit in 1944, termed "the most impressive

right: 132. JACOB LAWRENCE. *Pool Parlor.* 1942(?).
Gouache on paper, 31 × 22¾″.
Metropolitan Museum of Art, New York
(Arthur H. Hearn Fund, 1942).

below: 133. RICHMOND BARTHÉ. *The Boxer.* 1943.
Bronze, height 16″.
Metropolitan Museum of Art, New York
(Rogers Fund, 1942).

Visitors to the show may take away with them conflicting impressions as to the advisability of such restricted events. On the one hand they cannot but be impressed by the color, the eloquence, the directness of appeal that this painting and sculpture contains; on the other they may prefer to regard such works as an integral part of all American art rather than as a racial manifestation which segregation inevitably implies.[34]

display of paintings by Negro artists that has been brought together so far," the validity of the all-Black show was first challenged. The show was held at Washington's "G" Place Gallery and sponsored by members of the Washington community who were interested in encouraging "Negro artists" and awakening public interest to the qualities inherent in "Negro art." It elicited the following comment from an *Art News* reviewer:

Two deliberately interracial shows were held during the last year of the war. One, the feature event of the new International Print Society, was designed, according to the gallery director, to promote the use of art as a method to develop better race relations. The paintings were of such high quality, claimed one review, "that the fact that the artists were of different races seemed incidental." The other was sponsored by the Fur Dressers and Dyers Union. Its theme was "The Negro in American Art," its stated intention, to

emphasize for its members through visual means the importance of solidarity between Blacks and whites.[35]

When artistic organizations united to boost morale during the war, Black artists were included. An exhibition sponsored by "Artists for Victory" at the Metropolitan Museum of Art was planned to show the status of American art a year after Pearl Harbor. Prizes were awarded to Jacob Lawrence for *Poor Parlor* (Fig. 132) and to Richmond Barthé for *The Boxer* (Fig. 133).[36]

Since 1942 Atlanta University has each year invited Afro-American artists to submit samples of their best work for exhibition at the university galleries (Fig. 134). The program was initiated by Hale Woodruff, a former professor at the university; its purposes were to present the best and most promising creative works by living Afro-American artists, to stimulate art education, and to increase appreciation of the fine arts. The Negro Collection of Art at the university is composed of the prize-winning works from each exhibition. For many years the Atlanta Annual provided the only forum in which the southern Black could communicate to his people through his art. In its announcement of the Fifth Atlanta Annual, *Art Digest* clarified the need for an exclusively Black show:

> This is not a case of racial segregation, but a valuable means of giving encouragement to a minority group that has a rich backlog of creative attainments. . . . Negroes paint like Americans because they are Americans; it is not a question of race, but of social and cultural environment.[37]

Atlanta Annual award-winners have included: Charles Alston and Lois Mailou Jones, 1942; Hughie Lee-Smith, 1943; William Artis, 1944, 1947, and 1951; Richmond Barthé, 1945, 1946, and 1948; Joseph Delaney, 1946; Jacob Lawrence, 1948; Charles White, 1946, 1949, and 1951; Merton Simpson, 1950 and 1956; and Hale Woodruff, 1952.[38]

The increased concern of the Black middle class with Black art and culture was reflected by the Pyramid Club, Philadelphia's leading Black social organization. In order to promote "better racial understanding and cultural sympathy," the club began in the

134. Exhibition at Atlanta University. April 19–May 10, 1942.

forties to sponsor open art exhibits. The first few shows required subject matter concerned with Afro-American life, but later exhibits left content to the discretion of the artist.[39] In the summer of 1940 an Exhibition featuring the "Art of the American Negro (1851–1940)" was held at the American Negro Exposition in Chicago. The show was assembled by Alonzo Aden of the Howard University Art Gallery, with the cooperation of the Harmon Foundation and the W.P.A. Many young artists—such as Eldzier Cortor, Lois Mailou Jones, Jacob Lawrence, and Hughie Lee-Smith—received the wide recognition they deserved for the outstanding quality of their work. The art from the exhibit formed a major part of Alain Locke's now-classic volume, *The Negro in Art.*[40] Encouraged by the success of the Chicago exhibition, Aden opened a gallery in his mother's home in Washington. The Barnett Aden Gallery was dedicated to discovering and presenting "new talent, white and colored, American and foreign, to the community."[41]

The last major event of the period specifically concerned with the creative achievements of the Afro-American was held in Albany, New York, in 1945 at the Albany Institute of History and Art. In their desire to eliminate the patronizing attitude often displayed toward Black artists, the organizers of the exhibit sought "such work as could compete on an equal footing with any produced in this country, regardless of color."[42] Alain Locke, author of the catalogue essay, found the exhibit an encouraging comment on the progress of the Black artist. Aside from the similarity of time and place, Locke found a sense of "commonality" in the output of Black artists of the 1930s and 1940s, an overtone of "common emotional factors of racial life and experience . . . among these, one can note to an unusual degree strength and virtuosity of color and rhythm and vivid originality of imagination." Commenting on the multiplicity of styles in the Albany exhibit—from complete abstraction to social realism—Locke was especially committed to the paintings of Ernest Crichlow, Jacob Lawrence, Norman Lewis, Charles White, and John Wilson for their "ability to blend the somewhat conflicting approaches of a social message with the abstractly aesthetic into a balanced, mutually reenforcing synthesis."[43] In other words, Locke saw in the work of the artists represented at the Albany Institute the beginnings of a school of Afro-American art, a school in which Black artists looked for their inspiration to the art of their ancestors and the life of the Black population around them. Other artists exhibiting in Albany included Aaron Douglas,

Richmond Barthé, Eldzier Cortor, Joseph Delaney, Palmer Hayden, Archibald Motley, Horace Pippin, James Porter, William Edouard Scott, Hughie Lee-Smith, and Hale Woodruff.[44]

Growth of Modern Art

Through the first decade of the 20th century, the American art world as a whole was complacently entrenched in the 19th. A few progressive artists and collectors concerned themselves with the series of upheavals that had shaken European art circles, and, in fact, the photographer Alfred Stieglitz had sponsored small exhibitions of the new European art at his Gallery 291 in New York. Still, most Americans remained unaware of the new trends until one dramatic event captured their attention. On February 17, 1913, the International Exhibition of Modern Art, sponsored by the Association of American Painters and Sculptors, opened in New York. Held at the 69th Regiment Armory building, the exhibit was and is more commonly known as the Armory Show.

More than fifteen hundred paintings and sculptures were shown, and although a large portion of these were the work of American artists, it was the International Section, which later traveled to Boston and Chicago, that caused the greatest furor. Cézanne was represented by thirteen oils, Van Gogh by seventeen; there were several Fauve works by André Derain and Henri Matisse. The Cubist paintings of Georges Braque and Pablo Picasso provoked the greatest shock, and their work became the butt of many newspaper cartoons. However, despite the scorn of critics and the general public, the innovations presented at the Armory Show challenged the complacency of most American artists, both Black and white, and influenced the direction of American art well into the middle of the century.

Whereas the goal of the Impressionist painters had been to capture the fleeting moment of optical sensation, the work of Paul Cézanne (1839–1906) involved a lifelong search for a dynamic vision of reality that could express the permanent, stable structures underlying the forms of visible objects and, at the same time, accommodate not only the deep, three-dimensional space of nature but also the realities of pictorial space, which is the two-dimensional surface of a rectangular canvas (Fig. 135). In remarks ascribed to him, Cézanne stated that he "wanted to make of Impressionism something solid and durable, like the art of museums," and to do this the painter should seek in nature the evidence of the cone, the sphere, and the

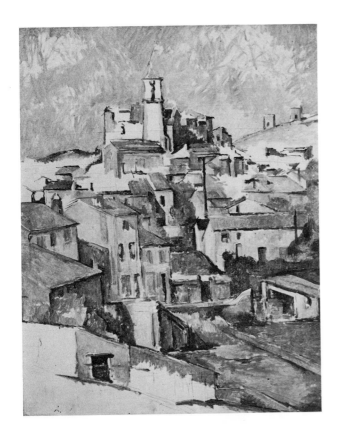

cylinder. Cézanne's art derived from a process of his realizing in formal terms the "small sensations" he had of the motif before him.

Also departing from Impressionism in its most mature phase was Paul Gauguin (1848–1903), who rejected the pure opticality of Monet's art (Fig. 61) for an expression based more upon the artist's personal feelings than upon a subject in nature apprehended objectively (Fig. 136). His procedure was to obtain a highly decorative composition by synthesizing a visible motif with an abstract notion of design and make this expressive, or symbolic, of a personal sense of the mysterious forces in life. Gauguin's compelling interest in the imagination as a human, semidivine faculty superior to reason caused him to be fascinated by such "primitive" cultures as those of Brittany and Polynesia. Characterized by flat patterns of sinuous black contour lines and resonant combinations of yellow, purple, green, orange, and blue, Gauguin's art had an arbitrary power that helped break forever the hold that traditional forms had upon European art.

Vincent van Gogh (1853–90), a Hollander whose painting career developed mainly in France during the last four years of a short and tragic life, brought to his art a psychological complexity that is distinctly non-

above: 135. Paul Cézanne. *View of Gardanne.* 1885–86.
Oil on canvas, 31 × 25½″. Metropolitan Museum of Art, New York (gift of Dr. and Mrs. Franz H. Hirschland).

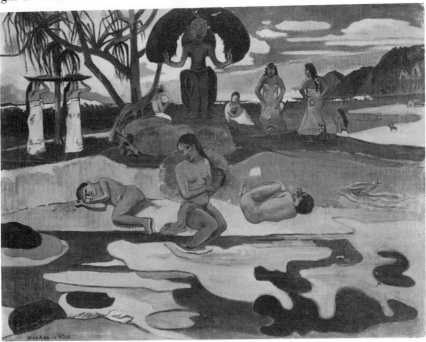

136. Paul Gauguin. *Mahana No Atua* (*"Day of the God"*). 1894.
Oil on canvas, 26 × 34½″.
Art Institute of Chicago.

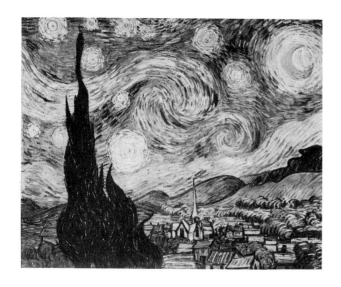

French (Fig. 137). Using pure, brilliant colors, often in smacking contrasts, a writhing line, strong, almost Japanese design, paint application so textural the strokes seem sculptured, and radical distortion of natural forms, Van Gogh created an art charged with the powerful energy of intense seeing and great emotional force. He was one of the first of the modern expressionists in Western painting.

The Norwegian Edvard Munch (1863–1944) was another non-French artist who participated in the modern art experience that developed in Paris around 1890. The serpentine line of Art Nouveau, already seen in the paintings of Gauguin and Van Gogh, appears in Munch's work as an especially elongated form that defines undulating shapes and repeats them in what seem to be echoing reverberations of anxiety (Fig.

above: 137. VINCENT VAN GOGH. *Starry Night.*
1889. Oil on canvas, 29 × 36½″.
Museum of Modern Art, New York
(acquired through the Lillie P. Bliss Bequest).

right: 138. EDVARD MUNCH. *Dance of Life.*
1899–1900. Oil on canvas,
4′ 1¼″ × 6′ 3″. Nasjonalgaleriet, Oslo.

below right: 139. HENRI MATISSE. *Blue Nude.* 1907.
Oil on canvas, 3′ ¼″ × 4′ 7⅛″.
Baltimore Museum of Art (Cone Collection).

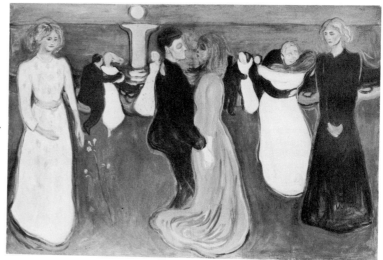

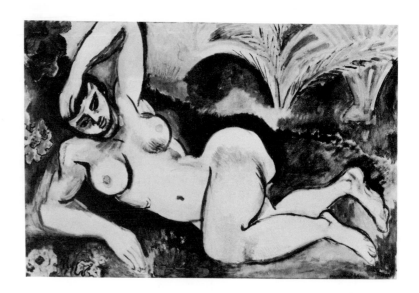

above: 140. Pablo Picasso. *Guernica.* 1937. Oil on canvas,
11′ 5½″ × 25′ 8¾″. Collection the artist,
on extended loan to the Museum of Modern Art, New York.

138). Distortions of natural images and dissonant colors
help to make of Munch's painting one of the most
expressionistic styles in late 19th-century art.

Fauves, or "wild beasts," was the term used to de-
scribe the brilliant, discordant colors, reckless
brushstrokes, and audacious patterns in the work of a
group of young painters who burst upon the Parisian
art audience in 1905. Led by Henri Matisse (1869–
1954), these prodigiously gifted modernists took their
inspiration from the expressive elements in the art of
Van Gogh and Gauguin and made of them a new cos-
mopolitan sophistication. The experience they drew
upon also included the growing awareness in Europe
of the vital, majestic art forms produced by the cultures
of Africa, Asia, and Polynesia recently colonized by
Europeans. To justify such a painting as *Blue Nude*
(Fig. 139), Matisse wrote:

> What I am after, above all, is expression. . . . I am unable
> to distinguish between the feeling I have for life and
> my way of expressing it. . . . The whole arrangement of
> my picture is expressive . . . everything plays a part.
> Composition is the art of arranging in a decorative
> manner the various elements at the painter's disposal
> for the expression of his feelings. . . . All that is not useful
> in the picture is detrimental.

Of all the exhibitors in the 1913 Armory Show in New
York, Matisse was perhaps the most pilloried. In Chi-
cago *Blue Nude* was hanged in effigy.

Working from Cézanne's structural principles, but
adding the cube to the older artist's primary forms of
cone, sphere, and cylinder, from the formal freedoms
of the Fauves, and from the expressiveness of Gauguin
and Van Gogh, as well as that found in works of early
medieval, African (Figs. 2, 3), and Polynesian art,
Pablo Picasso (b. 1881) and Georges Braque developed
during the last decade of the 20th century a new, radi-
cally abstract style that came to be called Cubism. In
it, forms were construed as a gridlike arrangement of
brief planes whose shifting relationships, like facets
joined in a shallow pictorial space, permitted the sub-
ject or motif to be represented as if seen simultaneously
from several vantage points. The element of multi-
plicity of experience was reinforced when the two ar-
tists began to compose by the technique of *collage*—
that is, gluing together a composition from an
assemblage of elements, which, like newspaper, sand,
and rope, were often disparate in nature, origin, and
function. In this way they realized works whose highly
structured, aesthetic character served to intensify the
expressive element inherent in the irrationally asso-
ciated subject matter. An example of Cubism in its
most seasoned state is *Guernica* (Fig. 140), a monu-
mental work that Picasso painted in 1937 in outrage
against the horrors of war and to memorialize the vic-
tims of the Spanish Civil War. At the 1913 Armory
Show it was the Cubist works that generated the great-
est scandal within the American public.

141. SALVADOR DALI. *The Presistence of Memory.*
1913. Oil on canvas, 9½ × 13″.
Museum of Modern Art, New York.

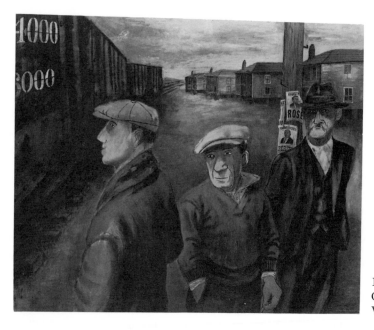

142. BEN SHAHN. *Scotts Run, West Virginia.* 1937.
Gouache, 22¾ × 27⅛″.
Whitney Museum of American Art, New York.

Just after the Armory Show and during World War I there emerged in New York and Zurich, among other places, certain manifestations having artistic possibilities that, developing ideas already suggested in earlier avant-garde art, commented on the irrational and arbitrary factor in human experience, an experience confirmed in the stupidities of the war. Initially known as the Dada movement (for a French nonsense vocable, meaning "hobby horse" in baby talk, picked at random from a Larousse dictionary), this grew into a massively theorized and poetic conception of art. As Surrealism,

it produced many styles all of which were more or less concerned with illustrating the dramas of dreams, intuition, and the subconscious, as these would be viewed by Freudian psychology. Working as if automatically, without the intervention of his rational faculty, the Surrealist could produce art "free from the exercise of reason and from any aesthetic or moral purpose." Perhaps representative are the Surrealist canvases that Salvador Dali (b. 1904) filled with meticulously painted images of strange and metaphysical import (Fig. 141). Surrealism dominated European art from the early

twenties until the end of World War II, at which time it had a marked generative effect upon developments in American painting of what came to be called the New York School.

During the twenties and thirties many American artists became disenchanted with the European styles and hoped to capture in art the essence of an America that was slowly disappearing. The Great Depression gave rise to a movement known as Regionalism, which attempted to re-create the old myths and celebrate the traditional values of grass-roots America. The "social commentators," on the other hand, were less concerned with recapturing the past than with improving the present. Painters such as Ben Shahn (1898–1969) grimly depicted the plight of the unemployed during the Depression years (Fig. 142).

Far and away the most visible product of the Depression was a mural program of unprecedented ambition sponsored by the Works Progress Administration. The Mexican muralists Diego Rivera, José Clemente Orozco, and David Alfaro Siqueiros had evolved a revolutionary art based on heroism and patriotic ideals (Fig. 143). Both Rivera and Orozco visited the United States during the twenties and thirties, and their efforts inspired many American painters. Armed with W.P.A. commissions, artists like Thomas Hart Benton (Fig. 144) began painting their interpretations of American history. Many Black artists, too, were caught up in the fervor for monumental art, and several of them, including Hale Woodruff and Charles White (Figs. 215–222), traveled to Mexico for study with the revolutionary muralists.

right: 143. JOSÉ CLEMENTE OROZCO.
Civil War. 1936–39. Fresco.
Government Palace, Guadalajara, Mexico.

below: 144. THOMAS HART BENTON.
Arts of the West (mural 2). 1932.
Tempera glazed with oil, 7′ 5⅜″ × 13′ 3⅛″.
New Britain Museum
of American Art, Conn.

145. WILLEM DE KOONING. *Woman I*. 1950–52,
Oil on canvas, 6′ 3⅞″ × 4′ 10″.
Museum of Modern Art, New York (purchase).

The upheaval created by World War II caused many of the influential European artists to immigrate to the United States, thereby enabling young American artists to study with and observe the great masters at work. With both Paris and Rome torn by the war, New York became the center of the art world. From the confluence of innovative Europeans, mostly Surrealists, and younger, well-trained American painters already sophisticated in the history of modern art emerged a new "school" of painting—Abstract Expressionism, the first new art of any significance to appear following World War II and the first of international import to derive from the New York scene. The movement received its name from the almost total absence of identifiable subject matter in the paintings produced by the New York group and from the deep, intense, personal involvement the artists had with the whole process of their art. Indeed, even where a motif might be identified, the evidence of the painter's preoccupation with the artistic process is such that this obviously became the true subject of Abstract Expressionist art. The sheer gestural power of the engagement that certain members of the group had in their work invited the label "action painters," among whom Willem de Kooning (b. 1904) must be counted (Fig. 145). The kind of allover, shallow, and pictorial conception of space that these painters adopted developed through the later years of Impressionism and Cubism, while the probing, self-analytical search for motivations and creative energy, the poetic content, and the "automatism" of the approach to technique could be found in the credo of Surrealism. Finally, the great expressiveness of the new art had influence from as far back as Gauguin (Fig. 136), Van Gogh (Fig. 137), and Munch (Fig. 138), as well as from such later European Expressionists as the Belgian James Ensor (1860–1949), whose *Entry of Christ into Brussels in 1889* is reproduced as Figure 146, and the Austrian Oskar Kokoschka (b. 1886), the author of the work in Figure 147.

In the period following World War II through the years of high optimism that attended the 1954 Supreme

Court desegregation decision, interest in the cultural life of the Black waned, and there was a corresponding decrease in the number of all-Black exhibitions.[45] The *Art Index* during those years published few articles dealing with the special problems and needs of the Black artist. It was not a question of deliberate neglect, but simply of "color blindness." Individuals were to be accepted on merit alone; race and religious questions disappeared from college and job applications. However, lacking organizations concerned with his welfare, the Black artist was largely abandoned. Blacks were rarely included in museum exhibitions. Only a few—Jacob Lawrence, Horace Pippin, Romare Bearden, Charles Alston, Norman Lewis, Merton Simpson, Thomas Sills, Richard Mayhew, Hale Woodruff—managed to present one-man shows. Isolated as he

was from the social contacts that are a way of life in the contemporary art world, the Black artist was again rendered invisible. As in the post-Reconstruction period, Black leaders and their white supporters were fighting for political, educational, and economic gains—voter registration, integrated schools, more jobs. Little energy or money was available for cultural endeavors. There is, of course, a certain validity to these preoccupations, for without a stake in society, a decent education, or job security, few are free to pursue art.

In the 1960s the emergence of the artist-militant and the growth of an educated middle class caused a new spate of Black art exhibitions at colleges, private galleries, and art museums. Once again writers took up their debate concerning the role of the Black artist, the nature of Black art, and the standards applicable to it.

146. James Ensor. *Entry of Christ into Brussels in 1889.* Oil on canvas, 8′ 5½″ × 14′ 1½″. Collection Louis Franck, London.

147. Oskar Kokoschka. *Hans Tietze and Erica Tietze-Conrat.* 1909. Oil on canvas, 2′ 6⅛″ × 4′ 5⅝″. Museum of Modern Art, New York (Abby Aldrich Rockefeller Fund).

The First
Black Masters
of Modernism

Many of the artists in this chapter began exhibiting with the Harmon Foundation, were supported by government art projects during the Great Depression of the thirties (or attended one of the art workshops sponsored by the W.P.A.), saw active duty during World War II, and continued to grow and develop as artists without experiencing more than minimal recognition from the Establishment art world. A few, like Jacob Lawrence and Horace Pippin, were widely hailed while relatively young, but most of the others pursued their art from an inner need, exhibiting for the most part in Black colleges and churches while making an occasional foray into the New York art world. Most supported themselves with teaching positions, and a few were fortunate in obtaining grants. By and large, recognition came only in the waning years of their

lives. Some adopted personal styles in their early careers and continued to refine them; others, like Beauford Delaney and Hale Woodruff, reflected the constant change and growth and the experimental mood embraced by the mainstream of American art during the 20th century.

Archibald Motley (b. 1891)

When in 1928 Archibald Motley was given a one-man show at the New Galleries in New York, he became the first Afro-American artist since Henry O. Tanner to be so honored. In this early group of paintings Motley drew his inspiration from Africa—not for "motifs or lessons in design," but for a sense of his past.[1] Of the exhibit, James V. Herring wrote:

Plate 7. Archibald Motley. *Parisian Street Scene*. 1929.
Oil on canvas, 23¾ x 28½".
Schomburg Collection, New York Public Library
(Astor, Lenox, and Tilden Foundations).

opposite: Plate 8. HORACE PIPPIN. *Roses with Red Chair.* 1940.
Oil on canvas, 14 x 10".
Collection Mr. and Mrs. David H. H. Felix, Philadelphia.

Plate 9. HALE WOODRUFF. *Vignettes.* 1966.
Oil on canvas, 40 x 45". Courtesy the artist.

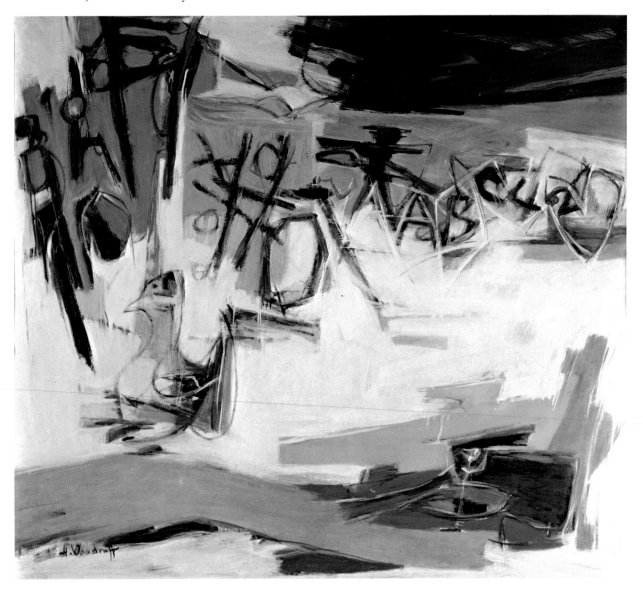

above: Plate 10. BEAUFORD DELANEY. *Greene Street.*
1951. Oil on canvas, 16 x 20".
Courtesy Roko Gallery, New York.

right: Plate 11. JOSEPH DELANEY. *Clara.*
1937. Oil on canvas, 40 x 24".
Courtesy the artist.

148. ARCHIBALD MOTLEY. *Old Snuff Dipper.*
1928. Oil on canvas. National Archives,
Washington, D.C. (Harmon Foundation).

In his paintings of Voodoo mysteries, in the interpretations of modern American Negroes at play, in the weird allegorical canvases and in the portraits, Motley directly or by subtle indirection lays bare a generous cross-section of what psychologists call the subconscious—his own and that of his race. The ancient traits and impulses of his ancestors in Africa, Haiti, or wherever they found their habitation, are a milestone on the unending march; but the phantasmagoria bears the imprint of the modern molds into which so much of the old race-life has been poured. The same fundamental rhythms are found, whether the setting be a jungle presided over by witchcraft or a cabaret rocking to the syncopation of jazz.[2]

Born in New Orleans in 1891, Motley served as a transitional figure in Afro-American art: He knew the ex-slave, and he became the "new Negro." When Motley was two, his family moved to St. Louis, then later to Buffalo, New York, finally settling in Chicago. The boy's artistic talent became obvious to his teachers when he was in high school. The president of the Armour Institute of Chicago offered to sponsor him in an architectural course, but this he refused in order to study painting at the Art Institute of Chicago. He stayed there for four years and in 1921 began sending paintings to the Institute's annuals. A portrait, *A Mulatress,* was an early prize winner.

In order to sustain himself at school, Motley worked as a day laborer, an experience that kept him in communication with Black "low life." He was not afraid to draw upon disreputable elements of society as subject matter for his paintings. Street-walkers, gamblers, and card sharps inhabit his powerfully painted, hard-edge pictures. *Old Snuff Dipper* (Fig. 148) marked a departure from the conventional depiction of the Afro-American. According to Locke, the objectivity of the painting represented a "peculiar psychological reaction and achievement," since the artist, a member of a persecuted minority, had been able to penetrate

149. ARCHIBALD MOTLEY. *Chicken Shack*. 1936. Oil on canvas.
National Archives, Washington, D.C. (Harmon Foundation).

"the vicious circle of self-pity or compensatory ideal-
ization" to achieve objectivity and a fine portrait.[3] The
ingenuousness of the painting has its roots in the work
of Early American limners.[4]

Several of Motley's paintings, such as *Parisian
Street Scene* (Pl. 7, p. 107), *Chicken Shack* (Fig. 149),
and *The Jockey Club* (Fig. 150), captured the spirit of
the twenties and thirties in Harlem and Paris—the two
playlands of the Western world. Classified in the "so-
cial comment" category, they stop just short of carica-
ture. A painting that suggested the influence of Derain
was included in a 1933 Whitney exhibit of Chicago
artists, and in the same year *Blues* was shown at the
Chicago Century of Progress exhibition.[5] During the

Depression, Motley was subsidized by the mural and
easel division of the Federal Art Project. His mural
The United States Mail (Fig. 151), a description of stage
coach postal service, is to be found on the walls of the
Wood River, Illinois, post office.[6]

Horace Pippin (1888–1946)

An Afro-American primitive painter of the 20th cen-
tury is far removed from the "primitive" art of his
ancestral home in Africa. His world-view is similar to
that of the untrained artists in Western culture since
medieval times, including the limners of 16th- and
17th-century England, the Colonial American artisan-

above: 150. ARCHIBALD MOTLEY.
The Jockey Club. 1929.
Oil on canvas, $25\frac{1}{4} \times 32''$.
Schomberg Collection,
New York Public Library
(Astor, Lenox, and Tilden Foundations).

151. ARCHIBALD MOTLEY.
The United States Mail. 1936.
Oil on canvas, $4 \times 3'$.
Post Office, Wood River, Ill.

painters, the 19th-century Frenchman Henri Rousseau (Fig. 152), and the 20th-century American Grandma Moses. Horace Pippin, the Black man from West Chester, Pennsylvania, was part of this tradition.

As a child of three, Pippin was moved from West Chester to the fashionable resort town of Goshen, New York, where his parents took jobs as domestics. He liked to draw but received no training, because there were no art lessons in the segregated school he attended, and his family was too poor to consider private instruction. In school, the boy encountered trouble when, in response to an expressive urge, he drew images to accompany the words the teacher required pupils in her one-room schoolhouse to letter—a dog, a cat, a cup, and so forth. For a Sunday School festival he cut and fringed supports from raw muslin and in brilliant crayon colors drew on them such Biblical scenes as Moses and the fiery bush. The resemblance of these works to decorative doilies was so great that the lady who purchased them mistakenly threw them into the laundry—to her own chagrin as well as that of the young artist. Pippin also submitted to a "Draw Me!" invitation published in a magazine, as he later explained:

> In this magazine there was a sketch of a very funny face. Under this face printed in large letters it said make me and win a prize. And I did and sent it to Chicago, to the address that was given. The following week the prize came. It was a box of crayon pencils of six different colors. Also a box of cold water paint and two brushes. These I delighted in and used them often.[7]

Pippin was forced to leave school to support his mother when his father died. After his mother's death in 1911, he left Goshen and was hired by a moving and storage company in Paterson, New Jersey. Five years later he became a molder with the American Brakeshoe Company, a job he held for only a few months. Upon the United States' entry into World War I, Pippin volunteered for the American army, and with a Black unit of soldiers he reached France in December 1917. As a corporal under French command, Pippin experienced the toughest kind of action during extended confrontation from trenches at the front lines. The war left him profoundly affected by memories of shelling, sniping, sudden death, and the wretchedness of suffering from wounds and exposure. It also left him with a lifeless right arm and a modest disability pension. Pippin returned to West Chester, married Jennie Ora Featherstone, a widow with a small son, and settled down to hold his crippled arm and grieve over the drawing he could no longer do. Finally, in 1929 Pippin devised his singular approach to drawing. Using a hot iron poker, he would gouge his compositions into wooden panels. He then filled in the areas with flat color, his painting arm propped up by his good left arm.[8] His first big canvas was a result of his convalescence—*The End of the War: Starting Home* (Fig. 153). It is thickly painted, the impasto built up with almost fifty coats of housepaint.

Thus Pippin worked for nine years (Fig. 242) until he was "discovered" by Dr. Christian Brinton of the West Chester Art Center and the famed illustrator

152. HENRI ROUSSEAU.
The Sleeping Gipsy. 1897. 4'3" × 6'7".
Museum of Modern Art, New York
(gift of Mrs. Simon Guggenheim).

N. C. Wyeth, who came upon a work by Pippin displayed in a West Chester shoemaker's window. Among those whom the art critic alerted to his find was Holger Cahill at New York's Museum of Modern Art, where the curator immediately arranged for four works to be included in the museum's 1938 exhibition "Masters of Popular Art." Brinton also introduced Pippin's painting to the Philadelphia art dealer Robert Carlen, which resulted in the artist's first one-man show, organized by Carlen. Even before this group of paintings could be hung, several of the works were seen and acquired by the remarkable Dr. Albert Barnes, who not only had assembled the great collection of modern art now known as the Barnes Foundation of Merion, Pennsylvania, but also had written, for *The New Negro*, an essay on the promise and potential of America's developing Black artists. In high enthusiasm for the genius of Horace Pippin, Barnes prepared a new introduction to the show's catalogue:

> It is probably not too much to say that [Pippin] is the first important Negro painter to appear on the American scene and that his work shares with that of John Kane the distinction of being the most individual and unadulterated painting authentically expressive of the American spirit that has been produced during our generation.[9]

153. HORACE PIPPIN. *The End of the War: Starting Home.* c. 1931. Oil on canvas, 25 × 32″. Philadelphia Museum of Art (given by Robert Carlen).

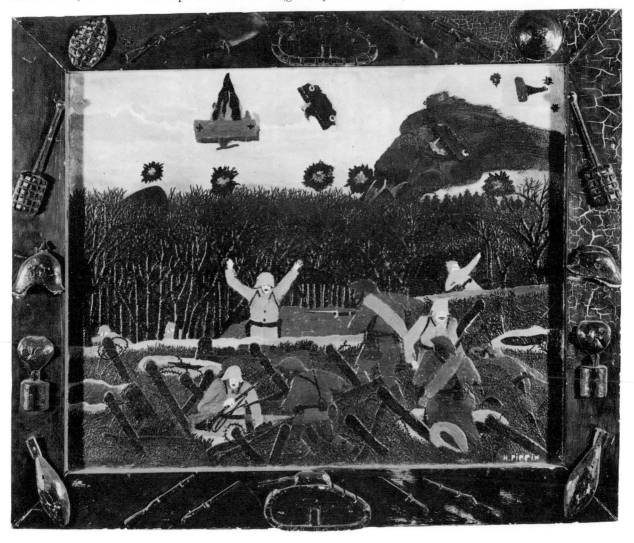

154. Horace Pippin.
Victorian Interior. 1946.
Oil on canvas, $25\frac{1}{4} \times 30''$.
Metropolitan Museum
of Art, New York
(Arthur H. Hearn Fund, 1958).

Pippin had his first exposure to modern art during a prestigious lecture series at the foundation. He was extremely critical of Matisse, an artist with whom he was often compared, and overwhelmed by the abundance of pink nudity emanating from the paintings of the French Impressionist Pierre-Auguste Renoir.[10]

The artist explained his own approach to painting in the following way:

> ... The colors are very simple such as brown, amber, yellow, black, white and green. The pictures which I have already painted come to me in my mind, and if to me it is a worth while picture, I paint it. I go over that picture in my mind several times and when I am ready to paint it I have all the details that I need. I take my time and examine every coat of paint carefully and to be sure that the exact color which I have in mind is satisfactory to me. Then I work my foreground from the background. That throws the background away from the foreground. In other words bringing out my work. The time it takes to make a picture depends on the nature of the picture. For instance the picture called "The Ending of the War, Starting Home" which was my first picture. In that picture I really couldn't do what I wanted to do, but my next pictures I am working my

thought more perfectly. My opinion of art is that a man should have love for it, because my idea is that he paints from his heart and mind. To me it seems impossible for another to teach one of Art.[11]

Pippin's Victorian interiors (Fig. 154) were either memories of boyhood visits to the white man's home with his laundress mother, or possibly interpretations of the mansions to which he had recently gained access. Brilliantly colored and with the tension created by a slightly off-center composition, his interiors, such as *Roses with Red Chair* (Pl. 8, p. 108), captivated the sophisticated art patrons in the Philadelphia area. In the mid-forties a richness and clarity—"color so clear it delights the mind as much as the eye"—appeared in his work. Pippin was also capable of achieving "astonishing effects" with a limited palette of black, gray, and white, as in *Quaker Mother and Child* (Fig. 155) and the *John Brown* series (Fig. 156).[12]

The saga of John Brown had haunted Pippin since childhood, for his mother, as a young slave, had witnessed the trial and years afterward related the details to her son. A series of paintings, culminating in *John Brown Going to His Hanging*, retells the story.

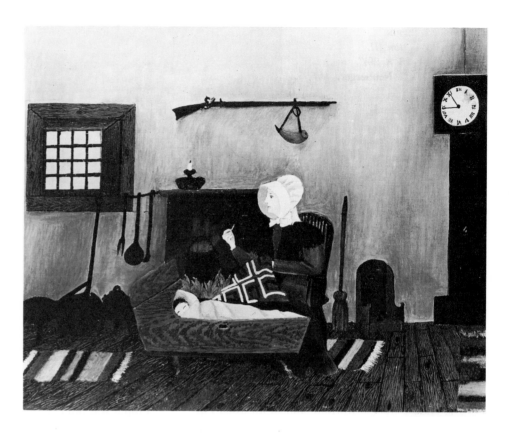

evening, with B
gether. Another
Domino Players
more subdued th
artist achieved
against an almos

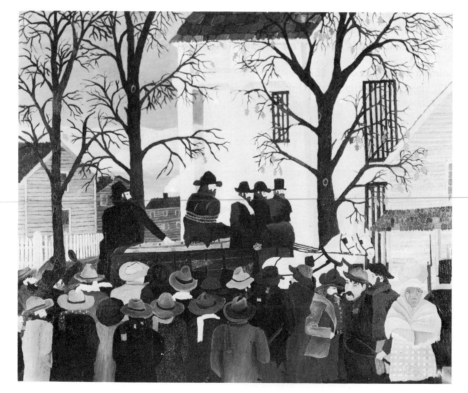

above: 155. HORACE PIPPIN.
Quaker Mother and Child. 1940s.
Oil on canvas, 16 × 20″.
Museum of Art, Rhode Island
School of Design, Providence.

left: 156. HORACE PIPPIN.
John Brown Going to His Hanging,
from the *John Brown* series. 1942.
Oil on canvas, 24 × 30″.
Pennsylvania Academy
of the Fine Arts, Philadelphia
(Lambert Fund Purchase, 1943).

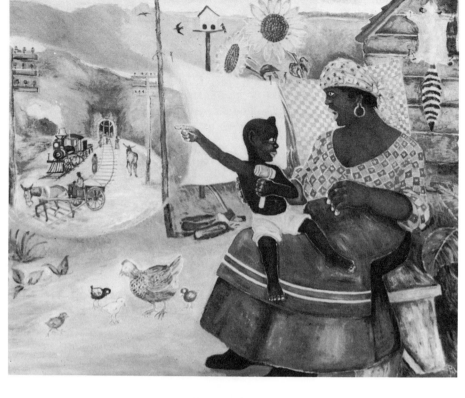

157. HORACE PIP[...]
Cabin in the Cot[...]
Oil on canvas, 2[...]
Collection Roy [...]
New York.

The 1944 C[...]
pin an honorabl[...]
157). The latter[...]
award, for the [...]
though he had [...]
entry was thou[...]

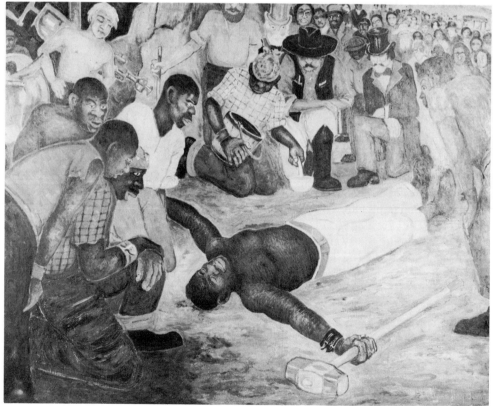

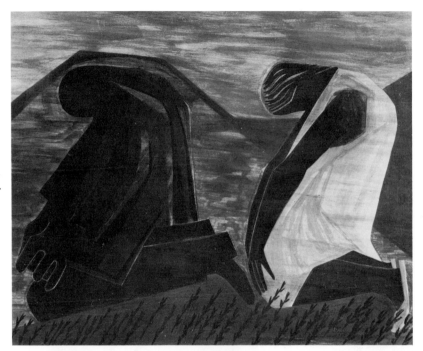

tured the loneliness of the ship on the sea and of man seeking contact with God."[63]

Working in a style reminiscent of Shahn (Fig. 142), Lawrence first achieved recognition for his *Migration of the Negro* series (Fig. 196), painted when he was 24. *They Were Very Poor* (Fig. 197) is the tenth in the series of sixty panels, which detail conditions in the South that encouraged the migration of Black families to northern industrial centers before and during World War II. In stark, simple forms it evokes the poverty and hunger of the ghetto Black in both North and South. As a result of this series, the young artist became a celebrity. His paintings appeared in popular magazines, including *Fortune,* which reproduced *And*

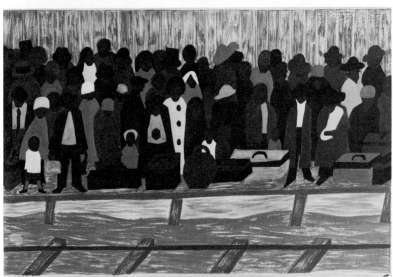

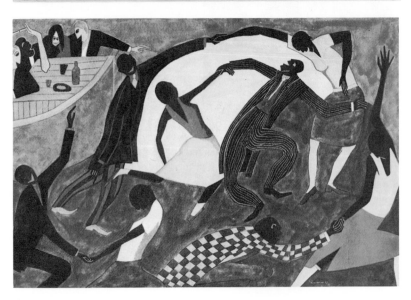

left: 197. JACOB LAWRENCE.
They Were Very Poor, panel 10
from *The Migration of the Negro* series.
1940–41. Tempera on composition board,
12 × 18″. Museum of Modern Art,
New York (gift of Mrs. David M. Levy).

center: 198. JACOB LAWRENCE.
And the Migrants Kept Coming,
panel 60 from *The Migration
of the Negro* series. 1940–41.
Tempera on composition board, 12 × 18″.
Museum of Modern Art, New York
(gift of Mrs. David M. Levy).

bottom: 199. JACOB LAWRENCE.
Dancing at the Savoy, from the *Harlem* series.
1943. Gouache, 14 × 21″.
Courtesy Downtown Gallery, New York.

the *Migrants Kept Coming* (Fig. 198). Praising Lawrence's achievements, the author of the commentary in *Vogue*—which reproduced *They Were Very Poor*—wrote: "In his work he has an extraordinary pattern..., insistence on idiomatic detail, and the harsh, high colors of Matisse."[64] His approach to the series paintings was unique. To keep the colors coordinated, Lawrence would first sketch in all the panels, then mix a large quantity of color and apply it to a specific area on each panel. He would then repeat the process until the series was finished, working on all the different panels simultaneously.[65]

Many critics felt that Lawrence's *Harlem* series (Fig. 199), painted in 1943, was better than the *Migration* group—more brilliant in color, more mature in design. To at least one observer, the paintings were "in the finest sense propaganda painting . . . with a dignity and simplicity which has the making of great art."[66] Lawrence seemed to fulfill all that Alain Locke had hoped for in the Black artist. He painted his people with warmth and humor but without sentimentality, utilizing the rhythms and patterns derived from his African heritage.

A series dealing with the life and legend of John Brown (Fig. 200) followed in 1945, and a fourteen-panel group based on Lawrence's war experiences, and funded by a Guggenheim grant, was exhibited in 1947. The artist's figure groupings had become more complex, so that in composition they resembled Egyptian wall paintings. Lawrence was described as "one of the few painters who can make stylization and design function beyond decorative ends."[67]

In 1947 Lawrence was invited by the former Bauhaus master Josef Albers to teach at Black Mountain

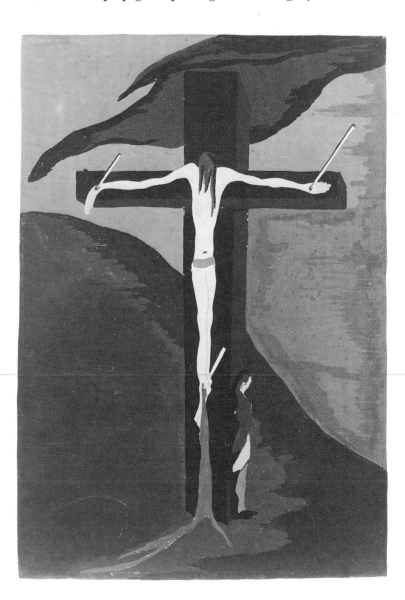

200. JACOB LAWRENCE. Panel 1 from the *John Brown* series. 1945. Detroit Institute of Arts, Mich.

College, the tiny avant-garde art school in North Carolina where many of the artists who were eventually to become leaders in the New York School of painting were then in residence. Of this experience, Lawrence commented:

> This was a milestone for me as it initiated me into the ranks of teacher. It was an experience also for all of us concerned, for this was the South. Most of all, through Albers, I came to know something of the Bauhaus concept of art, which, simply put, stresses design, the theory, and dynamics of the picture plane. Regardless of what you are doing, form, shape, color, space, and texture become the important things with which you deal.[68]

By 1957, when Lawrence held his first exhibition in six years, the fashions of the art world had changed, and critics no longer treated him kindly. Parker Tyler described the series of thirty exhibited paintings (from a projected sixty), which Lawrence entitled *Struggle: The History of the American People* (Fig. 201), in the following manner:

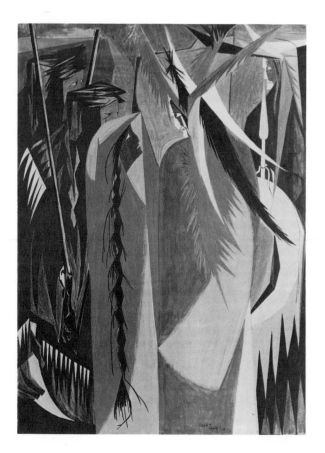

... both in conception and technique ... unsensationally simple and direct; ... [differing] little from comic strip history fables ... [combining] a clean and competent pictorial formula blending Orozco's and Tamayo's Cubist variations with Shahn's anecdotal imagism. The fluid balance between abstract and realist rendering is the most interesting (and surprising) facet of this suite of illustrations.[69]

The power and simplicity of the earlier two-dimensional paintings were superseded in the fifties by decorative, patterned constructions. The twelve temperas dealing with the theater, executed in 1953, were said to be as "artificial as the situations portrayed." In *Vaudeville* (Pl. 15, p. 161) the figures are rigid and locked into the bold patterning of the background. It is like a poster promising an evening of enchantment.

Lawrence, like Shahn, became an illustrator of the first order, but he thereby failed to fulfill his early promise as the leader of a school of Afro-American artists. A gouache portrait by Lawrence of the Black leader Jesse Jackson decorated the cover of a special 1970 issue of *Time* devoted to Black America.[70] An earlier cover, in August of 1968, portrayed Biafra's Lieutenant Odumeywa Ojukwu.

After leaving Black Mountain College, Lawrence taught at the Art Students League, Brandeis University, the New School for Social Research in New York, and the California State College at Hayward, an experimental school designed to meet the needs of "third-world" students. He is currently a professor of art and coordinator of arts at Pratt Institute in Brooklyn.

In 1970, Lawrence received the NAACP's Spingarn Medal, becoming the first painter to be so honored. At the awards ceremony he commented on the meaning of his Blackness in relationship to his art:

> If I have achieved a degree of success as a creative artist it is mainly due to the black experience which is our heritage—an experience which gives inspiration, motivation, and stimulation. I was inspired by the black esthetic by which we are surrounded, motivated to manipulate form, color, space, line, and texture to depict our life; and stimulated by the beauty and poignancy of our environment.[71]

left: 201. JACOB LAWRENCE. Panel from *Struggle: The History of the American People* series. 1955–56. Tempera on panel, 16 × 12". Collection Mr. and Mrs. William Meyers, New York.

The Black Artist
at Mid-20th Century

Many black artists born in the twenties or just before, although not of the generation of angry young militants, have had their sensibilities challenged by the demand, issuing from the younger artists, for relevance—to the contemporary political scene or to an ancestral heritage. Some of these early modernists had accepted the challenge long before, even devoting their life's work to it, as in the instance of Eldzier Cortor and Charles White. Others developed their art independently of politics, believing with Norman Lewis, a lifelong political activist, that art should not be made to serve propagandistic purposes. However they may have viewed their art or managed their careers, it is only recently that, for the most part, these artists have experienced the wide acceptance and general visibility that enable a painter or sculptor to support himself from the sales of his work. Lewis drove a taxi until 1960, and Romare Bearden served intermittently, but up to 1966, as a caseworker for the New York City Department of Social Services. A number of their contemporaries taught and continue to teach, valuing the contact this brought them with the young. Having retired from a teaching career, Alma Thomas now feels that a new creative energy has been released in her by modern American technology.

Alma Thomas (b. 1895)

At the age of 77, Alma Thomas, the first graduate of Howard University's art department, was recognized with a one-woman exhibit at the Whitney Museum of American Art (April 25–May 28, 1972). When asked about the "youthful exuberance" in her work, Thomas explained:

> Creative art is for all time and is therefore independent of time. It is of all ages, of every land, and if by this

202. ALMA THOMAS. *Snoopy See a Sunrise.* 1970.
Acrylic on canvas, 4' square. Courtesy the artist.

we mean that the creative spirit in man which produces a picture or a statue is common to the whole civilized world, independent of age, race and nationality, the statement may stand unchallenged.[1]

Thomas was born in Columbus, Georgia, but her family moved to Washington, D.C., after she completed grade school. There was no further education for young Blacks in Columbus, and even the libraries were closed to them. Except for a few years spent in New York—where she earned her Master of Fine Arts degree from Columbia University in 1934—Thomas has lived in Washington all her life, and for many years taught at Shaw Junior High School. In 1950, under the auspices of the Tyler College of Fine Arts, Temple University, she toured the art centers of Europe. Since

her retirement from teaching, she has been free to devote most of her time to painting. "I'm over seventy," she has explained, "and painting has released me from the limitations of the past and opened the door to progressive creativity."[2]

During the mid-fifties the object was important in Alma Thomas' painting, but by 1959, when she completed *Tenement Scene, Harlem,* the artist was under the influence of the then-contemporary Abstract Expressionism. Her slashing, exuberant brush strokes are controlled by dark, almost gridlike lines, which begin to delineate the tenement buildings. Except for a brilliant red form in the lower half of the composition, the colors are muted.

Thomas' most recent work recalls the "wild" colors of the Fauves (Fig. 139). Vivid blobs of almost pure

acrylic pigment are applied in striped, rhythmic patterns—which she calls "Alma stripes"—or in circular, targetlike forms (Pl. 16, p. 162; Fig. 202). Intervals of white punctuate the irregular patterns. Despite their "abstract" form, most of Thomas' paintings are rooted in nature. A seemingly nonobjective work such as *Lunar Rendezvous* is really an interpretation of one of the artist's favorite gardens near Washington's tidal basin. "I visit the place every blossom time," she explains. "You see, all the gardens are so formal—they're formalized by man. The use of color in my paintings is of paramount importance to me. Through color I have sought to concentrate on beauty and happiness, rather than on man's inhumanity to man."[3]

The American space program and the lunar landings have set Thomas' "creativity in motion." Her enthusiasm is revealed by the titles of some of her most recent works: *The Launching Pad, The Blast Off, Sunrise Creeps on Earth, Man Walks on the Moon, Splash Down of Apollo 13.* Alma Thomas, born in the era of the horse and buggy, has adjusted well to the technological age.

Norman Lewis (b. 1909)

Norman Lewis was born in New York of parents who had immigrated from Bermuda. He was raised by an Armenian who ran a clothing shop in Harlem. As a youth Lewis learned to sew, to press clothing, to play pinochle—any activity that would keep him out of the pool room. Largely a self-taught artist, he enrolled at Columbia University to "get an education." In his twenties he gambled to support his "habit"—art—buying art books and supplies with his winnings. He was a seaman before World War II and at various times worked as a porter and housepainter. Until the late 1960s he drove a taxi.

As a young artist associated with the Harlem Art Center, a W.P.A. project, Lewis was considered a "commentator of mordant wit on Harlem life."[4] To Lewis, the W.P.A. was a "beautiful thing," and a "hell of a spiritual thing." After applying to a regional office with one of his paintings, the artist was granted a weekly stipend of $26.80. There was a great sense of community among the W.P.A. workers in all fields. For example, Lewis learned from the chemists how to prepare his paints. His work of the 1930s could be classed as protest art, for Lewis explored the plight of the poor, the lonely, the dispossessed. He belonged to the Artists Union, a group of politically involved artists who used their art to promote social change. Lewis is a political

activist who believes he has "paid his dues." He has picketed against Japan, against war, against racism, against fascism. Contrary to the wishes of his father, then a foreman on the docks, he even picketed for the longshoremen when they were trying to unionize. The artist believes this kind of involvement is more effective than political paintings.

An early canvas, *Yellow Hat* (Fig. 203), reflected Lewis' concern with the abstract elements in the human figure. Painted in large, simplified planes, it shows the influence of Orozco (Fig. 143). During a recent interview, the artist pulled the painting from his stacks and said, "I still like it. It has held up well." Another work of the period, *Dispossessed*, showed a family sitting, with all their belongings, on the street outside their former home. Like many Lewis canvases of the period, it has disappeared. Some paintings were covered when the artist had no funds for fresh canvas.[5]

203. NORMAN LEWIS. *Yellow Hat.* 1936.
Oil on canvas, 36 × 26". Courtesy the artist.

Lewis was an active participant in the Black aesthetic revolution of the 1960s. He was involved with Spiral, a group of Black artists who, after the 1963 March on Washington (Fig. 229), organized to show their concern for the Civil Rights Movement and to make a collective statement about the nature of Black art. *Processional* (Fig. 204), a friezelike abstraction painted in black and white—to conform to the limitations of the group's first show—celebrates the massive sit-ins and protest marches of the early sixties. Reflecting on the role of the Black artist during a period of social turmoil, Lewis said:

> I am not interested in an illustrative statement that merely mirrors some of the social conditions, but in my work I am looking for something of deeper artistic and philosophic content. . . . Our group should always point to a broader purpose and never be led down an alley of frustration. Political and social aspects should not be the primary concern; esthetic ideas should have preference.[6]

Nevertheless, Lewis has pointed out that being Black in the United States can be unpleasant, especially if one is interested in cultural pursuits. Black people do not buy many paintings, and, until recently, white galleries have not promoted the Black artist. Lewis has been associated with the Willard Gallery since the early fifties, and he is one of the few artists represented by that gallery who have not captured the attention of the New York art Establishment. At openings, the wealthy art patrons were more likely to ask him for a drink than to discuss his aesthetic theories. Still, there have been some changes. "All of a sudden we are becoming citizens," the artist commented recently.

Lewis' paintings frequently incorporate small, aerial shapes—sometimes massed, sometimes floating in small groups against washes of smoky gray, muted oranges, or golds. *Every Atom* (Fig. 205) has subdued colors brushed on with a gentle technique. Amoeboid shapes pick up the white in the canvas, and large areas are contrasted against smaller ones to create an exciting interplay. A musical analogy has sometimes been applied to Lewis' approach to the empty canvas: "He starts in softly on the blank page like a musician improvising and as he sees a suitable motif taking shape, swings into it with confidence, plays it up for what it's worth and then, satisfied he has gone the whole way with it, permits it to fade softly out." And again, Lewis'

204. NORMAN LEWIS. *Processional.* 1965.
Oil on canvas, 3′ 2″ × 4′ 10″. Courtesy the artist.

205. NORMAN LEWIS. *Every Atom.* 1951.
Oil on canvas, 4' 6¼" × 2' 10".
Courtesy the artist.

"exposed range is that of a solo instrument making variations on a theme."[7] Lewis, whose brother was a musician, sees a relationship among all the arts: writing has color, music has color, painting has music. He stresses these analogies in his teaching.

As an organizer of the Cinque Gallery in New York City and a teacher in Haryou-Act (a Harlem youth group), Norman Lewis is contributing to that aspect of the Black revolution with which he philosophically identifies—the encouragement and promotion of talented artists from all minority groups. His work is included in the collections of the Art Institute of Chicago and the Museum of Modern Art, plus many other

museums, galleries, and private collections. In addition, he has exhibited in group or one-man shows in most of the important museums in the United States, as well as in Ghana, Argentina, France, and Italy. "Afro-American Artists: New York and Boston," a major exhibition planned to demonstrate the contemporary mood of the Black artist, included two of his works—*Heroic Evening* and *Arrival and Departure* (Pl. 17, p. 163), the latter described by Lewis as a landscape.[8] In the Newark Museum's "Black Artists: Two Generations," the artist again showed two paintings—the Mexican-inspired *Yellow Hat* and the sensitive and graceful *Every Atom.*

Romare Bearden (b. 1914)

Born in Charlotte, North Carolina, Romare Bearden grew up in Harlem as a member of the educated middle class. He also spent time in Pittsburgh, where his grandmother lived. Bearden's mother was New York correspondent for the *Chicago Defender;* she also founded and was first president of the Negro Women's Democratic Association. His father worked as a sanitation inspector for the New York Department of Health.

At New York University Bearden took a degree in mathematics and drew humorous cartoons for the *N.Y.U. Medley.* Inspired by the success of E. Simms Campbell, a Black cartoonist for *Esquire,* Bearden sent cartoons to humor magazines and drew political cartoons for the *Baltimore Afro-American.* Finding no employment during the Depression, he attended the Art Students League and studied under George Grosz, the artist whose work scathingly depicted the plight of German citizenry caught in the political turmoil of the period between the two world wars. As Bearden recalled the experience:

> When he first saw me draw he knew I had done cartoons, even as he had done. But he worked at getting me to say more in my drawings than I said in cartoons and that led to my decision to paint. Most of what was done in those days dealt with social conditions—bread lines and such things as that. I began to study Rembrandt and Daumier, and my first oil painting was done in the Daumier style. Then I began to meet and know the angry, young black writers, Claude McKay and William Attaway.[9]

Soon, Bearden set up his own painting studio, on the floor above Jacob Lawrence's rooms. In 1936, he began to seek out 306 West 141st Street, an address frequented for purposes of informal association by a group of Black artists living in Harlem. Most of the group—Aaron Douglas, Jacob Lawrence, and Norman Lewis, among others—also saw each other at the studios of Henry Bannarn, the sculptor, and Charles Alston and were members of the Harlem Artists Guild, a more formal organization of Black artists active during the Depression years. Bearden's first show in 1940 was held at the studio of "Ad" Bates, on West 141st Street. About the same time, Bearden entered the New York City Department of Social Services and began to serve as a caseworker, a function he performed intermittently until 1966.[10]

Bearden joined the army in 1942. After World War II, using the benefits of the G.I. Bill, he studied at the Sorbonne and, while in Paris, came to know such Black intellectuals and writers as Samuel Allen and James Baldwin. In addition, he took an interest in *Présence Africaine,* a publication that expressed the "Negritude" philosophy of Leopold Senghor, now president of Senegal. This supplemented Bearden's long-held desire to reach into the "consciousness of black experience" and to relate this to universal experience.[11]

Bearden maintains that his principal preoccupation in art is not politicization or "Negro propaganda." Rather, his purpose, as he stated recently, is:

> . . . to paint the life of my people as I know it—passionately and dispassionately as Brueghel painted the life of the Flemish people of his day . . . because much of that life is gone and it had beauty. Also, I want to show that the myth and ritual of Negro life provide the same formal elements that appear in other art, such as a Dutch painting by Pieter de Hooch.[12]

During the Depression Bearden made his friends among the artists and writers committed to social and political action, and his work of this period reflects these concerns. The paintings of the early forties are direct, literal Social-Realist renditions of Afro-American life, evocative of Tamayo and Orozco. Cedric Dover made the following commentary about Bearden's painting of this time:

> [Bearden] is, in the best sense, an obsessed painter, moving in widening circles around the circumstances of being a Negro persistently devoted to the causes of Negro art. His earlier paintings were those of a social realist with a difference, the difference being an expressionist toughness suited to the mood and condition of the thirties.[13]

Another observer of Bearden's early paintings has described them as "stiffly archaic and willfully primitive."[14] *The Visitation,* which takes for its subject the meeting of two African women, was exhibited at the "Invisible Americans" show mounted by the Studio Museum in Harlem in 1968–69 and in Bearden's one-man show at the Museum of Modern Art. A deliberately "primitive" work, it is strong in form and forceful in sentiment.

By 1945, when the Samuel Kootz Gallery gave Bearden his first one-man show in New York (the "G" Place Gallery in Washington earlier had mounted a one-man Bearden exhibition), the artist had brought to his painting significant new interests along with new forms. Inspired by his enthusiasm for Picasso and the

Cubists (Figs. 3, 140), Bearden developed a less literal, more personal treatment of subject matter and a greater sophistication in form and structure. He found themes in the Bible and in literature. *He Is Arisen* (Fig. 206), a strong painting of death and religion—part of a series, *The Passion of Christ*—was purchased by the Museum of Modern Art. The poems of Garcia Lorca—particularly *Lamentations for Ignacio Sanchez Mejias* attracted him, while in other paintings he celebrated the pleasures of life in subjects taken from Rabelais.

Upon seeing *The Passion of Christ,* Ben Wolfe, associate editor of *Art Digest,* called Bearden "one of the most exciting creative artists I have viewed in a long time. . . . These semi-abstract and highly personal expressions point the way to a rich and far-reaching career. Triangular forms, an uncanny sense of space and what to do with it, a sensitive yet powerful feeling for color, combine to make each of the displayed works an experience not soon to be forgotten." [15] Commenting on the bullfight series, Wolfe explained that, although the bullfight has preoccupied many artists, including Goya and Picasso, Bearden "has much to say that is his own through the medium of his semi-abstract métier." [16] Bright colors and luminous glazes distinguish the Rabelais group, but an *Art News* critic, while finding the artist's talent exceptional and his handling richer and purer than formerly, complained of "a certain monotony in the series; the compositions are almost invariably set in interior, linear frames . . . the forms often defined by mere drawings on colored patterns without integration of color and line."

The artist's fourth one-man show featured sixteen watercolors based on themes from the *Iliad.* Meanwhile, he had become associated with Carl Holty, and

206. ROMARE BEARDEN. *He Is Arisen.* 1945. Watercolor and ink, 26 × 19⅜″. Museum of Modern Art, New York (Advisory Committee Fund.)

his work began to show Holty's influence. (Later, Bearden and Holty collaborated on a book, *The Painter's Mind* [New York: Crown, 1967], in which they expressed their concern with artistic structure.) In 1947 the United States Information Agency sponsored a show at the Galerie Maeght in Paris, entitled *Introduction à la Peinture Moderne Américaine.* Bearden showed five paintings: *Around, Around; Interior; Blue Note; The Drinkers;* and *The Fox Hunt.* Works by William Baziotes, Adolph Gottlieb, Robert Motherwell, and Carl Holty were also exhibited.

By the late fifties Bearden had eliminated the literary and Biblical references and was producing totally nonrepresentational paintings in a style that he has termed "lyrical abstraction." There were also mystical and exotic scenes featuring vaguely defined women in Oriental settings.[17]

In his recent work, Bearden has employed the collage technique to achieve a very distinctive, personal idiom (Pl. 18, p. 164; Fig. 240). Here, subject matter has reemerged, used in a manner suggestive of the documentary film, but with forms and images composed like the tightly knit structures of 17th-century Dutch painting, the Cubism of Picasso and his *Guernica* (Fig. 140), and "interlocking rectangular relationships" of Piet Mondrian (1872–1944). (The art of Mondrian would be recognized by the pure form of the white rectangular fields that the famed Dutch master articulated with straight black lines crossed at right angles to contain smaller fields of pure primary color, the whole constituting a style [Neoplasticism] expressive of a plastic concept of universal harmony.) Here, Bearden's subjects derive from Afro-American life, a theme that Bearden revived from his experience of the 1930s, because the artist felt the "need to redefine the image of man in terms of the Negro experience I know best." Bearden prefers the archetype to the too-specific image, using it to express content generalized out of autobiographical incident or a myth whose meaning all can share. With parts of cut photographs, cloth, and painted paper, he explores the experiences of the Afro-American, the sharecropper, the youth of urban culture, the Black child, the joys and sorrows of Black family life. In elegant designs, Bearden freezes moments in the Black person's life and locks his groups into the shallow picture space made classic by Picasso and Georges Braque in their Analytical Cubist paintings. He juxtaposes African motifs and masks with contemporary Black figures, creating what Hilton Kramer, writing for the *New York Times,* analyzed as the "morphology of certain forms that derive originally from African art, then passed into modern art by way of cubism, and are now being employed to evoke a mode of Afro-American experience."[18]

Decorative as these collages are, their close assimilation of form and subject achieves an expressive content that is Bearden's most mature statement about art and life. The designs have great formal rigor but possess rhythm, vigor, and vitality that are life itself. The 1964 *Projection* series (Figs. 207, 208) is composed of photographic enlargements of much smaller polymer and paper collages done in muted colors. Together with some later works and a few paintings from the early forties, the series was displayed in a one-man show at New York's Museum of Modern Art in April of 1971. Bearden served a visual elixir blended of the joy, humor, high spirits, and charm of people who, in their pathos, find themselves at one with nature. In still more recent works, he has imbued his images with a symbolic intensity that recalls Byzantine art and the works of Gauguin and placed them in fields of secondary colors of extraordinary intensity.

Bearden believes that each artist, Black or white, should find his personal style, his unique method of communicating with his fellowman. Commenting on the role of the Black artist, Bearden has said:

> You can't speak as a dictator of art or of what art is going to be.... You take what you can find, for art is that kind of a venture. It would seem to me that what the young black painter has that is unique is that he has experiences and a way of looking at them that is unique.[19]

Thomas Sills (b. 1914)

Thomas Sills, a "sophisticated primitive" from Castalia, North Carolina, is a self-taught artist who paints abstractions with "grace, subtlety and suavity." Sills did not know of the existence of "art" until he was almost 40; by the time he was 56 his work had been acquired for the permanent collections of the Museum of Modern Art, the Whitney Museum, and most other important museums throughout the United States.

Sills was the youngest of eleven children. As a boy he was passed from one member of his family to another in the South, before he moved to Harlem, at age eleven, to live with a brother. His first introduction to art was through the mosaicist Jeanne Reynal, whom he later married. Reynal's home was filled with the paintings of Gorky, de Kooning, Matta, Magritte, Pollock, Newman, Reinhardt, and Rothko.

... [the ballad] appealed to me chiefly because it told in sober words and tune the life and tragic death of a powerful and popular working man who belonged to my section of the country and to my own race. . . . The epic . . . dramatizes the beginnings of the movement of the Negro from agricultural into industrial labor in the development of industrial America.[19]

The *John Henry* series was again exhibited at Fisk University in 1970, and in New York at the Community Art Gallery. Hayden also showed his more sophisticated views of French streets and fishing villages and his protest paintings, which reveal, according to a reviewer for *Art News,* "an accomplished, well-grounded

artist who can assume a raw Expressionist format to expand on and decry the raw problems of his race."[20]

Hale Woodruff (b. 1900)

A native of Cairo, Illinois, Hale Woodruff was educated at the local schools in Nashville, Tennessee, and at the John Herron Art Institute in Indianapolis. He left for Paris in 1927, where he spent some time in the atelier of Henry O. Tanner as well as at the Académie Moderne. Woodruff's early paintings were quite derivative; he had absorbed the Parisian atmosphere well. *Atlanta Landscape* (Fig. 165) looks remarkably like

opposite above: 163. PALMER HAYDEN. *When John Henry Was a Baby,* from the *Ballad of John Henry* series. 1944–54. Oil on canvas, 30 × 40″. National Collection of Fine Arts, Smithsonian Institution, Washington, D.C. (on extended loan from the artist).

opposite below: 164. PALMER HAYDEN. *Died Wid His Hammer in His Hand,* from the *Ballad of John Henry* series. 1944–54. Oil on canvas, 29 × 38″. National Collection of Fine Arts, Smithsonian Institution, Washington, D.C. (on extended loan from the artist).

165. HALE WOODRUFF. *Atlanta Landscape.* 1936. Oil on canvas, c. 30 × 36″. National Archives, Washington, D.C. (Harmon Foundation).

Cézanne's interpretations of the French countryside (Fig. 135), and *The Card Players* (Fig. 166) combines Cubist distortion with the neoprimitive influences of Picasso (Fig. 3). Returning to the United States in 1931, Woodruff was employed as instructor of art at Atlanta University, where he greatly advanced the cause of Afro-American art and artists throughout the South with his initiation of the Atlanta Annual art exhibitions.[21] He later became a professor of art education at New York University, a post from which he recently retired.

Woodruff's three panel murals at the Savery Library at Talladega College in Alabama show the influence of Orozco (Fig. 143) and Diego Rivera, the Mexi-

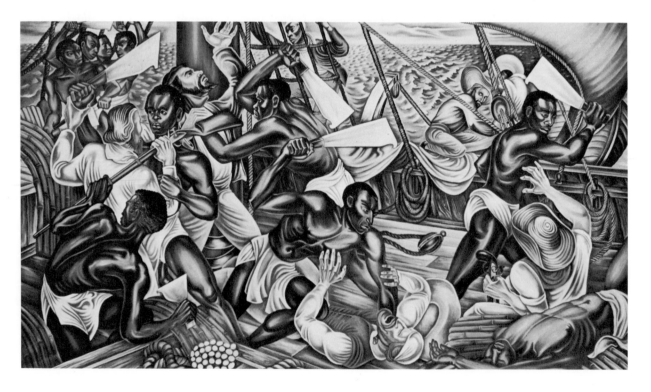

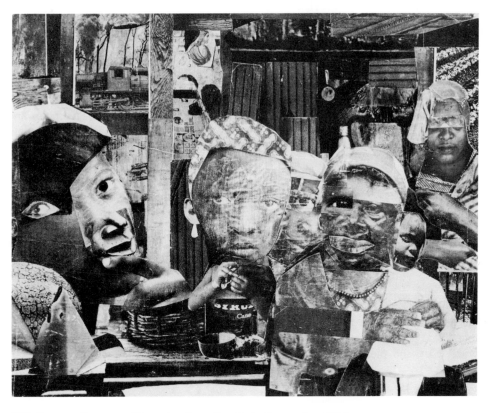

207. ROMARE BEARDEN. *Mysteries,* from the *Projections* series. 1964. Photomontage, 6 × 8′. Courtesy Cordier & Ekstrom, Inc., New York.

208. ROMARE BEARDEN. *Evening, 9:10, 461 Lenox Avenue,* from the *Projections* series. 1964. Photomontage, 6 × 8′. Courtesy Cordier & Ekstrom, Inc., New York.

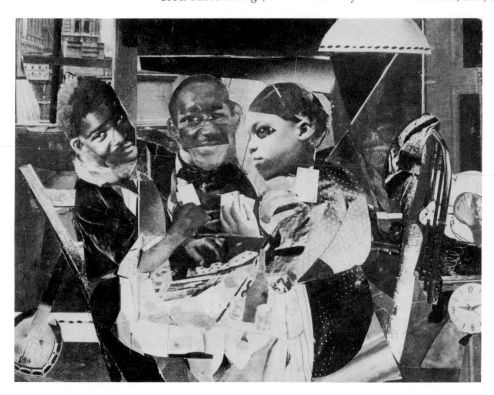

Sills rarely intellectualizes about his work or explains his titles. However, he has said: "I paint something, but I don't know what I'm painting. What comes out, comes out."[20] Although the artist denies any "Black" content in his work, some paintings bear provocative titles: *Africa* (1968) and *The South* (Pl. 19, p. 165), for example. Sills claims there is prejudice against Blacks in the art world, but that attitudes are changing, however slowly. He has written:

> I hate to be classed as a black painter. I figure I am a painter. Take five of my works and mix them up with a lot of other people's and I say, "You pick out the black painter." . . . Black artist! You know, once you get labeled, it's hard as the devil to get it off of you. But guys still keep working and that's the only thing. You got to walk in that studio and close the door and say, "Now I'm boss."[21]

Sills' earliest works were nonobjective, but in his first one-man show in 1955 there was a suggestion of imagery. The canvases had the "terror of nightmares with desire and pleasure at the core." The paintings in his second one-man show, two years later, were described as "blurred, variegated-colored oils in themes which seem related to cosmic explosions." His most recent work is distinguished by "broad, irregular canals of color and stroke."[22] Sometimes his forms are hard-edged, while at the other times they flow gently, one into the other, the color and form changing gradually (Fig. 209). Sills is continually preoccupied with color, and he has been surrounded by it all his life. As a youth he joined his family in itinerant farm work. Later he was employed in a greenhouse and as a window decorator in furniture and shoe stores.

There is a certain naïveté in Sills' paintings of the late fifties; they represent a kind of "folk-art abstraction." As a self-taught modern, he has missed the years of growth and experience, the years of accepting and rejecting aesthetic theories, that most painters have undergone during their development. According to an *Art News* critic, divorced from the process of "analyzing and understanding the objects of the visible world, artists like Sills, plunging directly into the world of abstraction become decorative."[23]

209. THOMAS SILLS. *Nightcap*. 1970. Oil on canvas, 4' 1" × 4' 2". Courtesy Bodley Gallery, New York.

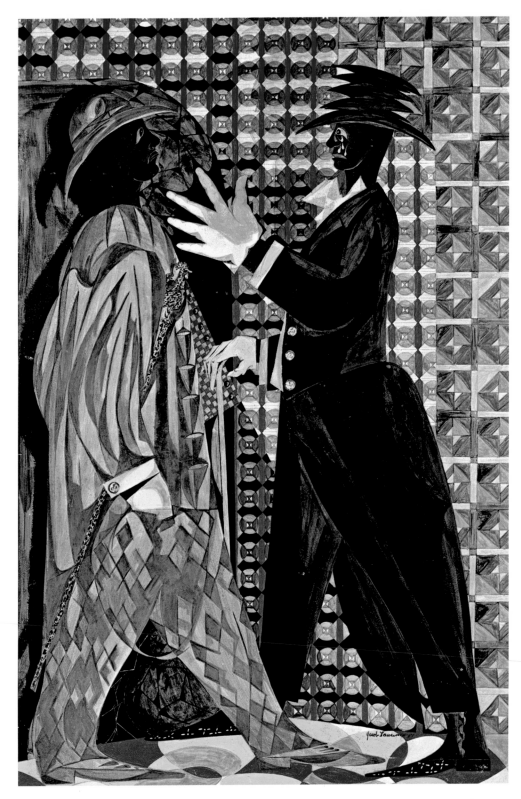

Plate 15. JACOB LAWRENCE. *Vaudeville*. 1951. Tempera on gesso, 29¼ x 19½".
Hirshhorn Museum and Sculpture Garden, Smithsonian Institution, Washington, D.C.

above: Plate 16. ALMA THOMAS. *Light Blue Nursery.* 1968.
Acrylic on canvas, 4'2″ x 4'. National Collection of Fine Arts, Smithsonian Institution,
Washington, D.C. (gift of Alma Thomas).

opposite: Plate 17. NORMAN LEWIS. *Arrival and Departure.* 1963.
Oil on canvas, 6' x 4'2″. Courtesy the artist.

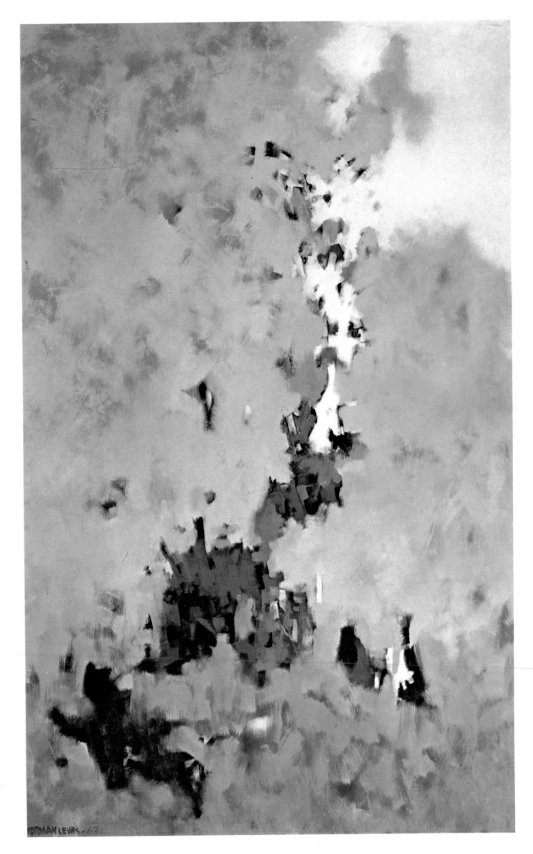

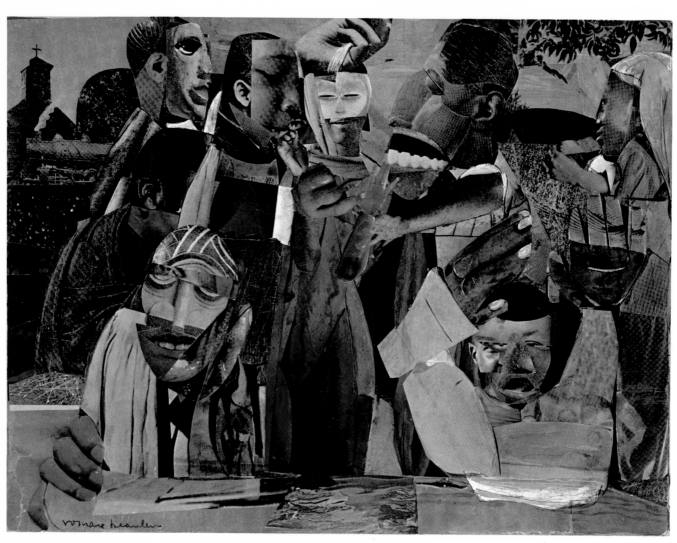

Plate 18. ROMARE BEARDEN. *The Prevalence of Ritual: Baptism.* 1964.
Collage of paper and synthetic polymer paint on composition board, 9 x 11⅞".
Hirshhorn Museum and Sculpture Garden, Smithsonian Institution, Washington, D.C.

Plate 19. THOMAS SILLS. *The South*. 1968.
Acrylic on canvas, 4′1″ x 4′2″. San Francisco Museum of Art
(gift of Mrs. Annie McMurray).

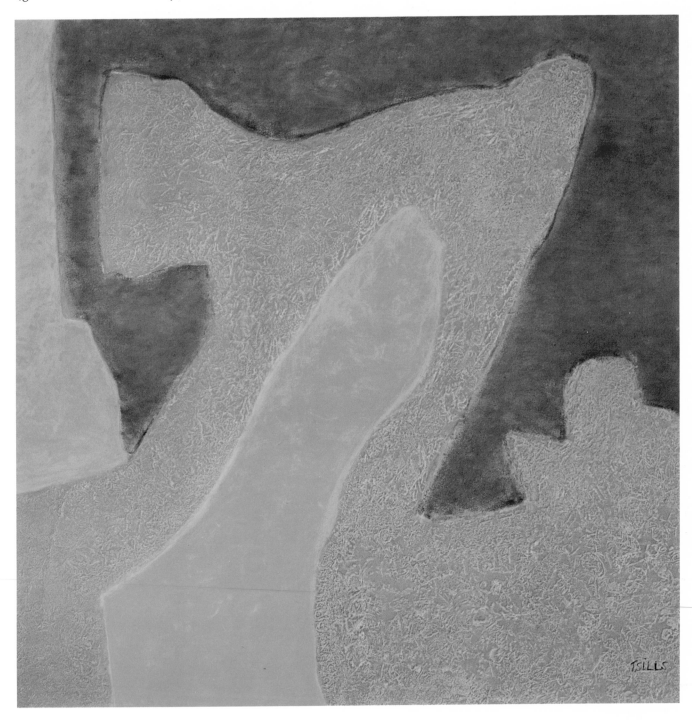

Plate 20. ELDZIER CORTOR. *Room No. V.* 1948. Oil on board, 37 x 27".
Collection Mr. and Mrs. Richard M. Rosenwald, Beverly Hills, Calif.

210. Thomas Sills. *Cage.* 1971.
Mixed media on wood, 18 × 14″.
Courtesy Bodley Gallery, New York.

A new series, painted on wooden planks, was shown in his March 1972 exhibit at the Bodley Gallery in New York. By preserving and enhancing the integrity of the wood with ink, pencil, stains, and paint—or by simply gouging out certain areas—the artist, in works like *Nightcap* and *Cage* (Figs. 209, 210), has produced personal statements of unusual elegance.

Eldzier Cortor (b. 1915)

Eldzier Cortor is fortunate in having had for his mentor George C. Neal (1906–36), an artist and intellectual trained at the Chicago Art Institute, who was the spiritual leader of a group of young Blacks in the Chicago area. Neal sought to break the Black artist of his conservatism, his loyalty to academic techniques, and his sentimental approach to the Afro-American as a source for subject matter.[24]

Cortor was cited by Ralph Pearson in *The Modern Renaissance in American Art* as one of two Black artists—the other being Jacob Lawrence (Figs. 194–201)—who contributed to the renaissance.[25] He was born in Richmond, Virginia, but his family moved to Chicago's South Side in 1916 to ensure a better education for their son. Cortor studied at the Art Institute of Chicago from 1936 to 1939. During this time he received no encouragement from his family or friends, who thought him mad for wanting to pursue an art career. Working at odd jobs during the day, Cortor studied for two years at night; later, he managed a year of full-time study.[26] His interest in African art was awakened by a southern white teacher at the Art Institute. "Her enthusiasm for African art . . . really got to me," recalled the artist. "That was the most important influence of all in my work, for to this day you will find in my handling of the human figure that cylindrical and lyrical quality

right: 211. Eldzier Cortor. *The Bathers.*
1944. Oil on gesso, 27 × 21″.
(Destroyed by fire.)

below: 212. Eldzier Cortor. *Americana.* 1946.
Oil on gesso, 5′ × 3′ 5″.
Collection Mrs. Felicia Ford, Chicago.

I was taught by Miss Blackshire to appreciate in African sculpture."[27]

In 1937, while still in Chicago, Cortor became an easel painter in the W.P.A. art project. His paintings of life in Chicago's South Side were hung in the local schools. The artist later attended Columbia University and the Pratt Graphics Center in New York. Under the sponsorship of the Rosenwald Foundation, Cortor traveled and painted in the Southeast. He spent a year in the Sea Islands off the coast of Georgia, where he studied the Gullah Negroes, a group having little contact with the mainland before 1930. A series of paintings featuring elegantly elongated Gullah women—a type he has perpetuated in most of his work—dates from this period. Cortor has explained his interest in the Gullah woman as a subject:

As a Negro artist I have been particularly concerned with painting Negro racial types, not only as such, but in connection with special problems in color, design and composition that interested me. I felt particular interest in painting Negroes whose cultural tradition had been only slightly influenced by whites.[28]

Another Cortor series depicts the life of slum dwellers. The backgrounds are replete with posters, newspapers, magazines, and calendars—artifacts that often decorate the walls of poor southern homes. *Room No. V* (Pl. 20, p. 166) describes a setting of bleak poverty, with a single dresser in the center of the room. The mirror reflects a pensive nude, distorted in the Cortor manner, sitting on an old brass bed under a naked light bulb. Cortor's paintings are never mere propaganda, for the artist is equally concerned with problems of design and composition. Of his "room" series, painted in the 1940s, Cortor has written:

[The paintings show] the overcrowded conditions of these who are obliged to carry out their daily activities of life in the confines of the same four walls in the utmost poverty. I attempted to combine the figure studies, the bed and the other elements of the room in an interesting pattern.[29]

At the Chicago Art Institute's 1945 Annual, Cortor won a hundred-dollar prize for *The Bathers* (Fig. 211), a "dreamy, dark-toned, and highly romantic vision of a bronze-skinned girl resting against an ancient tree in a graveyard with a river beyond." (He won another prize the following year.) In 1947 *Americana* (Fig. 212) received an honorable mention and was awarded a purchase-prize at the Carnegie Institute Annual. The painting, which has been described as a "collage in paint," shows an elongated Black woman standing with her foot in a wooden bucket, the walls of her room adorned with an assortment of then-contemporary miscellany.

During this phase of his career Cortor was lavish with his pigment, piling on the paint with bas-relief thickness to achieve depth.[30] By the early 1950s the heavy textures were gone from his canvases, for the artist believed he was "becoming too chained to this attempt at reality and tactile impression." However, he was still concerned with visual textures to achieve certain effects, claiming that "the paint brush isn't sensitive" and the artist "must go back to pen and pencil often to resensitize his hand."[31]

Cortor's paintings and drawings often delineate fragments of the figure, for he believes the part can be more interesting than the whole. The symbolism in his work is less important to the artist than his concern for composition and color. Cortor has written: "When people explain the symbolism in my work, they only explain themselves. . . . If I could tell in words what my painting says then I wouldn't have to do the painting."[32]

Cortor's paintings do not attempt to describe the life of the Afro-American in realistic terms. The extended vistas and distorted figures—isolated in time and space and abruptly cut off at the canvas boundary—when subjected to the artist's technical virtuosity, add a surrealistic element to paintings such as *Trio V* (Fig. 213). Cortor was represented at the "Afro-American

213. ELDZIER CORTOR. *Trio V*. 1959.
Oil and tempera on wall board, $36\frac{1}{2} \times 17\frac{7}{8}''$.
Collection Margaret Parry, Elkhart Lake, Wis.

214. ELDZIER CORTOR. *Environment V.*
1969. Intaglio, 27 × 37″.
Courtesy the artist.

Artists: New York and Boston" exhibition with three intaglios. A recent work, *Environment V* (Fig. 214), elicits the same mood as his earlier efforts.

Charles White (b. 1918)

Charles White held his first one-man show in 1938 at the Art Institute of Chicago, in the city to which his father (a Creek Indian) and mother had migrated from the South. White experienced the loneliness and isolation of a Black youngster in all-white schools, and it was not until he discovered *The New Negro,* by Alain Locke, that he realized the Black had made and could make a contribution to American culture. When he was sixteen he was taken to the studio of dancer Katherine Dunham in Chicago, where he met a group of artists and writers who articulated the ideals of the social revolution occurring in depressed America—among them Nelson Algren, Archibald Motley, Gwendolyn Brooks, and Richard Wright. As part of the coterie of young artists surrounding George Neal, White helped form the Arts and Crafts Guild, which provided a place where young Blacks could work, exchange ideas, and exhibit.

White's talent was discovered by sympathetic teachers, and in 1936 he entered and won a nationwide sketching contest for high school students. His prize was an art scholarship, but when he appeared at the school to enroll, he was rejected because of his color.

He subsequently was granted a scholarship to the Art Institute of Chicago, an institution with a long record of hospitality toward Black students. At an early age White committed himself to articulating, through his art, the goals of the Black man. In a 1940 interview with Willard Motley he stated:

> . . . I do know that I want to paint murals of Negro history. That subject has been sadly neglected. I feel a definite tie-up between all that has happened to the Negro in the past and the whole thinking and acting of the Negro now. Because the white man does not know the history of the Negro, he misunderstands him.
>
> I am interested in the social, even the propaganda angle of painting. . . . I am interested in creating a style of painting . . . that will say what I have to say. Paint is the only weapon I have in which to fight what I resent. If I could write, I would write about it. If I could talk, I would talk about it. Since I paint, I must paint about it.[33]

Armed with a Rosenwald Fellowship, White traveled through the South, recording his impressions of the southern Black at work, at play, and at prayer. The artist's words are fulfilled in powerful murals that relate the experiences of the Black in America, painted in a style based on that of the Mexican muralists (Fig. 143). As a W.P.A. muralist, White "compounded an amalgam of compelling forms and dynamic design"

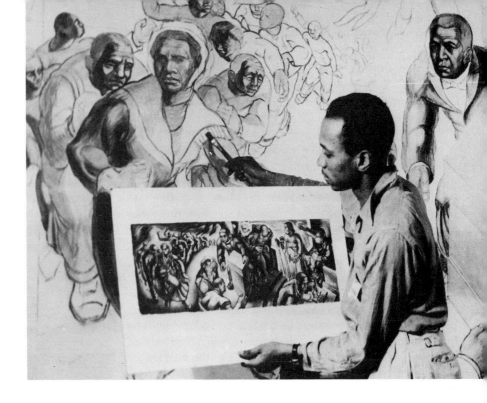

in *Five Great American Negroes* (Fig. 215).[34] In 1940 the Associated Press commissioned a mural for the American Negro Exposition held in Chicago. Of the resulting work, a reporter commented: "... White has an insatiable hunger for life itself, for cures that will make his people free. His works show constant protestation of the economic and social limitations of the Negroes ..."[35] *The Contribution of the Negro to American Democracy* (Fig. 216), prepared for the Hampton Institute, explodes with vitality and dynamism as it

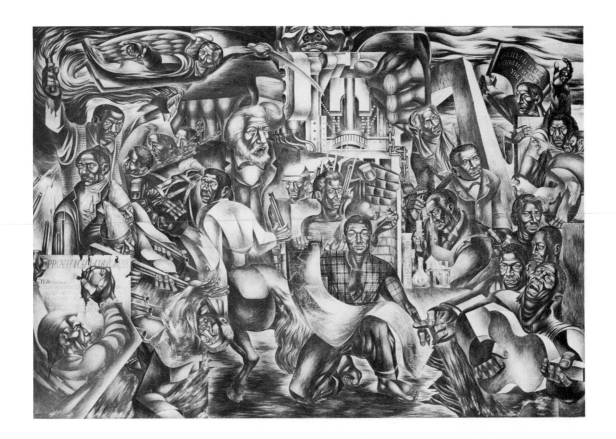

shows the Black in his various roles in American history—soldier, worker, scientist, musician, civic leader.

In 1947, White was granted his first one-man show in New York, at which he exhibited a group of "semi-abstract" drawings and paintings. A strength and sadness pervaded this work; single figures were projected against stark backgrounds, creating a sense of alienation and isolation. Three years later he displayed a group of large pen-and-ink drawings protesting inequities in the Black man's past and present history. The latter drawings were criticized as lacking in the subtle qualities demanded by the medium. The figures evidenced a hard monumentality more appropriate to the lexicon of the muralist than to that of the draftsman.[36]

In time, White developed into an exacting draftsman, achieving a delicacy and sensitivity of line and an expert control over his medium. His later work is in multiples, mostly lithographs, or in sketches that combine charcoal and ink to achieve the richness of paint. Whether he is depicting the heroes of Afro-American history, such as John Brown, Sojourner Truth, or Booker T. Washington; or such creative artists as Mahalia Jackson, or *Fred O'Neal, Rex Ingram and Georgia Burke in "Anna Lucasta"* (Fig. 217); or the preachers and sharecroppers who are a part of the Afro-American folk culture—Charles White always portrays the Black in massive, bold forms. The Black people who take shape under his brush resemble the Mexican peasants of David Alfaro Siqueiros and Diego Rivera, two artists whom White admired and studied with in Mexico.

White spoke of his purposes and goals as an artist in an interview:

> I use Negro subject matter because Negroes are closest to me. But I am trying to express a universal feeling through them, a meaning for all men. . . . All my life, I've been painting a single painting. This does not mean that I am a man without anger—I've had my work in museums where I wasn't allowed to see it—but what I pour into my work is the challenge of how beautiful life can be.[37]

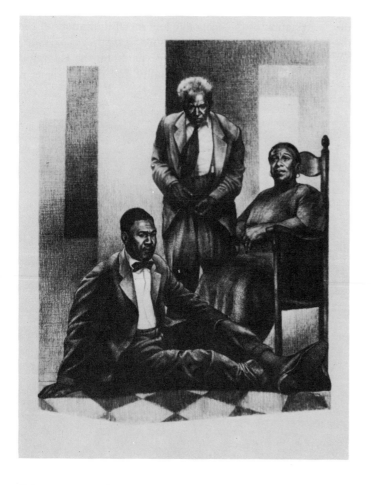

217. CHARLES WHITE. *Fred O'Neal, Rex Ingram and Georgia Burke in "Anna Lucasta."* 1958. Wolff crayon. Courtesy the artist.

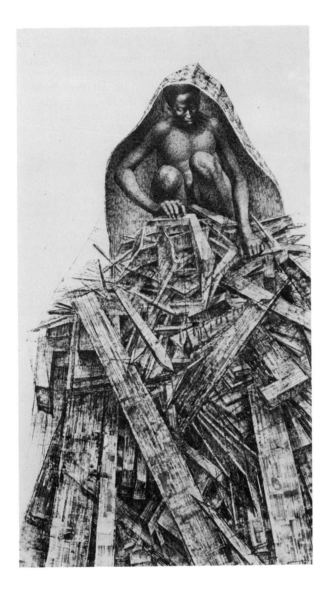

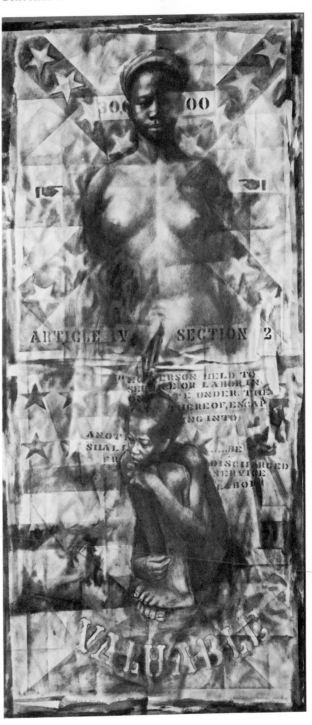

left: 218. CHARLES WHITE. *Birmingham Totem.* 1964.
Charcoal and chinese ink, 6′ 1″ × 3′ 7″.
Collection Benjamin Horowitz, Los Angeles.

below: 219. CHARLES WHITE. *Wanted Poster No. 6.* 1969.
Oil on board, 4′ 11″ × 2′ 3″.
Collection Dr. Edmund Gordon, Pomona, N.Y.

Indeed, White's latest works reveal a great deal of anger. A recent exhibition of eighteen "paintings-drawings"—in sepia, black, and white; with ink, oils, cotton, felt tips, and Q-tips; using poster paper, Civil War posters, and stenciled numbers of price tags from slave auctions—demonstrated the artist's "heightened achievement in expressing his deep and sensitive understanding of his people."[38] *Birmingham Totem* (Fig. 218), a drawing in charcoal and Chinese ink, shows a man atop a pile of dynamited wood and was inspired by the atrocities inflicted on the Black in Birmingham during the 1960s. His *Wanted Poster* series (Figs. 219, 220) was one of the most powerful statements at the Whitney Survey of Contemporary Black Artists—a

220. CHARLES WHITE.
Wanted Poster No. 4 (Sara). 1969.
Oil on board, 24″ square.
Whitney Museum
of American Art, New York
(gift of the Homent Corp.).

propaganda piece couched in subtle technique and monumental form.

White achieves an unusual and quite remarkable intensity in his drawings executed in charcoal and conté crayon. In the following way he has explained something of his technique and aesthetic intention:

> I begin to work lightly in halftones which I fix very strongly. I then work from that and fix another layer as I keep building up the compositions. In this way, when I work with conté or charcoal, I can get very strong blacks because of the chemical reaction of the fixative to the medium that I'm working on top of. Using this method I can get a far more extensive range of values than I would ordinarily.[39]

White's interest in drawing and printing is based on philosophic as well as aesthetic ideals. When he returned from Mexico in the late forties, he realized that his work had begun to sell—to museums and wealthy collectors. However, this was not the audience that concerned him:

> The primary audience that I was addressing myself to was really the masses of black people, and they were not turning out in hundreds to see my shows, and I had to find some way of reaching them, since my subject matter was related to them and should be made available to them, particularly in a national way.[40]

The artist sees drawing as a means of communicating with the Black people as a whole. Since graphics can be easily reproduced and inexpensively disseminated, he has continued to work in that area. Several portfolios of drawings (Figs. 221, 222) have been reproduced: *Portfolio of Six Drawings—the Art of Charles White* (1953), *Portfolio 10/Charles White* (1961), and *Portfolio 6/Charles White* (1964). Since 1965 White has been on the faculty of the Otis Art Institute in California.

221. CHARLES WHITE. *Mother and Child.* 1953. Wolff crayon, 20 × 30″.
Collection Francis B. White, Altadena, Calif.

222. CHARLES WHITE. *Preacher.* 1952. Ink on cardboard, $21\frac{3}{8} \times 29\frac{3}{8}''$.
Whitney Museum of American Art, New York.

Marie Johnson (b. 1920)

Marie Johnson's painted plywood constructions portray the hope, the dreams, the vitality, and the frustrations of the Afro-American experience. The figures are silhouettes cut from plywood, painted to achieve a three-dimensional effect and clothed in discarded garments. Sometimes they stand alone, like *Mrs. Jackson* (Fig. 223)—a figure universally familiar as a person once known and liked. At other times Johnson creates an environment, a "tableau-like niche" for a single figure or a group. In *Hope Street* (Fig. 224) an elderly Black man is framed by a window on which is perched a bird cage containing a live canary.

In a time of coldly impersonal art, Johnson is preoccupied with human values. She has said:

> My work aims to depict the disparity between humanistic ideas and an increasingly impersonal and repressive society. I am trying to create images which are intimate reflections of the lives of black people, images which are deeply rooted in black dreams, black suffering, black pride, black anger, black strength and black love.
>
> It is important to me that black people understand and identify with my work. When a black person looks at one of my pieces and says, "Yeah, that's mama, that's grandmama, that's sister, that's me," I am gratified. Now is not the time for me to be so esoteric, so obscure or so individualistic, that my meaning is lost to all except the narrow world of the "art-minded." Blacks are a family bound and unified by common experiences in a hostile land. I aim to speak to, of and for "my family."[41]

Born in Baltimore, Johnson first attended Coppin State Teachers College there and was awarded an elementary school teaching certificate. In 1952 she won her B.A. in art education from Morgan State College, also in Baltimore, and she later received an M.A. in painting from San Jose State College. Presently, she is an assistant professor in art and Black studies at the latter institution and also continues her elementary-school work as a consultant on Afro-American art and art history.

Marie Johnson is a busy, committed woman. In addition to her professional activities, plus an active exhibition schedule, she is involved in community work. She serves on the San Jose Urban Coalition Steering Committee, was an organizer and teacher for "Self Image Art" (an art program for minority group children), is a member of the Board of Directors of the San Jose Civic Art Gallery, and has been a visiting art teacher in classes for the blind. Furthermore, she is much in demand as a lecturer on Afro-American art in the San Francisco Bay area.

Johnson is dedicated to the human values that unite mankind, the values that have too often been abandoned in the name of technological and economic progress. As a Black and an artist she is seeking to rediscover her roots, to examine the poignancy, dignity, humor, and beauty in the Black experience. These are the themes of her work. Her goal is "to produce

left: 223. MARIE JOHNSON. *Mrs. Jackson.* 1968.
Mixed media: carved and painted weathered wood and clothing; height 3'. Courtesy the artist.

224. MARIE JOHNSON. *Hope Street.*
1971. Mixed media (usually shown
with live canary), 3′ square.
Courtesy the artist.

a portrait of a people—a portrait that is universal in its humanness." In a recent interview, Johnson told a reporter she sees the Black artist and his work as "the antidote to all this involvement with death obsessions in the white art world, the tendency to machine-looking art, automated art, art that looks like nobody touched it. This is our potential. We could be the people who ended up humanizing America."[42]

James Lewis (b. 1923)

James Lewis was born into a family of sharecroppers in Phenix, Virginia. When life on the farm became unbearable, the elder Lewis moved the family to Baltimore, where he worked successively as a mechanic, a laborer, a custodian, and—until his death in 1943—a mail handler for the Post Office. As a child Lewis loved to draw, and he was encouraged in his youthful attempts by Leon Winslow, a Baltimore educator to whom Lewis is still grateful. The young artist also enjoyed singing, and he performed in W.P.A. Federal Theatre project musicals.

When he was a sophomore in high school, Lewis was awarded a Carnegie Foundation grant for evening study in art, but he found that the segregated art schools were less than receptive to young Blacks. The Maryland Art Institute solved this problem by hiring an advanced student to give Lewis private instruction. Of his college studies, Lewis recalled: "I had been aware of a kind of poetic justice that was coming to those advocating a system of racial segregation in Maryland."[43] If a Black student was interested in a course of study not offered in a state-supported Black school, the state was obliged to provide tuition, room, board, and travel to the school of his choice, anywhere in the country. Some of the affected students chose the University of California, but Lewis enrolled at the Philadelphia College of Art. He stayed there only one year, for the United States had entered the war, and Lewis was drafted. He entered the Marine Corps in 1943.

When the war was over, Lewis returned to school and, upon graduation, was hired as a drawing instructor. He had wanted to be an illustrator, but employment was difficult to find, especially for Blacks. Advancement in teaching also seemed remote in the Philadelphia area, so, after completing his Master's degree at Tyler College of Fine Art, Temple University, Lewis accepted a position at Morgan State College, a Baltimore institution that is preponderantly Black. At the end of his first year, he was offered the chairmanship of the art department, and he has been at Morgan State ever since. His memorial to Frederick Douglass (Fig. 225) is a landmark on the campus.

Lewis has worked hard to develop the art department, now one of the best among colleges with largely Black student populations. Designed especially to meet the needs of the "culturally disadvantaged," the art program at Morgan State is committed to a dual mission.

> To provide an art education for prospective artists, a small group, and a larger group of prospective teachers; and to contribute to the general education of all Morgan students in the field of the humanities. The art program is based on the assumption that the fundamental imperative in both these domains must be the effacement of the banalities of vision brought by the student and his placid acceptance of the gray, visual conformity of our cities and society.[44]

Through the generosity of the Hirschl and Adler Galleries in New York, the college has a small "study collection" of representative examples of the work of Western artists. There is also a valuable collection of African art.

A Ford Foundation grant in 1954 and 1955 enabled Lewis to work with Josef Albers, who by this time was at Yale. Like Jacob Lawrence before him, Lewis was

left: 225. JAMES LEWIS. *Frederick Douglass.* Completed 1956. Bronze, height 8'. Morgan State College, Baltimore.

below: 226. JAMES LEWIS. *Sculptural Relief.* Completed 1969. Sheet bronze, 3 × 46'. North entrance, Cherry Hill Junior High School, Baltimore.

greatly influenced by the Bauhaus master. Lewis' early work had been considered academic, but Albers helped him discover his potential and expand his horizons. "With Albers my previous concepts were completely shaken up and I had to begin to think of art in a much broader sense than I had ever done before. And on the heels of that was a new and growing interest in art by black Americans and a new awareness and interest in traditional African art."[45]

Lewis is now considered an authority on African art. Since 1965 he has been associated with the American Society of African Culture, first as a lecturer and then as organizer of the Dakar Art Festival. Ekpoo Eyo, Director of Antiquities of the Nigerian National Museum, invited Lewis to participate in an archaeological expedition in Nigeria. Workmen cleared and roped off the site, and the group worked in 100° weather for over a month. The terra cotta fragments they found, once reassembled, helped to authenticate the Owa civilization, a culture that apparently existed between the Ife and the Benin.

Frequent visits to Africa have changed the style of Lewis' sculpture. A relief with Ashanti-inspired motifs welcomes students at the Cherry Hill Junior High School entrance door (Fig. 226); a gift to the Morgan State art gallery of 42 Ashanti gold weights inspired the decorative emblem on the large brass fountain designed for the Broadway median strip in a predominantly Black section of East Baltimore (Fig. 227). Lewis has commented: "I do not copy the Ashanti designs. Rather I adapt them to my own work in the hope that the black community will derive from them a sense of pride in their cultural heritage as seen through my adaptations."[46]

The Black artist, from the New Negro movement to the New Militancy, had come full circle. Supported by interested whites in the 1920s, he was free to express himself within the limitations set by his sponsors. Patronage declined with the diminishing fortunes of the Depression, but a new patron was found in a government that aided Black and white artists equally. World War II and the 1950s shifted interest toward political, educational, and economic gains; art and creativity were peripheral to the struggle for equality. The Black artist became invisible, which was tantamount to being ignored. However, a new militant spirit was on the horizon, a spirit similar to, yet different from, the mood of the New Negro movement. In the twenties the Black was considered an exotic; in the sixties and seventies he is seen as a threat. White support and patronage were rejected by political organizations, and many Black artists began to repudiate the traditional philosophy of Western art, which was white, in order to seek a "Black aesthetic." Some of the older artists participated in the search, growing more militant with each new success of their younger colleagues. Others continued to ponder their role as American artists, reared in the middle-class values of American society and educated in art schools designed to transmit the values of Western civilization.

The Militant
Sixties and Seventies

In the decade of the sixties another "new Negro" emerged on the American scene. Aware of his power, demanding his rights, and dedicated to the dignity of his race, he no longer called himself a "Negro." He was Black; he was an Afro-American. Impatient with the ineffectiveness of the courts and the Federal Government, his tolerance of the older Civil Rights organizations exhausted, the young Black rebelled. The decisive break with legal measures came in 1960, with the sit-in techniques begun by four Black students at North Carolina's Agricultural and Technical College in Greensboro. The students "sat in," waiting to be served, at a segregated lunch counter (Fig. 228). They were arrested, and students all over the country—Black and white, separate and together—"sat in" in restaurants or picketed the northern branches of industries practicing segregation in the South. The Black protest movement became an integral part of a general student move-

ment, and finally a student revolution with worldwide ramifications.

By 1963, the Black revolution had invaded America's consciousness. The March on Washington for Jobs and Freedom (Fig. 229), organized by Bayard Rustin, was seen on national television. For the first time, many Americans became aware of the Black citizen's genuine problems and his demands. Although the goals and ideals of the Black leadership remained constant, the movement had been injected with a new vigor that was not predicted by social scientists and historians. White America discovered itself to be unaware and unprepared.

The courage and discipline exhibited by the college student and the ordinary citizen—some of whom were participating in the struggle for the first time—were impressive. Black protest organizations, directed by Blacks, were proliferating. The revolution had become

a grass-roots phenomenon. The student movement re-activated the adult movement, and, encouraged by the gains of their youth, the older organizations began to employ direct-action techniques. Pictures of Black and white students peacefully resisting the billy clubs of southern law enforcers (who had become the symbol of southern resistance to change) were spread around the country and around the world. Inspired by the dedication of the Reverend Martin Luther King, Jr. (Fig. 230) the nonviolent revolution captured the imagination of a previously complacent society, which responded with funds, manpower, and political pressure to aid the cause of the Black. International events

above: 228. Sit-in at an F. W. Woolworth store, Greensboro, N.C. 1960.

left: 229. March on Washington. August 28, 1963. View from the top of the Lincoln Memorial.

230. THE REVEREND MARTIN LUTHER KING, speaking in Cleveland, Ohio. July 28, 1965.

also strengthened the Black's sense of racial pride. State after state in Africa won independence from European "mother" countries and were rewarded with seats in the United Nations. Black American leaders visited Africa, hoping to create a "third-world" movement.

Now an urban man, concentrated in the largest cities in the most populous industrial states, the Black became a political force to be considered. President Truman admitted he owed his victory in 1948 primarily to Black voters. President John F. Kennedy credited his narrow margin of victory in 1960 to the Black support he gained from intervention in behalf of the imprisoned Dr. King. Because of this political force, the power elite in Washington began to demonstrate concern for the Black. Under the direction of President Kennedy, Blacks were recruited and promoted more equitably in government installations; visible upper-level appointments were made; and a Civil Rights Bill, which provided for an effective Fair Employment Practice Commission, was sent to Congress. By executive mandate, an "equal opportunity in housing" plan was ordained, covering community development programs and government-financed housing. The Justice

left: 231. Patrolling the streets of Newark, N.J., during the 1967 riots.

right: 232. Black Panther leaders HUEY NEWTON (*second row left*) and DAVID HILLIARD (*third row center*) arriving at Philadelphia International Airport, September 4, 1970, for the Panthers Revolutionary Constitutional Convention at Temple University.

Department entered the area of voter registration in the South, where, since post-Reconstruction days, most Blacks had been semilegally prevented from voting.

Mass marches, picketing, and nonviolent protest did not engender change rapidly enough for the young Black militants and the masses of poor whom they led. Doors were opening for the middle-class Black, and there was token representation in business, government, the arts, and the communications industry. For the great majority, however, conditions were the same, if not worse, for they lived with a sense of rising expectations that contrasted sharply with actuality. During the first half of the 1960s there was much rhetoric and little action; there were many programs, but lim-

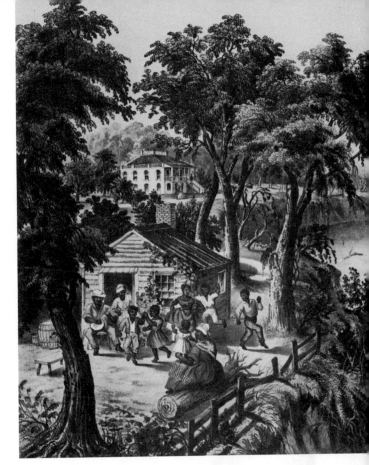

ited funds for implementation. The government was creating an image of things to come without substantive backing. The inevitable result was an increasing militancy and impatience with hopes that were never realized. With a growing sense of his own exploitation, the Black took to the street and rioted against the nearest oppressor—the white merchant. He destroyed the house he lived in and his neighborhood (Fig. 231). The substandard real estate in the ghetto was for the most part owned by white absentee landlords, and the only way to improve it was to destroy it. This the Black did, first in the Watts section of Los Angeles, then in Detroit, Newark, and countless other cities.

Many Blacks have chosen to reject the traditional American society, claiming that the richness of Black life affords a culture different from, but at least equal and perhaps superior to the white American culture. Consequently, the young Black has begun to search for his identity in the Black ghetto or in Black Africa. Although this recent quest resembles the spirit that motivated the Black during the Harlem Renaissance, there is one important difference. The earlier movement depended on white financial support for its life and folded when that support was withdrawn; the current movement is Black oriented, Black directed, and Black supported. In fact, the militant Black has grown suspicious of white liberals and has removed them from policy-making positions in all his organizations. He rejects almost all aspects of American society and the middle-class way of life. While the older Civil Rights organizations fought to give the Black an option to enter mainstream America, increasingly militant groups, such as the Student Non-Violent Coordinating Committee, the Congress of Racial Equality, and more recently the Black Panthers (Fig. 232), assert that only through radical change in the country's social structure—including an overthrow of the military-industrial-labor complex and the creation of a new society—will there be economic and social justice.

The shame and discomfort experienced by the older intellectual in the presence of the "folk Negro" no longer affects the young, committed Black. Before the renewal of "Black consciousness," the educated Black scorned the lower-class members of his race. He became conservative, often reactionary, and did little to transmit the benefits of his education to the Black pop-

ulation as a whole. The young Black collegian today is frightened by the example of his older brother. He is afraid of absorbing too much of the life style offered by the universities that have opened their doors to him and is forming his own group within the university, demanding studies with which he can identify and that will prepare him for work in the ghettoes. Most large universities have acquiesced to Black students' demands, and throughout the country Black Studies programs exist in predominantly white institutions.

The Black collegian's demands have also filtered down to the elementary and secondary schools. From the first primer—which depicts Black children and white children sharing play experiences—through the high school history texts—in which the role of the Afro-American in society is receiving at least a cursory recognition—books are being desegregated. Publishers have rushed to fill the void with paperbacks, pamphlets, films, and displays portraying the struggle of the Black. The myths perpetuated by historians eager to placate the defeated South after the Civil War (Fig. 233) are finally being destroyed, and distortions about the causes of the war and the illiterate Black's corrup-

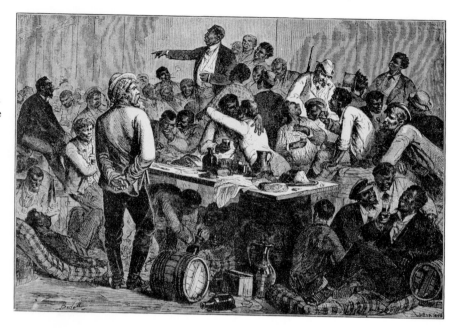

tion during Reconstruction (Fig. 234) are being corrected. The Black is no longer invisible in American history, thanks to the vigorous efforts of the Black militants on college campuses.

The recent spate of Black art exhibitions and the sudden attention proffered the Black visual artist certainly has political ramifications, for art and politics cannot be separated. Were the young Black militants not demonstrating and demanding reparations, the white art Establishment would not respond so eagerly. Suddenly, gallery owners and museum directors, the patrons of art and the purveyors of taste, are seeking the services of the Black artist. As if to compensate for three hundred years of neglect, Black artists are now included in the private collections of the Rockefellers and the Joseph Hirshhorns, in the latest Whitney Museum of American Art Annuals, in the Museum of Modern Art, and in most major art institutions in the country. Blacks have received many of the prestigious foundation grants and awards. Major museums have opened inner-city branches: the Brooklyn Children's Museum operates a neighborhood branch called MUSE in the Bedford-Stuyvesant area (Fig. 235); the Anacostia Museum was launched in Washington, D.C., under the auspices of the Smithsonian Institution; the Walker Art Center in Minneapolis and the Whitney Museum in New York encourage talented Black children to participate in their art programs. Even though galleries and museums have not always *consciously* neglected the Black artist—since those dealing in the arts often seem less prone to prejudice than the general population—"the real thing," according to Charles Alston, is that Blacks miss out on the social situations, on the parties and gatherings where they might meet collectors and people important in the Establishment structure.[1]

The artist-militant's need to create a separate identity has given rise to a grass-roots movement. Black art galleries, community art centers, workshops, and mu-

seums are proliferating in urban centers throughout the nation. The museums are interested in preserving the Black's African and Afro-American heritage through research, scholarship, and the organization and sponsorship of exhibitions; the community art centers and workshops are attempting to undo the "cultural homogenization" of the public schools by working with the various ethnic forms of art and with the child's ethnic background. Some of the organizations refuse support from the white community; others use university or museum staffs as consultants. Many are Black directed but must rely on foundation money to facilitate their program development. A few groups are controlled by integrated boards of directors, and one, the Museum of African Art and the Frederick Douglass Institute, was founded by a white man, a former foreign service officer. The purposes of these various organizations are as diverse as the artists and the communities that support them. Each, in its own way, has developed programs to bring a sense of identity and pride, through art, to the Black community.

Black Art Institutions

Founded in 1964, the Museum of African Art and the Frederick Douglass Institute in Washington, D.C. (Fig. 236), is considered a pioneer among museums dedicated to the exhibition and preservation of African and Afro-American culture. The museum has a permanent collection of 2500 African items that is frequently on tour at colleges and small museums, a collection of modern art influenced by African sculptural forms, and one of the largest collections of 19th- and 20th-century Afro-American art in the United States. With an interracial board of trustees and a staff that is 70 percent Black, the museum exists to serve the capital community (whose public school population is 94 percent Black) and as a "prototype institution for the hundreds of museum, school and university officials, community organization leaders and others who have come to view its exhibits and consult with its staff."[2]

Edmund Barry Gaither, the young Black director of the Museum of the National Center of Afro-American Arts in Boston (Fig. 237), accepts as the museum's

top: 236. Young visitor at the Museum of African Art, Washington, D.C., admiring sculpture carved by the Luba tribe of Zaïre.

left: 237. EDMUND BARRY GAITHER, at the Museum of the National Center of Afro-American Arts, Boston.

special charge the creative life of the Black people. To Gaither, the major role of the Black art museum and the Black art historian is four-fold:

1. To create literature around the work of Afro-American artists.
2. To project the Afro-American artist into the scholarship of American art.
3. To broaden the acquaintance of the Black community with the Black artist.
4. To stimulate the production and preservation of the work of Black artists.[3]

To accomplish these ends, the museum has developed a five-part program of exhibitions, collection and conservation, publications, slide and microfilm archives, and public education promoted through the use of a trailer museum.

According to Gaither, the existence of predominantly Black institutions does not absolve the major art museums of their responsibility to integrate their collections, exhibitions, and scholarly research; nor does it negate the role of universities and galleries in educating the general public to the existence of Afro-American art and artists. The Museum of the National Center of Afro-American Arts accepts financial aid and organizational advice from the Boston Museum of Fine Arts. Together, the two museums sponsored the largest exhibition ever devoted to the Black artist: "Afro-American Artists: New York and Boston."[4]

The focus of Black cultural activity in New York is the Studio Museum in Harlem (Fig. 238). Equally concerned with the quality of life in the community and with the world of contemporary art, the museum maintains an exhibition program wherein both community-based and "downtown" artists can exhibit, as well as a studio program in which free work space is provided for artists and their students. The museum is now a force in the New York art world; its exhibits receive critical attention and are often controversial.

Black artists of the Depression years gained renewed attention as a result of an exhibition, "Invisible Americans: Black Artists of the '30's," held at the Studio Museum, November 19, 1968, to January 5, 1969. The show was organized to protest the exclusion of Blacks from the Whitney Museum of American Art's reevaluation of the Depression years, "Painting and Sculpture in America: The 1930's." The Harlem show—organized by Henri Ghent, a Black curator at the Brooklyn Museum—was exclusively Black. Simultaneously, Black artist-militants picketed the Whitney. The Whitney curators claimed the absence of Black artists was an oversight, not a deliberate exclusion, and this point of view must be given some credence (although not excused), since the sources most curators consult when mounting exhibitions—art historical

238. "Fragments of a Spiritual: Paintings and Drawings by Le Roy Clarke." Installation view of a 1972 exhibit at the Studio Museum in Harlem.

239. JACOB LAWRENCE. *Street Clinic.*
1937. Gouache on paper, 29 × 30″.
Collection Mrs. Jacob Lawrence.

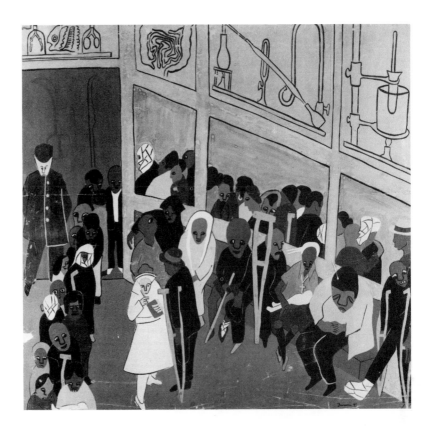

writings and magazine articles—have rendered the Black artist invisible.[5]

The artists represented in the Harlem show reflected the mood of the 1930s—social realism, social commentary, paintings derived from European styles. Although the exhibit demonstrated no "blinding achievement," many of the works were at least as respectable as the white offerings of the period, and perhaps remarkable when judged in relation to the circumstances under which they were produced. Yet, neglecting an artist of the "stature of Joseph Delaney . . . is, in itself, testimony that the central contention of the Black artists is true—that the white critical world is, in fact, unaware of Black artistic achievement."[6]

Hilton Kramer of the *New York Times* found some work of considerable merit—Joseph Delaney's *Waldorf Cafe* (Fig. 180), Jacob Lawrence's *Street Clinic* (Fig. 239), Archibald Motley's *In the Streets*, and Hale Woodruff's *Forest Fire* (Fig. 171)—but overall, Kramer wrote, it was an "extremely feeble show," and the paintings were mainly banal and academic. Citing many white artists of considerable merit who were also excluded from the Whitney exhibition, Kramer claimed the neglect was void of racial implications. He continued:

Mr. Ghent has no doubt served notice . . . that he is not primarily interested in artistic quality. It is this indifference to quality—not any differences over justice to the Black artist—that separates his enterprise from [the Whitney's].[7]

Kramer's harsh critique drew a well-publicized retort from Ghent, who claimed the *Times* critic used different standards of judgment in reviewing the exhibits: the Whitney artists were viewed in the light of what was happening in American painting during the 1930s, the Black artists in relation to the history of Western art. Ghent admitted that the hastily organized Harlem show was not composed entirely of masterpieces, but, for that matter, neither was the Whitney exhibit. Nevertheless, there *were* works of outstanding quality, and the intention of Ghent and his colleagues was to present these to the public. Why were the artists of considerable stature cited by Kramer and Pincus-Witten (see p. 136) ignored by the Whitney? According to Ghent, William Agee, the coordinator of the exhibition, did not know they existed; to him they were "invisible Americans." Ghent accused Kramer and other members of the "New York art establishment" of "per-

left: 240. ROMARE BEARDEN. *Eastern Barn.*
1968. Collage of paper on board, 4′ 7½″ × 3′ 10″.
Whitney Museum of American Art, New York.

below: 241. JACOB LAWRENCE. *Depression.*
1950. Tempera on paper, 22 × 30½″.
Whitney Museum of American Art, New York.

242. HORACE PIPPIN.
Buffalo Hunt. 1933.
Oil on canvas, $21\frac{1}{4} \times 31''$.
Whitney Museum of
American Art, New York.

petuating a pervasive myth, one that could be explosively dangerous: the myth of the inferiority of Black artists; in fact the myth of the inferiority of Blacks generally in areas of intellectual endeavor."[8]

In a plea for recognition and understanding, Ghent wrote:

> ... we are all Americans anxious to make our most significant contribution.... However, the establishment forces Black artists to set themselves apart (physically but not esthetically), thereby robbing America and the world of the opportunity to share in their creativity, which is, and always has been, an integral part of their aspirations.[9]

Evidently, the protest activity by the artist-militants bore fruit. "American Art of Our Century," an exhibition mounted by the Whitney during the summer of 1969, included at least five Black artists: Charles Alston with *Family Group* (Pl. 13, p. 127), Romare Bearden with *Eastern Barn* (Fig. 240), Jacob Lawrence with *Depression* (Fig. 241), Horace Pippin with *Buffalo Hunt* (Fig. 242), and Richard Hunt with *Extending Horizontal Forms* (Fig. 284). All were from the Whitney's permanent collection, but none had been illustrated in a Whitney publication of the same name prepared in 1961.[10]

"Harlem '69," an invitational exhibit open to any artist who had ever lived in Harlem, was equally controversial. The show was organized to survey the mood of the Black community. Many styles were represented—social commentary, abstraction, and banal realism—and a few paintings incorporated African symbolism or motifs. Unfortunately, the quality of the art was low because of faulty selection. (The artists had been chosen from among the director's friends, a situation that does not lead to objectivity.) However, another exhibit, called "Impact Africa," was widely hailed. Examples of Yoruba and Benin sculpture were displayed alongside drawings by Picasso and Amedeo Modigliani—the Italian artist who, like Picasso, had been influenced by African sculpture (Figs. 2, 3). These two elements in the exhibit served as a counterpoint to the work of contemporary Black artists who were trying to incorporate the African heritage into their art. As a result of these contrasts and comparisons it is difficult to surmise whether the African primitive influences observable in Afro-American art are rooted in the ancestral soil or have traveled the well-worn path of modern art taken by Matisse, Picasso, and Modigliani.

Although the Studio Museum has an integrated Board of Directors—headed by City Councilman Carter Burden—a roster of sponsors composed of New York's leading Black and white citizens, and the financial support of the "white liberal establishment," Edward Spriggs, the director, claims to be autonomous.[11]

Also in Harlem is the Weusi Nyumba Ya Sanaa, a communal group of Black artists seeking roots in the

Recently, Ringgold has produced a series of "black paintings" which she claims disturb white viewers because she excludes them, she works outside their realm of interest and experience. "I got all the reactions as I painted with black that white people must get in trying to deal directly with us—the fear and uncertainty—the inability to handle details of it with ease . . . because it is hard to see."[18]

Kay Brown

Kay Brown's striking collages were exhibited at the Acts of Art Gallery, the Greenwich Village gallery owned and operated by Nigel Jackson, a painter dedicated to the exhibition and sale of works by Black artists independent of Establishment support. Brown's collages are topical: one is titled *Remember Biafra.* They are also political (Fig. 263); various works have featured Dick Gregory, the Black comic and raconteur; Medgar Evers, the Mayor of a small Mississippi town; and LeRoi Jones (Imamu Amiri Baraka), the poet, essayist, and Black separatist leader.

A radical feminist and contributor to the *Feminist Art Journal,* Brown has written of the Black woman and her special responsibilities:

Black Woman,
Yes, the Wisdom of Waiting
For she knew as she strived
That the New Day would finally arrive
And the burden of her life's storywould
Well worth the eternal glory.
No more time for Pain
Past troubles or all that strain
For the Wanton, wretchedness of life
Has past to emptiness, as her strife
And, yes, the future is no longer
. It is now.[19]

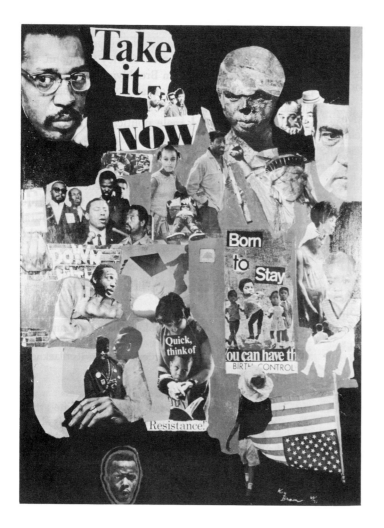

263. KAY BROWN. *Take It Now.* 1968–71. Collage, 42 × 32″. Courtesy the artist.

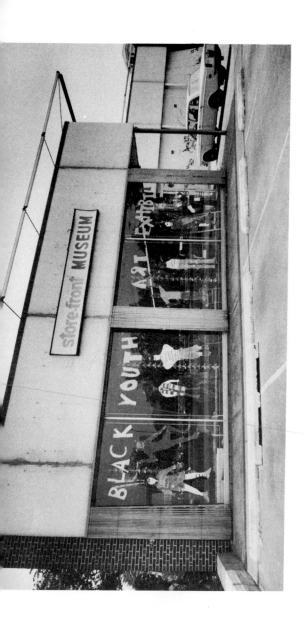

art of Africa. In Jamaica, New York, the Store-front Museum of black history and culture (Figs. 243, 244) is staffed by community workers, college students, and young adults from the area's youth corps. Founded and directed by Tom Lloyd (Figs. 274, 275), the Store-front has an average weekly attendance of three hundred, many of whom are first-time museum-goers. Like others of the grass-roots enterprise, the Store-front incorporates dance, music, and drama—all the communicative arts—into its programs.

The aggressive young painter Nigel Jackson directs the Acts of Art Gallery in New York's Greenwich Village (Fig. 245), a successful venture committed to the exhibition and sale of works by Black artists. The gallery director made news by staging an exhibit for the dissident artists who boycotted the Whitney Museum's "Contemporary Black Artists in America" (April 6–May 16, 1971). The "Rebuttal to the Whitney" exhibit (April 6–May 10, 1971) received critical acclaim, and the Acts of Art shows are now regularly reviewed by the New York art critics.

The Cinque Gallery (Fig. 246) is an "antiseptically professional" showroom in Manhattan's East Village named for the tribal prince who led the Amistad rebellion (Figs. 167–169). Founded by Romare Bearden, Norman Lewis, and Ernest Crichlow, all Black artists who matured during the 1930s and 1940s, the Cinque Gallery provides a showcase for under-thirty minority-group artists. Planning to nurture talented young members of minority groups, who have traditionally had difficulty in making gallery contacts, the Cinque Gallery is intended as a "way station"; when the artist matures, he will be directed toward an "uptown" gallery. The first exhibit was devoted to Malcolm Bailey's

top: 243. Store-front Museum, Jamaica, New York.

above: 244. "West African Ceremonial Costumes." Inaugural exhibition at the Store-front Museum. June 15, 1971.

242. HORACE PIPPIN.
Buffalo Hunt. 1933.
Oil on canvas, 21¼ × 31".
Whitney Museum of
American Art, New York.

perpetuating a pervasive myth, one that could be explosively dangerous: the myth of the inferiority of Black artists; in fact the myth of the inferiority of Blacks generally in areas of intellectual endeavor."[8]

In a plea for recognition and understanding, Ghent wrote:

... we are all Americans anxious to make our most significant contribution.... However, the establishment forces Black artists to set themselves apart (physically but not esthetically), thereby robbing America and the world of the opportunity to share in their creativity, which is, and always has been, an integral part of their aspirations.[9]

Evidently, the protest activity by the artist-militants bore fruit. "American Art of Our Century," an exhibition mounted by the Whitney during the summer of 1969, included at least five Black artists: Charles Alston with *Family Group* (Pl. 13, p. 127), Romare Bearden with *Eastern Barn* (Fig. 240), Jacob Lawrence with *Depression* (Fig. 241), Horace Pippin with *Buffalo Hunt* (Fig. 242), and Richard Hunt with *Extending Horizontal Forms* (Fig. 284). All were from the Whitney's permanent collection, but none had been illustrated in a Whitney publication of the same name prepared in 1961.[10]

"Harlem '69," an invitational exhibit open to any artist who had ever lived in Harlem, was equally

controversial. The show was organized to survey the mood of the Black community. Many styles were represented—social commentary, abstraction, and urban realism—and a few paintings incorporated African symbolism or motifs. Unfortunately, the quality of the art was low because of faulty selection. (The artists had been chosen from among the director's friends, a situation that does not lead to objectivity.) However, another exhibit, called "Impact Africa," was widely hailed. Examples of Yoruba and Benin sculpture were displayed alongside drawings by Picasso and Amedeo Modigliani—the Italian artist who, like Picasso, had been influenced by African sculpture (Figs. 2, 3). These two elements in the exhibit served as a counterpoint to the work of contemporary Black artists who were trying to incorporate the African heritage into their art. As a result of these contrasts and comparisons it is difficult to surmise whether the African primitive influences observable in Afro-American art are rooted in the ancestral soil or have traveled the well-worn path of modern art taken by Matisse, Picasso, and Modigliani.

Although the Studio Museum has an integrated Board of Directors—headed by City Councilman Carter Burden—a roster of sponsors composed of New York's leading Black and white citizens, and the financial support of the "white liberal establishment," Edward Spriggs, the director, claims to be autonomous.[11]

Also in Harlem is the Weusi Nyumba Ya Sanaa, a communal group of Black artists seeking roots in the

series of drawings and paintings depicting various aspects of the 19th-century slave trade (Fig. 246).[12]

Detroit's International Afro-American Museum, a grass-roots institution supported and staffed from within the community, is dedicated to a single theme: "that generations of Black children to come will be aware of and take pride in the history of their ancestors and their magnificent struggle for freedom." Although the museum has a permanent mailing address, its main activities center around a large trailer that tours the schools.[13]

The Art and Soul community workshop and gallery is located in the heart of what its director, artist Donald McIlvaine, calls the "classical ghetto," of Chicago. A community-dominated organization that is also supported by the University of Illinois at Chicago Circle, Art and Soul concentrates its efforts on educating the youth of the neighborhood through art. The activities, according to McIlvaine, "help create a desire in youth to excel in life, to expand their goals, to relieve frustrations by expressing with various tools of art those expressions the heart alone sometimes cannot express."[14]

Named for the legendary African "City of the Gods," the Ile-Ife Museum of Afro-American Art and Culture in Philadelphia has a close relationship with the Studio Museum in Harlem. The two museums sometimes share their exhibits. Founded by Arthur Hall, organizer of the Afro-American Dance Ensemble and the Ile-Ife Black Humanities Center, the museum has manifold purposes. Besides housing a library, a music-listening room, and a day-care center, the Ile-Ife

Museum seeks to be a "clearing house for information from African embassies."[15]

The New Thing Art and Architecture Center, a community organization in Washington, D.C., is also dedicated to the development of the Black community through art and education. The director of the center,

top: 245. DINDGA McCANNON. *Shackles, Slaves, and Prods.* Poster for a group show at the Acts of Art Gallery. New York, June–July, 1972.

left: 246. MALCOLM BAILEY, with a painting from his *Separate but Equal* series. Inaugural exhibition at the Cinque Gallery, New York. 1969.

191

247. Topper Carew at the New Thing Art and Architecture Center, Washington, D.C.

Topper Carew (Fig. 247), is a former Boston gang leader with a Bachelor of Arts degree from Yale University. Carew rejects the tenet "art for art's sake" as irrelevant to the life of the Black man. To him "art is a means to make people more aware of their presence in the world, more aware of their historical origins and the vitality of their own culture." Hence, most of the teaching at the New Thing attempts to aid Black people deal with their situation in the world by heightening their awareness of their responsibilities to themselves and to their community. Since the New Thing is a cultural organization, rather than a political one, its purpose is to bring about a change in values—a decreased emphasis on material gains and a reassertion of basic human values. The New Thing also functions as an unincorporated high school for Black youngsters in Washington who have spurned the public schools. About 250 students are enrolled in a course of study that includes Black history, African music and dance, graphics, design, and photography. Carew's relationship with his students is unique—that is, when compared with the student-teacher relationship in traditional schools. He is not an autocrat; the students

respect him because they value his knowledge. He is their brother as well as their leader.[16]

Organized in 1967 by a group of Black "street artists," the Black Man's Art Gallery of San Francisco is attempting to redefine "Black art" within the framework of an Afro-American philosophy. The founders had long been frustrated by the "bias," "run arounds," and "outrageous commissions" typical of most galleries, and they now reject both the white-dominated art galleries and their token acceptance of the Black man who conforms to white aesthetic standards. William O. Thomas, a spokesman for the group, described the philosophy of the artist-members:

In Black art, you actually create life in a visual image. Western and European philosophy is based on, "I think, therefore I am." Black African philosophy is, simply, "I am." The artists in the gallery have a tribal relationship based on brotherhood, spirituality, helping each other. We determine for ourselves what Black art is, artistically, aesthetically and ethically, based on our African origins, enlightened by the frustrations and anxieties of living in a white racist society.[17]

right: 248. "Harlem on My Mind."
January 18–April 6, 1969.
Metropolitan Museum of Art, New York.

While members of the Black Man's Art Gallery were repudiating the white aesthetic and the white art world, a number of Black artist-militants began to protest racism as a general phenomenon in American cultural life. The latter group wanted equitable representation on all levels within the museum and gallery structure. Organized at first to protest the Metropolitan Museum of Art's "Harlem on My Mind" (Fig. 248) exhibition (January 18–April 6, 1969), a show that was almost universally criticized for its slick and superficial representation of the Harlem experience,[18] the Black Emergency Cultural Coalition picketed the Metropolitan Museum. Later, the same group picketed the Whitney Museum, after it had ignored the Black artists of the thirties in "Painting and Sculpture in America: the 1930's." The coalition made the following demands of the Whitney:

1. Stage a major exhibition of Black art works.
2. Establish a fund to buy more works of Black artists.
3. Show at least five annual one-man exhibitions of Black artists.
4. Have more Black artists represented in the Whitney Annuals.
5. Consult with Black art experts.[19]

The Whitney has capitulated on most of the coalition's demands. More Black artists were represented in the last Annual; Mel Edwards, a Black sculptor (Figs. 323, 324), was given a one-man show in the museum's small gallery in March of 1970; Malcolm Bailey (Pl. 36, p. 277; Figs. 246, 333, 334) exhibited his paintings there in April 1971; and in the latest survey of American art of the 20th century, at least five Black artists were represented, where none had been before.[20] With the proliferation of exhibitions devoted exclusively to Black artists, the coalition is now pressing for the employment of Black curators and art scholars. Tom Lloyd (Figs. 274, 275), an artist aligned with the Art Workers Coalition (an integrated artist-militant organization) and founder-director of the Store-front Museum, warned that Black artists will not accept "Negro" administrators with conservative political and artistic views. Rather, the artists want Blacks who will instill "pride and identity in Black people and counterbalance the exclusivity of the dominant white culture."[21]

Establishment Support of Black Artists

In response to political and social pressures from the Black community, white-controlled colleges, museums, and foundations have begun to sponsor Afro-American art exhibits. Until the mid-1960s, Black shows were usually mounted in churches, social halls, or Black colleges. Now, with Black Studies departments thriving on so many campuses, it has become fashionable for university galleries and other Establishment institutions to present Afro-American exhibits. The most significant show of the mid-sixties was "The Evolution of the Afro-American Artist: 1800–1950," which took place at the City University of New York. The exhibition was organized by Romare Bearden and Carroll Greene, Jr., curator of the Afro-American Cultural History Project at the Smithsonian Institution. For the first time the general public became aware of the sustained efforts of the Black artist. Encouraged by the success of this exhibit, other museums, galleries, and colleges began to focus attention on younger artists. In 1967 there was "Counterpoint" at Lever House in New York; in 1969 Brooklyn College sponsored "Afro-American Artists Since 1950"; Mount Holyoke College in Massachusetts offered an exhibition of "Ten Afro-American Artists," organized by Henri Ghent in November of 1969; the Staten Island (New York) Museum presented an informal showing of seven Black artists in the spring of 1970. The Minneapolis Museum, with the financial sponsorship of Ruder and Finn, Inc.—a New York public relations firm—organized an exhibit of "30 Contemporary Black Artists," which visited

museums in Atlanta; Flint, Michigan; Syracuse, New York; and San Francisco; and, on the West Coast, in 1968 the Oakland Museum presented "New Perspectives in Black," and San Jose State College mounted "Black Arts Today." Finally, in the spring of 1970, the Museum of the National Center of Afro-American Art and the Boston Museum of Fine Arts combined to present the largest exhibition of Afro-American artists to date, which has perhaps at last convinced the gallery-going public that a large body of creative work by Black Americans does exist. The Black art shows of the 1960s differed from the earlier shows in two respects: They were sponsored by major institutions, and they were presented without apology, without an appeal for a "double standard" in judgment.[22]

The exclusively Black art show is a temporary phenomenon that may already have served its purpose. "The Black artist need[ed] and desire[d] special encouragement by our museums because of the impediments which segregation ha[d] raised in his path."[23] The group exhibit stimulated public interest, drew critics who would not have responded to an individual show, and gave the artist accustomed to indifference the support of a group.[24] The all-Black exhibit fulfilled three aims:

1. It challenged the viewer to judge and enjoy works of art on their own merit, not measuring his response by sympathy with the artist.
2. It challenged the establishment, by recognizing the achievement of these artists, to acknowledge the potential and desire for quality urgently developing in our community.
3. It encouraged the Black youth of America.[25]

While most Blacks are enjoying the new opportunity to exhibit, many resent being celebrated merely because they are Black. Now ready to be judged on their own merit, Black artists have the support of the Black Emergency Cultural Coalition, which views its new role as one of assuring that Black artists are equitably represented in galleries and museums. However, according to John I. H. Baur, "the cause of the Black artist will be poorly served indeed if museums lower their aesthetic standards to accommodate his art. That would be an act of condescension as well as racial discrimination."[26] Many critics and museum directors do not know how to cope with this new phenomenon—the Black artist. Critics will write patronizing reviews of Black exhibits, praising work of obviously inferior quality. It is almost as though they are saying,

"Isn't it wonderful, the savage can paint?" Equally contemptuous is the white museum director who demands a blatant display of "Blackness" in the work of the Black artist. Henri Ghent, as director of the Brooklyn Museum's Community Art Center—an institution created under pressure from the Black community—presents an alternative position. Neither a nationalist nor a separatist, Ghent is "fighting for the recognition of those Black artists who adhere to the universal artistic standards."[27]

Mainstream, Blackstream, and the Black Art Movement

The range of art created by Black Americans extends from the crude storefront exhibitions in Harlem to the elegant productions of the expatriate living in Paris. There are almost as many attitudes about the nature of Black art as there are artists who are Black. After a series of interviews with Black artists, Barbara Rose concluded that their work was reminiscent of pre-World War II American art—"Social protest, illustration, deliberate or unconscious primitivism, work derivative of established artists." She continued:

Like the precisionists, realists and American-scene painters who tried to find dignity in native American themes and authenticity in native American forms, many contemporary black artists are attempting to reclaim their own heretofore repressed cultural heritage.[28]

The artists who are currently exhibiting in all-Black shows can be classified into three groups: those who work in the generally recognizable contemporary styles but whose skins happen to be Black; those who derive their inspiration from the Black protest movement, the Black experience in America, or the motifs, symbols, and color of Africa yet work within an established tradition; and the Black nationalists who choose to create a Black art movement linked to Black separatist politics.

The social, political, and economic conditions of the United States gave birth to the third group of artists, young Blacks who disdain the white art Establishment and Western art traditions, and who seek to communicate with their brothers and sisters in the ghetto.[29] Unlike the middle-class Black artist who adheres to the mainstream of American art, this new breed, having scorned the traditional art school training, identifies completely with the ghetto resident, and his major concern is not aesthetic but political—to

249. KASIMIR MALEVITCH. *Suprematist Composition (Airplane Flying)*. 1914. Oil on canvas, 22⅛ × 19′. Museum of Modern Art, New York (purchase).

inspire "Black unity, Black dignity and respect." His paintings often seem crude, obvious, and primitive—but this effect is deliberate, for the artists believe that in this way they are speaking directly to the people.[30]

Since the work produced by the adherents of the Black nationalist position shares certain common characteristics, Edmund Gaither claims that it fits an art historical category—Black Art. Black Art and Black artists—as opposed to those artists whose skins happen to be Black—are committed to:

1. Use the past and its heroes to inspire heroic and revolutionary ideals.
2. Use recent political and social events to teach recognition, control, and extermination of the "enemy."
3. To project the future which the nation can anticipate after the struggle is won.[31]

Artists dedicated to the Black Art Movement eschew the solitude of the artist, his indifference to public reactions, and his isolation from the community. The Black Art Movement artist is offered a "new sense of identity based on a new sense of solidarity with a community—his own." He is aware of and concerned with his community's needs and problems; he becomes involved with his history and his people's destruction by white society, and he makes a commitment to rebuild his community and resurrect the Black's "manhood." The primary responsibility of the Black Art Movement artist is to liberate Black people from the power of whites.[32]

The Afro-American artist who chooses to work outside the Black Art Movement receives little sympathy from exponents of the new aesthetic. Etheridge Knight wrote on Black aesthetics in the *Negro Digest*:

1. Unless the Black Artist establishes a "Black aesthetic" he will have no future at all. To accept the white aesthetic is to accept and validate a society that will not allow him to live.
2. . . . the Black Artist who directs his work toward a white audience is guilty of aiding and abetting the enemy . . . [like] a worker in a foundry that forges his own chain.
3. The Black Artist has a duty . . . [to] make his heart beat with the same rhythm as the hearts of the Black people. He must listen to the drums, and then tell the people the message that they themselves have sent; that he and they are one, and that we got to get on with the get on.[33]

Henri Ghent is critical of several aspects of the Black Art Movement: a policy of reverse racism; the

abandonment of classic aesthetic criteria; and the preoccupation with what the artists have to say rather than how well they say it.[34]

There is a potential danger in the Black Art Movement. The politicization of art to glorify a people often leads to a society with no art at all. After the Bolshevik Revolution, radical abstractionists like Kasimir Malevich (Fig. 249) and El Lissitsky attempted to promote their style as the official art of a radical political system. The confluence was short-lived, however, and the political dictators replaced abstraction with a "Socialist Realism" (Fig. 250) that glorified the worker and the state. The political message thus became more important than the aesthetic one. A similar disaster occurred in Nazi Germany when all forms of modernism were declared decadent, and artists who did not conform to the official aesthetic—the glorification of the Aryan ideal—were banished from the country or sent to concentration camps.[35]

In the hands of a few deft practitioners—Francisco Goya in 19th-century Spain, Honoré Daumier in 19th-

250. D. NALBANDYAN, S. Ordzhonikidze and L. Beria at the Baku Oil Fields. c. 1939. Shown at "The Industry of Socialism," the All-Union art exhibition in Moscow.

century France (Fig. 251), George Caleb Bingham in 19th-century America (although some of his paintings tend to overdo the political message), and Picasso in his protest against the bombing of Guernica during the Spanish Civil War (Fig. 140)—the merger of art and politics has produced great art. These artists were not necessarily castigating a particular event. Rather, a more general crisis, a more universal message was communicated: man's inhumanity to man or the ridiculousness of the human condition. The subject matter for the painting may have been politically motivated, but the method of communication conformed to prevailing aesthetic standards.

In each society art exists on many levels. There is the folk art that springs from the people for use by the people. There is a popular art for the masses, created by those who hope to educate, manipulate, or control the tastes and thinking of the masses; posters, magazine and calender art, and popular music belong in this category. And there is "fine art," the product of education and leisure, which is not usually appreciated by the general public until its effects have been absorbed by the popular culture. The Black Art Movement, a

251. HONORÉ DAUMIER. Council of War. 1872. Lithograph, 10 × 8¾". Metropolitan Museum of Art, New York (Shiff Fund, 1922).

politically motivated art form, belongs in the second group. Art as propaganda, art to create national heroes, art to glorify historical events, art to dignify a people, art to interpret mass experience to the masses, art that ignores the traditions of Western aesthetics—all these can be classed as popular art.[36] Such art certainly has a right to exist, and moreover it should not be forgotten that there is ample precedent for a situation in which popular art—wholly or partially, altered or in its original form—has been absorbed into "high art."

For the Black who wants to communicate the Black experience through universally accepted aesthetic standards—or in avant-garde techniques—there exists the model of Picasso's *Guernica* (Fig. 140). Many Black artists have accepted the challenge, returning to figurative or abstract work that is inspired by the forms and shapes of African art or by the oppressed condition of the Black in America. Among them are Romare Bearden, Benny Andrews, Joe Overstreet, Ben Jones, and Mel Edwards. The balance is delicate, for one's emotional involvement with the Black experience can overwhelm the aesthetic values of art. Sculptors Richard Hunt and Barbara Chase-Riboud circumvent the problem in two different ways. Hunt (Figs. 283–291) separates art and politics, claiming that his Blackness is irrelevant to his art, but not to his life; Chase-Riboud (Pl. 32, p. 257; Figs. 319–22) makes a purely aesthetic statement and then dedicates the work to a Black hero.

The young Black creative artist is caught in a turmoil of political activity that distracts him from what should be his unique contribution to the Black experience—an art born of that experience. This, states Cruse, is a waste the Black people cannot afford.[37]

Most of the artists discussed in the following three chapters were unknown before the Black revolution of the 1960s began to focus attention on the Afro-American. Some, of course, were too young for recognition, but others would have remained obscure without the politically motivated Afro-American art exhibits. With few exceptions, they are from middle-class homes, and even those who are not were able to take advantage of the educational opportunities offered in the large urban art centers throughout the country.

For purposes of analysis, the artists are separated into three loosely structured categories: the Black Art Movement, "mainstream" artists, and "Blackstream" artists. It is not the author's intent to pigeonhole the contemporary Black artist into one category or another. Some of the artists discussed may feel uncomfortable in the chapters to which they have been assigned, while others, in maturing and redefining their goals, have discarded one philosophical viewpoint for a new one. The three groups were designed for the reader's convenience. They emphasize the variety of attitudes expressed by the Black artist today.

Although they are politically engaged, most of the artists identifying with the Black Art Movement reveal the sophistication of their training and are far removed from the "storefront" primitivism espoused by the movement leaders. A small but vocal segment align themselves with the political separatists who currently oppose school integration, for they believe they are on the threshold of a new art movement, a new aesthetic that negates the traditions of Western "racist" art. Only time will give credence to their point of view. The mainstream group includes those artists whose style conforms to accepted international art trends. Their reaction to the complexities of society becomes an aesthetic statement, and their work is, for the most part, nonobjective. The third classification embraces the artists who are responding, both emotionally and intellectually, to the political turmoil of which they are a part with a political statement painted in the styles and techniques of contemporary art. Their work tends to be figurative and, except for the skin pigment of the figures, differs little from the work of white artists who deal with the traumas of modern living. Also included in the third category are the "neo-African" artists, such as Joe Overstreet and Ben Jones (Pl. 30, p. 255; Figs. 316, 317; Pl. 34, p. 275; Figs. 329, 330), who reinterpret African symbols, totems, and colors in their work.

The art is as varied as the artists who have produced it. The Black community is not a monolith that responds to the dictates of a single charismatic leader, and the Black art community does not follow a single aesthetic philosophy. Each artist paints in a personal way, and each point of view is valid. On the whole, the artists discussed in Chapters 8 through 10 represent the kind and variety of work being done, but they may not necessarily be the best practitioners. Only time and distance will validate the selection of one artist over another. The length of each biography is not related to the quality of the artist's work. Each artist was given the opportunity to communicate his thoughts about art and about being Black in America. Those who are liberally quoted share many of the ideas and ideals of their colleagues. They reflect the spirit of the Afro-American artist in the United States of the seventies.

The Black Art Movement

For the Black Art Movement artist there is no separation between art and the oppressive conditions of society. Art is meant to be removed from the museums and displayed on tenement and playground walls, in schools and recreational centers, in storefront galleries, and on corner lots. Much of the work is collective, and therefore the personality of the artist is of secondary importance to the message or content. The paintings are deliberately naïve, the forms simple and bold, and there is little subtlety in color relationships. Many Black Art Movement murals have been painted by neighborhood children or young adults as storefront art center projects; others have been executed by college students under the direction of an artist-in-residence. Frequently, the murals are designed to teach the young about Black heroes who have contributed to the growth of America. In institutions attended by Black children, the murals thus become history lessons, the Black leaders men and women to be emulated.

The American flag is a recurrent theme in the paintings of many Black Art Movement artists. In this respect and many others, their work resembles that of the Pop (or popular) artists of the fifties and sixties (Fig. 252). Pop Art attempted to blur the division between "fine art" and the messages communicated by the mass media. The images are large and bold, and there is some suggestion, at least in spirit, of the naïve painting practiced by early American limners. Pop embraced the objects constituting the most public, commonplace facts of modern life and used them in such a way as to criticize that style of life. There is one great difference, however, between Pop Art and

Plate 21. *The Wall of Dignity*, Detroit, Mich.

Plate 22. FAITH RINGGOLD. *Flag for the Moon: Die Nigger.* 1969. Oil on canvas, 3′ x 4′2″. Courtesy the artist.

left: 252. JASPER JOHNS. *Flag.* 1954.
Encaustic and collage on canvas, 3′ 5¼″ × 5′ 3¾″.
Collection Philip Johnson, New Canaan, Conn.

below: 253. DANA CHANDLER and GARY RICKSON.
Mural at Massachusetts
and Columbus Avenues, Boston.
1968 (destroyed). Acrylic and gesso.

Black Art. While the Pop artists tended to objectify their images, stripping them of their original associations, the Black Art Movement artists are deeply committed to the images and forms in their work.

Black Power Murals

A series of Black Power murals, some painted in conjunction with the interracial Art Now Workshop, confront the casual passerby in Boston's inner city. In Boston's Orchard Park the wall of a handball court is dedicated to the Black's contributions to dance, theater, and music. Another Boston mural (Fig. 253), created by Dana Chandler and Gary Rickson, was conceived, according to Rickson, as an "out-door museum of functional art." (The geometric upper half, with a white figure, its neck in a rope, belongs to Rickson; the lower section—featuring Stokely Carmichael, SNCC, and graffiti—is Chandler's.) Intended partly as a protest against the lack of representation for Black artists in Boston museums, the mural provides a colorful backdrop for a playground used by neighborhood children.[1]

In Detroit the side of a building fronting a vacant lot has become the *Wall of Dignity* (Pl. 21, p. 199). It is painted in three horizontal panels: the top describes the history of the Black people from ancient Egypt to the Kingdom of Benin, the center is dedicated to contemporary heroes, and the lower panel presents a group of angry Black faces that glare accusingly.

At 43rd Street and Langley Avenue in Chicago, rising two stories above the ground, is the *Wall of Respect* (Fig. 254). Painted by Eugene Wade, Bill

Walker, Jeff Donaldson, and other members of the Organization of Black American Culture—a group that includes writers and community workers as well as artists—the mural depicts Black heroes who "incurred both the plaudits and scorn of the world of whiteness, but who, in their relation to black people, could by

no account be considered other than images of dignity." Mohammed Ali, the boxer, stands victorious in the center of a bay window; Malcolm X and Marcus Garvey are there, as are W. E. B. DuBois, Charlie "Bird" Parker, Nina Simone, LeRoi Jones, Stokely Carmichael, Sarah Vaughan, Thelonious Monk,

left: 254. EUGENE WADE, BILL WALKER, JEFF DONALDSON, et al. *Wall of Respect.* Chicago. c. 1967.

below: 255. *Black Music.* Mural painted by students at Knoxville College, Tennessee. 1971. Acrylic on masonite, 8 × 12'.

We must develop our standards concerning Black art and move away from past identification with, and adherence to, castrating white standards. Black art is a tremendous force for education and political development which we have ignored.[5]

Chandler considers himself a political reporter in terms of art. "I'm not trying to be aesthetically pleasing. I'm trying to be relevant." Working in a style he describes as "Black Expressionism," Chandler favors vivid, raw colors. The planes are flat, and Chandler surrounds his shapes with a hard, unbroken line—a device often used by the Pop artist.

Fred Hampton's Door (Fig. 256), an acrylic on panel, memorializes the slain Black Panther chief, vic-

256. DANA CHANDLER, JR., with *Fred Hampton's Door*. 1970. Acrylic on board, real bullet holes; 26 × 22". Collection the artist.

Gwendolyn Brooks, Wilt Chamberlain, John Oliver Killens, Max Roach, Ornette Coleman, and H. Rap Brown. In one corner Blacks and whites confront each other on a blood-red background; elsewhere a Klansman stands by as mounted police harass a Black man. A statement issued by the sponsoring group of artists revealed their goals:

Because the Black Artist and the creative portrayal of the Black Experience have been consciously excluded from the total spectrum of American arts, we want to provide a new context for the Black Artist in which he can work out problems and pursue his aims unhampered and uninhibited by the prejudices and dictates of the "mainstream."[2]

All the murals are boldly painted in primary colors. They are anti-art establishment, anti-museum, and part of the Black Art Movement's efforts to strip art of its preciousness and to "create a Black museum in the inner city."[3] In essence, these artists are saying to the people in the ghetto, "Our art is yours, you are us, and we are you."[4]

A mural painted by a group of students at Knoxville College in Tennessee could be considered another facet of the Black Art Movement desire to encourage Blacks to paint their feelings and interests. Created by students with little or no art training (the Interim project was open to all) and supervised by Dana Chandler (Fig. 256), *Black Music* (Fig. 255) commands the affection of the Knoxville students, for they identify with the subject matter and know the artists personally. The mural illustrates the contemporary Black music scene, with images taken from record album covers. Isaac Hayes dominates the left side of the painting, while Donny Hathaway, Roberta Flack, Aretha Franklin, the Poets, the Jackson Five, Sammy Davis, Jr., Ike and Tina Turner, the Supremes—all performers admired by young Black students—are shown at work. With *Black Leaders*, a companion piece, *Black Music* hangs in the cafeteria of the Martin Luther King Towers on the Knoxville campus.

Dana Chandler (b. 1941)

As an artist committed to the Black Arts Movement, Dana Chandler has written:

...I am a Black artist whose work is directed expressly toward the education of Blacks as to their true position of oppression in a White Racist Society, and to the development of a new third world concept in Black art.

tim of a Chicago police raid on Panther headquarters. The painting is a vivid red, Hampton's name is deliberately misspelled,[6] and the bullet holes are real. Other Chandler paintings are titled *Bobby Seale, Prisoner of War* and *Martin Luther King, Jr., Assassinated.*

Chandler was born in Lynn, Massachusetts, and grew up in the Roxbury ghetto section of Boston. A 1967 graduate of the Massachusetts College of Art, he has had one-man shows at Boston College and the Rhode Island School of Design, and has participated in many of the current Afro-American art exhibits.

Chandler's earliest paintings were abstract. However, when he saw friends who were active in the Black political movement "beat up and brutalized," he felt that his past work had been irrelevant, his art training just one more assimilationist trick perpetrated by the white world to make Black people think white.[7]

Billed as a Pan-African revolutionary artist, Chandler has lectured widely on college campuses throughout the United States. The paintings he shows on the lecture circuit could be described as "pop-porno-graphic-political," with colors and forms that are simplified in order not to confuse the audience. His work is a diatribe against white racist America, not a lesson in Black aesthetics. One canvas shows the silhouettes of two penises—the black one erect, the white one wilted. Another work portrays a pink female nude with yellow hair sprawled, legs apart, on a television screen. In the foreground are the forms of three Black children watching attentively. A third painting, called *Penal Colony* (Fig. 257), features a large erect black penis shackled by chains, while the background suggests the stripes of the American flag and the bars of a prison. Chandler speaks at both predominantly Black and predominantly white institutions. After each lecture, he sells prints of his paintings—for fifty cents each at the Black schools and, so he has announced, at least four times that amount at the white schools. Chandler also urges the students at predominantly Black colleges to purge their faculties of white instructors. The artist himself teaches at Simmons College in Boston.

According to Chandler, the role model for the contemporary Afro-American artist should be the African craftsman, who functions as a "repository of medical and spiritual information for the whole tribe." The figures, masks, bowls, and knives he makes are necessary for the spiritual, physical, and economic survival of the tribe. "He is just as concerned with the aesthetics of an object as any Western artist," claims Chandler, "but his concern goes deeper. How do I make this functional? How do I show reverence for the gods?"

257. DANA CHANDLER, JR. Print after *Penal Colony*, from the *Genocide* series. 1971.

Where in the household does this fit in? Who will wear it? What will it conjure up?"[8]

David Hammons (b. 1943)

David Hammons was the youngest of twelve children whose mother was on welfare. He found his home town of Springfield, Illinois—the birthplace of Abraham Lincoln—both dull and confining, and at the age of twenty he left for California. Hammons studied at Los Angeles City College and for two years at the Los Angeles Trade Technical College. He also worked briefly as a graphic artist in an advertising agency. His evenings and weekends were spent at the Otis Art Institute, where he discovered Charles White (Figs. 215-222), the only artist "that I really related to because he is black and I am black." Although Hammons was familiar with White's work, the experience of being in the older artist's drawing class had a profound effect:

I never knew there were "black" painters, or artists, or anything until I found out about him.... There's no way I could have got the information in my art history classes. It's like I just found out a couple of years ago about Negro cowboys, and I was shocked about that.[9]

Hammons claims that his work is not politically motivated. To him, message painting is "aesthetically restrictive." However, since he is a political being influenced by contemporary events, his prints often have political or social content. In a 1970 interview, the artist commented:

I feel that my art relates to my total environment—my being a black, political and social human being. Although I am involved with communicating with others, I believe that my art itself is really my statement. For me it has to be.[10]

Hammons' body prints are individual works of art, often combining the artist's unique body-printing process with silk-screen printing. He first places a smooth illustration board on either the wall or the floor, depending upon how intense he wants the print to be. (Body prints made on the floor are darker.) Next, Hammons coats himself all over with margarine—hair, body, and clothing, with the fabrics chosen for textural interest. Thus primed, the artist, without benefit of a preliminary sketch, presses himself against the surface to be printed. Separating himself from the board is always a problem, and Hammons often lies on the floor for several minutes designing the logistics of a smudge-less departure. He then sifts fine powdered pigments all over the board, so that the areas covered with margarine absorb the color, while the uncoated portions acquire a slight film of the same hue. Finally, additional forms are screen-printed in.

Hammons' prints show a preoccupation with the American flag. In *Pray for America* (Fig. 258) an elderly

258. DAVID HAMMONS. *Pray for America.* 1969. Silk screen and body print, 6′ 8″ × 3′4″. Brockman Gallery, Los Angeles.

259. David Hammons. *Injustice Case*, 1970. Mixed media body print, 5′3″ × 3′4½″. Los Angeles County Museum of Art (Museum Purchase Fund).

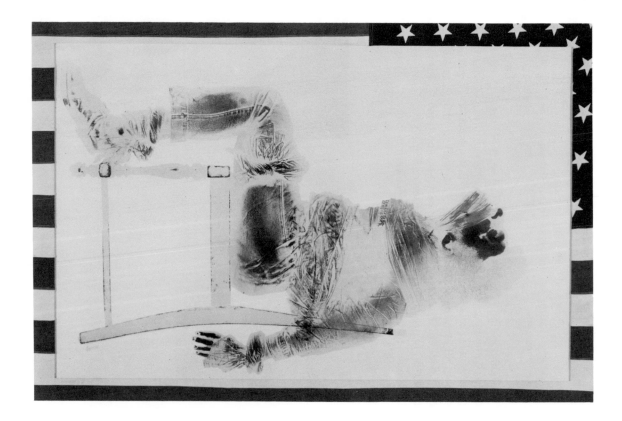

Black wrapped in an American flag is praying—perhaps for the future of America. In *America the Beautiful* a bodyprint is draped in an American flag shawl. *Injustice Case* (Fig. 259), a comment on the Black's treatment by the American judicial system, features a Black man strapped to a chair, straining to be free. He is framed by an American flag. The artist has spoken of his apparent obsession: "I don't know whether it's the black skin against the bright colors or the irony of the black flag being held by an oppressed people. I do use the flag for some kind of shock value."[11]

Cliff Joseph (b. 1922)

A founder, along with Benny Andrews (Figs. 310–313), of the Black Emergency Cultural Coalition, Cliff Joseph has written: "The Power of Art belongs to the People." To Joseph, the people mean Black people imprisoned in America, whether in the slums of Harlem, in the back wards of mental hospitals, or behind the high walls of "correctional institutions."

A graduate of Pratt Institute and of the Turtle Bay School of Therapy, Joseph is currently employed as an

instructor and clinical supervisor in a program for training art therapists at Pratt. As Senior Art Therapist at Lincoln Hospital in the Bronx, which is staffed and filled primarily by Blacks and Puerto Ricans, Joseph directs his teachings to the use of "art as an agent for the encouragement of community development, self-determination and social change." His lectures and demonstrations are designed to convey an "understanding of group dynamics, the nature of human interaction, the art productions of psychopathology, symbolism and the utilization of media specific to given disturbances." He encourages his audiences to participate in the creation of group murals, so that, by actually experiencing art, they can realize its therapeutic values.

During the 1971 disturbances at Attica Prison in upstate New York, an institution housing a large proportion of urban Blacks, Joseph and Benny Andrews, as co-chairmen of the Black Emergency Cultural Coalition, wrote to Governor Nelson Rockefeller offering their services as responsible citizens who also happened to be Black and artists. Among the prisoners' demands was a program of social and cultural rele-

vance, one that would aid in the development of creative social skills. To this end, the co-chairmen proposed a program that would:

Provide for the motivation and education of those prison inmates with proven and potential talent in Art.

Provide a program of Art appreciation through continuous exhibitions of the works of professional Artists and through lectures, slides and seminars held within the prison walls.

Encourage and provide for the exhibition of works of outstanding prison Artists in galleries, museums and centers outside the prison walls.

In addition to his work in hospitals and his interest in prison reform, Joseph acts as a consultant to community-service agencies and has worked with ghetto youths during summers, always trying to communicate to his charges through art. However, Joseph does not verbalize about his paintings, for he prefers that each viewer interpret the work for himself. *Blackboard* (Fig. 260), an oil shown at the "Afro-American Artists: New

260. Cliff Joseph. *Blackboard*. 1969. Oil on canvas, 26 × 36". Courtesy the artist.

The Black Art Movement **207**

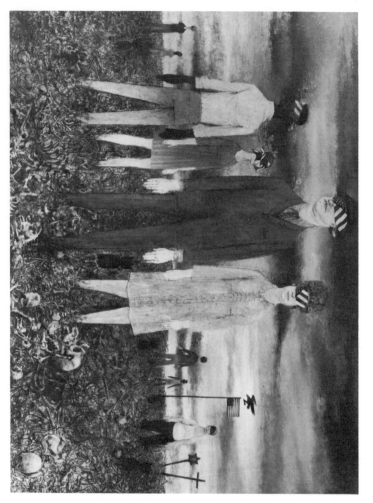

261. CLIFF JOSEPH. *My Country Right or Wrong*. 1968.
Oil on masonite, 32 × 48″. Courtesy the artist.

262. FAITH RINGGOLD. *The Flag Is Bleeding*. 1967.
Oil on canvas, 6 × 8′. Courtesy the artist.

"York and Boston" exhibit, is Joseph's conception of what the American schools should be, as opposed to what they actually are, for the Black child. A gentle and lovely Black woman stands behind a Black child, and the alphabet of the Black Revolution is scrawled on the blackboard: A is for Ashanti, D for DuBois, G for Ghana, N for Nat Turner, Q for Quality education, X for Malcolm X, P means Power to the People. Another work, My Country Right or Wrong (Fig. 261), shows a group of people, Black and white, on a desolate field, with skulls strewn about and American flags flying upside down. The people are blindfolded, and the American flag is their blinder.[12]

Faith Ringgold (b. 1934)

The American flag is a recurring theme in the canvases of many artists who use their art for political comment. According to Faith Ringgold, a native of New York City with a Master of Fine Arts degree from City College, "The flag is the only truly subversive and revolutionary abstraction one can paint." Ringgold is a member of the "Judson Three," a group of artists found guilty of desecrating the American flag on their canvases at the People's Flag Show in Judson Memorial Church, November 1970.[13]

Ringgold was born in Harlem. Her parents, natives of Jacksonville, Florida, were ambitious for their children and insisted they get a good education. Consequently, they were always "carted off" to the best schools in the area. The artist's father was employed by the New York sanitation department, and her mother, who had always designed and made the family's clothing, now works as a fashion designer. Ringgold took her undergraduate and graduate degrees at the City College of New York, where she studied with Robert Gwathmey and Yasuo Kuniyoshi. She began her teaching career at a junior high school in Harlem, but it was a difficult assignment and after a year she decided to seek employment at a senior high school. This was another matter, for New York high schools were not receptive to Black applicants in the early fifties. She was on the verge of filing a discrimination suit against the New York City school system, when she was hired by Max Greenberg, chairman of the art department at John Jay High School—"a sensitive and kind and beautiful man."[14]

Ringgold's first one-woman exhibit in 1968 was boldly political: Die focuses on a bloody street riot, with two Black children huddling in each other's arms to protect themselves from a terror they cannot comprehend. The Flag Is Bleeding (Fig. 262) shows a fair-skinned woman arm-in-arm with a knife-wielding Black man and an unarmed white. A bleeding flag forms the background. Continuing in her polemic style, Ringgold, in 1970, exhibited direct, posterlike paintings that were "straight-forward and effective." The flag, with its abstract and political possibilities, continued to absorb her. In Flag for the Moon: Die Nigger (Pl. 22, p. 200), an irregularly striped flag fills the canvas; when the painting is given a half-turn to the right, the stripes spell "NIGGER."[15]

About Black women artists, Ringgold has volunteered:

"Where we at," is where Black art, life and the bloodless revolution is at. . . . If black art is art at all, it must be expressive of some deep and pervasive truth; and for the black artist in America the most pervasive truth, the one with which he must daily contend, is the unmovable reality that he or she is black in America. To deny this reality . . . is to indulge oneself in dangerous, pathological fantasy.[16]

Black women are victims of discrimination on two levels—as Blacks and as women. Shirley Chisholm, the Black Congresswoman from Brooklyn, claims that she has suffered more oppression as a woman than as a Black. When she launched her 1972 campaign for the presidency, most Black male political leaders refused to take her seriously. To see that equity is meted out on every level, Faith Ringgold and several other Black women artists and art students organized Women Students and Artists for Black Liberation. Their goal is to ensure a 50 percent female representation in all future Black art exhibits. Ringgold has donated a large mural portraying the various roles of women in society to the Women's House of Detention in New York.

The artist also writes of another dimension in Black art—black as color, black as light:

Specifically black art must use its own color black to create its light, since that color is the most immediate black truth. Generally, black art must not depend upon lights or light contrasts in order to express its blackness, either in principle or fact.

All "black" artists are aware of this blackness . . . and with more black, black art to attest to it, white artists will also know what blackness and black truth is about. At present . . . black art is really brown.[17]

There is a pervading blackness, a somberness in Ringgold's paintings. Perhaps this is the "light" or the color to which she refers.

Recently, Ringgold has produced a series of "black paintings," which she claims disturb white viewers because she excludes them, she works outside their realm of interest and experience. "I got all the reactions as I painted with black that white people must get in trying to deal directly with us—the fear and uncertainty—the inability to handle details of it with ease . . . because it is hard to see."[18]

Kay Brown

Kay Brown's striking collages were exhibited at the Acts of Art Gallery, the Greenwich Village gallery owned and operated by Nigel Jackson, a painter dedicated to the exhibition and sale of works by Black artists independent of Establishment support. Brown's collages are topical: one is titled *Remember Biafra*. They are also political (Fig. 263); various works have

featured Dick Gregory, the Black comic and raconteur; Medgar Evers, the Mayor of a small Mississippi town; and LeRoi Jones (Imamu Amiri Baraka), the poet, essayist, and Black separatist leader. A radical feminist and contributor to the *Feminist Art Journal*, Brown has written of the Black woman and her special responsibilities:

Black Woman,
Yes, the Wisdom of Waiting
For she knew as she strived
That the New Day would finally arrive
And the burden of her life's storywould
Well worth the eternal glory.
No more time for Pain
Past troubles or all that strain
For the Wanton, wretchedness of life
Has past to emptiness, as her strife
And, yes, the future is no longer
. It is now.[19]

263. Kay Brown. *Take It Now.* 1968–71. Collage, 42 × 32″. Courtesy the artist.

Mainstream Artists

The mainstream artist has responded to the ferment and challenge of American art in the sixties and seventies, when every year seemed to hail a new movement until change became the only constant in the art world. First came Pop Art (Fig. 252) and a return to figuration and identifiable subject matter, which many critics viewed as a reaction to the formlessness of Abstract Expressionism (Fig. 145). Then, following rapidly upon one another, were Op Art, Minimal Art, Kinetic Art, and Conceptual Art. There was a new collaboration between engineers and artists. Some artists strove for the precise, sharply delineated "hard-edge" line in their work, while others simply poured their paint—often common house paint—on unprimed canvases. Molded canvases thrust painting into the three-dimensional world of sculpture, and, again narrowing the line between media, sculptors began painting their

constructions. New materials from our technological society—such as plastics and electronic lighting, joined the traditional paint, canvas, wood, and stone as acceptable materials for the creation of fine art.

The Op artist attempts, by means of fool-the-eye painting techniques, to create a sense of movement where in fact none exists. In some cases the dizzying patterns of identical forms or converging lines make it difficult to stare at the canvas for any length of time (Fig. 264). Minimal Art represents a reductionist tendency, a further development of color-field abstraction, in which the barest essentials—the shape of the canvas, closely related forms, and broad areas of color—are employed to create monumental art (Fig. 265). A Minimal painting may be all one color except for a crucially placed stripe, a Minimal sculpture nothing more than a slab of steel created at a foundry according to

the artist's specifications (Fig. 266). Both Op and Minimal are sometimes "hard-edge" in style, with the forms usually arrived at through the use of tape or mathematical instruments. The painted canvases rarely reveal individual brushstrokes or any other "hand-writing" of the artist.

264. BRIDGET RILEY. *Movement in Squares.* 1962. Tempera. Arts Council of Great Britain, London.

below: 265. FRANK STELLA. *Darabjerd I.* 1967. Fluorescent acrylic on canvas, 10 × 15'. Private collection.

above: 266. TONY SMITH. *Die.* 1962. Steel, 6' cube. Courtesy Fourcade, Droll, Inc., New York.

In contrast to the Op artist, the Kinetic sculptor introduces *actual* movement into his work, by means of motors or air currents. Computers are programmed to control changing patterns of fluorescent lights or oscillating forms, and if the artist himself is not an engineer, he will generally enlist the aid of specialists. The Conceptual artist is concerned more with the *idea* of art than with the art *object*, and his product, therefore, is a description or other record of a past event.

The mainstream Black artist has been touched by the rapid changes in the international art world. Like his white counterpart, he is incorporating the various styles into his visual vocabulary and is trying to find a signature of his own.

Richard Mayhew (b. 1924)

A fine colorist, Richard Mayhew has been described as both a landscape painter and an Abstract Expressionist. The confusion is understandable, since he is both. Many of Mayhew's most recent paintings, such as *Birth* (Fig. 267) or *The Gorge* (Pl. 23, p. 217), at first appear to be nothing more than pure lyrical color occupying a kind of fluid space, but on further study, one begins to see a panoramic yet poetic landscape with suggestions of water, sky, and scrub, the earthy colors merging with purples. The artist's approach to landscape may be 19th century, but his handling of paint and space is contemporary. In *Time and Space* (Fig. 268),

267. RICHARD MAYHEW. *Birth*. 1968. Oil on canvas, 40″ square. Courtesy Midtown Galleries, New York.

an oil displayed at UCLA's "The Negro in American Art" exhibition, a vertical shape on the left interrupts the horizontals of the landscape. It presents an ambiguous shape—is it a mushroom cloud or a tree?

Born in Amityville, Long Island, Mayhew is a product of the close collaboration between two oppressed groups before the Civil War. Escaped slaves traveled to Long Island, a stop on the Underground Railroad, and they were aided by the Indians. Mayhew's mother, who came from Georgia, was part Blackfoot; his father part Mohawk. The artist takes great pride in his dual heritage and feels the kinship between African art and that of the American Indians. His attachment to the land may derive from his Indian heritage, his identification with jazz and the Blues from the African-American strain.

Mayhew was a jazz singer and an actor during the 1940s, performing with small theater groups and with the Henry Street Playhouse in New York. Today he travels with a jazz group and shows slides of the art produced by Black Americans—a kind of multimedia presentation. He has been painting the Blues for years, so that his work has come to resemble that special form of music—sweet and sour, warm and cool, sad and happy, near and far. His paintings also have a close affinity with nature, for the symbolism is based on natural phenomena and the honesty of the land.[1]

The artist's earliest landscapes were related to the Barbizon school of painting (Fig. 58); his seascapes of the period had a quality reminiscent of Winslow Homer's work. They are saved from becoming banal by Mayhew's "sensitive eye and a love for nature." In 1957 his landscapes were described as having "a definite structure, a defined color, a developed texture and a consequent validity of expression, often about the unadorned, random American woodland." There is a sense of place in these early landscapes, a solidity of form, and an interest in textural relationships—a concern for "stippling the foliage of a single tree against a pale sky." Such works reveal Mayhew to be in the ascetic, somber, 19th-century American tradition of landscape painting. When he was selected as a newcomer for the 1962 Whitney Annual, Lawrence Campbell wrote that it took the "right kind of nerve" to include what he described as Mayhew's "spinach-tinged landscapes."[2]

A recipient of many grants and awards, Richard Mayhew has developed into "one of the best landscape painters around." Once a student at the Brooklyn Museum Art School, Mayhew is now teaching at the Art

below: 268. RICHARD MAYHEW. *Time and Space.* 1965. Oil on canvas, 3′ 2″ × 4′ 2″.
Courtesy Midtown Galleries, New York.

269. ROBERT REID. *Agon II.*
1964-65. Oil with collage
on canvas, 39½ × 41″.
Syracuse University Art
Collection, N.Y.

Students League and at Hunter College.[3] At Hunter he is part of a group who are attempting to develop a "cross disciplinary" approach to art that would "encompass a series of involvements, demonstrations and lectures of various media—music, dance, art, acting, film, photography and the humanities, stimulating eye, mind and body coordination through the study of optics in relationship to sound and gesture."[4] On the community level, Mayhew is helping to set up integrated art centers in the small towns and villages in New York's Rockland County, where he now lives. Local merchants, banks, and the Rockland Foundation join in financing the operation. Through teaching, performing, and exhibiting, the artist hopes to develop a new sensibility, a new aesthetic awareness among the residents of Rockland County.

According to Mayhew, the ultimate effect of Spiral (see p. 154) was that it encouraged the Black artist to "not deny his true feelings." Mayhew finds that young painters whose work is militant and political eventually get caught up in the profundities of "art." Com-

plete involvement with the medium fosters involvement in a new culture—the culture of art—and this in turn develops a self-realization and a new sensation of life. The act of doing becomes an aesthetic experience.

Robert Reid (b. 1924)

Robert Reid, a native of Atlanta, Georgia, arrived at the Parsons School of Design in 1948, after three years of study at Clark College in Atlanta and another three at the Art Institute of Chicago. He remained at the Parsons School for three years. Reid's first one-man show at the Grand Central Moderns in 1965 featured paintings that tended "toward poetic imagery, projecting forms and symbols that have little to do with nature."[5] His brushwork was playful, and he introduced the use of collage. The cryptic letters and numbers in his landscapes are canvas shapes cut and pasted on vast areas of thinly brushed canvas. Some of his paintings—such as *Agon II* (Fig. 269), an oil and collage exhibited at the First World Festival of Negro

Arts in Dakar, Senegal—are heavily textured with medallions or medals of war, also canvas cutouts.

Reid's latest series of oils, exemplified by *Figures on the Beach* (Fig. 270), reveals him to be a "subtle and deeply poetic iconographer."[6] His expanses of dune and beach and sea, peopled by numbers and letters, are invaded by flimsy beach houses, sensitively placed to control the immense areas of nothingness. Some of the beach houses come close to falling off the picture plane, as in *Big House with Falling 2* (Fig. 271). In *Figures on the Beach* the house is secured within a rectangle in the lower half of the canvas, while the figures or numbers are clustered at the center of the canvas along a horizontal stripe that separates beach from sky. Reid's colors are the blue-grays, grays, and muted sand tones characteristic of an overcast day at the beach.

Now a teacher at the Rhode Island School of Design, Robert Reid is also represented by the Alonzo Gallery in New York.

left: 270. ROBERT REID, *Figures on the Beach.* 1970. Oil with collage on canvas, 5′ 5″ × 4′ 2″. Courtesy Alonzo Gallery, New York.

below: 271. ROBERT REID, *Big House with Falling 2.* 1969. Oil with collage on canvas, 5′ × 3′ 4″. Courtesy Alonzo Gallery, New York.

Norma Morgan (b. 1928)

Norma Morgan inherits her inventive approach to life from her mother, a dressmaker-designer who has created fashions for the fashionable in the New York area for more than twenty years. Morgan has a cosmopolitan outlook—she has divided her time between the United States and Great Britain for the last ten years. One of her desires as an artist is to cause Europeans to become more aware of the creative side of American life. "They still think of us as a frontier-thinking people without much time for the cultural side of life . . . too busy paying taxes."

Plate 23. RICHARD MAYHEW. *The Gorge.* 1966.
Oil on canvas, 5' x 4'4". Collection Sidmore Parnes, New York.

opposite: Plate 24. Sam Gilliam. *Mazda.* 1970. Acrylic on canvas, 12'1" x 9'7".
Courtesy Jefferson Place Gallery, Washington, D.C.

below: Plate 25. Alvin Loving. *WYN II.* 1971–72. Mixed media, height 16'.
Courtesy William Zierler Gallery, New York.

Plate 26. Emilio Cruz. *Brown or Drown in Secret Blue.* 1972. Acrylic on canvas, 7′ square. Courtesy the artist.

272. NORMA MORGAN.
Alf, Man of the Moors.
1964. Engraving, 21¾ × 17¼″.
Courtesy the artist.

Morgan considers herself an artist born in America, not necessarily a Black artist. She is at home on both sides of the Atlantic and finds that in both England and America she is treated the same as anyone else—"on the basis of friendship, interesting outlook on life and a sense of humanity which is not restricted to any territory in particular." According to Morgan the role of the American artist of African descent is a matter of individual choice. If an artist believes he can serve the cause of American art through a "black-oriented" approach, this is his personal decision. Morgan occasionally uses a Black figure in her paintings and etchings—a 1954 oil portrayed a life-size Black couple fighting—but most of her work shows the brooding, remote terrain of the Scottish moors, the landscapes of northern England, or the demons and prophets of the Bible. She

is known for her intricate, meticulous, "magic-realist" etchings and copper engravings (Fig. 272), techniques she perfected at Stanley William Hayter's print workshop in Paris, Atelier 17. In her pursuit of the unusual, Morgan became fascinated with the Scottish moors. She has written:

A world of fantasy awaits any painter who longs to explore hidden subjects that do not meet the eye at first glance. With each visit to this unique world of the moors, for example, unusual forms are revealed. I am especially attracted by erosion and objects affected by it. I feel also that individuals strongly influenced by life which has worn itself into their character make the best subjects to portray on canvas. Erosion seems to me to be another dimension of the visual scene. Old buildings, hills and the like all yield a good source of exploration.[7]

Born in New Haven, Connecticut, Norma Morgan won her first art award for a self-portrait she entered in the New England division of the National Scholastic High School Art competition. She later attended the Hans Hofmann School of Fine Arts and the Art Students League, in both cases on scholarships. In 1954 she had her first one-woman show of oils and etchings in New York. Her subject matter was frightening, according to one report. "She seems possessed by some

273. NORMA MORGAN. *David in the Wilderness*. 1955–56. Engraving, 34⅛ × 17½". Museum of Modern Art, New York (Abby Aldrich Rockefeller Fund).

idea which makes her paint violently and oddly,"[8] Morgan received a John Hay Whitney Fellowship and a Lewis Comfort Tiffany grant in 1954. Her work is included in the permanent collections of museums in Washington, New York, England, and Scotland, as well as in many prestigious private collections. *A Cave Interior*, an engraving of 1967, was included in the Whitney exhibit of contemporary Black artists. It is dark, foreboding, melodramatic, and technically exquisite. Another engraving, *David in the Wilderness* (Fig. 273), is owned by the Museum of Modern Art.

Tom Lloyd (b. 1929)

"Art," claims Tom Lloyd, "should be interconnected with political and social action." Accordingly, Lloyd has urged his fellow artists to become involved in community art groups, dance workshops, storefront theaters, social action agencies, mental health centers, and drug addiction clinics. Although he had previously taught at Sarah Lawrence College and at Cooper Union, Lloyd has now disassociated himself from white Establishment institutions, in order to direct community art programs in South Jamaica, New York. A militant spokesman for the Black Art Movement, Lloyd edited *Black Art Notes*, a pamphlet printed to rebut the introductory essay in the catalogue of the "Contemporary Black Artists" exhibit at the Whitney. The pamphlet, according to Lloyd, became more than a counterstatement; it evolved into the philosophy of the Black Art Movement. Lloyd wrote:

Black art stems from Black culture; and Black culture, in spite of all the imposition of Western culture, cannot but depart from an African source and cannot but proceed along on its own line of development. A development which, in the last centuries, has been warped and mutilated but which is now seeking to shake off the trammels of oppression and to achieve its own natural peak of progression. Inherent in such development are conflicts and complexities which can be understood and analyzed only by the people involved in the struggle for itself—here the struggle for a *POSITIVE, SELF-AF-FIRMING BLACKNESS*.[9]

When viewing Lloyd's work, one becomes aware of the conflict between his aesthetic philosophy and his art. His sculpture is highly intellectual, abstract, and seemingly incapable of making a social or political statement. In his first one-man exhibit, in which he showed programmed light sculpture called "Electric Refractions" (Figs. 274, 275), he was assisted by an

of Modern Art. In addition, he was one of the four artists chosen to represent the United States at the 36th Venice Biennale. He currently teaches at the Maryland Institute of Art.

Concerned with color more as pigment than as skin tone, Gilliam, in his canvases, is searching for new methods of expression. This attitude has not endeared him to the Black militants, one of whom commented: "In what sense he calls himself black, I don't know." Gilliam remains aware of his blackness and tolerant of the militant artist. "I feel there is definitely a case for a black esthetic in terms of the present social context, considering the inability of so many blacks to rise within their occupations," wrote Gilliam. "There has to be some way to protest the lack of black curators, the tensions. To make it, at present, is still to make it in terms of being the best black painter."

Those militant black artists sacrifice in terms of giving up their chance to get into the market. This is a noble thing. It keeps the spirit of the people up. There's a sense of taking care of themselves and not waiting until the spirit moves the majority to give them a chance.

But I'm separated by a generation. One looks at my art in terms of a different esthetic. Underneath, what's important to me is to do what I want to do. The more you live, the more art and life, esthetics and politics

above: 277. SAM GILLIAM. *Watercolor 4.* 1969. Watercolor and aluminum powder on fiber-glass paper, $23\frac{7}{8} \times 18\frac{1}{8}''$. Museum of Modern Art, New York.

left: 278. SAM GILLIAM. *Herald.* 1965. Acrylic on canvas, 6' square. Collection Mr. James Younger, Washington, D.C.

tend to merge. You're less concerned with success and more concerned with the quality of your existence as an artist, how things look outside your own window.

You feel less afraid when someone says, "I can't believe these paintings express your blackness." [13]

Christopher Shelton (b. 1933)

Christopher Shelton's *Air Afrique II* (1971) occupied the central gallery of the Newark Museum during the "Black Artists: Two Generations" exhibit. It is 20 feet long by 8 feet high and composed of wood, canvas, paint, and steel. Starkly painted black and white forms jut out into space, as though ready to soar. *Air Afrique III* (Fig. 279), set in the rotunda of the Rutgers University gallery, is more than twice as big. All Shelton's pieces are called *Air Afrique*, reflecting his mixed heritage and his interest in capturing the grace of flight. The sculptural form and the spatial environment seem to be perfectly wedded, and this is no accident, since the artist constructs each piece in the area where he intends it to be displayed.

Shelton was born in New Orleans and spent his early years in St. Louis, Missouri. He attended Bradley

279. CHRISTOPHER SHELTON. *Air Afrique III.* 1971. Canvas, wood, paint, steel; 17 × 40'. Constructed for the "3 Sculptors" exhibition at Rutgers University. Courtesy the artist.

University in Peoria, Illinois, and received his degree in Fine Arts from the University of Iowa. A resident of New York for the last ten years, he has traveled extensively throughout Europe. Originally a painter, Shelton was associated with the Sidney Janis Gallery during the 1960s, when Janis was featuring Abstract Expressionism, Pop Art, and Op Art, all in rapid succession. During the late sixties and early seventies he experimented with "multi-dimensional" sculpture, combining painting with space in order to develop a personal imagery.

The artist has written eloquently about the role, heritage, and responsibility of the Black artist in the 1970s:

Black art, long dismissed as polemic social realism, has finally come into its own. The tumultuous sixties ushered in a social upheaval whose shock waves forecast a new epoch in American history. The emerging Afro-Americans, infected with new pride in self and therefore in blackness, have reached inside themselves and backward in time to recover their ties with Africa—the fecund mother that has spawned so many step-children; heretofore ashamed of her bountiful blessings. A shameful testament to our debasement is that a Picasso, a Matisse and a Brancusi, recognizing European sterility, had to reclaim and legitimize our rich heritage, thereby rekindling our bludgeoned creative impulse. Thus, the promise of the seventies is that as the black artist recognizes these untapped wellsprings of creative energy that are uniquely his legacy, and seeks to express *himself* through various media, a new vision will unfold. Unfortunately, too many young black artists are being lured by America's sirens—money and instant fame. Thus infected, they are tempted to capitulate. An artist must seek truth and honestly depict it—this is the substance of great art. For, to succumb to the fickle whimsy of markets is to stunt growth and invite decay. The Afro-American artist has a unique contribution to make. His role is therefore to be ever sensitive to himself, to follow where his spirit leads, to paint, to sculpt with integrity.[14]

Marvin Harden (b. 1935)

Marvin Harden was born in Austin, Texas, and from there the family migrated to southern California, where his father found work as a janitor and his mother as a laundry worker and domestic. Harden studied first at Los Angeles City College and then at UCLA, where he received his Bachelor of Fine Arts degree in 1959 and his M.A. in creative painting in 1963.

Harden is essentially a draftsman. His drawings are subtle and delicate, with many grayed areas, the figures

280. MARVIN HARDEN. *Little Boys Are Very Impressionable.* 1967. Pencil on paper, 14 × 13½". Courtesy the artist.

and patterns only slightly delineated. His titles are provocative, and he gives scant indication of their meaning. For example, it is difficult to find the boys in *Little Boys Are Very Impressionable* (Fig. 280). However, the drawings are not without content or meaning, the cryptic titles not simply attached as an afterthought. Each represents an extremely personal statement by the artist. Commenting on *A Fine and Secret Place* (Fig. 281), Harden wrote:

Part of a stone's surface was used as the model for the upper left hand corner of the picture. No specific model or scene was used for any other section of the work. The subject of the picture has special personal and symbolic significance. I often use the tree form as a symbol of myself, as is the case in this instance. The upper left hand corner in particular and the rest of the composition symbolize my innermost thoughts re a particular childhood (and continuing) dream; that of living on a

ranch or farm away from city or town. The composition, as a whole, symbolizes that dream, that place, and in addition "a fine and private place" in my mind.

Harden was the last of three children. When the younger of his two sisters died in an auto accident in 1966, after a short and unfulfilled life—and without having experienced any of the hope and opportunities that have only recently been offered Black people—the artist was left in a complete state of shock. His comment on her death, *What Can One Say About a Life So Suddenly Rushed, Soonly Hushed* (Fig. 282), was completed in 1970. According to the artist, "It took all those years for my feelings between the shock of her death in 1966 to 1970 to culminate into this particular expression." He further described the iconography in the drawing:

The complex border or frame symbolizes the oppressive acts, barriers, machinations, barbarisms, etc. of a cruel, unjust, unthinking and unfeeling society that creates so many private helpless individuals (of whom my sister was one). The cow symbolizes the individuals who have

ceased to be individuals and have opted to be a crowd in their nonthoughts and actions; those with herd instincts dominated by fear, hatred, apathy, who attempt to perpetuate non-change. As I see it, change is inevitable and the herd is pursuing an impossible task.

The way the expression is all put together reflects my internal and peculiar bent toward subtlety and understatement.

Harden's art reflects the sensitivity of the man: He is trying to convey his own nature. He wants his art to mirror his personal philosophy, his personal aesthetic, and his introspection. Concerning the role and responsibility of the Black artist in America today, Harden has commented: "An artist is an artist—he should learn to be himself first."

Harden was one of the eight Afro-American artists chosen by Henri Ghent to exhibit at the Rath Museum in Geneva (a show that also traveled in Western Europe, England, Russia, and West Africa). He was given a one-man exhibit at the Whitney and is represented in the permanent collections of that museum,

281. MARVIN HARDEN. *A Fine and Secret Place.* 1967. Pencil, 30 × 22¾". Museum of Modern Art, New York (Mrs. John D. Rockefeller 3rd Fund).

282. MARVIN HARDEN. *What Can One Say About a Life So Suddenly Rushed, Soonly Hushed.* 1970. Pencil, 30 × 22¼".
Whitney Museum of American Art, New York.

the Museum of Modern Art, and many other museums throughout the United States. Currently, he is an assistant professor of art at the California State University at Northridge.[15]

Richard Hunt (b. 1935)

Of all the young Black artists working today, Richard Hunt is perhaps the most widely applauded and exhibited. *Arachne* (Fig. 283), a welded steel sculpture made from sheet metal and "found objects," was purchased by the Museum of Modern Art when the artist was only twenty and still a student, and *Extending Horizontal Form* (Fig. 284) was acquired by the Whitney two years later. Another piece from this period, *Man on a Vehicular Construction* (Fig. 285), is smaller in scale, in part owing to the high cost of the material needed for such sculpture. In 1963 Hilton Kramer wrote that "Hunt is one of the most gifted and assured artists working in the direct-metal, open-form medium—and I

mean not only in his own country and generation, but anywhere in the world. What may not be so immediately apparent is the speed and aesthetic ease with which he has achieved so remarkable a position."[16]

Working with found objects and junked automobile parts that he welds into intricate compositions, Hunt has become a virtuoso of open-form sculpture, a medium the artist refers to as "drawing in space" (Fig. 286). His welded steel pieces are often reminiscent of insect and plant forms as seen through a microscope (Fig. 287). The forms are menacing, yet elegant, and are perhaps derived from the artist's six-year employment with the zoological experimental laboratory at the University of Chicago. In much of his work, Hunt is attempting to "develop the kind of forms nature might create if only heat and steel were available to her." According to Hunt, the direct-metal technique:

... gives the means to treat sculpture in increasingly expansive terms. We can graft on to this linear-spatial development elements of any former sculptural tradition, and are now able to position sculptural units freely in space, make dramatic changes in scale, mass, movement, weight, and employ heterogeneous materials in

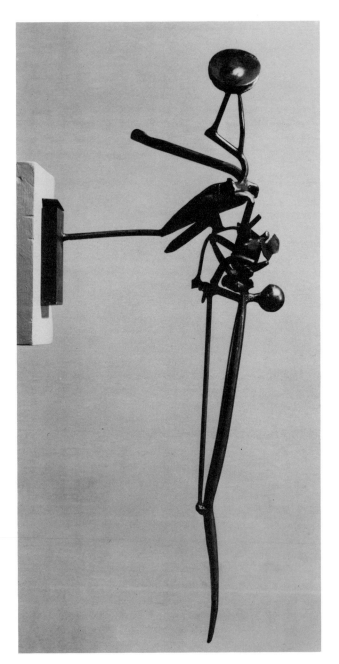

top: 283. RICHARD HUNT. *Arachne.* 1956. Welded steel; height 30″, diameter of base 18½″. Museum of Modern Art, New York.

above: 284. RICHARD HUNT. *Extending Horizontal Form.* 1958. Steel, length 4′ 9″. Whitney Museum of American Art, New York (gift of the Friends of the Whitney Museum of American Art).

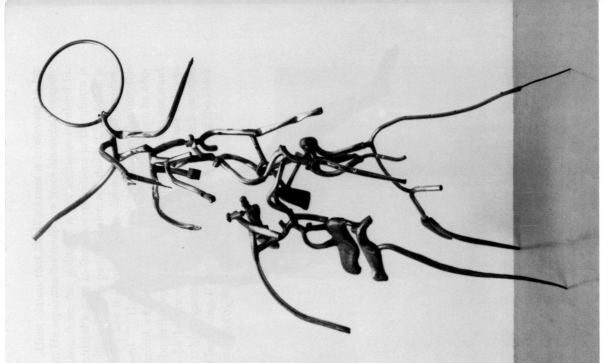

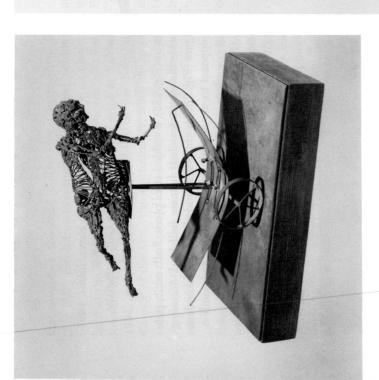

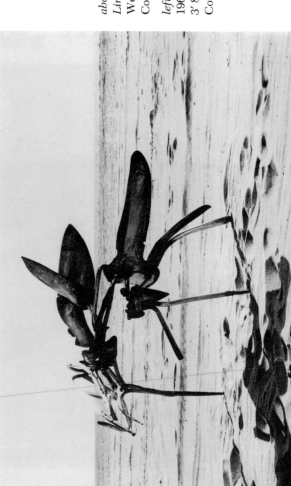

above: 286. Richard Hunt. *Linear Spatial Theme.* 1962. Welded steel, height 7′ 1½″. Courtesy the artist.

left: 287. Richard Hunt. *The Chase.* 1965. Welded steel, 3′ 8⅝″ × 5′ 6½″ × 4′ 4½″. Courtesy the artist.

above: 285. Richard Hunt. *Man on a Vehicular Construction.* c. 1956. Soldered wire with silver-soldered metal parts; height 8″, wood base 1⅛ × 5½ × 10⅜″. Courtesy the artist.

a single work. . . . Now sculpture can be its own subject, and its object can be to express itself, by allusion to its traditions, involvement with its new means, and interaction with its environment.[17]

Hunt was recently honored with a retrospective exhibition of forty of his works at the Museum of Modern Art (March 23–June 7, 1971). His sculpture is extremely personal, delicate, and exciting. He creates a new and strange environment for the museum-goer.

and cosmic energy of his insights . . . and expresses this
appreciation in terms derived from the values of his
total experience, past and present, his attitude about his
role in America is bound to be as lifeless as that of his
white colleague—namely, get the money.[23]

The artist is primarily concerned with making what
he does qualify as "art," and in this he feels he has
succeeded. His wish is to communicate so clearly that
those who behold his work will have no question about
its intent, for "the intention of the work will disappear
in front of the *fact* of the work's presence." Hutson
has no illusions about great numbers of Black people
coming either to view his work or to support the Black

artist. The Black artist receives attention when some-
thing has been destroyed, burned down, or boycotted,
or when a challenge is made to an institution. These
aggressive acts are committed by people who want to
improve their lot in life, because the burden of daily
existence has left them no room to cultivate the arts.
According to Hutson, the Black artist has a respon-
sibility to communicate to the masses of Black people
that "cultural expression is every bit as important to
our people's survival in America as are better and more
just living conditions."

Bill Hutson's paintings are large. Eight feet in
height is *Sasa of the First Creation Crossing a Bone Path
North by Northeast* (Fig. 294), exhibited at the Newark

294. BILL HUTSON. *Sasa of the
First Creation Crossing
a Bone Path North by Northeast.*
1971. Oil on canvas, 8 × 6'.
Newark Museum, N.J.

below: Plate 27. ROBERT THOMPSON.
Expulsion and Nativity. 1964.
Oil on canvas, 5′3″ x 7′2½″.
Courtesy Martha Jackson Gallery, New York.

right: Plate 28. FREDERICK JOHN EVERSLEY.
Untitled. 1970.
Three-color, three-layer cast polyester resin;
diameter 20″. Courtesy the artist.

Plate 29. WILLIAM T. WILLIAMS. *Elbert Jackson L.A.M.F. Part II*. 1969.
Synthetic polymer and metallic paint on canvas, 9'1⅞" x 9'7¼".
Museum of Modern Art, New York
(gift of Mrs. Donald B. Straus, Mrs. John R. Jackobson, and Carter Burden).

above: 295. BETTY BLAYTON. *Concentrated Energies.*
1970. Oil collage, diameter 4′ 10⅜″.
Courtesy the artist.

Museum's "Black Artists: Two Generations." In this
technically excellent painting the forms and volume
are suggestive of the surreal, and one is indeed con-
scious of the fact of the painting rather than its intent.
Upon reading the artist's statements about himself and
his art, one begins to understand the communicative
aspects of the work. "Sasa" may refer to life, or more
explicitly to a life of fulfillment and creativity. Ac-
cording to Hutson, his father had an "extremely short-
lived Sasa." The "bone path" may symbolize the slave
crossings, the path that countless Africans followed on
their way to becoming Afro-Americans.

Betty Blayton (b. 1937)

Betty Blayton's large, circular oil collages combine
stained areas and solid shapes. Her forms sometimes
describe parts of the human anatomy, but often they
are completely nonobjective. *Concentrated Energies*
(Fig. 295) is a collage of biomorphic forms; *Iconograph*

above: 296. BETTY BLAYTON. *Iconograph.* 1970.
Oil collage, diameter 40″. Courtesy the artist.

(Fig. 296) presents shapes and forms that are purely
of the artist's invention. In both canvases there is a
sense of "merging and meshing," a fluidity, a "visual
kaleidoscope."[24] Blayton's goal as an artist is to "learn
through self-expression of personal and impersonal im-
pressions of life."[25]

Born in Williamsburg, Virginia, Blayton was grad-
uated with honors in art from Syracuse University and
later studied at the Art Students League in New York
and the Brooklyn Museum. She is an active painter,
teacher, and lecturer, as well as director of the Museum
of Modern Art's Children's Art Carnival. Since her first
one-woman show in 1966, in which she displayed
"thinly painted, butterfly-colored lyrical abstrac-
tions,"[26] Blayton has exhibited widely—in the major

Afro-American shows, on college campuses, and in re-
gional museums. The following poem describes her at-
titude about the role of the Black artist in America
today:

Tune into Yourself by Betty Blayton

Anger hurts the angry man
dig it
feel yourself
hot with your black rage
heart beat's up
head throbbing
wan'ta blow you can

no-o-o baby that aint where it's at
sit back
dig your seen (ya the american sceen)
fine the flaws
and then
go with you'r stileto
and not a drop of blood has flowed

all of life is mind
and mind is like a radio
what you get
depends
on what you'r tuned in on
like, if it's "charlie on your back"
than that's what you get "charlie on your back"

Tune him out!
tune your on self in
ya, he's still out there
but not on your station

all men attract
what it is they think
if your love station's on . . .
and some one has his on hate
that hate becomes like static
cause it's got a missing link

tune into love
health and wealth
and
don't let nothing else in
no matter how high the frequency
turn those knobs
to these three stations
and "charlie's shit"
will lose it's patience.

Emilio Cruz (b. 1937)

In Figures 297 and 298 and in Plate 26 (p. 220) are reproduced works that New York artist Emilio Cruz considers representative of three key periods within the style he has developed during the last four years. The clean, hard edges and staining of *Orangescape* (Fig. 298) go beyond the technique of hair-combed surfaces seen in *Combed Brown* (Fig. 297). In the earlier work, tension has been set up between the textured surface and the color of the field. The pattern interlacement can be perceived as rhythm creating a sense of sequence in time. Thus, static repose communicates its opposite, movement.

Color is equally fundamental to *Brown or Drown in Secret Blue* (Pl. 26), a work that Cruz executed in 1972. Here, vertical planes placed side by side provide variations in hue, value, and intensity, as well as in surface tension and texture. The artist sees his patterns as constituting a significant difference from most hard-edge painting, in that they emerge from an introverted awareness of meaning rather than from a desire to be decorative. Meaning functions in this sophisticated art as it does in primitive art, as symbols capable of being experienced in opposites. For instance, movement can be expressed, not by gesture, but by serialization, which is repetition of formal units so as to make a pattern. Pattern designed to become static repose forces the internalization of the movement inherent in pattern, since the viewer tends to visualize the pattern as a whole and all at once, not as a sequence. This is writing that communicates to the unconscious, bypass-

297. EMILIO CRUZ. *Combed Brown*. 1971. Acrylic on canvas, 7 × 8'.
Courtesy the artist.

298. EMILIO CRUZ. *Orangescape.* 1971. Acrylic on canvas, 7 × 10′. Courtesy the artist.

ing the protocols of civilization and eliciting a reaction in the form of impulse. The symbols derive out of desire rather than reason. Cruz says this is "very important since I realize no matter how much I can gain in knowledge, I'm dying every day in obedience to certain natural laws, and that no individual lives on this earth and is understood. What we have is wonderment and eternal ignorance; put more politely, naïveté."[27]

Color, space, surface, creating tension, the stress that exists in the void, ambiguous relations, a metaphysical experience, zero, the no-thing, a sign signifying nothing. Where you are is where you are not. The absence of any particular, a diaphanous paradox, translucent, opaque—contradictions all. Candy-colored gases threatening the night where day has never been. A violent struggle for life where there is no adversary, only phantoms and the weapon gaiety, devoured by beauty, caressed by nails. A nontranslatable language filled with secrets that cannot be decoded, a message desperately scratched in a moment of great risk, etched on the surface of the unconscious. If ever deciphered, the link to one's origin is suddenly realized, the primordial beginning that contains the knowledge of the end, a useless possession awakening absolute terror of death. What you do not know is the only thing you know, the ironic myth of intelligence negating instinct, the ultimate link with the all. And so everything is frozen into a state

of atrophy; a fossil is found embedded in the surface of the brain.

Out of a deep disgust with the teachers of dancing bears, I try naïvely to sever the umbilical cord, the chain and ball of civilization, the builders of giant tombstones and the grandiose phallics pressed against the sky the merchants believe to be their own, the great symbol of eternal antagonism between man and man. For this I strip myself naked, I try to give paint the freedom I desire for myself. I use any tool able to make a mark— paint rollers, hair combs, tooth brushes, squeeze bottles —tools that allow for a quick response to a stimulus; color is my catalyst. I try to know very little about what I'm going to paint so that the painting can ask for what it most desires; when it needs me to act, it signals me through its peculiar language. This is the method I use, and I believe the only method to approach the unknown.[28]

Cruz studied at the Art Students League. He received John Hay Whitney Fellowships in 1964 and 1965 and a Cintas Foundation Fellowship in 1966. Cruz' work is included in the collections of Joseph Hirshhorn, Martha Jackson, Virginia Zabriskie, Meyer Schapiro, and James A. Michener. The artist was represented at the "First World Festival of Negro Arts" in Dakar, Senegal, and has participated in many other Afro-American art exhibitions.[29]

Robert Thompson (1937–66)

A full-scale retrospective exhibit of Robert Thompson's figurative Expressionist paintings was held at the New School for Social Research in February of 1969. The artist became a legend after his untimely death in Rome at the age of twenty-nine.

Thompson was born in Louisville, Kentucky. His mother, a schoolteacher, wanted him to be a physician, her way of ensuring that her son would have the dignity and security she thought he deserved. Young Robert, however, wanted to be an artist, and he drew on any surface he could find—even on window shades. Eventually, he studied at the University of Louisville and the Boston University School of Fine Arts.

Thompson's work was influenced by the masters of the past, an unusual phenomenon in young artists, many of whom reject the lessons of history. Commented Thompson: ". . . Why are all these people running around trying to be original when they should just go ahead and be themselves and that's the originality of it all, just being yourself."[30] Thompson's paintings were also influenced by Jon Mueller, the young German-born Expressionist artist he met in Provincetown, Massachusetts, in 1958, in what was to be the last year of Mueller's life. His work has also been compared to Gauguin's exotic studies. Gauguin, however, set his figures in specific environments—dressed in the native costume of Tahiti or the peasant garb of Brittany. In Thompson's paintings there is no suggestion of time or place. In their pure color and form his paintings convey a sense of passion and mystery. They are "highly (though roughly) patterned, hot-colored, intensely rhythmic . . . [and] redolent at once of joyous sensuality and fierce anxiety." His paint is often crudely applied and his forms anatomically awkward, but this effect seems deliberate, for the artist understood the methods of the Fauves and the German Expressionists.[31]

Many of Thompson's canvases are based on compositions and subject matter used by the old masters. For example, *Expulsion and Nativity* (Pl. 27, p. 237) borrows its format from Masaccio's *Expulsion from the Garden* (Fig. 299) and Piero della Francesca's

right: 299. Masaccio. *Expulsion from the Garden.* c. 1427. Fresco, 6′ 6″ × 2′ 9″. Brancacci Chapel, Church of Santa Maria del Carmine, Florence.

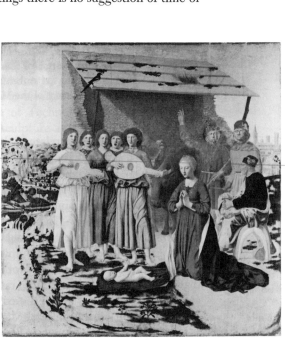

left: 300. Piero della Francesca. *Nativity.* c. 1470. Panel, 49 × 48½″. National Gallery, London.

Hollingsworth was born in New York of West Indian parents. His father worked for the Treasury Department and for the post office; his mother was the Reverend Hollingsworth of the Divine Harmony Church in Washington Heights. The young artist showed talent during his early teens. At thirteen he was drawing "Catman Cartoons" and was accepted as a student at the High School of Music and Art. Later, at the Art Students League, he again was employed as a cartoonist, and his "Scorchy Smith" strip was syndicated in 140 newspapers. Severe eyestrain caused Hollingsworth to change his emphasis, and he began to concentrate on the fine arts, a decision he has never regretted. He received his Bachelor of Fine Arts (with election to Phi Beta Kappa) and Master of Fine Arts from the City University of New York and is currently enrolled as a doctoral candidate at New York University; his thesis concerns fluorescent materials.

When Hollingsworth left City College, he became involved with the art and intellectual scene of Greenwich Village, at a time when the "beat generation" was in flower. The result was a series of paintings called *Beat Scene*. As early as 1958 he was working with fluorescent paints, but galleries told him it was too "gimmicky." A group of canvases using ultraviolet pigments for dramatic emphasis were featured at an exhibit called "Exodus" at the Ward Eggleston Gallery in 1961. Meanwhile, the artist became fascinated with the Guggenheim Museum, and the Frank Lloyd Wright structure served as the leitmotif for an endless production of prints, paintings, drawings, and sculptures, plus a children's book entitled *I'd Like the Goo-*

305. ALVIN HOLLINGSWORTH. *Inner Reflections.* c. 1963. Oil and collage, 24 × 28″. Courtesy the artist.

Gen-Heim (Reilly & Lee Co., Chicago)—all of which was exhibited in 1972 at the Lee Nordness Galleries in New York.

After his 1961 show, Hollingsworth began to focus on the problems of his people. Collecting the rubble of the city—hangers, glass, cloth, paper, fishbones, teeth—he created a series of protest paintings called *Cry City,* which were exhibited at the Terry Dintenfass Gallery in 1965. The first of the series—*Inner Reflections* (Fig. 305)—won him an Emily Lowe Award in 1963 and a Whitney Fellowship in 1964.

An active man who is interested in many aspects of the Black's creative life, Hollingsworth has illustrated an anthology of Black verse, *Black Out Loud;* moderated a television series, "You're Part of Art," covering the gamut of the artist's world; and supervised the New York City Board of Education's "Turn On" project, which instigated teaching programs, gave demonstrations, and directed personnel.

Hollingsworth's peripatetic activities have evidently been a handicap in his creative development. An artist of considerable talent, whose work is frequently exciting, "he is frustrating in that he always seems to have dodged, at the very last instant, the discipline or ambition, which would make him an artist of importance."[3] His large silhouettes of dark children with brooding eyes set against the debris of city streets make a sentimental appeal to the viewer. *Why: Black Guernica* (Fig. 306) is a collage of metal, cloth, broken glass, wire, wood, and plastics, with both oil and acrylics. The letters spelling out "no colored" provide the only light, decorative relief in an otherwise somber canvas. First shown in 1965 at the Terry Dintenfass Gallery, it was the focal point of the "Harlem '69" exhibition at the Studio Museum. His *Cry City* series utilizes similar technique and iconography.

Hollingsworth is currently an Assistant Professor of Art at Hostos College, a division of the City University of New York—a creative experiment in higher education designed with a staff and curriculum to meet the educational needs of New York's minority groups.[4]

Merton D. Simpson (b. 1928)

Merton D. Simpson is a dealer in African Art, through the Merton D. Simpson Gallery of Primitive and Modern Art in New York, as well as an artist. He was born in Charleston, South Carolina, and educated at Cooper Union and New York University. From 1951 to 1954 Simpson was an official United States Air Force artist.

One of the few Black artists to receive recognition during the 1950s, Simpson was represented in the 1954

306. Alvin Hollingsworth. *Why: Black Guernica.* 1965. Oil and acrylic collage, 4 × 8'. Courtesy the artist.

Benny Andrews (b. 1930)

Limned by rags and ropes, Benny Andrews' *Champion* (Fig. 310) sits in the corner of a boxing ring waiting for the bell. His sagging face is built up with plastics, glues, and resins—materials the artist uses for sculptural effects. In this painting Andrews attempts to "show the strength of the Black man, the ability to persevere in the face of overwhelming odds."[6] While the boxer symbolizes the Black's strength, he also reflects the artist's sense of indignation at the role American society has forced upon the Black man. Stripped of his masculinity, he could find glory only in the prize ring. For the unlettered young man newly arrived in the urban complex—be he Afro-American, Italian-American, Irish-American, or Puerto Rican—the boxing ring offered one of the few areas of activity in which he could acquire fame, fortune, and manhood.

Andrews' first paintings to be shown in New York—in 1962—utilized the collage technique for building textures. The figure groups and still lifes were "awkward and harsh, but forceful." His 1966 exhibition at the Forum Gallery marked the beginning of a trend—the serious review of Black "social-comment" art by the art Establishment. The sentiment of the show was obvious, but paintings like *Farmer* and *First Day* (Fig. 311), because of the strong, geometric compositions, were also effective works of art.[7]

Benny Andrews was born in the South—Madison, Georgia—and many of his paintings describe scenes of

310. BENNY ANDREWS. *Champion.* 1968. Oil and collage, 4' 2" square. Courtesy the artist.

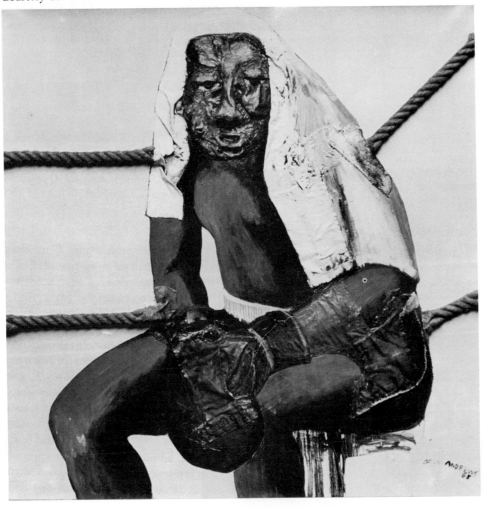

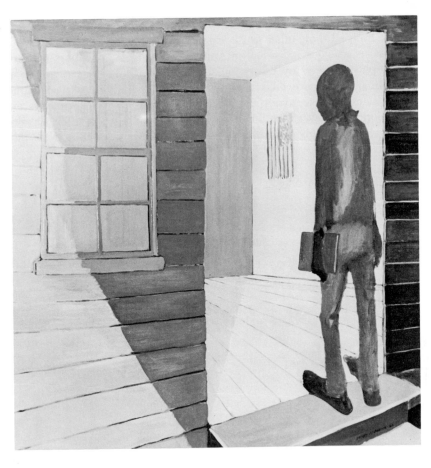

311. BENNY ANDREWS. *First Day.* 1965.
Oil on canvas, 36″ square.
Courtesy the artist.

his southern childhood. His parents, George and Viola Andrews, were sharecroppers, and Benny worked the farm for as long as he was needed—which often meant starting school in November when the cotton was picked and quitting in March for the planting. The young Andrews was the first member of his family to attend high school. His mother's determination and his ability to draw combined to keep him in school, and then his association with the 4-H Clubs earned him a scholarship to one of the three Black colleges in Georgia. He stayed at Fort Valley State College for two years before enlisting in the Air Force, which the artist describes as his "salvation." [8]

With his G.I. Bill Andrews headed north for Chicago and studied first at the University of Chicago and then at the Art Institute, where he received his Bachelor of Fine Arts degree in 1958. During this period the Abstract Expressionist aesthetic dominated the art schools, but this sophisticated New York idiom was irrelevant to Andrews' view of art. Except for Boris Margo and Jack Levine (the commentator on Jewish life), both students and faculty at the Art Institute were unanimous in their ridicule of Andrews' social comment paintings. The artist found his inspiration outside the classroom, with the musicians and street people in Chicago's South Side. He began to design record covers for the Blue Note Recording Company.[9]

Now an instructor at Queens College in New York, Andrews has also taught at the New School for Social Research in New York and at the University of California in Hayward. Since his organization of the Black Emergency Cultural Coalition, he has become a spokesman for the Black artist. Articles bearing his signature have appeared in the *New York Times*, as well as in many leading art periodicals. Moreover, he has been widely sought by universities for their visiting-artist chairs. Andrews was represented in the Museum of Modern Art's "The Artist as Adversary" exhibition (summer 1971) with *No More Games* (Fig. 312), a painting that is in the Museum's collection.

Like most artists, Andrews tries to express his personal essence in his paintings. "But," he maintains, "the

key to what makes my attempts to express myself different from all those other artists is really my identification as a unique individual in America. That is, a Black person, so in my expression there are contradictions and the unexpected that are often only identifiable by others, like myself, Black."

Andrews believes that the Black artist offers the United States its only opportunity to create something intrinsically American, something not based on European cultures. "Like jazz, and even poetry, we in the graphic arts are America's best chance for a unique American art, because we are the products of a unique American experience, the Black experience." [10]

Andrews' exhibit at the ACA Galleries in the spring of 1972 was dominated by *Trash* (Fig. 313), an enormous work that focuses on contemporary American

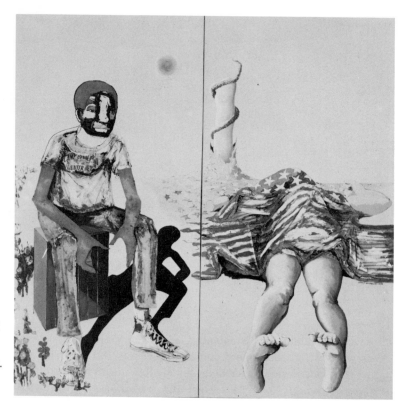

right: 312. BENNY ANDREWS.
No More Games. 1970.
Oil and cloth on canvas; each panel 8′ 5″ × 4′2″. Museum of Modern Art, New York.

below: 313. BENNY ANDREWS. *Trash* (detail).
1971. Oil and collage (in 12 sections);
entire work 10 × 28′. Courtesy the artist.

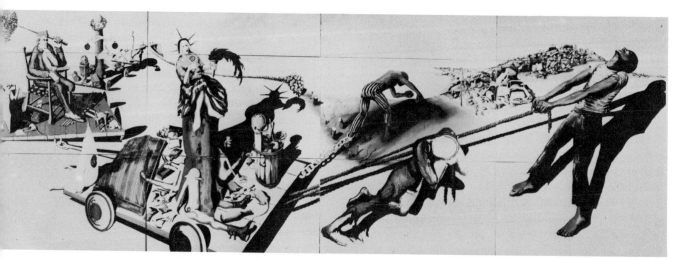

Plate 30. Joe Overstreet. *Justice, Faith, Hope, and Peace.* 1968. Acrylic on canvas, wall size. Courtesy the artist.

opposite: Plate 31. RAYMOND SAUNDERS. *Marie's Bill.* 1970.
Oil on canvas, 6'9" x 4'6". Courtesy Terry Dintenfass, Inc., New York.

below: Plate 32. BARBARA CHASE-RIBOUD. *White Zanzibar.* 1970.
Silver and silver chain, 6 x 3". Courtesy the artist.

culture. Three Black men are pulling a train of wooden platforms. Two of them are pulling with ropes, but the third is shackled to a platform. In the distance is the new American landscape—junked cars—while the platforms contain a symbolic representation of the debris created by American society. On Platform 1 Miss Liberty rests on an erect penis, surrounded by discarded limbs, bottles, a mattress, and a trash can topped with a football helmet and an overstuffed rat. Platform 2 bears a soldier, his shirt opened to reveal mammoth breasts, his feet astride a fallen American eagle. The third paltform supports another erect penis crowned with a floral wreath; clinging to the penis is a white woman holding two balloons. On the fourth platform are the Star of David, the Cross, and the Star and Crescent—the religious and political symbols that have often been used to justify man's actions. To Edmund B. Gaither *Trash* presents an equation: "false religion plus sexism plus militarism plus false democracy equal deception equals trash or waste."[11]

Milton Johnson (b. 1932)

In *Another Birthday* (Fig. 314) Milton Johnson, a compassionate artist from Milwaukee, Wisconsin, presents a "wearied Black face drenched ironically in color—to the point where it becomes a brooding presence." The "brooding presence" is that of old age and loneliness, a human tragedy that transcends racial boundaries. The paint is applied freely and richly in a combination of

opposite: Plate 33.
DANIEL LARUE JOHNSON.
Homage to René d'Harnoncourt.
c. 1968. Acrylic on wood,
1′ 9″ × 2′ 7″ × 6′ 1″.
Collection Joy and I. J. Seligsohn,
Armonk, N.Y.

right: 314. MILTON JOHNSON.
Another Birthday. 1969.
Oil on canvas, 6′ 7″ × 5′ 5″.
Museum of the National Center
of Afro-American Artists, Boston.

Museum of Fine Arts—and at Tufts University, Johnson is involved in a wide variety of community activities, chief of which is an accredited art program for adults through the Model Cities program. Although he is primarily a painter, he receives many commissions for book illustration. He has completed a series of ten books for young adults. Johnson's greatest concern is with the creative process. He is too busy illustrating books, teaching, painting, printing, and working in the community to "get involved with the publicity of himself." It is his responsibility as an American citizen and an artist, and not necessarily a Black artist, that has motivated Johnson in his community involvement, sometimes at great personal sacrifice, for there are weeks in which he is actually too busy to stand before his canvases.

Johnson is aware of the problems in America for Blacks, but he is not obsessed with them; he exists comfortably in both worlds. His five years of study and

above: 315. MILTON JOHNSON. *Limited.* 1958.
Woodcut, 42 × 30″. Courtesy the artist.

right: 316. JOE OVERSTREET. *The New Jemima.* 1964.
Construction, 8′ 6½″ × 5′ 1″ × 1′ 5″.
Menil Foundation, Houston.

Abstract Expressionism and figurative painting, of social commentary and aesthetic consideration. In a similar vein, a woodcut called *Limited* (Fig. 315), which portrays a crippled man supported on crutches, communicates the despair felt by the victim of war, riot, or neglect.

Johnson studied at the Milwaukee Layton School of Art and the Minneapolis Institute of Art. Now teaching at his alma mater—the school of the Boston

317. Joe Overstreet, with *Indian Sun*. 1969. Diameter 12′. Courtesy Ankrum Gallery, Los Angeles.

travel in Japan (from 1961 to 1966) and his subsequent travels in Europe have enabled him to adjust and adapt himself to the values of many cultures.[12]

Joe Overstreet (b. 1934)

From Conehatta, Mississippi, Joe Overstreet migrated with his family to California, where he began painting at age three. He attended the local public schools and the California School of Arts and Crafts. Overstreet's early paintings were ironic social protests (Fig. 316). Today he works with shaped canvases, and his stretchers are of rope and wood. The bold patterns, colors, and symbols show American Indian as well as African derivation (Pl. 30, p. 255).

Overstreet is concerned with sculptural space in his work. He believes that a painting should entice the observer to enter into its space, using a different route each time it is viewed. His large "target" canvas (Fig. 317), pulled taut by ropes, imposes itself upon the viewer and envelops him. It is difficult to view such a canvas passively.

When he begins a painting, Overstreet first searches his inner self, then organizes the symbols and patterns to give the painting a meaning. Next, he finds an emotional motive that will intensify his feeling during the

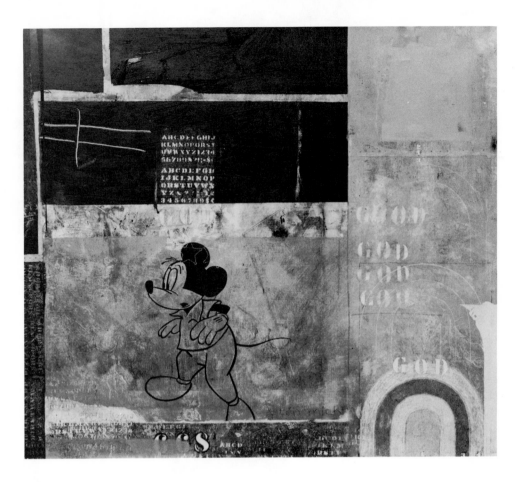

above: 318. RAYMOND SAUNDERS. *Doctor Jesus.* 1968.
Oil on canvas, 3′ 9″ × 4′ 10″.
Courtesy Terry Dintenfass, Inc., New York.

creative process, meanwhile organizing the painting so
that the message conveyed meets his intent. As a Black
artist who has achieved some measure of success,
Overstreet believes it is his moral obligation to make
it easier for the young Black to gain entrance into the
galleries and museums. "I want to show the world that
the Black artist really has so much to offer this culture
and the culture of the world."[13]

Raymond Saunders (b. 1934)

When Raymond Saunders exhibited at the Whitney's
contemporary Black American show, John Canaday,
art critic of the *New York Times*, wrote that the only
thing new he learned about Saunders, an artist he had
long admired, was that he was Black. Although many
of his paintings seem to have been inspired by the

graffiti found on urban ghetto buildings—including
several in his February 1969 exhibition at the Terry
Dintenfass Gallery—Saunders has written that "racial
hang-ups are extraneous to art. No artist can afford to
let them obscure what runs through all art—the living
root and the ever-growing aesthetic record of human
spiritual and intellectual experience." In a privately
printed pamphlet, *Black Is a Color*, Saunders expressed
his attitudes toward art and life, and the Black artist's
role and responsibilities:

Art projects beyond race and color; beyond America.
It is universal, and Americans—Black, white or what-
ever—have no exclusive rights on it.

No one can honestly deny the existence of discrim-
ination and oppression against black people (and black
artists, by extension) in America, but the black man is
not the only human being ever to have suffered these
ills. Counter-racism, hyper-awareness of difference or
separateness arising within the black artist himself, is
just as destructive to his work—and his life—as the threat
of white prejudice coming at him from outside.

Pessimism is fatal to artistic development. Perpetual anger deprives it of movement. . . . For the artist this is aesthetic atrophy.

Certainly the American black artist is in a unique position to express certain aspects of the current American scene, both negative and positive, but if he restricts himself to these alone, he may risk becoming a mere cypher, a walking protest, a politically prescribed stereotype, negating his own mystery, and allowing himself to be shuffled off into an arid overall mystique. The indiscriminate association of race with art, on any level —social or imaginative—is destructive.[14]

Born in Pittsburgh, Pennsylvania, Saunders studied at the Carnegie-Mellon Institute (earning his B.F.A. in 1960), at the Barnes Foundation, the Pennsylvania Academy of Fine Arts, and the University of Pennsylvania. In 1961 he received his M.F.A. from the California College of Arts and Crafts. He was the first Black artist to be granted the Prix de Rome, a much-coveted award made for study at the American Academy in Rome. Now living in Berkeley, California, Saunders is artist-in-residence at the University of California in Hayward. He has held similar positions at Dartmouth College, the Rhode Island School of Design, and New York's High School of Music and Art.

Saunders' paintings successfully combine an Abstract Expressionist feel for paint with graffiti, letters, and Arabic calligraphy. Mickey Mouse appears frequently in his canvases (Fig. 318). *Marie's Bill* (Pl. 31, p. 256), in brilliant reds, blues, and purples, with scratches of yellow, incorporates stars, scrawled numbers, and stenciled letters. The broad strip of red at the top of the canvas, the only pure color, is emblazoned with the graffiti of adolescent love—the ubiquitous heart alongside the names of the lovers. Saunders claims that some of his images are derived from experiences in the Middle East, Japan, and Russia.

Barbara Chase-Riboud (b. 1936)

Barbara Chase-Riboud dedicated the sculpture in her first one-woman show in New York—at the Bertha Schaefer Gallery in February of 1970—to the memory of Malcolm X. Her catalogue was replete with political statements—from Arthur Rimbaud's *Une saison en enfer* (1873) and Eldridge Cleaver's *Soul on Ice* (1968) —but her art was not. With coils of silk and wool ropes cast in bronze and some aluminum, she displays a "most impressive show of strength, sensitivity, vision and technical prowess." The four *Monuments to Mal-*

colm X (Fig. 319) are hung on the wall. The bronze has been cast as in a bas relief, while the wool and silk retain their original characters, so that the contrast in textures is rich and provocative. By dedicating her sculpture to a Black hero rather than specifically detailing his achievements, Chase-Riboud avoids polemic in her art.[15] She has lived in Paris since 1961, and her

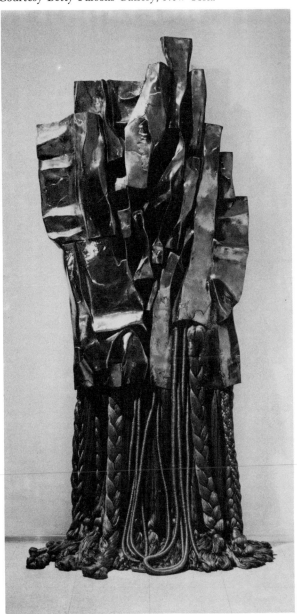

319. BARBARA CHASE-RIBOUD. *Monument to Malcolm X, No. 2.* 1969. Bronze and wool, 6' × 3' 4''. Courtesy Betty Parsons Gallery, New York.

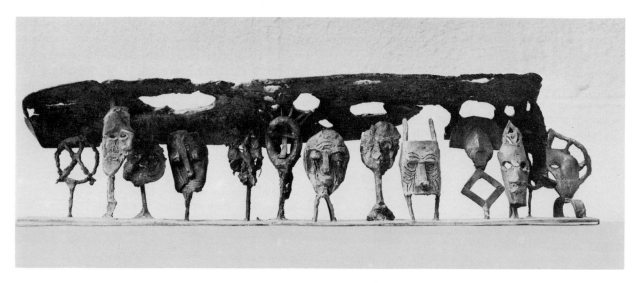

above: 320. Barbara Chase-Riboud. *The Last Supper.*
1958. Bronze, $8\frac{1}{2}'' \times 2' 4\frac{3}{4}'' \times 4\frac{1}{2}''$.
Collection Mrs. Ben Shahn, Roosevelt, N.J.

below: 321. Bakota skull guardian from Gabon.
19th–20th centuries.
Wood covered with copper and brass, height 30''.
Ethnographic Collection, University of Zurich.

right: 322. Barbara Chase-Riboud. *Mother and Child.*
1956. Orangewood, height 3'.
Courtesy Betty Parsons Gallery, New York.

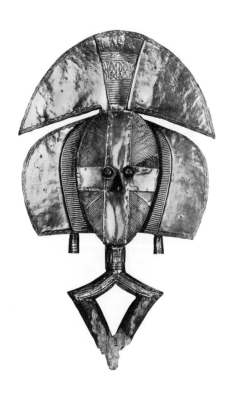

work can be described as "French elegant" rather than "Black expressionist."

Artists like Barbara Chase-Riboud and Richard Hunt (Figs. 283–291), who are essentially nonpolitical, have been attacked by Imamu Amiri Baraka (LeRoi Jones). To him they do not "actually exist in the black world at all. They are within the tradition of white art, blackface or not. And to try to force them on black people, as examples of what we are at our best, is nonsensical and ugly." To this charge, Chase-Riboud might respond that "nobody should attempt to limit artists in their response to the world."[16] Moreover, despite Baraka's comment, it is clear that Chase-Riboud's art is deeply rooted in her African heritage.

Born in Philadelphia, Barbara Chase received her Bachelor of Fine Arts degree from the Tyler School of Art at Temple University in 1957, and her Master of Fine Arts from Yale University three years later. At the age of fifteen she won a *Seventeen* magazine award for one of her prints, which was later purchased by the Museum of Modern Art. In 1957 she received a John Hay Whitney Fellowship. According to the artist, a side trip to Egypt during her year in Rome enabled her to sever herself from the mainstream of Western (white) art and freed her to search for a past rooted in the African (nonwhite) tradition. The New York School is reductionist or Minimal; Chase-Riboud describes her work as "maximal." The search for beauty is no longer important to most contemporary artists, but for Chase-Riboud "sculpture should be beautiful."[17]

Recognition came early to the young artist. Cedric Dover's 1960 publication, *American Negro Art,* contained six illustrations of her work. An early linear bronze, *The Last Supper* (Fig. 320)—which shows the influence of African masks and fetishes (Fig. 321)—was owned by Ben Shahn. *Mother and Child* (Fig. 322) symbolizes, through form and thrust, the strength and warmth of motherhood.[18]

For five years—from 1960 to 1965—Chase-Riboud worked little. Her time was spent traveling with her photographer-husband to Siam, Peking, and Mongolia, where she became fascinated by Oriental art. When in 1966 she again exhibited in Paris, Chase-Riboud showed drawings and sculpture based on the "theme of the couple: . . . where opposite forms confront each other with sensuality and aggressivity. . . ." The artist explained her fascination with the idea of the couple as "banal and impossible, the need to join opposing forces, male/female, negative/positive, black/white. One never stops demanding the impossible. It's touching and diabolic."[19]

Opposites continue to permeate the life and work of Barbara Chase-Riboud. She is a female casting in bronze, a traditionally masculine technique; a Black in a white milieu; an American from Philadelphia surviving in a Parisian society. She employs powerful bronze forms that must coexist with delicate silk and wool braidings, "the burnished and the mat, the hard and the soft, the forceful and the tender, what resists and what submits."[20]

When using the lost-wax casting technique, a method popular in Africa since ancient times, Chase-Riboud likes to think of herself as an artisan, someone uniting art with craft. The silk and wool cording she had introduced with the *Malcolm X* series reappeared in her second New York show in 1972 (Pl. 32, p. 257). At first the cords had served only to ease the transition between the object and the floor, because the traditional pedestal seemed too bulky and the legs on her figurative pieces too thin. Then, from the weaver Sheila Hicks she learned techniques of knotting, wrapping, braiding, and cording—methods used for the raffia and hemp appendages on African dance masks. On such masks, the fibers are employed to cover the figure, which acts like the armature in a Chase-Riboud sculpture.[21] Describing the relationship between her work and the masked African dancing figure, Chase-Riboud has pointed out that her sculptural compositions have "African connotations, especially if one considers how the African dancing mask (wood) is always combined with other materials: raffia, hemp, leather, feathers, cord, metal chains or bells. Each element has an aesthetic as well as a symbolic and spiritual function. My idea is to reinterpret the aesthetic function in contemporary terms, using modern materials (bronze and silk, bronze and wool, steel and synthetics, aluminum and synthetics)."[22]

Mel Edwards (b. 1937)

Although Mel Edwards disclaims any political intent in his choice of materials for an exhibit at the small gallery in the Whitney Museum (March 2–29, 1970), a friend revealed that many of the pieces of wire and metal were rubble picked up by Edwards in the aftermath of the Watts riots (Fig. 323). Edwards called them his "lynch fragments." By suspending chains from the ceilings with barbed wire or metal tubing, Edwards manages, in his linear constructions, "to imbue an otherwise cool minimalist style with some strikingly brutalist connotations."[23] He recently explained his fascination with wire:

above: 323. MEL EDWARDS, with
Curtain for William and Peter.
Environment constructed for exhibit
at New York's Whitney Museum
of American Art.
March 1970 (dismanted after show).
Barbed wire and chain;
entire length c. 30′.

right: 324. MEL EDWARDS.
Double Circles. 1968 (installed 1970).
Painted steel, height 8′.
142nd Street and Lenox Avenue,
New York.

325. DANIEL LARUE JOHNSON.
Yesterday. c. 1963.
Construction with headless doll, $2\frac{1}{2}'$
square. Courtesy the artist.

I have always understood the brutalist connotations inherent in materials like barbed wire and links of chain and my creative thoughts have always anticipated the beauty of utilizing that necessary complexity which arises from the use of these materials in what could be called a straight formalist style. . . . Wire like most linear materials has a history both as an obstacle and enclosure but barbed wire has the added capacity of painfully dynamic and aggressive resistance if contacted unintelligently. To use this chain with all its kinetic parts crisscrossing the line as invader and potent container.[24]

Black art critic Frank Bowling sees in Edwards' sculpture something he claims the white art critic missed—a wit, in the tradition of the contemporary "Black humorists." There is the irony of elegance describing pain, of sophisticated art created from the rubble of humanity. "Inherent in this delivery," according to Bowling, "is the bondage neurosis in top hat and kid gloves."[25]

A native of Texas and a graduate of the University of California, Edwards currently teaches at the University of Connecticut in Storrs. His earlier pieces, although they incorporated chains and found objects, were more conventional in conception. *A Necessary Angle*, shown at the UCLA art galleries in 1966, was set on a pedestal, a custom Edwards has since, for the most part, abandoned. In recent years he has experimented with outdoor sculpture in a serial style; two characteristic pieces have been erected as monuments, one of which is reproduced as Figure 324.

Daniel Larue Johnson (b. 1938)

Daniel Larue Johnson's early constructions—during his "black box" period—were identified with the Civil Rights movement. *Yesterday* (Fig. 325), a construction that includes a decapitated doll with its hand caught in a mousetrap beside a crumpled American flag, was conceived in reaction to the 1963 church bombings in Birmingham, Alabama.

Today, Johnson's work focuses on brilliantly colored "slab-sided totems" of enameled wood (Fig. 326), which are a hybrid of color-field painting and Minimal sculpture, with overtones of the rhythms of Africa and American jazz. A group of these sculptures were shown at French and Company, his gallery, in March of 1970.

Johnson calls the spirit that moves him "Rohoism, the Swahili word for connected spirit."

At the Museum of Modern Art's exhibition honoring Dr. Martin Luther King, Jr., *Homage to René d'Harnoncourt* (Pl. 33, p. 258) attracted attention. It is multileveled, combining curvilinear shapes with a horizontal slab. Johnson's colors are vibrant. "Color talks of power, sex, lust and life," says the artist. "A motivating spirit that makes my mind see changing patterns of color is the music of Charles Lloyd and Miles Davis." One reviewer wrote that Daniel Larue Johnson "sees

left: 326. DANIEL LARUE JOHNSON.
The Boy Wonder Dejohnette. 1969.
Oil on wood, height 7'. Courtesy the artist.

above: 327. WALTER JACKSON. *Lapis II,*
from the *Iconetic Consciousness* series. 1970.
Steel, plastics, and light; height 8'. Courtesy the artist.

plastic ideas musically and translated jazz into primary color chords with mathematical precision."[26]

After studying at the Chouinard Art Institute and the California Institute of the Arts, Johnson, a product of the Watts ghetto, worked his way to New York, where he was befriended by Willem de Kooning (Fig.

145). He received many of the important fellowships offered by the white art Establishment, including a Guggenheim, which enabled him to live and work in Paris and enjoy the privilege of study with the Swiss sculptor Alberto Giacometti. Regarding his role as a Black artist, Johnson now claims: "Such questions are frivolous. They have nothing to do with the consciousness of people who attempt to make art." However, Johnson would like to redirect the hostility of the ghetto into creative channels. With this in mind, he has worked with emotionally disturbed children at Lincoln Hospital in New York, where he now lives.[27]

Walter Jackson (b. 1940)

Working outside the New York art market but well within the mainstream of modern art,[28] Walter Jackson, from Holmes County, Mississippi, draws his inspiration from today's technology. His current sculpture series, constructed with steel and Plexiglas, incorporates electronic devices that trigger unexpected movement and/or lights. The movement is primarily internal—plastic spheres controlled by air pressure—and is meant to symbolize life—the life of man and the life of the machine (information systems). Concerned with the "nature-culture dichotomy" as it relates to the "man-machine symbiosis," Jackson is fascinated with the potential for information retrieval systems. To this, he adds what he has learned "spiritually, from so-called 'Primitive' African Art," thus creating a strange alliance that is perhaps a unique interpretation of W. E. B. DuBois' "double consciousness." The highly technical works in his current series, which he calls *Iconetic Consciousness* (Fig. 327), have the directness and simplicity of African sculptural form. They achieve a coexistence of two cultures: the African tribe and industrial America. Printmaker Byron McKeeby, a colleague of the artist, sees in Jackson's sculpture a kind of humor and wit, the sort of "black humor" displayed by Mel Edwards (Figs. 323, 324).

To Jackson, "art is and must be a vital resource in the consciousness of mankind. It is the means by which reality is defined. It is the humanizing force in man's life. Because art is all of these things, an artist has an obligation to mankind to create as vital an expression as is possible."

Jackson is concerned about the role of the Black artist in America today. Should he devote his life and work to the eradication of social injustices, or should he retreat into his studio and detach himself from the political turmoil in order to produce "Art"? For Jack-

son, the role is obvious. Anyone who is in touch with, or who seeks, reality, cannot help but become involved in the Black consciousness in terms of heritage or protest, overtly or subtly. According to the sculptor, "The Black artist must become an integral part of the Black consciousness, in a mental struggle of give and take, infuse and in turn be infused by things beyond mere knowledge, things that he alone has the wisdom to know because he alone has lived them."

A graduate of Mississippi's Jackson State College, Jackson now teaches at the University of Tennessee, where he earned the Master of Arts degree in sculpture.

Ben Jones (b. 1942)

African art influences the work of Ben Jones, an instructor of drawing, painting, and art appreciation at Jersey City State College in New Jersey. Working with plaster life casts of black arms, faces, and legs—sometimes grouping them, often displaying them singly—Jones decorates his human appendages (Pl. 34, p. 275) as though preparing them for a tribal ritual (Fig. 328).

328. Ngere girl painted for a festival.

Some of the masks are gaudily painted with flourescent acrylic on mat black plaster (Pl. 34); others, like *Black Leg* (Fig. 329), are delicately gilded with gold leaf. The arms and legs hang from the walls or from metal supports. They are not completely rounded like poured plaster, but are open in the back, as though the mold had been lifted from flesh. The hands and fingers assume a variety of expressive gestures. Jones' two-dimensional canvases are of mixed media. Using crayon, washes, acrylics, cut-out stars, paper dots (like children's color-forms), and painted dots, *High Priestess of Soul* (Fig. 330) pays homage to Black woman.

Jones is a graduate of Paterson State College with a Master of Arts degree from New York University. He has written about the nature and content of his work:

above: 329. BEN JONES. *Black Leg.*
1969. Mixed media, life-size.
Courtesy the artist.

right: 330. BEN JONES. *High Priestess of Soul.*
1970. Mixed media, 40 × 30″.
Newark Museum, N. J.

331. GARY A. RICKSON. *Capitalism in Organic Brown.* 1970.
Oil on canvas, 18 × 24″. Courtesy the artist.

Through color, form, and material I try to create works which I feel are attuned to my present attitudes and which point a direction to an evolving Black Aesthetic and existence. Presently my work is not primarily concerned with just form and visual perception but spiritual, social, political and psychological content. I hope my work is of the calibre to give my people an awareness and inspiration for changing their lives.[29]

Gary A. Rickson (b. 1942)

Although Gary A. Rickson studied briefly at the Boston School of Practical Art (he also has a Ministry Degree in basic religions from a Moorish Science Temple), he is largely a self-taught artist. Rickson was born in Boston. From his self-educated mother and father came the beginning of Rickson's "exploration spiritually and physically of our inner and outer worlds."

Rickson is equally concerned with his "inner and outer worlds, the spiritual in relationship to the physical through the medium of man." His paintings and his social commitments reflect this dual concern. Rickson considers himself a "community artist," not an easel painter. His oils are used to sell his mural ideas,

and when he receives a mural commission, he presents the canvas to his client. With Dana Chandler (Figs. 256, 257), he has helped make sections of Boston's Black ghetto a veritable outdoor art gallery (Fig. 253). Rickson's African- and Afro-American-inspired murals can be found at local markets and branches of the Y.M.C.A., at the African Studies Department at Brandeis University, at Boston's Unity Bank and Trust Company, at the Roxbury Comprehensive Service Health Clinic, and at Sol's Fish Market. He was a founder and the first president of the Boston Negro Artist Association, organizer of Boston's Annual Outdoor Arts Festival, vice-president of the Black Arts Association, and cultural chairman of the Malcolm X Foundation. With a grant from the Soviet-American Relations Committee in 1966, Rickson traveled through Europe and Russia, accompanying a group of prints by Afro-American artists.

The paintings exhibited by Rickson in the "Afro-American Artists: New York and Boston" show reflect his social concerns. In *Capitalism in Organic Brown* (Fig. 331) ambiguous amoeboid shapes—perhaps the shapes of the American states or the states of Africa—are imprisoned and framed behind bars. Another

left: 332. GARY A. RICKSON. *Eastward Through the Westgate.* 1970. Oil on canvas, 33 × 25″. Courtesy the artist.

example of the dues you pay and the changes you go through to become free and then in turn to set others free. . . . In order to become natural you must psychologically leave through these Western influences into those Eastern influences and combine them to make the world whole and healthy.

Rickson's murals differ from the typical Black Art Movement outdoor paintings. They are more surrealistic than realistic, symbolic rather than obvious. *Africa Is the Beginning* (Pl. 35, p. 276), a 30-by-50-foot mural, adorns the side of a new Senior Citizens-sponsored Y.M.C.A. at the corner of Warren Street and Martin Luther King Boulevard in Roxbury. The mural features a pyramid floating in space on a platform that separates day and night, with lightning reflecting off the pyramid—again separating day from night. An eclipse of the sun appears in the upper right corner, and the moon is in the far left corner. According to the artist, "The floating pyramid represents the knowledge that mankind rejects or cannot rightly receive."[30]

Malcolm Bailey (b. 1947)

The social philosophy of Malcolm Bailey is expressed in a large unstretched canvas called *Hold* (Fig. 333), part of his *Separate but Equal* series. The painting is a schematic representation of a slave ship blueprint, with two groups of figures trapped in the hold—one Black, the other white. It was purchased by the Museum of Modern Art while he was still a student. Bailey insists that "real revolution won't occur until poor whites as well as poor Blacks realize they are oppressed." Inherent in Bailey's art is a message as well as an aesthetic quality. He is trying to universalize the Black experience. In fact, his own experiences have not been Black only, for his formative years were spent both inside and outside the ghetto, and he has been influenced by a variety of people with different viewpoints. In essence, Bailey dreams of a world in which art, artists, and the whole art scene could be color blind, and he believes most Black artists share his concern. His identity is that of a human being, and he resents being labeled or stereotyped. The artist considers himself to be something of a "social phenomenon—" one of the youngest artists showing at major museums and galleries, yet creating a bit of turmoil in the art

painting, done in 1969, was called *Segregation, B.C.* Rickson has issued a declaration regarding his aims and goals as an artist. They are:

> To benefit and resurrect "mankind" using the art mediums available for this day, age and time . . . to project information of the finest degree to the masses in a way that is attractable and functional. Only true education can redirect the will of humanity to its natural origin and place. Only by exposing the masses of people to its culture in a truthful and realistic capacity can we hope to achieve the peace and understanding that is needed in our space and time.

Eastward Through the Westgate (Fig. 332) shows a pregnant female walking through an extended vista, bleak and surreal, her limbs cut off abruptly and dripping blood. Such a work enters the realm of the metaphysical. It represents, according to the artist:

> . . . the black man, individually and collectively, in search of the truth through this stark reality. The process of truly resurrecting one's own self is the most difficult and complex undertaking any human being can endeavor to achieve. [The painting] is just such a visual

world. Bailey has commented that initially he attracted attention because he was talented, young, and Black. Now he is ready to compete in the open market of aesthic ideas, with no specific reference to his Blackness.[31]

Bailey was born in Harlem of a Jamaican father and an American Indian-Pennsylvania German mother. His talent was recognized when he was a child, and he was able to take advantage of the educational opportunities newly offered to young Blacks. He was awarded a scholarship to the private, integrated, and experimental New Lincoln School and later studied at the High School of Art and Design, Pratt Institute, and the Yaddo artists' community in Silver Springs, New York, where he lived and worked for a year. A scholarship to the McDowell Colony, a residential community for artists in Peterborough, New Hampshire, was granted the following year. In the last Whitney Annual devoted to painting, Bailey was considered an outstanding talent. He was the first young artist honored with a one-man show at the Cinque Gallery in New York's Greenwich Village (see p. 190).[32] A group of his precisely executed drawings, shown in the small gallery at the

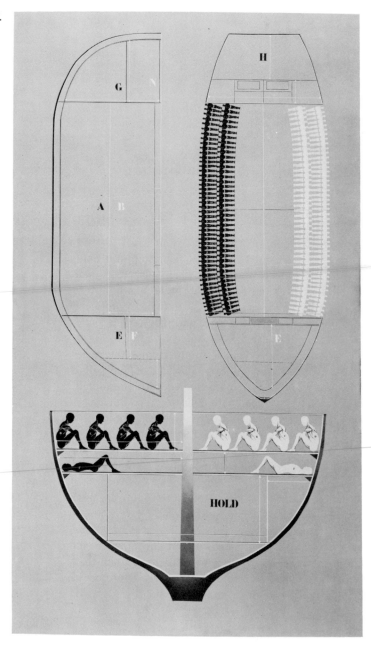

333. MALCOLM BAILEY. *Hold: Separate but Equal.* 1969. Synthetic polymer paint, presstype, watercolor, and enamel on composition board; 7 × 4′. Museum of Modern Art, New York (Mrs. John Jakobson Fund).

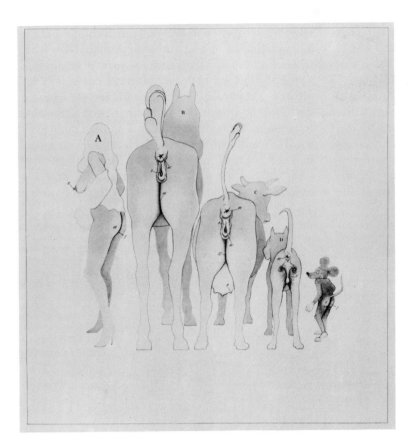

334. MALCOLM BAILEY. *Untitled.* 1970. Watercolor, pen, and ink; 27 × 22⅛". Museum of Modern Art, New York. (Alva Gimbel Fund).

335. ERNEST TROVA. *Untitled,* from the *Index* series. 1969. Serigraph; sheet 15 × 12½". Pace Editions, New York.

Whitney Museum of American Art in April of 1971, were erotic as well as political, amusing, and enigmatic. A comment upon male chauvinism and male sexual fantasies, the series was Bailey's attempt to work through his own sexism. The drawing reproduced in Figure 334 portrays a pink and rosy female nude, as seen from the rear, accompanied by a horse, a cow, a dog, and Mickey Mouse. Another from the series features pink vaginas drawn with the delicacy of a Victorian floral design, intermingled with charmingly delineated trees topped with delicate green foliage.

A later series of paintings includes elegant and sophisticated works spray-painted on Plexiglas (Pl. 36, p. 277). Large areas of pure color are interrupted by a small, white, crouching figure—the same figure that appeared in the *Separate but Equal* series. According to Bailey, the color and the shape of the figure are used for their design possibilities. The small figure is jumping off into the unknown, into a large area of cosmic space, while the larger one is upside down, again—according to the artist—for compositional rather than symbolic reasons. Nevertheless, the large figure could be construed as a mother image. The small, decorative area within the larger figure began as an anatomical study but became a problem in design. It could be that, in this series, the artist was influenced by Barnett Newman, for the large white figure acts in much the same way as the stripe that interrupts the serenity of the picture plane in a Newman canvas. Bailey was also impressed by the cosmic figurative works of Ernest Trova (Fig. 335).

Although many of Bailey's paintings and drawings employ a Black iconography, they are personal, subjective, and idiomatic.

Plate 35. GARY A. RICKSON. *Africa Is the Beginning*. 1969.
Acrylic mural, 2′6″ x 4′2″.
Warren Street and Martin Luther King Boulevard, Roxbury, Mass.

Plate 36. MALCOLM BAILEY. *Untitled No. 7*. 1972.
Enamel on Plexiglas, 4½″ x 6¾″. Courtesy William Zierler Gallery, New York.

left: Plate 37. Children draw and paint
at a street festival sponsored by MUSE,
Brooklyn. 1971.

below: Plate 38. Mural designed by BETTY BLAYTON
from paintings by students aged seven to eleven
and executed by the students
at "Childrens Art Carnival" (1971) under the patronage
of the Museum of Modern Art, New York,
and the Reader's Digest Association, Inc.
Lenox Avenue and 140th Street, New York.
(See also Fig. 342.)

336. Lovett Thompson. *The Junkie.* 1970.
Wood, 35 × 16″. Museum
of the National Center
of Afro-American Artists, Boston.

Lovett Thompson

A long rusty nail pierces the neck of *The Junkie* (Fig. 336), providing a sharp textural and directional contrast in Lovett Thompson's wood carving, featured in the "Afro-American Artists: New York and Boston" exhibition. With the tortured face of an African ritual sculpture and the linear flow reminiscent of a Brancusi marble, the piece, according to Benny Andrews (Figs. 310–313), speaks directly to the Black. (Brancusi, influenced by African sculpture in the early 20th century, sought to simplify his forms while maximizing his symbolism.) Andrews wrote that he "stood there transfixed by the artistic transference of this pathetic and tragic figure."[33] However, drug addiction is no longer a "Black problem," and Lovett Thompson, the self-taught sculptor, jewelry craftsman, and painter from Georgia, relays his message to all.

Conclusion and Commencement

Is There a Black Art?

When a group of Afro-American painters were asked the question, "What is Black art?" their responses were as varied as their art, ranging from militant Black artist Paul Keene's claim that Black art is the "graphic language of self-assertion and imminent maturation of Black people living in a degrading and oppressive society that offers little liberation of Black potential" to Tom Lloyd's rhetorical: "What is white art?"[1] To Jacob Lawrence (Pl. 6, p. 90), "Black art is that art which has a particular form that is recognized as 'Black'—regardless of content"; to Lois Mailou Jones (Pl. 12, p. 127) Black art is merely a "name of title given to work done by Black artists in an effort to bring about an awareness that Black artists exist."[2] Hale Woodruff (Pl. 9, p. 109) claims that: "There is some-

thing in Black art which is absent from the art of other people."[3] And Frank Bowling, Black artist and art critic, has written: "Black art, like any art, is art. The difference is that it is done by a special kind of people."[4] Hughie Lee-Smith (Pl. 14, p. 128) considers the vigorous, rough-hewn paintings produced by the artist-militants to be the early development of a grassroots Black art. Black art, writes Lee-Smith, is an art that:

> ... derives its inspiration and sustenance from the struggle of Black people for economic, social and cultural power; an art which reflects, celebrates, and interprets that struggle in a stylistic manner which is meaningful to the Afro-American community and members of other oppressed minorities.[5]

According to Malcolm Bailey (Pl. 36, p. 277), Black art cannot be defined. He writes of the absurdity of clas-

sifying together artists of different styles and points of view because of the similarity of their skin color. Bailey sees the role of the artist as something beyond "mirroring life (the political statement); he must instead interpret life in a very subjective abstract way."[6]

The impetus for creating a Black school of art began with Alain Locke during the New Negro Movement of the 1920s (see Chap. 4). If the Black artist were encouraged to seek inspiration from his ancestral heritage and from the ghetto community, Locke believed, an art unique to the Black man would emerge. Leopold Senghor, the "poet-philosopher of Negritude" and President of Senegal, holds that there are certain patterns of behavior and life styles indigenous to Africa that have survived in the United States and are indelibly stamped on all works of the Black—"the sense of communion, the gift of myth-making, the gift of rhythm."[7] Most Black intellectuals reject this concept, because it replaces science with mysticism. Anthropologists, while agreeing that the stated qualities exist in the Afro-American, describe them as characteristic of folk societies anywhere. Because he was isolated in the rural South, the Black developed a folk culture which he then transplanted to urban centers during the great waves of migration in the 20th century.[8]

If the qualities that the Black derived from his American experiences are not unique to him but are functional elements in folk cultures of other societies, and if, in most situations, cultural continuity with Africa was denied, what then separates the Black American artist from the white American artist? Little, save that which separates one artist from another artist —his time and place of birth, his genetic heritage, his talent, education, and training, his unique experience in maturing, his interaction with society, and society's responses to him. All these factors are influenced by the fact that the individual artist is Black, but they would pertain if the artist were female rather than male, rural rather than urban, poor rather than rich, or untalented rather than gifted. The question, "What is Black art?" is political rather than aesthetic. "Black art" is a convenient term used to identify the product of artists who happen to be Black at a time when political and social pressures force established American institutions to recognize the achievements of the Black.

Artists and critics continually seek to identify that which is uniquely Black in Black art, and they have usually failed to find common elements in the creative efforts of the Black. To resolve their commitments as artists in the Civil Rights movement, the Spiral group (see p. 154)—including Charles Alston, Romare Bearden, Hale Woodruff, Alvin Hollingsworth, Norman Lewis, Felrath Hines, and Merton Simpson—sponsored in 1963 an art exhibit that was limited, for symbolic reasons, to black-and-white paintings. No unifying theme emerged, nor did any evidence of an identifiable Black quality or Black art appear.[9] A similar conclusion had been reached in 1943 by the editors of an anthology of Afro-American writing. Seeking a unifying theme or an essence that would identify the authors as Black, the editors concluded that the label "Black Literature" described nothing:

> . . . [Afro-American literature] has no application if it means structural peculiarity, or a Negro school of writing. The Negro writes in the forms evolved in English and American literature. . . . [We] consider Negro writers to be American writers, and literature by American Negroes to be a segment of American literature. . . . The chief cause for objection to the term is that "Negro literature" is too easily placed by certain critics, white and Negro, in an alcove apart. The next step is a double standard of judgment, which is dangerous for the future of Negro writers.[10]

Much of the Blackness in Black art is imposed upon the artist by the white art world. Not willing to accept the Black into the established world of arts and letters, the leaders of that club have often courted lesser talents who exhibit identifiably Black elements in their work. Black art will continue to be American art, because its creators are Americans, and American influences continually mold it. To find a direct link with the art of his ancestral home, the Black artist must approach Africa with a fresh eye, which is difficult in this age, since the art of Africa has molded the aesthetic possibilities of almost all 20th-century art.

The Role of the Black Artist in American Art

The contribution of Afro-American art has been minimal, and this is not due to any generic lack of talent on the part of the Black. African art refutes that claim. Rather, it results from a combination of several factors —the early stifling of the African visual art tradition, economic and educational deprivation, the child-rearing practices of the Black middle class, and the psychological effects of the system of segregation. While Blacks have excelled in the performing arts, greatness in the visual arts has been denied them, according to the Swedish sociologist and economist Gunner Myrdal, by these conditions:

[They] can seldom get the training usually considered necessary to highest achievement in the arts; their segregated schools are usually inadequate; they are restricted in their contacts and, much more than whites, lack the atmosphere congenial to creative work. They are seldom allowed to get far from the race problem; many white critics have a double standard—more indulgent to Negroes—when comparing the products of Negro and white artists. . . .[11]

The enforced separation from the African visual heritage created a people whose nonvisual orientation was self-perpetuating. The Black people had not produced many painters and sculptors; therefore, the Black community was but rarely exposed to the Black as a creative artist. The Black artist remained unknown to the children in the Black community and, until recently, art exhibitions were seldom offered to ghetto residents; young Black children were not often brought to museums by their parents; a significant communication gap existed among Black artists, and between the Black artist and the community; the Black middle class has not supported the Black artist; and Black scholarship has emphasized social and historical criticism, rather than art criticism. In order for the Afro-American to make a contribution to American art, the Black community must be educated to produce not only artists but also consumers and critics of art, as well as urban specialists capable of planning the visual environment.[12]

Because of their poverty, most Blacks do not have the finances or leisure to launch artistic careers and until the last few years they have had little encouragement or support from their communities or schools. Black educators evidently thought art was peripheral to the learning experience. In the 38 years of its existence, the *Journal of Negro Education* has published one article—in 1935!—related to the visual art needs of the Black child. The author claimed that the Black, with his "particular genius . . . for rhythm" and "natural forte for lyrical intensity," could create a highly individualized art. He blamed the schools for not encouraging the Black artist—on the elementary and secondary levels, where few schools had faculty and equipment to facilitate creativity, and on the college level, where few, if any, courses were offered in creative fields other than music.[13]

The visual environment of the ghetto child (Fig. 337) acts to thwart his aesthetic development, and the child-rearing practices of the Black middle class, the group that usually produces artists, tend to inhibit the spontaneity needed for creative development. The studies of psychologist Cynthia Deutsch hypothesize that an "early noisy background impedes the proper development of auditory discrimination." The complex visual stimuli presented to the ghetto child may have a similar effect. Rather than learning to discriminate among visual stimuli, the child may "turn it off." His home—a visual environment of cracked plaster, chipped linoleum, and crowded sleeping quarters—affects him in a negative way (Fig. 338).[14] The child of the lower classes is impulse-oriented and present-oriented. He acts out his aggressions in a physical way. In order to avoid identification with the lower-class Black, the child of middle-class parents has been thwarted early in his independent and assertive tendencies. He is taught to control his impulses, to adhere to the rigid rules of middle-class respectability, and to conform to

left: 337. Children in an abandoned lot, New York.